Sicily is the pearl of this century, for its qualities and its beauty, for the uniqueness of its towns and inhabitants. Since old times, travellers from the most far away countries […] boast of its merits, praise its territory, rave about its extraordinary beauty, and highlight its strengths and the various gifts it enjoys, because it brings together the best aspects from every other country.

AL-IDRISI, ARAB GEOGRAPHER, *THE BOOK OF ROGER*, AD 1138–54

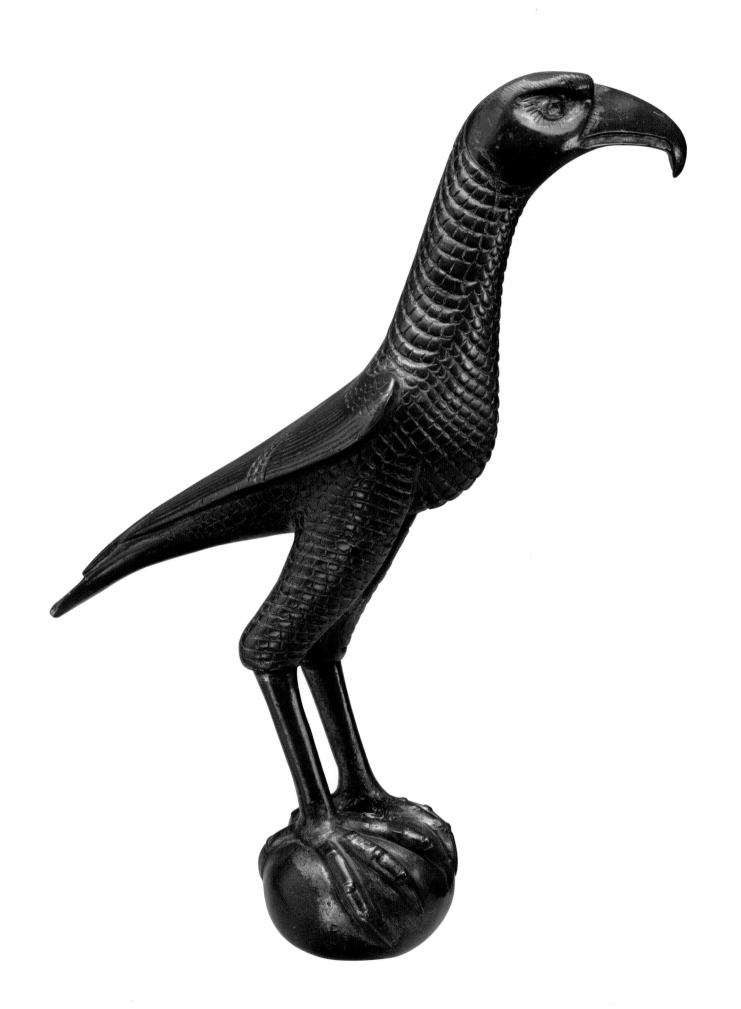

Sicily
culture and
conquest

Dirk Booms and Peter Higgs

The British Museum

This publication accompanies the exhibition *Sicily: culture and conquest* at the British Museum
21 April–14 August 2016.

The exhibition is sponsored by

In collaboration with

Regione Siciliana,
Assessorato dei
Beni Culturali e
dell'Identità Siciliana

The exhibition has been made possible by the provision of insurance through the Government
Indemnity Scheme. The British Museum would like to thank the Department for Culture, Media
and Sport, and the Arts Council England for providing and arranging this indemnity.

First published in 2016 by The British Museum Press
A division of The British Museum Company Ltd
38 Russell Square, London WC1B 3QQ

Many of the images in this book are © Regione Siciliana, Assessorato dei Beni Culturali e
dell'Identità Siciliana – Dipartimento dei Beni Culturali e dell'Identità Siciliana, and are reproduced
with their kind permission. For a full list of illustration acknowledgements, see pp. 279–81.

A catalogue record for this book is available from the British Library

ISBN 978 0 7141 2289 2

Designed by Will Webb Design
Printed in Italy by Printer Trento SRL

Papers used by The British Museum Press are recyclable products made from wood grown in
well-managed forests and other controlled sources. The manufacturing processes conform to the
environmental regulations of the country of origin.

Half-title page: Detail of a map of Sicily from a copy of al-Idrisi's 'Book of Roger' (see fig. 188).
Cairo, Egypt, 1553. The Bodleian Libraries, University of Oxford.

Frontispiece: Gilded bronze falcon (see fig. 212). Sicily, 1200–20. Metropolitan Museum
of Art, New York.

p. 5: Ceramic bowl decorated with a bull or fantastical animal. Sicily, 950–1050. Soprintendenza
Beni Culturali e Ambientali di Palermo.

p. 7: Limestone column in the form of a woman (see fig. 98). Iaitas (Monte Iato), *c*.200 BC.
Parco Archeologico di Monte Iato.

Contents

Foreword by the Regione Siciliana

The exhibition *Sicily: culture and conquest* is part of a fruitful cultural collaboration between the British Museum and the Assessorato dei Beni Culturali. Among this collaboration's most significant moments is surely the loan of the 'Mozia Charioteer', which was displayed in the Parthenon Gallery on the occasion of the 2012 Olympics.

This new exhibition explores four thousand years of history through some of the most important objects from museums in Sicily and around the world: a journey through time which emphasizes the central role that the island has played in the history of the Mediterranean.

The ability to communicate with different peoples and cultures has been, in the past as much as today, Sicily's most distinctive feature, and the island has drawn its essence and drive for innovation precisely from this extensive network of contacts and exchanges between East and West.

We are extremely proud to be present at the British Museum through this extraordinary exhibition, which, along with its numerous accompanying events, will raise awareness of our rich cultural heritage as well as promote the understanding of and interest in our art. We also invite visitors of the exhibition to explore our museums and archaeological sites and to discover more of the extraordinary history of this island.

We hope to continue on this journey with the British Museum, promoting new initiatives and mutually worthwhile opportunities for dialogue and discussion between the ancient and the new.

GAETANO PENNINO

Il Dirigente Generale
dei Beni Culturali
e dell'Identità Siciliana

CARLO VERMIGLIO

L'Assessore
dei Beni Culturali
e dell'Identità Siciliana

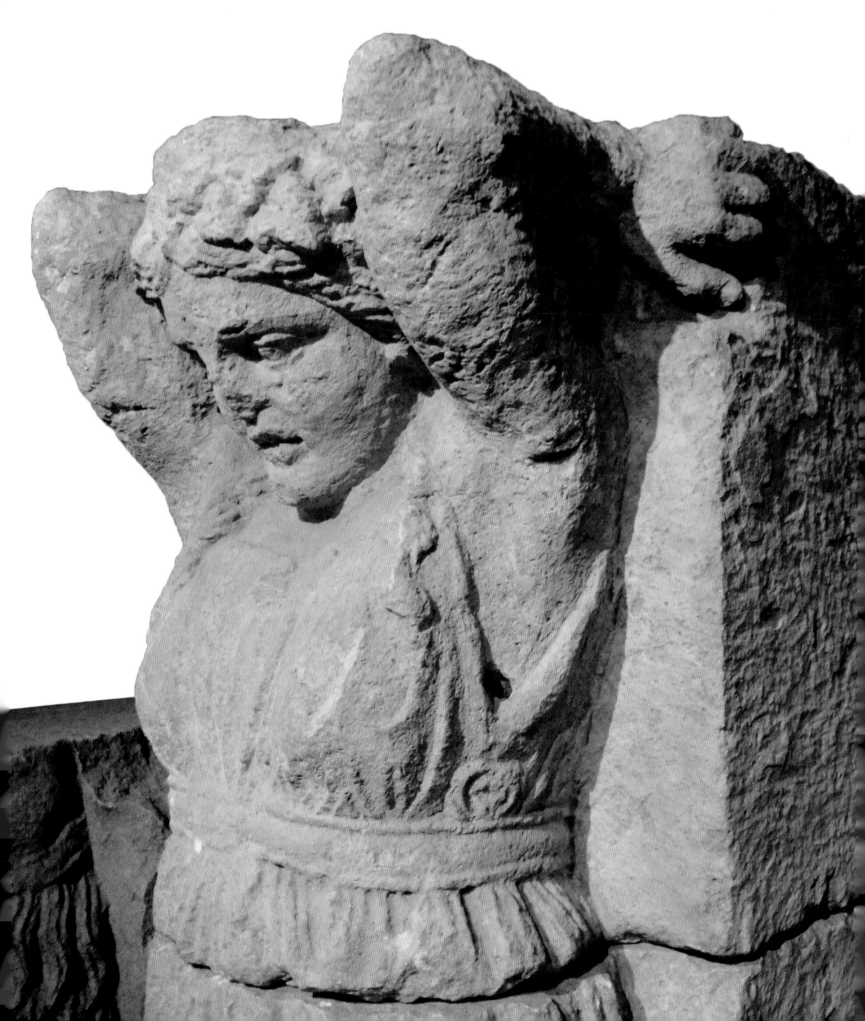

Sponsor's Foreword

Julius Baer, a leading Swiss private banking group, is immensely proud to extend its partnership with the British Museum for the exhibition *Sicily: culture and conquest*.

Being in business for more than 125 years has given us a deep understanding of client care, a passion for bespoke investment services and a tradition of excellence in all we deliver. This also applies to the many engagements with arts and culture we have developed over the past decades. Both expert wealth management and impressive exhibitions such as this one rely on organisations that work together over the long-term and are united by common ambitions. By sponsoring this exhibition we support the values that the British Museum has represented for centuries. Exploring the pivotal role that Sicily played in the history of the Mediterranean and the different peoples and cultures that shaped it over the centuries is not only of benefit for cultural enthusiasts but also opens up a depth of understanding for society at large.

I hope that visitors share our enthusiasm for this exhibition and all of the supporting work beautifully presented in this accompanying book. We are delighted to be associated with such an important institution as the British Museum.

DAVID DURLACHER

CEO of Julius Baer International Limited,
United Kingdom & Ireland

Julius Bär
YOUR WEALTH MANAGER

Director's Foreword

Sicily, located at the heart of the Mediterranean and made fertile by the volcanic soils of Mount Etna, has over the centuries seemed a desirable prize to successive waves of conquerors and settlers. Those who made their lives there, surrounded by the island's natural wealth, created an equally rich and extraordinarily diverse cultural heritage. The island now preserves treasures of architecture and art that reflect the layered history of all the peoples in its past.

Thanks to the friendly collaboration and great generosity of the Regione Siciliana, Assessorato dei Beni Culturali e dell'Identità Siciliana, the exhibition *Sicily: culture and conquest* has been created to highlight two vibrant periods in this history. The first is that of the sweeping expansion of the Greeks, who would prosper on Sicily, and mark the island's landscape by building temples on a truly impressive scale. The second is the period following the invasion of the Normans, when enlightened rulers created multicultural courts that were the envy of the world. Outstanding pieces from Sicily, often coming to the UK for the first time, are combined with important loans from other collections, along with material from the British Museum, to tell this fascinating and often unexpected story.

None of this would have been possible without the exceptional generosity of our sponsor Julius Baer who share our belief that the multicultural worlds of the past are of significant interest to us in the global present day. We are immensely grateful to them for their unstinting support.

HARTWIG FISCHER

Director
The British Museum

Authors' Acknowledgements

This book accompanies the exhibition *Sicily: culture and conquest*. Neither could have been achieved without the help of a large number of people, and it is a pleasure to express here our warmest thanks to all involved, both within and outside the British Museum. The in-house teams have, as ever, been impressive in their efficiency and heart-warming in their willingness to go the extra mile, especially in the Department of Greece and Rome, the Conservation Department, the Exhibitions Department, and the Registrar's Department. External collaborators and advisors have provided not only essential content but also guidance and inspiration. All have supported us during this exploration of Sicily – a truly lovely island with an intricate and remarkable history.

Our research took us to the island on many occasions, and over and over again our hosts could not have done more to welcome and assist us. Special honours should go to Maria Lucia Ferruzza, Valeria Sola, Alessandra Merra and Sergio Alessandro, who believed in the project from the start. Their continuing efforts made the exhibition and its accompanying publication a joy to work on. At every site and every museum we visited we were greeted with the highest degree of hospitality, and we were overwhelmed by the immense knowledge of Sicily and its history that the directors and curators seemed to display quite effortlessly. We benefited enormously from meetings and discussions with the following: Carla Aleo Nero, Rosalba Amato, Gioacchino Barbera, Giuseppe Barbera, Paolo Baressi, Beatrice Basile, Stefano Biondo, Gaetano Bongiovanni, Carlo Castello, Enrico Caruso, Enza Cilia Platamone, Evelina De Castro, Gabriella Costantino, Laura Danile, Maddalena De Luca, Pippo D'Ippolito, Giovanni Di Stefano, Maria Luisa Famà, Padre Nicola Gaglio, Caterina Greco, Tommaso Guagliardo, Lucia Iacono, Gioconda Lamagna, Angela Maria Manenti, Donatella Mangione, Guido Meli, Sebastiano Messineo, Giuseppe Mineo, Maria Musumeci, Francesca Oliveri, Pierfrancesco Palazzotto, Dino Pantano, Giuseppe Carmelo Parello, Maria Concetta Parello, Lorella Pellegrino, Gaetano Pennino, Elena Pezzini, Antonio Purpura, Mons. Giuseppe Randazzo, Viva Sacco, Giovanni Scaduto, Mariarita Sgarlata, Orietta Sorgi and everyone at the CRicd, Francesca Spatafora, Giovanna Susan, Claudio Torrisi, Emanuele Turco, Sebastiano Tusa, Stefano Vassalo, Carlo Vermiglio and Maria Elena Volpes.

We were also lucky enough to be able to count on the enthusiasm, encouragement, generosity and professionalism of institutions outside Sicily, and invaluable support was given by: Bruce Barker-Benfield, Heinz Beste, Christine Brennan, Caroline Campbell, Thomas Campbell, Francina Chiara, Andrea Clarke, Padre Gerardo Cioffari, Ortwin Dally, Savino De Bonis, Marco Delogu, Emma Denness, Helen Evans, Sarah Hardy, Melanie Holcomb, Esther Iseppi, Kirstin Kennedy, Roly Keating, Professor Nasser D. Khalili, John Lewis, Claire Lyons, Griffith Mann, Barbara O'Connor, Cilian O'Hogan, Richard Ovenden, Nicholas Penny, Claudio Parisi Presicce, Jerry Podany, Mateusz Polakowski, Jonathan Prag, Anooshka Rawden, Daniela Ricci, Paul Roberts, Mariam Rosser-Owen, Martin Roth, Jeffrey Royal, Teresa Saibene, Paola Santarelli, Suzanne Smith, Alexandra Sofroniew, Alasdair Watson and Paul Williamson.

For help specifically with the publication, we are hugely indebted to a number of scholars, all of whom were generous in sharing with us their deep knowledge, their enthusiasm, their Sicilian experiences and their thoughts: Caroline Barron, Andrew Burnett, Franco De Angelis, Corisande Fenwick, Matthew Fitzjohn, Caroline Goodson, Jeremy Johns, Charles Little, Alexander Metcalfe, Nahla Nassar, John Julius Norwich, Cilian O'Hogan, and Roger Wilson.

Also many colleagues at the British Museum helped us in various ways, and it is a great pleasure to acknowledge amongst them: Richard Abdy, Charles Arnold, Barrie Cook, Lloyd DeBeer, Sami De Giosa, Amelia Dowler, Celeste Farge, Dudley Hubbard, Alan Johnston, Thomas Kiely, Vanessa Moore, Kate Morton, Elisabeth O'Connell, Venetia Porter, Charo Rovira, Andrew Shapland, Naomi Speakman, Fahmida Suleman, Judith Swaddling, Ross Thomas, John Williams, Jennifer Wexler and Neil Wilkin.

In addition, this book was created by a fantastic team at the British Museum Press. Our editor Coralie Hepburn, along with Axelle Russo-Heath, Laura Fox and Kate Oliver, worked tirelessly to get our text into shape, always patiently waiting for the next chapter and invariably needing to shift deadlines to help us out. Their diligence and eye for detail made the book really come alive.

It is always perilous to give lists of names when all cannot be included, so we can only hope that a catch-all but nonetheless heart-felt thanks, like an ancient dedication 'to all the gods', might be felt to fill the gaps. Nevertheless, special recognition should go to Project Manager Matthew Payne, Interpretation Officer Rebecca Penrose, Designer Jonathan Ould, Loans Administrator Christopher Stewart and our Head of Department Lesley Fitton.

Finally, we should thank our respective partners, Samantha Cox and Maria Gonet, for their patience and ability to endure a project not their own over the course of the last four years.

DIRK BOOMS AND PETER HIGGS

List of Lenders

The British Museum would like to thank all the lenders to the exhibition for their generosity:

ITALY
Archivio di Stato, Palermo
Deutsches Archäologisches Institut, Rome
Fondazione Antonio Ratti, Museo Studio del Tessuto, Como
Fondazione Dino ed Ernesta Santarelli, Rome
Galleria Interdisciplinare Regionale della Sicilia di Palazzo Abatellis, Palermo
Musei Capitolini, Rome
Museo Archeologico Regionale Antonio Salinas, Palermo
Museo Archeologico Regionale, Gela
Museo Archeologico Regionale Paolo Orsi, Siracusa
Museo Archeologico Regionale Pietro Griffo, Agrigento
Museo Diocesano di Palermo
Museo Nicolaiano, Bari
Parco Archeologico di Monte Iato
Soprintendenza Beni Culturali e Ambientali del Mare
Soprintendenza Beni Culturali e Ambientali di Palermo

UNITED KINGDOM
The Bodleian Libraries, University of Oxford
The British Library, London
Nasser D. Khalili Collection of Islamic Art, London
The National Gallery, London
Society of Antiquaries of London
Victoria and Albert Museum, London

UNITED STATES OF AMERICA
The Metropolitan Museum of Art, New York

Chronology

2500–1500 BC
Early Bronze Age

1500–1200 BC
Middle Bronze Age

1200–900 BC
Late Bronze Age

900–734 BC
Early Iron Age

900–700 BC
Phoenicians establish trading posts on the island at Ziz (Palermo), Motya and Solunto in western Sicily.

734–580 BC
Period of Greek settlement on the island.

734 BC
Naxos founded as first permanent Greek settlement.

570–554 BC
Phalaris becomes the first 'tyrant' ruler on the island at Akragas (Agrigento).

480 BC
Battle of Himera between the Carthaginians and the combined forces of the tyrants Gelon I of Gela and Syracuse and Theron of Akragas.

474 BC
Battle of Cumae: Hieron I, Tyrant of Syracuse, defeats the Etruscans.

452 BC
Sicel leader Ducetius (died 440) leads a revolt against Greek rule, which is crushed by Syracuse.

415–413 BC
Athenian Invasion of Syracuse. The Athenian army and naval fleet are destroyed, leaving 7000 soldiers as prisoners.

410–405 BC
Carthaginians invade western Sicily, destroying the important Greek cities of Himera, Selinous, Akragas, Gela and Kamarina.

405–367 BC
Dionysios I is Tyrant of Syracuse.

400 BC
Carthaginians establish a permanent presence at Palermo.

398 BC
The philosopher Plato visits Syracuse.

339 BC
Timoleon restores democratic law in Syracuse after a series of unpopular rulers.

317–289 BC
Agathokles, native of Himera, first becomes Tyrant of Syracuse, then King (304 BC).

310 BC
Greeks under Agathokles invade Carthaginian territories of African coast. A treaty is signed in 306 BC.

270–215 BC
Long and relatively peaceful reign of Hieron II of Syracuse, who unites much of Greek Sicily.

263 BC
Hieron II allies with the Romans.

241 BC
Battle of the Egadi Islands between Carthaginians and Romans. Sicily becomes Rome's first province. Syracuse remains autonomous.

213–211 BC
Siege of Syracuse by Romans.

212/211 BC
Death of Archimedes, the Syracusan scientist and mathematician.

135–132 BC and 104–100 BC
Slave revolts on the island, violently put down by Rome.

44–36 BC
Sextus Pompey (son of Pompey the Great) rules the island. He blocks export of grain to Rome until it (Octavian) recognizes him as ruler.

AD 68
The provincial governor in Carthage, Lucius Clodius Macer, seizes Sicily and blocks the export of grain to Rome.

AD 468
Vandals conquer Sicily.

AD 476
Odoacer, King of Italy, conquers Sicily.

AD 493
Ostrogoths conquer Sicily.

AD 535
The Byzantine general Belisarius conquers Sicily for Emperor Justinian, as a base to reconquer the rest of Italy from the Lombards.

AD 660s to AD 668
Emperor Constans II makes Syracuse capital of the Byzantine Empire, to counter the continuing threat of the Lombards from the north, and the Arabs from the south.

AD 660s
Start of repeated Arab raids on Sicily from North Africa.

AD 827–965
Arab conquest of Sicily.

AD 1038
Byzantine-led army under general George Maniakes invades Sicily.

AD 1061–1091
Norman conquest of Sicily by Robert Guiscard and Roger de Hauteville.

AD 1112
Roger, son of Roger de Hauteville, becomes Count of Sicily.

AD 1130
Count Roger crowned King of Sicily.

AD 1130–54
Rule of Roger, King of Sicily (commonly known as Roger II; † 1154).

AD 1146–8
Norman conquests of parts of North Africa (lost again in 1158–60).

AD 1147–9
Normans fight with Byzantines, the Norman fleet even reaching the walls of Constantinople.

AD 1154–66
Rule of William, King of Sicily (commonly known as William I; † 1166).

AD 1154–5
The German Emperor Barbarossa plans to take southern Italy and Sicily with help of the pope, but he loses heart.

AD 1155–7
The Byzantine fleet tries to conquer southern Italy and Sicily, but William I defeats it.

AD 1161
Revolt against William I by the baronial class, and pogroms against Muslim population.

AD 1166–89
Rule of William II, King of Sicily († 1189).

AD 1189
At death of William II, pogroms against Muslim population break out. An illegitimate grandson of Roger II, Tancred of Lecce, is crowned King.

AD 1189–1194
Roger II's daughter and legitimate heir Constance and her husband, the German Holy Roman Emperor Henry VI (son of Frederick Barbarossa) try to reconquer Sicily.

AD 1194
Birth of Frederick II, son of Constance († 1198) and Henry VI († 1197). Henry VI crowned King of Sicily.

AD 1198
Frederick II Hohenstaufen crowned King of Sicily.

AD 1220
Frederick II crowned Holy Roman Emperor in Rome.

AD 1228–9
Frederick II goes on the Sixth Crusade, peaceful surrender of Jerusalem. Frederick crowned King of Jerusalem.

AD 1250
After Frederick II's death, his heirs Conradin and Manfred have to fight successive popes to keep the island.

AD 1266
Death of Frederick's illegitimate son Manfred. Sicily taken by pope and his champion, Angevin French prince Charles of Anjou. French invade Sicily.

AD 1282
Sicilian Vespers: rebellion against the French, while Charles of Anjou is in southern Italy.

AD 1282
Peter of Aragon (husband of a daughter of Manfred) crowned King of Sicily.

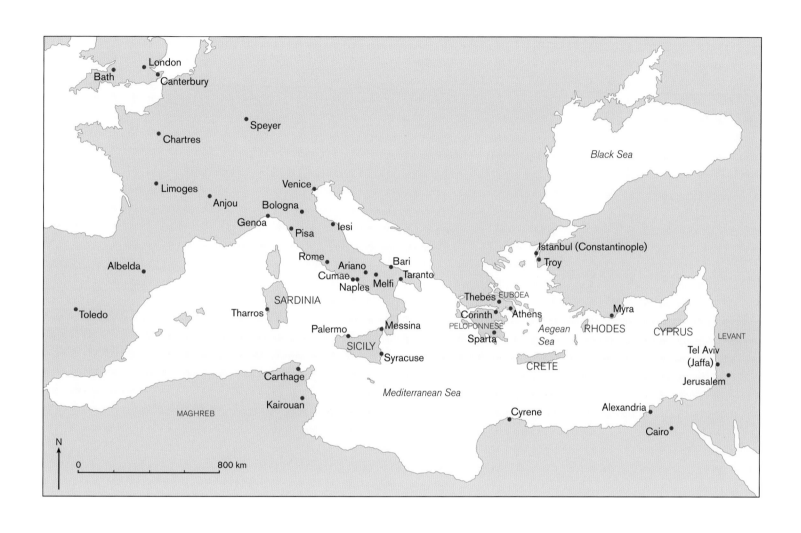

London
Bath
Canterbury
Speyer
Chartres
Black Sea
Limoges
Venice
Anjou
Bologna
Genoa
Iesi
Pisa
Istanbul (Constantinople)
Rome
Bari
Troy
Albelda
Ariano
Taranto
Cumae
Melfi
Naples
Thebes
EUBOEA
Toledo
SARDINIA
Corinth
Athens
Tharros
PELOPONNESE
Myra
Palermo
Messina
Aegean Sea
RHODES
CYPRUS
LEVANT
SICILY
Sparta
Syracuse
CRETE
Tel Aviv (Jaffa)
Carthage
Jerusalem
Kairouan
Mediterranean Sea
Cyrene
Alexandria
MAGHREB
Cairo

N

0 800 km

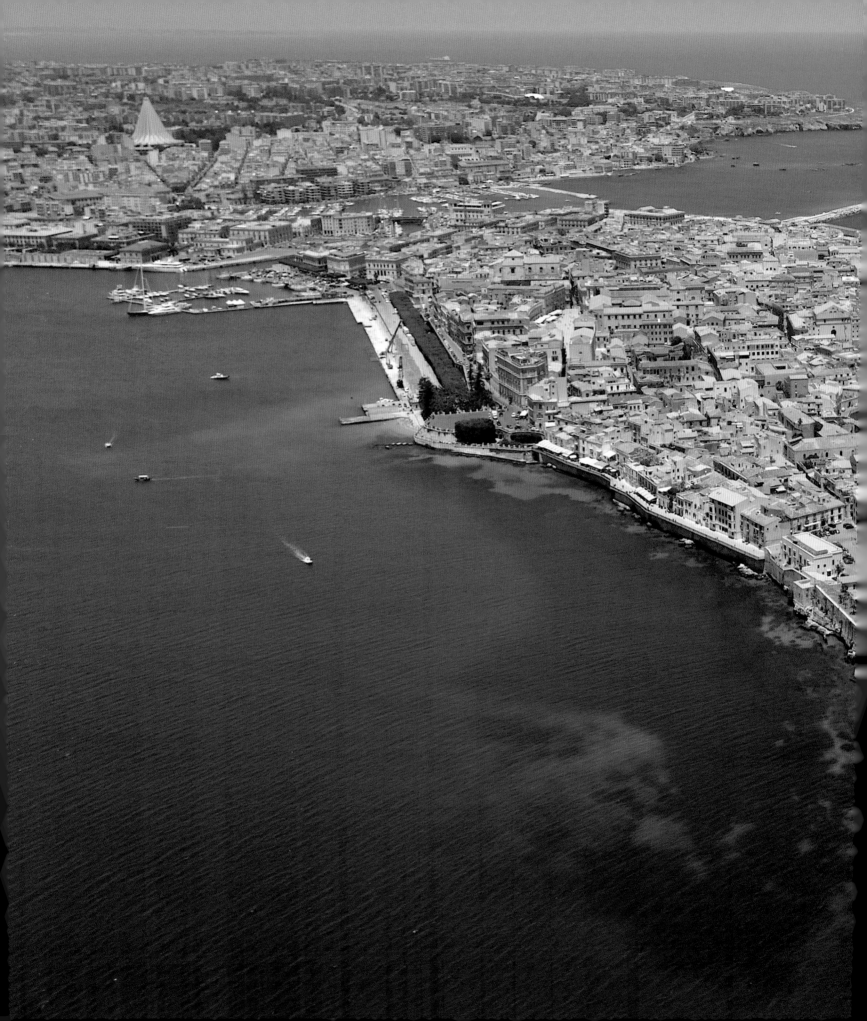

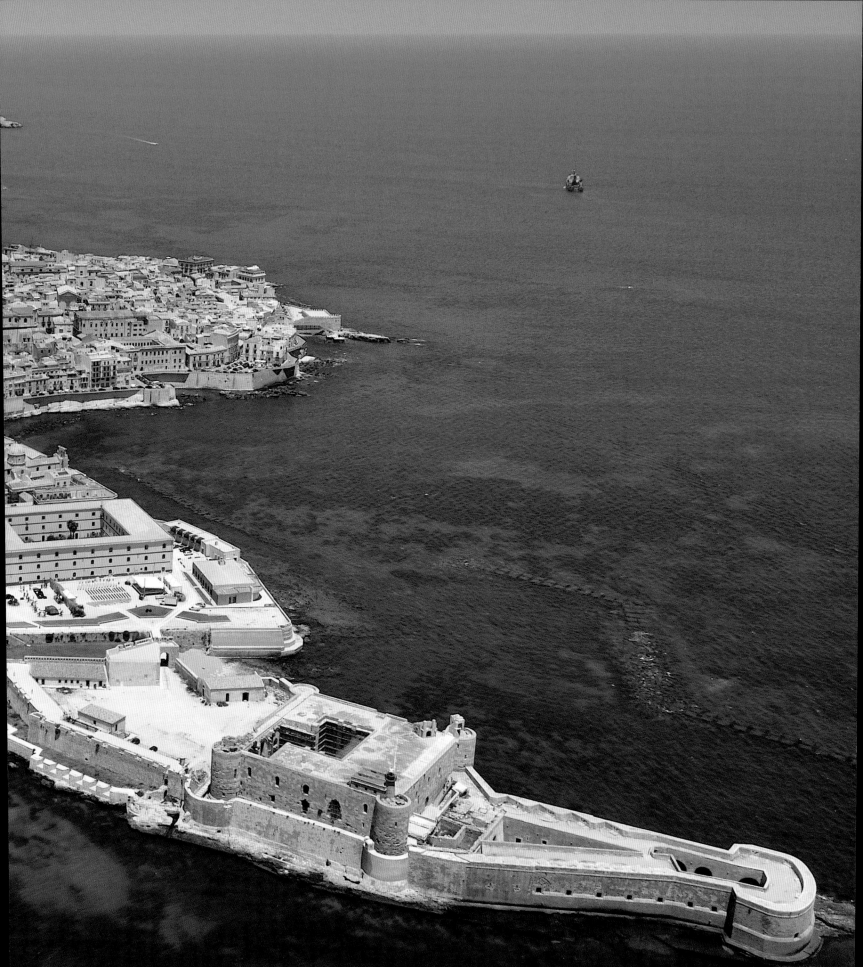

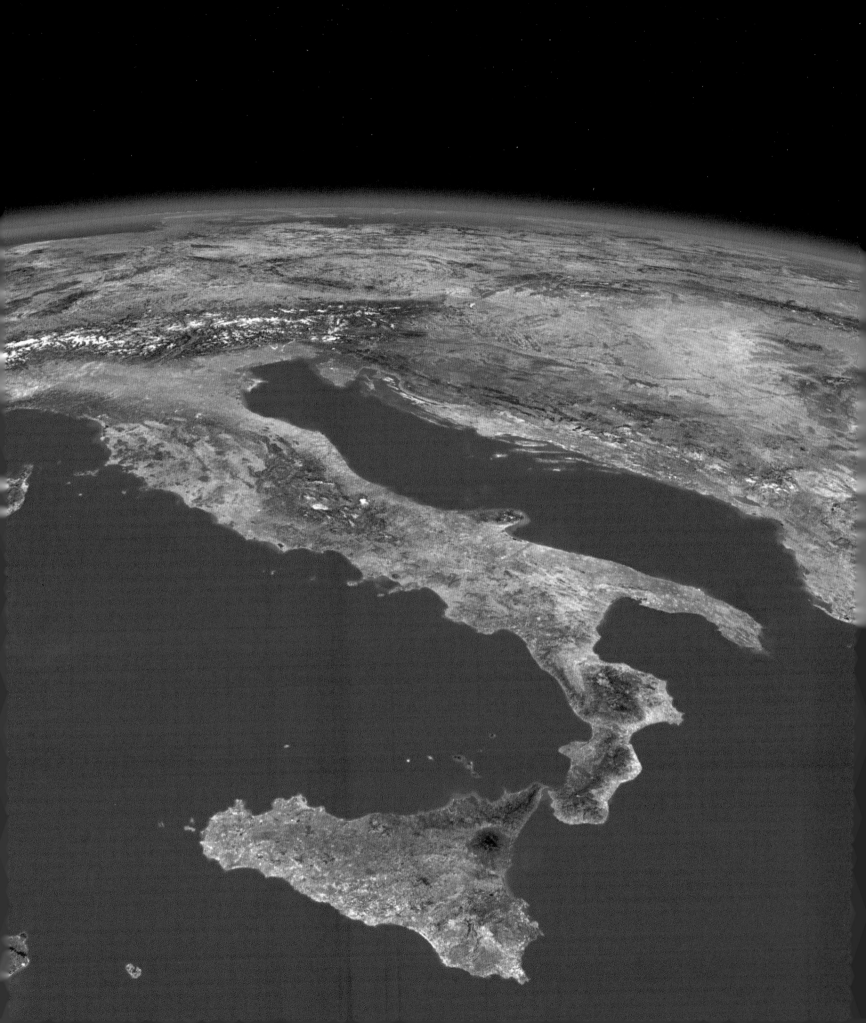

Italy without Sicily leaves no impression on the soul,
for Sicily is the key to everything.
JOHANN WOLFGANG GOETHE, *ITALIENISCHE REISE*, 1816–17

Sicily is simply a landscape, but it is a landscape in which
one finds absolutely everything which on this earth seems to
have been made to seduce the eyes, the soul and the imagination.
GUY DE MAUPASSANT, *EN SICILE*, 1886

Sicily, the largest island in the Mediterranean Sea, lies also exactly at its centre and as such has been a meeting ground for almost every culture bordering it. Although in modern times mostly thought of as European, it has an incredibly multicultural history, with at various times extremely close cultural and political ties to places as diverse as Spain, Morocco, Egypt, England, and even modern-day Turkey and Asia Minor, via the Ionian and Aegean Seas. As an island at the border of Europe, physically and culturally detached from the rest of Italy, it looked south as much as it looked north. Its wealth and allure lay in its fertile soil, continuously fed by the volcanic dynamics of Europe's most active volcano, Mount Etna. Those fertile lands and its position as a gateway have made it one of the most fought-over lands in both ancient and modern times.

Ultimately, Sicily's culture and identity were shaped by successive waves of conquest, settlement and co-existence by different peoples. Periods of decline, exploitation and neglect alternated with those of enlightenment and prosperity, during which art flourished. Two periods in its history stand out, not surprisingly two periods when Sicily was being ruled as its own kingdom by leaders based on the island, rather than as a peripheral province by an outside force.

From the latter half of the eighth century BC, the Greeks started settling on parts of Sicily, encountering Phoenician settlers and other groups of people who had migrated to the island much earlier. The result was a Greek society that was not only influenced by these other cultures, but that also wanted to proclaim its independence from the motherland by creating and building differently. This period peaked between the fifth and third centuries BC, during which Sicily's main city Syracuse managed to annihilate Athens' military fleet in 413 BC that had come to subjugate the island. It also saw the emergence of one of the most enlightened courts of antiquity under Hieron II, who invited the most talented people to his court: poets, writers, and inventors such as Archimedes. When that society was defeated by the up-and-coming Roman empire, which made Sicily its first province, a dark period of almost 1,300 years started, that saw the island subsequently conquered by the Vandals, the Goths, the Byzantines and the Arabs, the leaders of all of which, based far away from the island, were solely interested in its wealth.

A second period of enlightenment arose towards the end of the eleventh century, when Norman adventurers in search of new opportunities took the island from the Arabs. Though encountering a Muslim-dominated society with Christian and Jewish elements, these Christian conquerors deliberately chose to create a new artistic and architectural style that emphasized the different cultural elements already present, and further incorporated influences from Constantinople and, of course, their former homeland, Normandy in France. These Norman

Fig. 1 (previous page)
The island of Ortygia, the core of the city of Syracuse.

Fig. 2 (opposite)
Sicily's proximity to both the Italian peninsula and North Africa is clearly visible on this satellite image.

kings repeatedly but successfully fought popes, Byzantine emperors, and Arab dynasties of North Africa to keep their island. They eventually only reigned for one century, but they rivalled every superpower of the time. The Norman kingdom would continue and experience a final sparkle during the reign of the Holy Roman Emperor Frederick II, the most enlightened medieval ruler of Europe. But at his death in AD 1250 Sicily became a battleground between different European nations, a toy to be handed out to whomever was on better terms with the pope. The next several centuries saw Sicily lose its multicultural aspects and relive dark periods under subsequent Angevin, Aragonese, Habsburg, Savoy and Bourbon rulers, few of whom actually resided on the island, but all of whom (and the viceroys in their service) exploited the population. Those things that made Sicily unique – a multicultural land of tolerant rulers who at the same time were philosophers and scientists, poets and academics – disappeared when the Middle Ages started to fade. The island itself was virtually ignored by the Renaissance, and Sicily would never create another artistic legacy it could call its own, only varieties of other

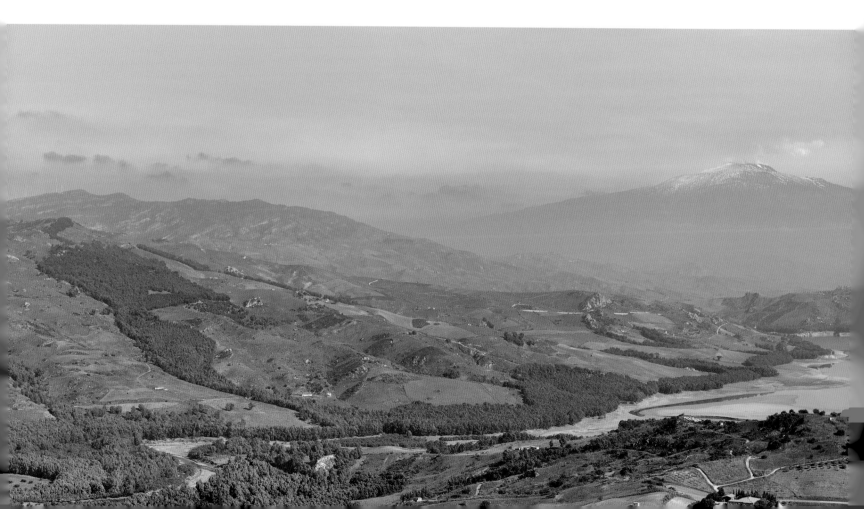

styles, the most famous one being the so-called Sicilian Baroque. It became the poorest region of Italy, forgotten, neglected and looked down upon, not even connected to the mainland. Whoever could leave, would leave. This would never, however, prevent Sicily from bringing forth some of the greatest of artists, sometimes even leaders and forerunners of Italy's artistic and cultural movements, from the Renaissance onwards until today: Antonello da Messina, Mario Minniti, Giacomo Serpotta, Vincenzo Bellini; or in the last century, Luigi Pirandello, Renato Guttuso, Giuseppe Tornatore and Andrea Camilleri.

> *We Sicilians have thought for too long of Sicily only as a point of departure. Instead, we need to reclaim our land … Sicily carries within it a special magic that is difficult to put in words. One has to live it to understand it: the smell of bitter almonds, Etna, the waters of the Mediterranean, the fragrance of oranges.*

CARMEN CONSOLI, SINGER–SONGWRITER, *L'UNITÀ*, 17 DECEMBER 2003

Fig. 3
Mount Etna to the east, from the town of Agina. In the foreground, Lake Pozzillo.

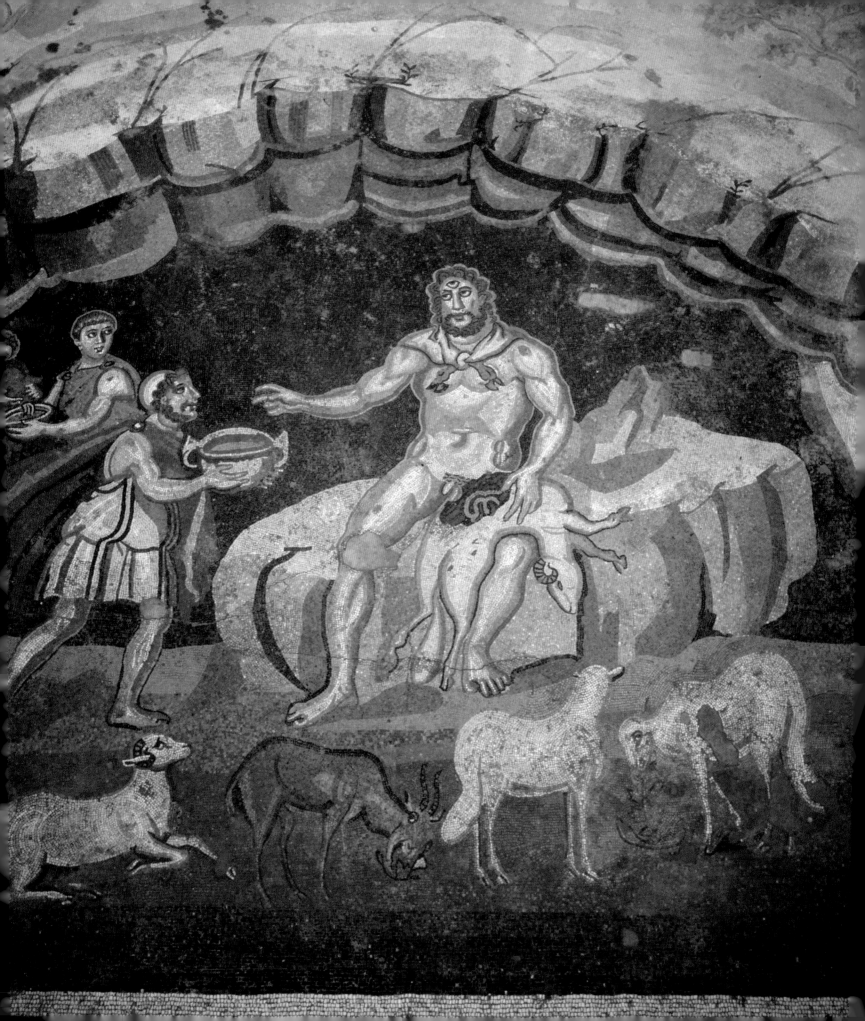

Land of Gods and Heroes

This is the homeland of the Gods of Greek mythology. Near these places, Hades abducted Persephone from her mother. In this wood we just walked through, Demeter ceased her swift running and tired of her fruitless search, sat on a rock, and despite being a goddess, she wept, the Greeks say, since she was a mother. In these valleys, Apollo pastured his flocks; these groves, stretching down to the seashore, have echoed with Pan's flute; the nymphs got lost under their shade and breathed their scent. Galatea fled from Polyphemos and Acis, close to succumbing to the blows of his rival, enthralled these shores leaving his name here [...] In the distance you can see the lake of Herakles and the rocks of the Cyclops. Land of gods and heroes!

ALEXIS DE TOCQUEVILLE, *VOYAGE EN SICILE*, 1861

'Land of gods and heroes!' is how the French historian Alexis de Tocqueville described Sicily in his *Voyage en Sicile*. His words deftly sum up the rich and diverse ancient stories that revolved around the island. The ancient Greeks loved travelling and treasured storytelling; writers, poets and historians consumed these tales of gods, heroes and monsters, weaving them into epic tales of exploration and wonder.

More than anything, it was Sicily's geology that inspired a host of ancient stories, many of its most distinctive features rationalized through legendary heroes and heroines. For instance, the so-called Isole dei Ciclopi ('the Islands of the Cyclopes'), to the north-east of Catania, found their mythical origins in Homer's *Odyssey*. It was here that the one-eyed giants once lived, the most infamous being Polyphemos, son of the sea god Poseidon.[1] In Homer's epic tale, Polyphemos captured and imprisoned Odysseus and his companions in his cave, sealing the entrance with a huge, immovable boulder.[2] Almost at once the giant Cyclops seized two of Odysseus' men and began to feast on their flesh and bones. More of the prisoners were devoured the following day until Odysseus sprang into action, got Polyphemos intoxicated with wine (fig. 4), and then blinded him with a stake.[3] He and the surviving men escaped from the cave by clinging under the bellies of Polyphemos' sheep, which were kept in the cave overnight (see fig. 32). In great fury at Odysseus' trickery, the blind Polyphemos threw huge rocks at Odysseus' boats, which narrowly missed them, and the heroes escaped from the island. Although this wonderful story lives on, the reality is that these enormous 'Cyclopean' rocks were formed by volcanic activity (fig. 5).

An even more celebrated story concerning Sicily's coastline and seas also derives from Homer's account of Odysseus' adventures. The tale prompted the modern phrase 'between Skylla and Charybdis': an expression used when a decision has to be made between two equally hazardous choices. In Homer's epic tale Odysseus has to sail through a narrow channel, one that in later tradition was identified as the Strait of Messina between Sicily and mainland Italy. Skylla was described as a six-headed monster, while Charybdis was a perilous whirlpool. Strabo, the ancient geographer, vividly describes this treacherous maritime feature:

Fig. 4 (opposite)
Fourth-century mosaic of Polyphemos from the Villa Romana del Casale at Piazza Armerina.

Fig. 5
The Isole dei Ciclopi (the Islands of the Cyclopes).

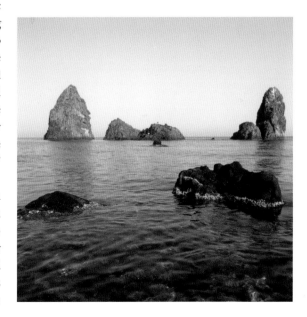

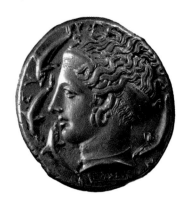

Charybdis is visible a short distance in front of the city in the channel, an extraordinary depth into which the reflux of the Strait cleverly pulls down boats, which are swept away with the twisting around a great whirling. When swallowed down and broken up, the wreckage is carried along to the Tauromenian shore, which, because of what happens, is called Kopria *(refuse).*
STRABO, *GEOGRAPHY*, BOOK 6, 2.268–9[4]

The terrible dilemma was which route to follow for, whichever was taken, neither danger could be avoided. Odysseus chose Skylla, believing that his ship would be less likely to be lost following this path, and more lives saved. Representing a treacherous whirlpool was a challenge for ancient Greek artists, but Skylla was a popular subject, particularly in southern Italy and Sicily (see figs 7 and 9).

Another pertinent story relates the mainland of Greece to Sicily through a tale of love and adventure. Arethousa was the chaste daughter of the sea god Nereus who, while bathing in a clear stream in Arkadia on the Greek mainland, encountered Alpheios, the river god, who instantly fell in love with her. Alpheios pursued her relentlessly, despite her protests of wishing to remain pure to the goddess Artemis, to whom she prayed for help. This help arrived in the form of a metamorphosis, for in her flight Arethousa had perspired so much that she transformed into a stream (fig. 6).[5] She escaped Alpheios by running under the sea, finding refuge at Ortygia on Sicily, where her fresh-water spring remains to this day. Her migration from mainland Greece to the shores of Sicily echoes with the journey of the Greek settlers from Corinth who founded Syracuse, by Ortygia, where they gave her special honours in the city for centuries after.

Fig. 6 (above)
Silver coin of Syracuse showing a head of the nymph Arethousa. Minted *c.*405 BC. Diam. 2.5 cm.
British Museum, London.

Fig. 7 (right)
Silver roundel with Skylla, which probably decorated the interior of a shallow bowl. From the so-called Morgantina treasure (see p. 124). *c.*300–212 BC. Diam. 10.5 cm.
Museo Archeologico Regionale, Aidone.

OPPOSITE
Fig. 8 Lake Pergusa, near Enna.

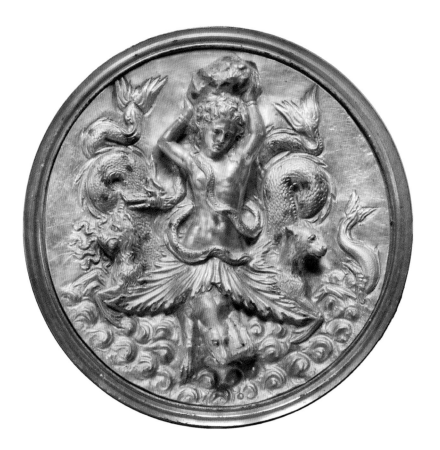

In addition to stories explaining particular geological features and the dramatic coastline, Sicily also laid claim to one of the most poignant and evocative myths of the ancient Greeks: the myth of Persephone's abduction by Hades, god of the underworld.[6] The island's fertile landscape saw the establishment of a great number of sanctuaries to Demeter and her daughter Persephone, the goddesses of agriculture, fertility and the seasons.[7] These were a great testimony to the people's desire to give thanks to and to appease the earth through offerings and sacrifices to the goddesses. This widespread devotion to Demeter and Persephone, the two Olympian deities who undoubtedly served the greatest need of humankind, naturally led to the island laying claim to the dramatic event that was fundamental in explaining the cycle of the seasons and the precarious nature of the natural world. Tradition relates that Persephone was snatched by Hades at a spot near Lake Pergusa, close to the city of Enna, located almost exactly in the centre of the island (fig. 8). Due to Demeter's grief, while Persephone was with Hades in the underworld, the earth was barren. Persephone was eventually permitted to spend two-thirds of the year with her mother, which once again caused the flowers to grow and crops to ripen. A less romantic reason for Sicily's fertile landscape, however, is its geology and climate, and of course the dominant force of Mount Etna.

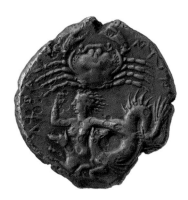

Fig. 9
Silver *tetradrachm* of Akragas (Sicily), showing Skylla and a crab. *c*.420–410 BC. Diam. 2.5 cm.
British Museum, London.

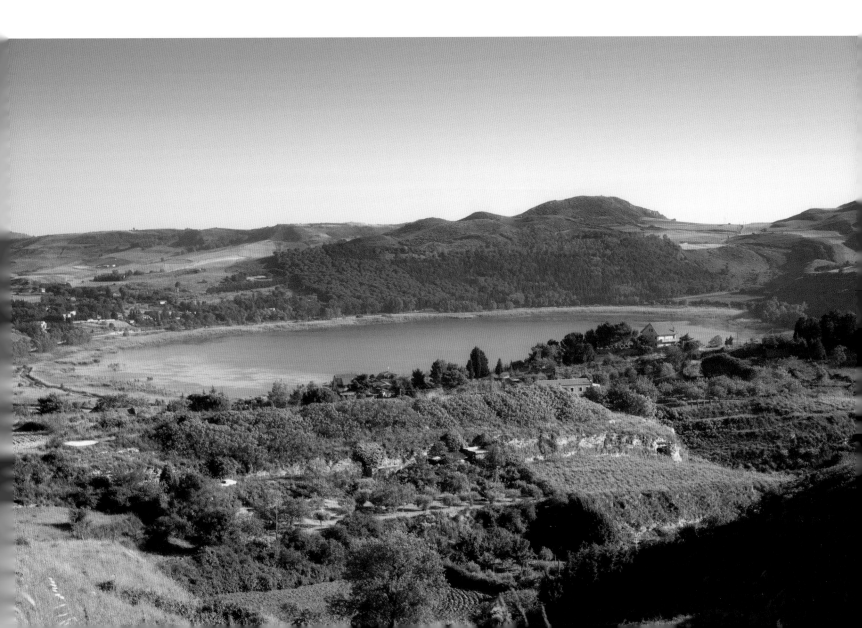

Landscape

All that nature has of great, all that it has of pleasant and all that it has of terrible can be compared to Etna, and Etna cannot compare to anything.

DOMINIQUE VIVANT DENON, *VOYAGE EN SICILE*, 1788

By far the most prominent geological feature on Sicily is Mount Etna, one of the world's most active volcanoes, which dominates the landscape on the east side of the island. Reaching over 3,300 metres, Etna is Europe's largest volcano and has been erupting almost continuously for nearly half a million years. The name 'Etna' may be a composite name formed from the Latin and Greek words meaning 'to burn', although more interestingly some linguists have offered up an alternative meaning claiming that it was so named from the Phoenician word *athana* meaning 'furnace'. According to myth, during the battle between the Olympian gods and the giants, the goddess Athena threw a huge rock, the entire island Sicily, at the giant Enkelados.[8] It landed on top of him, squashing him, but so powerful and intense was his anger that it burst through the rock and out of the ground as a volcanic eruption.

Most of the modern land mass of Sicily was created when the limestone seabed contracted and pushed upwards to form mountain land ranges, as throughout much of the Mediterranean. Because of the volcanic activity on Sicily, however, other minerals formed, including tufa, a volcanic rock composed of ash. Sicily was the world's largest source of sulphur until the early decades of the twentieth century. The Sicilian climate varies slightly geographically, with the south and east sides being somewhat warmer and drier than the north and west.[9] Rainfall increases with altitude, and on the highest mountains, above 1,600 metres, there is often snow. One of the biggest impacts on the landscape has been deforestation, which during antiquity was managed in accordance with the needs for agriculture but began wholesale from the sixteenth century AD onwards.[10] Sicily gradually became drier and more arid. Now, one of the most striking features of the Sicilian landscape is the dryness of the soil. Along the coasts the plants are typically Mediterranean, while at higher altitudes inland the woodland is alpine with chestnuts and oak trees.

Fig. 10
Silver *tetradrachm* of Aitna showing a seated Zeus and symbols of Mount Etna.
476–466 BC. Diam. 2.6 cm.
Cabinet de Médailles, Bibliothèque Royale de Belgique, Brussels.

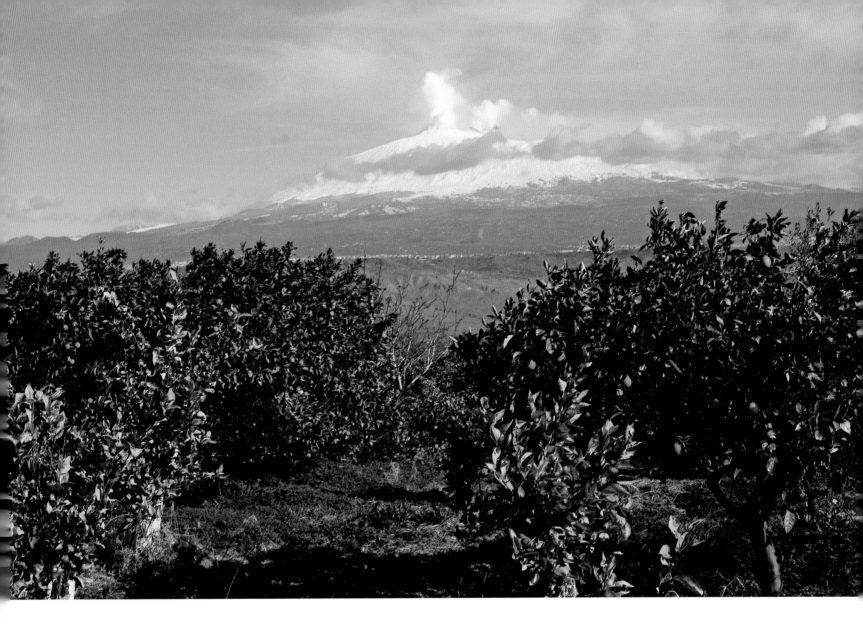

Despite these dramatic changes to the landscape and environment, agriculture is as important today as it was in antiquity, and Sicily's climate is unlikely to have changed too much over the past 2,000 years or so. 'Indigenous' plants and crops thrive alongside non-native varieties, introduced by the different groups of settlers. The Greeks introduced the cultivation of the grapevine and the olive, while the Arabs brought citrus fruits. The prickly pear arrived on Sicily more recently from Mexico and South America and has become a common sight on the island. Although the fauna of the island was much more diverse in antiquity, some species of wild animals still roam the countryside, ranging from wild cats and deer to beavers and the occasional porcupine and wild boar. Fishing has always been an important part of the economy, with tuna, sardines and swordfish being common catches. The production of wine was as important in antiquity as it is today. The history of Sicily and wine are intertwined, from mythology to reality: from Odysseus' intoxication of Polyphemos, to the heady, sugar-sweet Marsala, the fortified wine much celebrated by Admiral Horatio Nelson. He claimed, 'The wine is so good that any gentleman's table might receive it, and it will be of real use to our seamen.'[11]

Fig. 11
Landscape around
Mount Etna.

Phoenician merchants, who traded by sea but also settled on the island from the tenth century BC onwards, brought new varieties of grapevines. The Greeks advanced the techniques of pressing the grapes and also introduced new cultivars. The reputation of Sicilian wine reached beyond the island by the fifth century BC, and it was shipped from Akragas (today Agrigento) to Carthage in modern-day Tunisia. By the Roman period, wine was big business, with large vineyards established; even Julius Caesar favoured wines from Sicily.[12] Further new cultivars were introduced by the conquering Arabs during the ninth century AD. Sicily is now among the best-loved Italian winemaking regions.

While describing Sicily, Strabo (64/63 BC–AD 24) commented on the excellence of the soil as a primary motive for Greek settlement on the island.[13] It cannot be overestimated just how significant agriculture (not least grain) was to the ancient economy. As with all things specifically Sicilian, it was a combination of the diverse 'indigenous' peoples with richly imaginative groups of settlers that generated a culture of innovation, experimentation, cooperation and dissemination.

The island's shape, its rich mythological and historical past, and its prodigious fertility are all still evident in its identity today. Sicily is in essence not an integrated region of Italy. Its island outlook leaves it separate; its history, language and traditions make it unique.

Fig. 12 Field of Poppies, Persephone's flower.

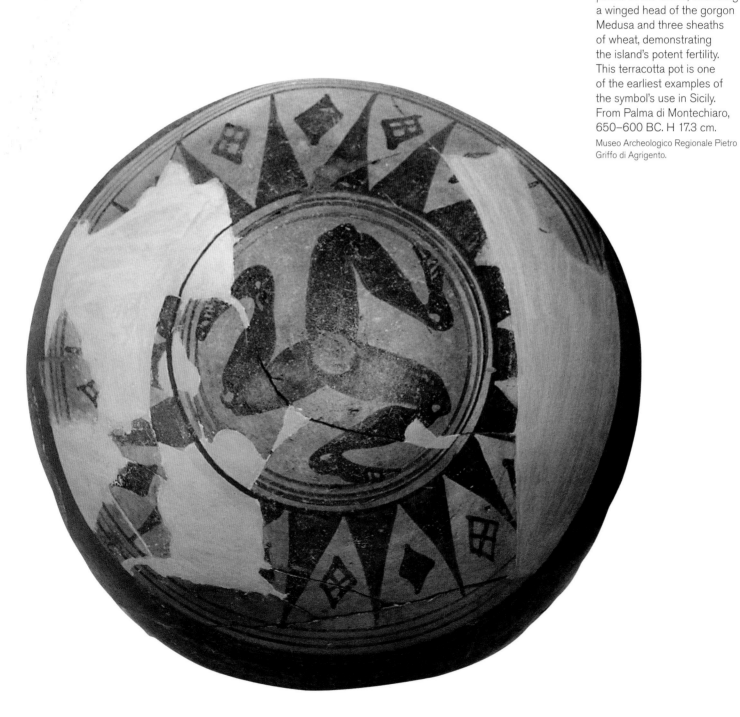

Fig. 13
The Trinacria is the official symbol of Sicily, translated from the Greek words *tria* (three) and *akra* (promontory). The emblem, also known as a *triskelion*, combines three legs, representing the three points of the island, encircling a winged head of the gorgon Medusa and three sheaths of wheat, demonstrating the island's potent fertility. This terracotta pot is one of the earliest examples of the symbol's use in Sicily. From Palma di Montechiaro, 650–600 BC. H 17.3 cm.
Museo Archeologico Regionale Pietro Griffo di Agrigento.

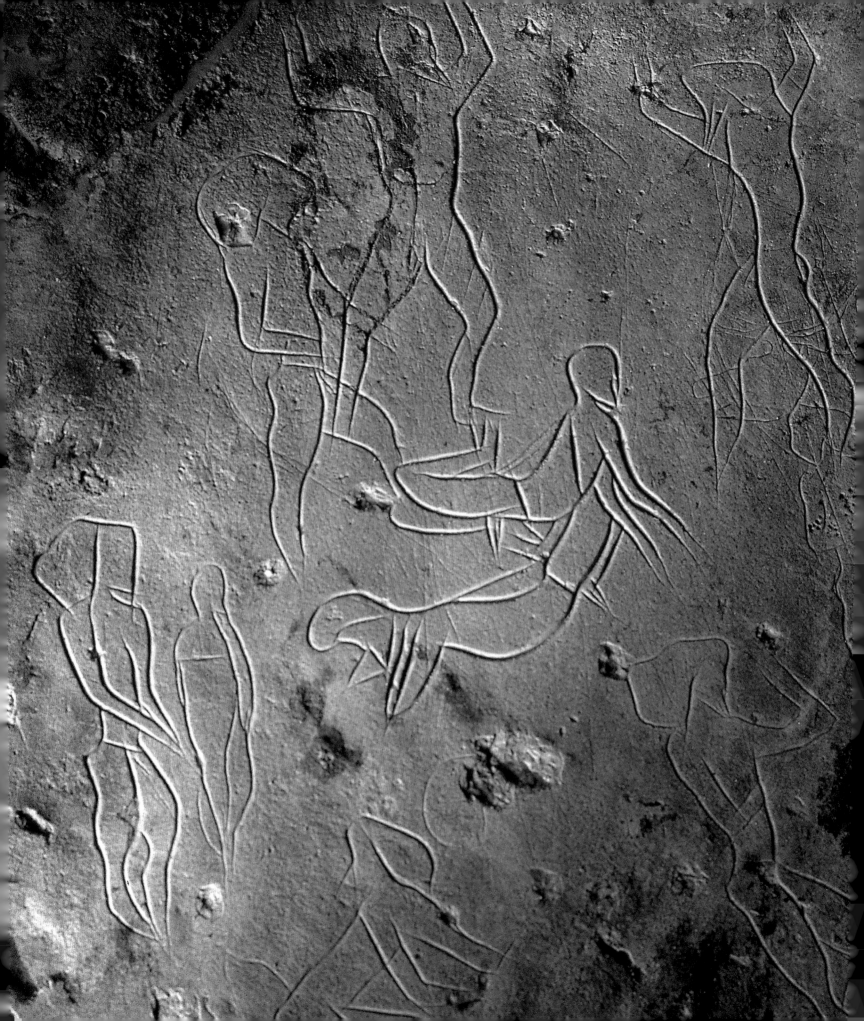

Here is how it was originally settled, and these are all the people who occupied it all told. The earliest mentioned as living in some part of the area are the Kyklopes and Laistrygones, but I have no idea what their race was, where they came from or where they went; what has been said by the poets and what any person may know of them is suffice.

THUCYDIDES, *HISTORIES*, BOOK 6, CHAPTER 2[1]

1
Peoples of Sicily

Sicily's strategic location in the heart of the Mediterranean stimulated centuries of invasion and occupation by foreign powers. The island echoes with the rise and fall of virtually every empire since the eighth century BC. Despite being the birthplace of one of the most celebrated Greek historians, Diodorus Siculus (of Sicily), few ancient sources refer to Sicily's early history. Our primary source is Thucydides (460–400 BC), an Athenian historian, who briefly describes the early peoples and different settlers on Sicily as part of his introduction to the story of the ill-fated Athenian military expedition to the island in 415–413 BC against the powerful city of Syracuse (see p. 116). The ancient sources on early Sicily tend to be biased towards a Greek interpretation of events, so we rely on archaeological excavation to reveal how the early communities lived, interacted and died. Much more is now known about the different peoples who shaped and moulded the prehistoric cultures on the island.

Thucydides starts his brief survey of the history of Sicily by mentioning mythical, Homeric races, which to an author of his period would have appeared so far back in time as to be incomprehensible. Moving into historical times he tells us about three major groups of people who inhabited the island before the arrival of Phoenician and Greek settlers in the eighth century BC. Firstly, he describes the Sicani, 'people from Iberia', who settled on the west of the island. Next he refers to the Elymians, refugees from Troy in western Anatolia, who founded the cities of Eryx and Egesta (later called Segesta). Finally, on the eastern side were the Sicels, originating from Italy. Thucydides then refers to the Phoenicians who had settled there to trade with the Sicels. He mentions all these early peoples before finally discussing the settlement of the Greeks, and all of the non-Greeks are casually referred to as Barbarians.

Thucydides' division of peoples on the island was understandably simplified, but the reality was much more complex. His version of events seems to stem from the tradition of Greek travellers' tales, which derived from the oral traditions of seafarers and traders who would have heard wondrous stories from the different peoples they encountered. More tangible information has been discovered during decades of digging the ancient sites all over Sicily. Archaeologists have striven to identify differences between the Sicels, Sicani and Elymians, but it has proved difficult to detect distinct ethnic and cultural identities from the archaeological remains.[2] These pseudo-cultural names are useful labels, but in reality the cultures and groups attested in the archaeological record should be our primary concern. Real cultures have been identified and named by modern archaeologists and anthropologists after the principle sites that they occupied, such as the Castelluccio and Thapsos cultures.[3] The earliest evidence for human habitation on the island dates to about 13000 BC, and takes the form of stone tools. Later, dating from between 13000–8000 BC, depending on which theory you follow, there is a series of remarkable paintings and carvings found in the Addaura, Genovesi and Niscemi caves near Palermo (fig. 14).[4] Like many prehistoric images they show the relationship between man and wild animals, usually in the form of hunting scenes.

Fig. 14
Engravings made between 13000 and 8000 BC in the Addaura cave near Palermo are the earliest known images of people from the island.

Sicily played a central role in the trade networks that formed as societies emerged and began to explore the Mediterranean for resources. During the Neolithic period, from the fifth millennium BC onwards, the islands around Sicily were part of the network trading and distributing obsidian; the black, volcanically formed, glass-like rock so prized by early peoples as a material for sharp-edged blades. The obsidian was exported from the not too distant island of Sardinia, and closer still, Pantelleria to the south-west and Lipari to the north of Sicily.[5] This industry collapsed when people started to seek out sources of copper for metalworking, from the middle of the third millennium BC onwards. There was a vast and growing network of merchant ships from the Aegean to the Tyrrhenian Sea and Sicily was quick to respond to the market by creating ports on the Aeolian Islands such as Salina, Stromboli and Filicudi. By the next millennium these trade connections are attested by relatively large quantities of imported Mycenaean pottery discovered in early settlements in eastern Sicily and the neighbouring islands.[6] Metals are rare on Sicily, but sources of copper, zinc, silver, iron and antimony were possibly exploited in the Monti Peloritani in the north-east.

The Chalcolithic or Copper Age of the island saw further developments in agriculture, the formation of settlements and burial practices. Influences from as far afield as Anatolia permeated into the early metallurgical societies that were establishing and developing on Sicily and its offshore islands. The Early Bronze Age on Sicily (2500–1500 BC) is best known through the so-called Castelluccio culture, which was dominant in the eastern half of the island.[7] The economy was based on agriculture, particularly the rearing of sheep, goats, cattle and pigs, and there was extensive exchange between local communities, but also with overseas, notably with the islands of Malta and Sardinia and with southern Italy. The funerary practices of the Castelluccio cultures show signs of a hierarchical structure, where some of its rock-cut tombs had imposing carved facades as an ostentatious display of prestige.

A few of the rock-cut tomb chambers at the site of Castelluccio (south-west of Syracuse) were sealed with rectangular stone portal slabs. One of the surviving examples has provocatively schematic designs that represent sexual acts (fig. 15). While the man has been reduced to a potent, full set of male genitalia, the straddling woman is seen as if from outside and within. The spirals have been interpreted as breasts or eyes, but are more likely the ovaries encased here by some protective carved feature, the function of which is obscure. The fact that the carving may resemble female internal anatomy is remarkable. Some scholars have interpreted the use of spirals as metaphysical, while others see them as either purely decorative, or as a symbol of the eternal soul. Some would see internment within a rock-cut tomb as a journey back to the safety of the womb, a return to mother earth. The potent symbolism on the limestone door slab resonates with such a belief. The spiral motifs are similar to carvings on prehistoric temples on Malta, although those are much earlier in date. The example from Castelluccio, however, is more overtly sexual in nature than any other of its type.

Dating from around 2500 BC, this example (fig. 16) of early pottery associated with the Castelluccio culture is characterized by vivid black patterns on warm red fabrics.[8] Sicily has abundant supplies of fine-quality potting clay, ultimately derived from the volcanic feldspars and glass that worked their way into the geological formation of the island, and this clay has been utilized throughout the island's history. Cups like this, with sharp profiles, high 'ear-shaped' handles and elegant geometric patterns, composed in panels, mark a relatively early stage in painted pottery on Sicily. The vast majority of Late Chalcolithic/Early Bronze Age pottery was plain and coarse in production; therefore cups like this would have been made for, owned by and then buried with the high-ranking members of the community.

One of the most prominent cultures that have been identified as belonging to the Middle Bronze Age (1500–1200 BC) on Sicily centred on the settlement at Thapsos, a peninsula off the

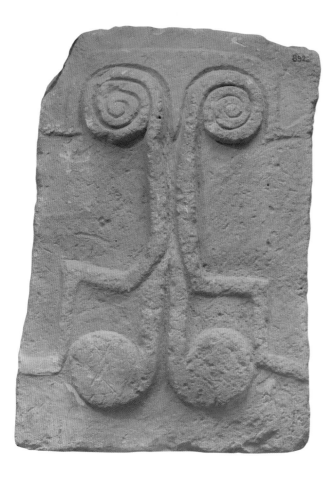

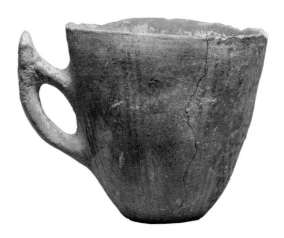

east coast of Sicily.[9] Excavated material from Thapsos and at other locations nearby indicate close contact with sites in the Aegean and further east. Mycenaean and Cypriot pottery has been found in tombs alongside wares of local manufacture, some of which copied imported vessels. Some of the most distinctive vessels from Thapsos sites are tall, pedestalled basins with high backs, terminating in stylized horns (fig. 17). Found alongside drinking vessels in domestic structures, these basins, sometimes reaching over a metre in height, were probably a focal point in drinking ceremonies or festivities. Such activities demonstrate that societies were developing into communities who shared common practices and customs. Archaeologists discovered at least one placed centrally in a tomb housing multiple burials, perhaps indicating how the elite aspired to continue these drinking ceremonies into a blissful eternity.

A characteristic of the Late and Final Bronze Age (1200–900 BC) on Sicily was that coastal settlements began to decline in importance while those inland developed in terms of their social hierarchy and in economic status. The collapse of the sea trade routes that accompanied the decline of Aegean societies left the peoples of Sicily to develop and evolve with less influence from the eastern Mediterranean. This led to increasing contact with the

Fig. 15 (above left)
Limestone 'door' from Tomb 31 at Castelluccio. Carved c.2000 BC. H 1.02 m.
Museo Archeologico Regionale Paolo Orsi di Siracusa.

Fig. 16 (above)
Orange pottery painted with black designs (Castelluccio style) is found in eastern Sicily, dated by archaeologists to between 2200 and 1500 BC. H 12.1cm
British Museum, London.

mainland of Italy, via the Aeolian Islands, particularly Lipari, where the so-called Lipari-Ausonian culture was dominant (1250–850 BC). The Ausonians were, according to ancient sources, a people from Italy.[10] Archaeologists have discovered that around the same time on Sicily the so-called Pantalica culture prevailed, its eponymous site being Pantalica in south-eastern Sicily. This culture flourished between 1250 and 650 BC, witnessing the end of the Bronze Age and the Early Iron Age (900–734 BC) with the arrival of the first Phoenician and Greek settlers. Pantalica is perched high on the mountainous hinterland, a typical site for settlements of this period. Pantalica culture spread around southern Sicily and is also evident at Sant'Angelo Muxaro and Caltanissetta. Characteristic of the Pantalica site is a large series of red-burnished pottery vessels, some of them deep, globular basins elevated on high pedestals, again indicating a communal drinking custom amongst the inhabitants (fig. 18).

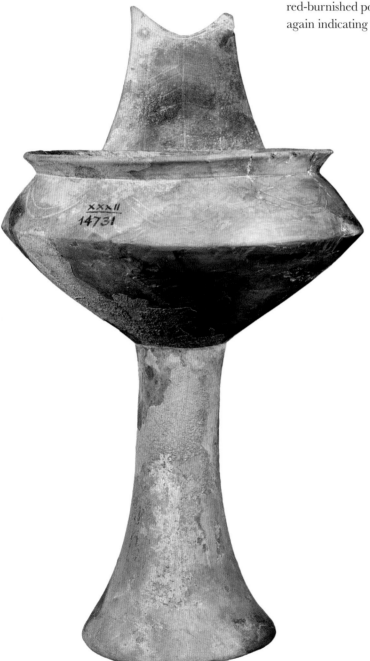

Fig. 17
Pedestalled basin from Thapsos. Archaeologists have proposed that people knelt by these tall vessels. c.1400–1300 BC. H 86 cm.
Museo Archeologico Regionale Paolo Orsi di Siracusa.

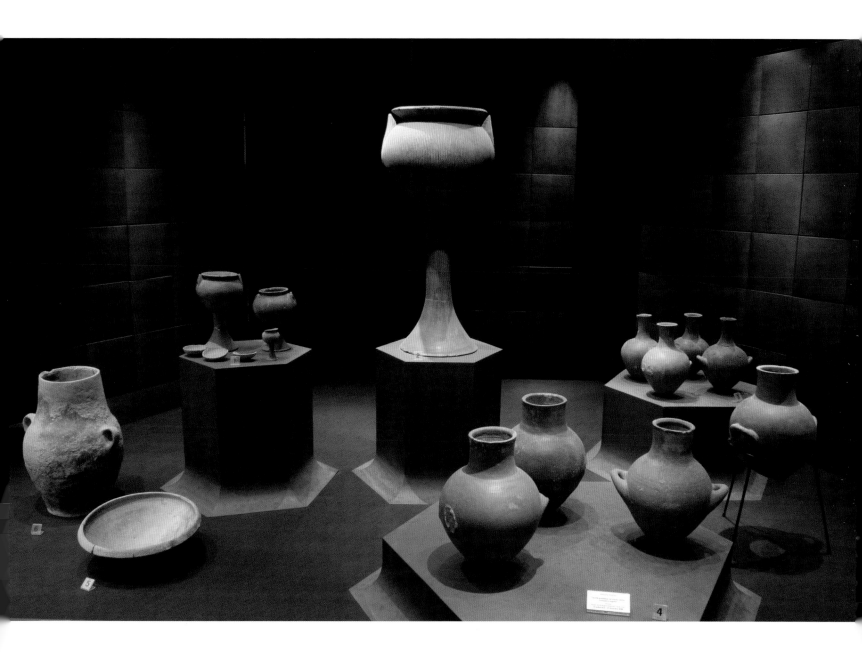

In the ninth century BC the eastern Mediterranean emerged from what scholars traditionally termed a Dark Age, following the collapse of the trade routes and economy of many cultures in the region at the turn of the first millennium BC. However, over the past few decades new archaeological excavations have altered the traditional view and the evidence seems to suggest that some Greek regions thrived from the Late Bronze to the Early Iron Age. Euboea, for instance, went through a richly innovative phase in its cultural activity during this period, and was to play a major role in the development of new settlements in the Mediterranean from the eighth century BC onwards. As the economic and political situation gradually improved, peoples reacted either in the positive form of trade and/or in following the negative path of war and conflict to control trade routes and resources. The most enterprising traders came from Phoenicia, sailing from the south Syrian and Lebanese coast.

Fig. 18
Group of red burnished pottery vessels made during the early stages of the Pantalica culture.
Museo Archeolgico Regionale Paolo Orsi di Siracusa.

Phoenicians on Sicily

Phoenician sea traders had traded with Sardinia, an island to the north-west of Sicily, and possibly Spain, from around 1000 BC, but it was not until the eighth century BC that permanent Phoenician trading posts were established on Sardinia, the most important of which was Tharros.[11] Roman sources differ about how and when the principle Phoenician city of Carthage, in Tunisia, was founded, but the most romantic attributes its foundation to the legendary queen Dido in 814 BC.[12] Whether it was established much earlier than this or not, Carthage was to become one of the most influential and powerful cities in the western Mediterranean, and its culture and people came to be known as Punic.

Sicily probably saw its first influx of Phoenician traders in the ninth century BC but, according to Thucydides, settlements and trading posts had been formally established by 720 BC at Motya (modern Mozia), an island just off the north-west coast of Sicily, and at Panormos (Palermo) and nearby Soloeis (Solunto) on the north coast.[13] Archaeological excavations at Motya have provided us with the most vivid evidence for the activities and life of the Phoenician settlers on Sicily. Remains of their houses and graves are preserved, including the sinister *tophet*, a sanctuary where, according to later Greek, Roman and Jewish

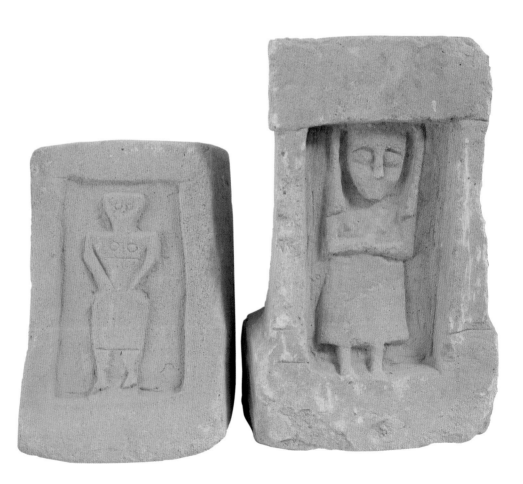

Fig. 19
Limestone *tophet* grave markers from Motya, perhaps showing the goddess Tanit. They were set up over burial mounds for infant children. 6th century BC.
H 50 cm (left), 40 cm (right).
Museo Whittaker Giovinetti di Motya.

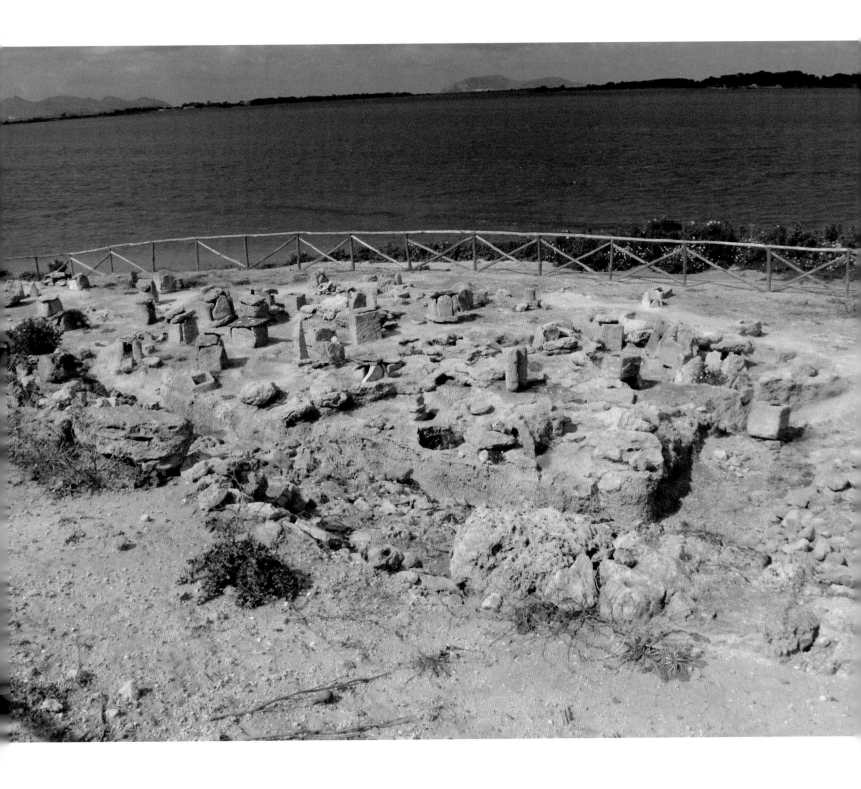

Fig. 20
The site of the *tophet*
at Motya.

authors, Phoenicians sacrificed their sons to the gods by burning them alive. Some still adhere to the belief that such a practice occurred in Phoenician sanctuaries, but many archaeologists now believe that this gruesome accusation was a misinterpretation of Phoenician religion. Rather than burning young children alive as an offering, instead it was stillborn babies or dead infants who were presented to the gods through the ritual of cremation. The deceased were then honoured with a memorial gravestone of the type shown in fig. 19.[14] Some of these graves contained terracotta masks of wrinkle-browed, grinning-mouthed, demon-like figures, which are thought to have had an apotropaic function.[15] Find-spots for these bizarre images range from Sicily and Sardinia to Carthage itself. The material culture of Motya exhibits a combination of different influences, with graves of the seventh and sixth centuries BC having a mixture of locally produced pottery, Greek imports and home-made versions of imports.

The relationship between the Phoenician settlements and the rest of Sicily will feature throughout this history of the island, with the Carthaginians in particular regularly interfering with the political affairs of the island.

Figs 21–2
Carthaginian grotesque terracotta masks made between 550–475 BC. They would have been placed in tombs to ward off evil spirits.

(right)
Mask found in tomb 7 at Tharros, a Phoenician settlement on Sardinia. H 17.7 cm.
British Museum, London.

(opposite)
Mask from a *tophet* burial at Motya. H 20 cm.
Museo Whittaker Giovinetti di Motya.

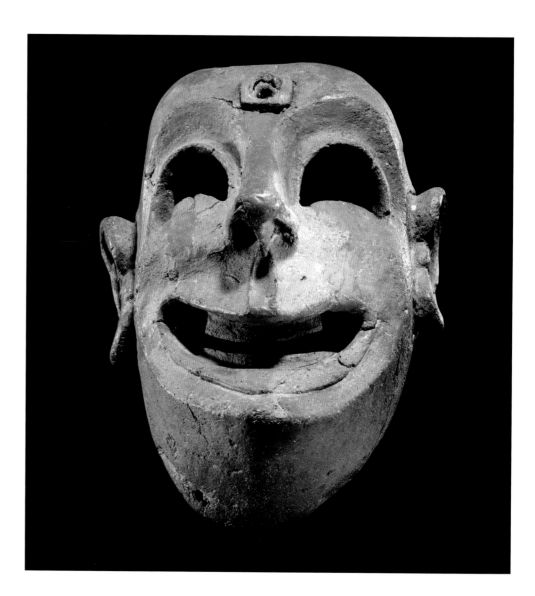

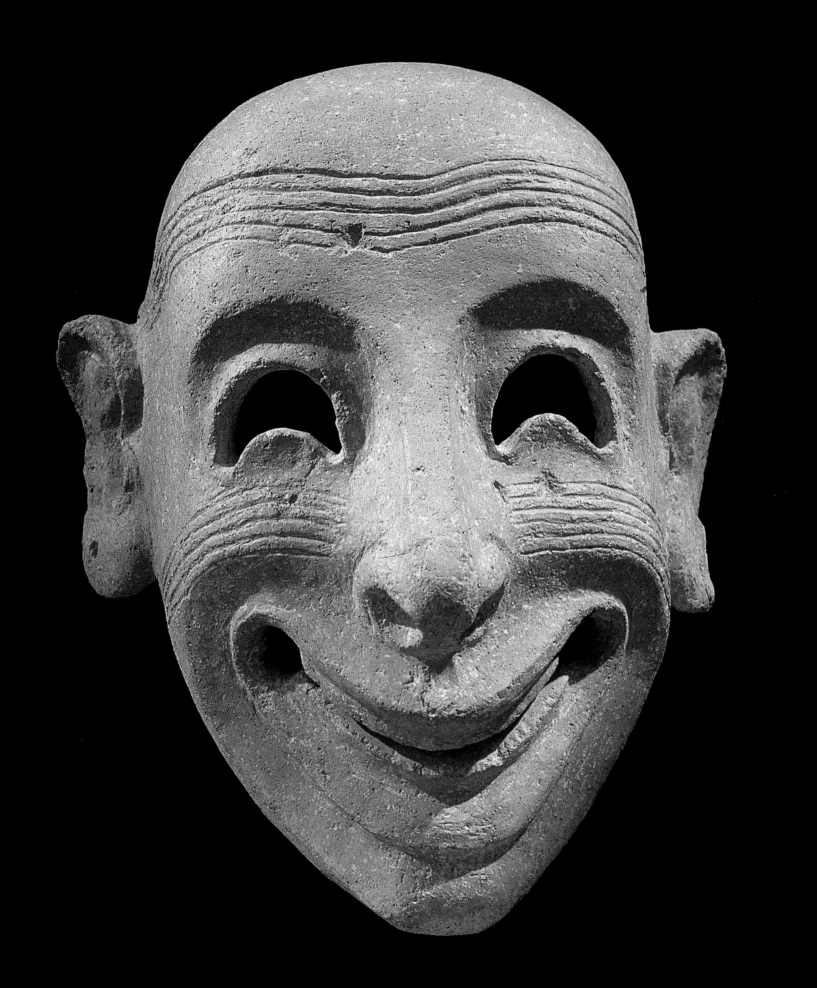

Arrival of Greek Settlers

By far the largest influx of people into Sicily came from the Greek mainland and islands with the intention of permanently settling there. The Greek historian Thucydides says that Greeks started coming to Sicily in large numbers in 734 BC, and that their first permanent settlement was located at Naxos in north-east Sicily.[16] Despite simplification and likely factual inaccuracies, Thucydides' words effortlessly conjure up the spirit of the migration, peppering what is essentially a chronological survey with little anecdotes to convey the human journey:

> Of the Hellenes, the first were Chalkidians from Euboia who sailed with their leader Thoukles, founded Naxos and built the altar of Apollo Leader of Colonies, which is now outside the city, where religious delegations sacrifice first whenever they sail from Sicily. In the following year, Archias of the Herakleidai in Corinth founded Syracuse, first driving the Sicels from the island, today no longer surrounded by water, which contains the city; afterward over time, the city outside it was also included within the walls and became populous. Thoukles and the Chalkidians setting out from Naxos five years after the foundation of Syracuse, expelled the Sicels in a war and founded Leontinoi and then Katana; the Katanians themselves chose Euarchos as their founder.
>
> Around the same time Lamis also arrived in Sicily, leading a 'colony' from Megara, and after he founded a place called Trotilos beyond the Pantakyas river, and then left to occupy Leontinoi jointly with the Chalkidians for a short period, and was then driven out by them and founded Thapsos, he died, and the others were driven out of Thapsos and, since Hyblon, a Sicel king, gave them the land and conducted them there, founded Megara known as Hyblaian. After living there for two hundred forty five years, they were expelled from the city and territory by Gelon, the tyrant of Syracuse. Before their expulsion, they sent out Pamillos and founded Selinous; he took part in the settlement after coming to them from Megara as the mother city.
>
> Antiphemos from Rhodes and Entimos from Crete joined together in leading settlers and founding Gela in the forty- fifth year after the colonisation of Syracuse. Although the city took its name from the Gela river, the site where the city is now and the first part fortified is called Lindioi. And they were provided with Dorian institutions. Close to one hundred eight years after their own 'colony', the Geloans settled Akragas, and they named the city after the Akragas river, appointed Aristonous and Pystilos as founders, and gave Geloan institutions.
>
> Zankle was originally settled when pirates came from Kyme, the Chalkidian city in Opikia, but later large numbers came from Chalkis and elsewhere in Euboia, and occupied the area along with them; the founders were Perieres and Krataimenes, the first from Chalkis, the second from Kyme. At first it was called Zankle, a name given by the Sikels, because the place is sickle-shaped, and the Sicels call a sickle a zanklos; but later these were driven out by Samians and other Ionians who landed in Sicily fleeing the Medes, and not long afterward, Anaxilas, the tyrant of Rhegion, after expelling the Ionians, colonised the city himself with a mixture of people and renamed it Messene after his original homeland. Himera was colonised from Zankle by Euklides, Simos, and Sakon, and although mostly Chalkidians came to the 'colony', Syracusan exiles called the Myletedai joined them after being defeated in a civil war. Their speech was a cross between Chalkidian and Dorian, but Chalkidian institutions prevailed. Akrai and Kasmenai were colonised by Syracusans, Akrai in the seventieth year after the foundation of Syracuse, and Kasmenai nearly twenty years after Akrai. And Kamarina was first colonised by Syracusans, close to one hundred thirty-five years after the foundation of Syracuse; its founders were Daskon and Menekolos. But since the Kamarinaians were made homeless by the Syracusans in a war because of a revolt, at a later time Hippokrates, the tyrant of Gela, who had received the territory of

Kamarina as ransom for Syracusan prisoners resettled Kamarina as founder. After it was once more depopulated, by Gelon, it was settled for a third time by Geloans.
THUCYDIDES, *THE PELOPONNESIAN WAR*, BOOK 6, 3–5[17]

The historical and archaeological evidence for the motives and processes of Greek settlement in Sicily are certainly much more complicated than Thucydides would have us believe.[18] It was not the case that the Greeks arrived and everything changed overnight. Each Greek settlement developed according to the different 'ethnic' origins of its inhabitants. Some of the new Greek communities absorbed the cultural practices of the island's resident communities more than others. It seems that a series of independent locales evolved gradually, creating innovative and unique hybrid cultures that then further interacted with other peoples on the island.[19] The arrival of Greek settlers on Sicily forms part of a wider migration of Greeks across the Mediterranean and Black Sea, from the eighth to fifth centuries BC, in search of new trade networks and social and political opportunities for personal advancement. Explanations have ranged from the thirst to encounter different peoples on exotic shores, inspired by the travelling Odysseus in Homer's epic tale, to the expulsion of power-hungry aristocratic families from newly emerging, democratic city states. A host of additional reasons have been considered, from overpopulation to a possible series of poor harvests from the Greek mainland's less-fertile soil.

However, the Greeks most certainly would have been motivated by a desire to participate in the trade links that were being regenerated across the Mediterranean, not least in the west, largely prompted by the Phoenicians' considerable interest in Iberia (Spain), the coastal parts of southern Italy and Sicily, Sardinia and North Africa. The commercial aspirations of the Etruscans also played a part. The Greeks wanted in on the action, but theirs was not a policy commanded by a leading Greek city state or political figurehead. Instead it was initiated by different city states or their ruling families, who would also no doubt have funded the initial reconnaissance missions required to seek out new territories. One unifying element of the process was that, according to literary sources, the advice of the Delphic Oracle would be sought by the *oikist*, the expedition leader, who would eventually found the new settlement. He would consult the oracle to determine the likelihood of success.

In modern times we tend to think of colonies as being under the political control of a home state or country. This sense cannot be applied to the ancient Greek migrations, and the Greeks had no word for such a practice: the word 'colony' derives from the Latin word *colonia*; the Greek word is just *apoikia* – a settlement far from home. Some reverence might have been shown to the mother city by the newly founded settlements, perhaps in the form of religious practices and trading links, but the new colonies in Sicily were autonomous. At this early stage these Greek settlements were perhaps best considered by their mother cities as overseas communities, gateway settlements or *emporia*, trading posts. The term 'culture contact' has been suggested as an alternative to describing this process as Greek colonization or the establishment of colonies, in an attempt to distance the ancient situation from the modern association of the terms.

Greek settlers initially established settlements in Sicily's coastal areas, while the pre-existing communities tended to live inland, and so neither diplomacy nor violent confrontation was usually required. The first Greek settlers on Sicily were predominantly from Chalcis in Euboea, an island north-east of Athens. Thucydides claimed they set up camp under the direction of Theokles, on the north-east coast, establishing a town called Naxos, perhaps named after the Greek island from where many of the settlers originated. The Euboeans were famous for their metallurgical skills. Ever in search of new sources of metal, they established settlements in

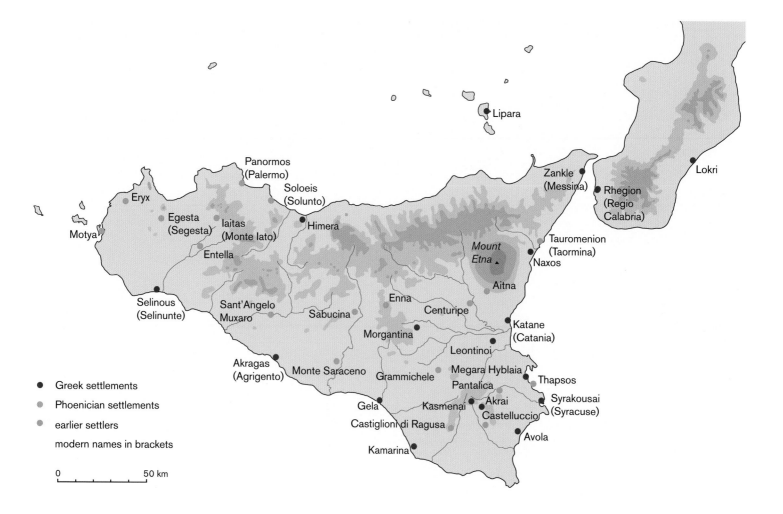

Map showing locations across Sicily including:

Lipara, Panormos (Palermo), Soloeis (Solunto), Zankle (Messina), Rhegion (Regio Calabria), Lokri, Eryx, Egesta (Segesta), Iaitas (Monte Iato), Himera, Tauromenion (Taormina), Naxos, Mount Etna, Motya, Entella, Aitna, Selinous (Selinunte), Sant'Angelo Muxaro, Sabucina, Enna, Centuripe, Katane (Catania), Akragas (Agrigento), Monte Saraceno, Morgantina, Leontinoi, Gela, Grammichele, Megara Hyblaia, Pantalica, Thapsos, Kasmenai, Akrai, Syrakousai (Syracuse), Castiglioni di Ragusa, Castelluccio, Avola, Kamarina

- ● Greek settlements
- ● Phoenician settlements
- ● earlier settlers

modern names in brackets

0 50 km

Fig. 23
Map of ancient sites on Sicily.

areas rich in metal ores: for instance, in southern Italy, at Pithekoussai and Cumae, in Sicily and elsewhere. The strategic location of Sicilian Naxos meant that its enterprising occupants had access to the increasing trade networks and could exploit this as ships passed through the Strait of Messina. The *oikist* Theokles was to go on and found other settlements on Sicily including Leontinoi (modern Lentini), an existing Sicel township, with which he probably made some kind of treaty to share the town. Another Euboean 'colony' was established at Katane (modern Catania), on the fertile slopes of Mount Etna, and later 'sub-colonies' were found at Zankle, today's Messina, on the north coast. Then another settlement was established at Himera, further west along the north coast of the island, near Termini Immerese.

Syracuse was the first of the colonies set up by Corinth, under the auspices of Archias, an aristocrat from the ruling Bacchiad family. Syracuse was in a prime location on the island, with Ortygia to the east, substantial harbours and the fresh-water spring named after the nymph Arethousa (see p. 24). The hinterland was fertile and so offered rich pickings. Antiphamos, the *oikist* of Gela, also took the potential to control ports, trade routes and fertile agricultural land into consideration when he founded his city. These *oikists* were later given hero status, and their tombs were places of ritual activity and worship, sometimes located in a prominent central part of the city. An Athenian imported cup found at Gela bears a Greek inscription with a dedication to Antiphamos by Mnasithales.[20] This dates to the later fifth century, almost two centuries after the foundation of the city.

Despite their different motives or methods, the newly founded Greek settlements followed similar basic town planning. Areas were designated for different functions, whether private and domestic or for public use, and burial grounds were placed outside the settlement boundaries. Priority was also given to developing sanctuaries for public worship of the Greek gods. They were gradually introduced into the ritual framework of the island, with the 'indigenous' residents also taking up these new cults and assimilating them into their own religious practices. Settlers also, over time, began to exploit the agricultural wealth of the hinterland and encroach upon the territories of each other and of the local, non-Greek populaces. Each town would have had a *chora*, an area outside the main city. While most of the first Greek settlements had been coastal, attention was subsequently diverted inland. Syracuse, for instance, set up two of its own 'colonies' inland at Akrai and Kasmina, where the 'indigenous' populations were encouraged either to move away or to assimilate, probably by force. Another Syracusan settlement was Kamarina on the south coast, and it is not difficult to imagine that Syracuse might have developed contact points there to check the expansion of nearby Gela, and in doing so control a vast portion of the south-east of the island. Gela responded by expanding its influence westwards and founding the city of Akragas, which may also have been prompted by the 'sub-colony' of the Megarians of Megara Hyblaia, who sent out a new group of settlers to Selinous, on the south-west coast. Both Akragas (Agrigento) and Selinous were later to become two of the most impressive cities in terms of monumental temple building. In both instances it appears that many of the settlers, including the *oikists*, may have actually come from Rhodes and from Megara as well as from their 'colonies' in Sicily.

Contact and trade increased between the new settlements, which by the sixth century BC had generally grown in size and economic prosperity. Rich tombs and temples were designed to impress and to demonstrate each settlement's power and influence. They both emulated and competed with other sanctuaries, both at home and in the rest of the Greek Mediterranean. Attention was also given to the architectural embellishment of the *agora*: as a central public place, it was not only the focal point for commerce but also a venue for cultural activities. From the late seventh century to the early fifth century BC, the disparity in the wealth of grave offerings and the emergence of larger private houses suggest an increase in personal wealth for the minority, and it was undoubtedly they who pumped finances into the public and religious buildings that served to function, but would also have impressed outsiders. The imported pottery found in some of the graves is suggestive of trade links, and the fact that Sicilian Greeks bought these vessels and their contents indicates that they had something to trade in return. Grain is the most obvious commodity, but other agricultural produce, such as wool, fruits, wine and livestock, was produced or reared in Sicily and traded. Some of the landowners or merchants who grew rich from this trade eventually rose to the same level as the aristocratic founding families who came from the old Greek states and mother cities. As elsewhere throughout the Greek world, members of the elite families held religious positions in sanctuaries. Corinth had dominated trade in the Aegean up until the mid-sixth century BC, especially the export of pottery vessels filled with olive oil in return for grain. Athens later emerged as a primary commercial centre and producer of pottery, and eventually overtook Corinth as the foremost exporter of ceramics.[21]

THE MYSTERY OF THE FOUR GOLD CUPS

In 1908 the eminent Sicilian archaeologist Antonio Salinas visited the British Museum, where his attention was struck by a gold bowl in its collection. This was one of the very few gold vessels to be found among the classical antiquities in London and was in the form of a *phiale* (offering dish)[22] The vessel follows a general type and design from the Achamenid Empire in modern-day Iran to ancient Greek settlements in France. Six bulls stroll around the outer perimeter of the vessel, each formed from the same clay or wooden die. The bulls are lean, their ribs marked by four ridges, each reducing in size from shoulder to hindquarters. Their eyes are alert while their tails droop, and their horns curve up following the shallow profile of the vessel. The next circular band is plain but for a small crescent moon neatly formed by small, punched depressions into the gold. In the centre is a raised shallow cylinder, with remains of tiered granulation rising up, the uppermost layer having lost most of its granules. The rim of the vessel is decorated with a shallow twisted, beaded design.

The reason for Salinas's excitement was that he knew of a drawing of a similar vessel published in the travel volumes of the French artist Jean-Pierre Houël (1735–1813), who passed through Girgenti, later Agrigento, as part of his tour of Sicily, Malta and Lipari between 1776 and 1779.[23] In his sumptuous publication of 1787, Houël reported a story from 1773 that the Baron de Reidesel had earlier seen four cups, two plain and two decorated, in the library of the Episcopal Palace. By Houël's time only two cups remained in the Treasury at Girgenti and the artist indignantly remarked that two other cups had been given to an 'Englishman', and that the canon who had presented them had no right to do so. One of the gold *phiale* with oxen ended up in the collection of Sir William Hamilton, the British ambassador at Naples, and is now in the British Museum. Hamilton might have been that 'Englishman' and the bowl a gift from the canon to the ambassador – or perhaps Hamilton acquired the precious artefact through a third party. The *phiale* that Houël drew differs slightly in that the bulls appear better fed, their bellies full, but the most apparent difference in design between this cup and that in the British Museum is the omission of the crescent moon. The other cup that Houël drew was smaller and plain. The most important fact about the origin of the four gold cups, however, was that Houël mentions that they were found in a tomb in the modern town of Sant'Angelo Muxaro, about 19 kilometres (12 miles) north of Agrigento.

The fate of the second bull *phiale* is less clear. It was seen in 1781 by the Prince of Biscari, but the last time we hear about its whereabouts was when it belonged to Giuseppe Lanza Branciforte, Prince of Trabia. The cup is illustrated in an article by its owner, who claimed that it had been purchased by him in 1814. But the mystery deepens, for this *phiale* has a crescent moon, like the one in London, but unlike the one in Houël's article. Even more perplexing is the fact that Branciforte's vessel then differs from the London example, for its central device seems to have been formed by a series of concentric circles, not tiers of granulation. So we are either dealing with a third cup of similar design, or we have to accept that Houël might have omitted the crescent moon, for an inexplicable reason, and that the drawing in the Branciforte article over-elaborated the central design.[24] Whatever the truth might be, we can only hope that one day the other three vessels might be rediscovered.

Fig. 24 (above)
Houel's engraving of the gold cups in the library at Girgenti, Agrigento.

Fig. 25 (opposite)
Gold *phiale* (offering dish) from a tomb at Sant'Angelo Muxaro. *c.*600 BC. Diam.14.6 cm.
British Museum, London.

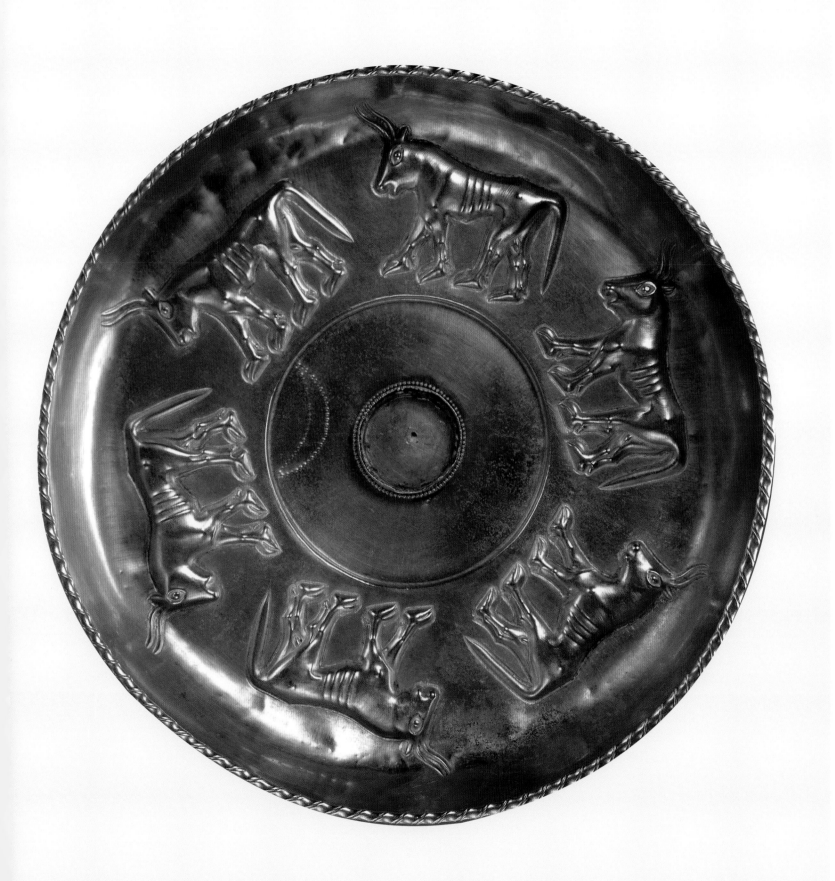

The site of Sant'Angelo Muxaro, home to a community of 'indigenous' people, has yielded exceptionally rich finds from tombs that reflect contact with both Greeks and Phoenicians.[25] The archaeological discoveries demonstrate how a wealthy, 'native' Sicilian, aristocratic class had developed from the tribes and clans of the Iron Age. Systematic excavations of the town's necropolis began in the 1930s under the direction of Paolo Orsi and they continue today. The ancient site dominates the plateau above the Platani, a navigable river used to transport goods to and from the coast. Rich reserves of alum and rock salt perhaps fuelled its early economy, and the settlement's strategic position overlooking the river might have inspired enterprising officials to regulate trade along its route.

Although some areas of habitation have been excavated, archaeologists have concentrated on the extensive necropolis, which, although dating back to the Middle Bronze Age, largely consists of tombs of the seventh to sixth centuries BC. Prominent are a series of large, domed, chamber tombs, often found containing multiple burials. During Orsi's investigations many of these tombs were explored. Tomb VI held one of the most significant finds. Among a mixture of locally produced pottery ranging from the eighth to sixth centuries BC and some imported vessels from Corinth and Athens were a number of human remains. Two of the bodies had been elevated above the others, laid on a raised rock-cut bench, their heads originally on an ornate wooden headrest. Still clinging to the finger of one of the skeletons was an extremely heavy gold ring engraved with a panting wolf (fig. 26).[26]

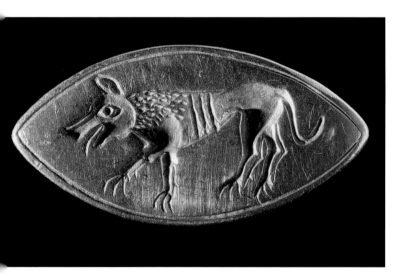 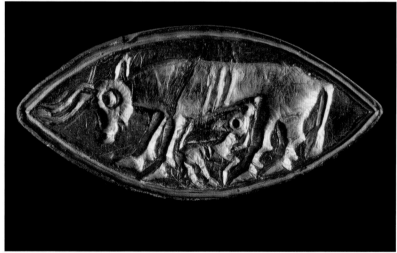

Fig. 26 (above left)
Gold ring with wolf. Sant'
Angelo Muxaro. c.600 BC.
L 3.6 cm.
Museo Archeologico Regionale
Paolo Orsi di Siracusa.

Fig. 27 (above right)
Gold ring with suckling calf.
Sant'Angelo Muxaro. c.600
BC. L 3.5 cm.
Museo Archeologico Regionale
Paolo Orsi di Siracusa.

This animated beast, creeping sneakily on open claws, has its tongue hanging down, its tail raised and its ribs indicated in a similar manner to those of the bulls on the gold *phiale* (see p. 25). Wolves roamed the island of Sicily and were no doubt the bane of shepherds' lives from antiquity until the 1940s when they were hunted to extinction. The funerary assemblage in this tomb consisted of simple bronze rings and fibulae, and masses of pottery both locally made and imported from Greece, especially from Corinth, as was usual at that time. The gold ring was evidence that the tombs held people of high status and gave credence to the fact that the gold *philai* and cups seen by Houël were likely to have originated from this or similarly rich tombs and not from another ancient site. A further clue arrived in the form of yet another hefty gold ring of the same almond-shape and style. This was discovered by chance by a farmer in 1927. An engraved image of a cow suckling her calf occupies almost the entire bezel of the ring (fig. 27). The large eyes, pronounced ribs and drooping tail all match with the bulls on the gold *phiale*.

Opinions concerning the dates and origin of manufacture for the gold vessels and rings have varied enormously. Some scholars have proposed that they were heirlooms from a time when the Mycenaean Greeks had trade links with settlements such as Thapsos on the east coast of the island. Others have proposed that their style and technique were influenced by earlier Aegean, specifically Cretan, precursors: the bull was a characteristically Minoan symbol. Perhaps Gela was their place of manufacture; a settlement of people of mixed Cretan and Rhodian origin. There is no source of gold on Sicily, so the raw material must have been imported. Were the vessels and rings imported fully crafted, or were they produced on the island? We might reasonably propose that the range of different opinions regarding these objects suggests that they were made in Sicily itself. The truth may well be that they were made sometime in the later seventh century BC by some talented craftsman in a workshop where all these inspirations played a part.

The Cretan connection is interesting, however, not least because of another ancient legend. Sant'Angelo Muxaro has been identified by many archaeologists as the ancient site of Kamikos, a town referred to by historical sources in relation to the myth of Daidalos and King Minos of Crete. Daidalos had created the famous labyrinth for King Minos as a prison for his wife's monstrous hybrid son, the Minotaur. Daidalos fashioned the maze so intricately that it was unfathomable, and as a result Minos imprisoned him, too, as he was the only one who could unlock its mystery. Not able to escape by land or sea, Daidalos devised an enterprising plan, creating feather and wax wings for his son Ikaros and himself. The tragic outcome is well known: Ikaros died when his waxen wings melted from passing too close to the sun, but Daidalos survived and found refuge at the Sicanian city of Kamikos, ruled by King Kokalos. Minos pursued him and eventually caught up with him, but rather than let Daidalos be captured, Kokalos had Minos murdered by his daughters, either in the bath or scalded by boiling water.

Most scholars nowadays do not overly stress the Minoan connection as bull iconography is not restricted to that culture. Rather, the iconography of both bulls and the wolf on the gold vessels and jewellery might provide clues as to the social standing of the tomb occupant, and also the society in which he lived. Bulls and cattle were expensive livestock and whoever could afford such beasts would have enjoyed a particularly significant status in the settlement.[27] Any indivdual able to offer a prize bull as a sacrifice must have been exceedingly wealthy: his family is likely to have owned more than one bull. The relevance of the wolf on the ring, still on its owner's finger, is also indicative of status and social standing within the community. In antiquity, wolves were high on the list of Sicily's top predators: a threat to livestock and therefore livelihoods.[28] Only the bravest and best protected by armour and weapons would

have volunteered to command in hunting parties, aiming to eradicate the threat of wolves. Through such activities the chief of the settlement would expect high praise for protecting the inhabitants and their livestock from such a predator. The wolf on the ring may thus have been an example of its owner demonstrating his power: man versus beast. These rich gold vessels and the two rings indicate a wealthy elite emerging among the Sicani communities of Sicily, their economic status displayed through elaborate tomb architecture and rich contents. The local communities were perhaps exploiting the presence of the early Greek settlers and Phoenician traders in the western coastal settlements, absorbing their ideas and sharing techniques, styles and iconography.[29] In return for the precious metal, traders might have received agricultural produce, such as wool or textiles.

Fig. 28
Limestone architectural block known as the 'Warrior of Castiglione'. *c.*600 BC.
H 70 cm.
Museo Archeologico Ibleo, Ragusa.

A more tangible indication of the emergence of a social hierarchy and the influence of Greeks on local societies is provided by a relief of a warrior from Castiglione (fig. 28), dating from sometime between the late seventh and early sixth centuries BC.[30] Carved from a monolithic slab of limestone, it is a hugely imposing sculpture that might have originally formed the lintel of a tomb doorway. Its idiosyncratic nature lends the monument an air of cultural and iconographic diversity to our modern eyes. Rising from the centre is a roughly modelled head peering out above an oversized circular shield carved in relief, which screens much of the horse's elongated body. The observer is challenged to imagine the body of the figure as if concealed behind the shield, transfiguring the modelling from three dimensions (the head) to two dimensions (the low-relief body of the warrior sitting on the horse). To confuse the image further, only the rider's left lower leg and foot are carved, appearing in front of the forelegs of the horse. At either end, a bull's head and part of a sphinx were carved almost in the round.

This monument conceivably began life with only one image, perhaps the relief carving of the front, but might later have been adapted, perhaps after damage or the deliberate reuse of an earlier monument. The three larger heads of the sphinx, bull and man might then have been carved later, altering the perspective, scale and perception. The figure is identified as a warrior by his spear and shield. Numerous significant elements are present, from the apotropaic device of the sphinx; to the bull with its implications of social and economic supremacy and fertility; to the aristocratic status symbol of the horse; and finally the physical protection of the shield and the spear. Another horse is discreetly carved on the sculpture's underside. What makes this intriguing and unique funerary monument even more remarkable is the text, carved in Dorian Greek script, on the left front side, beneath the head of the horse:

τοίΠυτίκ(κ)α
Πυρ(ρ)ινοι
Εποίεσε
Σθύλ(λ)ος

The dedicatory inscription names one Skyllos as sculptor, who carved the monument presumably showing Pyrrinnos, son of Pyttikas, as an aristocratic warrior.

We are fortunate that some of the burials of Sicily's 'indigenous' townspeople tell us something about the aspirations of the deceased for the afterlife. Unfortunately, though, they tell us precious little about their social organization and public and civic life. We can barely guess at how the pre-existing communities really viewed the increased influence of the Greek settlers. That Pyrrinnos had his dedicatory inscription carved in Greek, however, demonstrates his desire to emulate the newly established aristocratic families originally from the mother 'colonies' and to blend styles, imagery and text in a way that would appeal both to the diverse community he probably governed, as well the inhabitants of nearby Greek settlements.[31] The 'Warrior of Castiglione' has been associated with a circular tumulus containing multiple burials and a mixture of imported Greek, chiefly Corinthian, and locally made pottery. Those interred were probably 'indigenous', perhaps Sicels, although the Greek iconography and text were perhaps inspired by the proximity of Kamarina, the relatively newly founded 'sub-colony' of Syracuse. The monument was created in an environment where craftsmen reworked and transposed designs and motifs from the Greek world further east, and in the process formed an innovative hybrid style. The actual Greek settlements on Sicily were following a similar pattern of influences; one of the most interesting is Megara Hyblaia, which during the sixth century BC was emerging into a prominent settlement, worthy of detailed discussion here.[32]

Megara Hyblaia and Early Greek Settlements

The early Greek settlement of Megara Hyblaia, near Syracuse, is one of the best attested archaeologically. Although the ruins of the town do not stand much above ground level, the relative lack of later habitation has meant that archaeologists have revealed a clear picture both of how the settlement was planned and of how it developed over time.[33] The Megarians came from the city of Megara in the Corinthian Isthmus. As Thucydides recounts (see p. 40), they suffered many frustrations in their quest to locate a suitable permanent home. According to ancient sources their expedition leader was Lamis, who began by attempting, but failing, to set up a settlement at Trotilon, north of Syracuse. Then, invited by the Naxian colonists at the city of Leontinoi to join them on the condition that the Megarians evicted the local Sicel people, they were then themselves evicted, despite having been successful in routing the locals. They then set up camp at the older city of Thapsos, where Lamis died, but were then ejected by the Syracusans. It was a diplomatic move by an enterprising Sicel leader, Hyblon, that was to lead to the Megarians finally finding a new home at a coastal site in Hyblon's territory, just north-west of Syracuse. According to Thucydides this took place in the year 728 BC or thereabouts.

Ancient sources aside, the early settlement, with an estimated population of as few as 50–100 people, was nonetheless carefully planned and designed. The early dwellings developed over time from simple huts to more permanent, one-roomed structures, and were carefully positioned so as to allow each household enough land to be self-sufficient. During the seventh century the population grew, as did the size and form of at least some of the houses, perhaps an indication of the emergence of differing social classes. The end of the seventh century BC saw the arrival of new forms of buildings, serving not just individual requirements, but rather the needs of the community as whole. The development of public buildings, such as the *bouleuterion*, or council house, at Megara Hyblaia, echoed that of other towns in Sicily, such as Gela and Syracuse. Religious sanctuaries also developed architecturally, with stone replacing less durable materials for construction. The development of the public space, or *agora*, arose from the changes in society and politics that were occurring all over the Greek world during the later seventh and sixth centuries BC. The presence of an *agora* suggests that the populace needed a designated place to trade goods, both with each other and probably also with other communities. Megara Hyblaia commanded a considerable hinterland of fertile arable and pastoral land. Surpluses of grain, honey and maybe even salt might have been traded for other goods including the imported Corinthian and then later Attic wares, which held perfumed oils. The production of textiles, hinted at through the discovery of a profusion of loom weights and spindle whorls, perhaps indicates an industry that would have provided for both local and possibly foreign consumption. In return, the Megarian Hyblaians acquired the raw materials needed for metalworking, or finished metal articles. The relative wealth of the town, reflected through high-quality pottery, elaborate tomb monuments and rich grave goods, indicates a thriving community by the end of the sixth century BC. The finds from the town illustrate how the people were reactive to Greek imports whilst also forging their own distinct style, seen both on their pottery and in their architectural design.

Pottery production and consumption provide us with interesting glimpses into the society of a Greek town on Sicily from its foundation to its demise. Both tombs and settlement sites have yielded a range of pottery. Some was locally made, perhaps produced by the 'indigenous' communities who might have lived within the Greek settlement or nearby; other wares were imported. At first, pottery from Corinth dominates the archaeological profile at Megara Hyblaia, but through the seventh and into the sixth centuries BC, increasing imports

come from Ionia, east Greece, and from Athens and Attica. The finest painted vessels were usually imports, but during the middle decades of the seventh century BC, potters created a pictorial style painted in a range of colours. This was the local version of a polychrome style prevalent on the Cycladic Greek islands and the mainland of Greece.[34] The quality of these vessels and of their decoration rivals those from other Greek pottery workshops. It is perhaps surprising, then, that production seems to have been limited to workshops at Megara Hyblaia and Syracuse, although a few examples have been discovered at Selinous, the Megarian 'sub-colony' on the south-west coast.[35] Painted pots show scenes of Greek mythology; heroes and deities that reflect the Greek traditions of the settlers at Megara Hyblaia and Syracuse. The vivid use of colour and the animated compositions create a picturesque style.

A few fragments of pottery painted in a similar style were discovered at Ortygia, by Syracuse, one piece perhaps showing the ever-popular scene of Odysseus and Polyphemos. This pottery is almost exclusively found in domestic or religious contexts, rather than in tombs. The presence on some of the fragments of hoplites – soldiers wearing expensive armour and sometimes mounted on horses – again no doubt alludes to the importance of the aristocratic military classes in some of the Greek settlements.[36] The vessels are mostly open-shaped *kraters*, suitable for mixing wine and water, and were perhaps used at *symposia*, drinking and discussion parties for the wealthy men of the community. One of the most striking examples shows, on one side, two volatile rearing horses (fig. 30). Each horse raises one foreleg, knocking it against that of its counterpart as if in combat, while the other leg rests on a palmette motif. A frolicking dog on the right eagerly observes the battle, seemingly desperate to join in, while a calm and stately animal, perhaps a foal, watches the event from the left. The two central horses are magnificent creatures, enlivened by the free painting: the lines are fluid, the mane of the horse on the right, buoyant yet dense, contrasting with the simple braided mane of the left-hand horse. Two extremes are shown here: a tamed and domesticated horse on the left, plain coloured, perhaps accompanied by her foal; while the horse on the right is fiery, the orange-red paint of the upper body, mane and head emphasizing its wild and unbridled nature, with the wild dog behind it reinforcing this sense of ferocity even further. But man alone cannot tame a wild beast and only divine intervention can assist man in his desire to control nature. On the reverse side of the pot (fig. 29), two goddesses calmly attend the scene, one holding a stag by its tail with her right hand while raising a flower-like fan in the other. The less well-preserved figure of the goddess behind her raises both hands in adoration. The woman with the stag might be identified as the nature goddess Potnia Theron (meaning 'mistress of the animals') who, by Homer's time, was usually associated with the goddess Artemis. 'Potnia' was a Mycenaean word inherited by the later Greeks and she is one of the few recognizable figures on Corinthian pottery of the seventh century BC. However, Potnia Theron is usually shown winged, so here her image might have been merged with that of Artemis. The same designs, rosettes and diamonds appear as filling ornaments on the body of the vessel as well as on the women's elaborately decorated garments. Were actual textiles produced in the city as ornamental as these?

The most enigmatic, yet vividly painted fragment of Archaic pottery from Megara Hyblaia (fig. 31) was broken from the rim of a *dinos* (mixing bowl).[37] Five men grab a thick rope, the one furthest back holding the coil. Four wear an unusual garment, two in black and two in red, which is secured over one shoulder with an ornamental trim, but leaves very little of their thighs covered. The rearmost is bare-chested and wears a skirt pulled up to his chest. Some have pointed beards and some are clean-shaven, while at least two have long hair pulled behind their ears, and one has a skullcap hairstyle. The preserved eyes are eager, with upper lids raised and enlivened by the rich use of colour and bold painted lines. Yet the

Fig. 29
Detail of storage vessel (*stamnos*) illustrated overleaf (fig. 30) showing a nature goddess. Made at Megara Hyblaia, *c.*650 BC. H 56 cm.
Museo Archeologico Regionale Paolo Orsi di Siracusa.

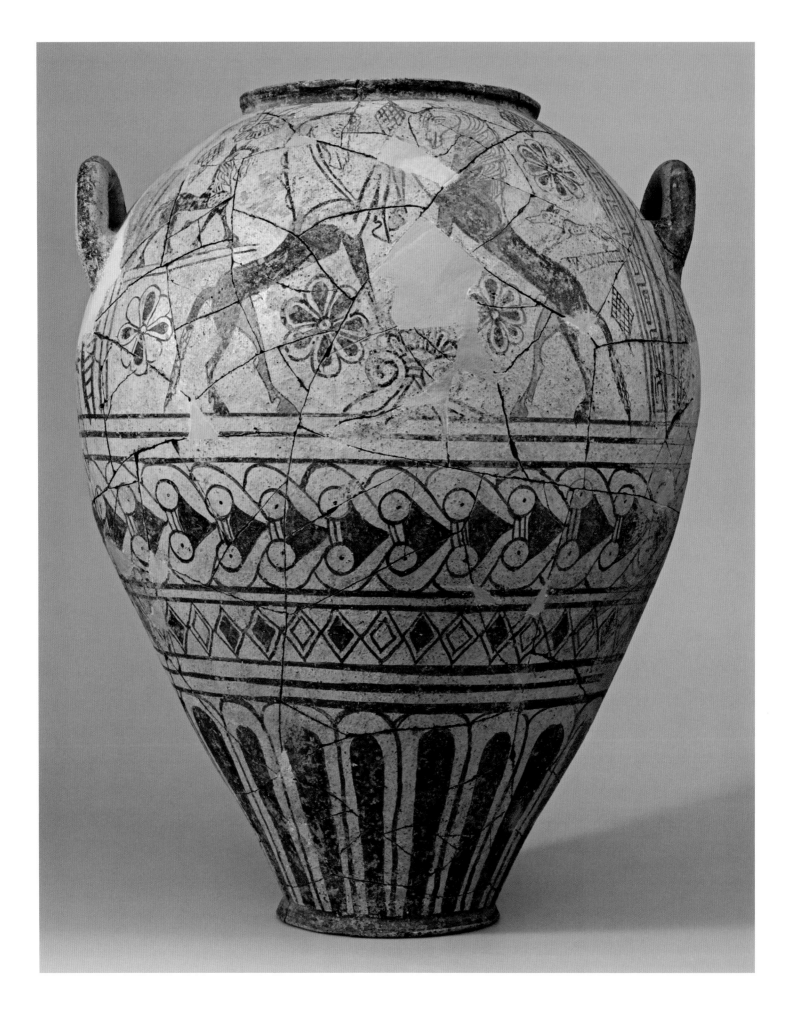

scene is difficult to interpret. Some scholars claim that the men are pulling the Trojan horse up to the walls of Troy, a surprisingly rare scene in Greek art. An alternative view would have the men as Argonauts, followers of the hero Jason, who are bringing their ship the *Argo* into port or shore. This potsherd shows a developed polychrome style of pottery, with a mixture of painting and engraving, and less use of filler motifs than earlier examples.

Greek iconography and selected excerpts from myths were also used to decorate religious artefacts, such as the miniature *arulae*, domestic altars that were a peculiar phenomenon of the Greek, Phoenician and culturally mixed settlements of Sicily. They were produced in and traded from workshops on either side of the Strait of Messina in both southern Italy and Sicily, but are not commonly found elsewhere in the Greek Mediterranean. These rectangular, box-shaped altars are one-sided, with a scene modelled in bold relief, framed above with an overhanging cornice, and below by a plinth: in essence the scenes appear like excerpts from

a long, architectural, figured frieze. The inspiration for their design might have been the Athenian black-figured pottery that was being imported into southern Italy and Sicily during the middle decades of the sixth century BC, when most of these altars were produced. The *arulae* show how innovative Sicilian Greek workshops were in adapting Greek subjects and themes from one medium to another. *Arulae* have been discovered serving various functions but primarily as platforms to burn appropriately sized offerings to either deities, when found in household shrines and temple precincts, or to the dead, when found in graves.[38] It is perhaps surprising then that the scenes portrayed rarely relate to a specific cult of a deity, nor do they show ritual activity. Instead, mythological stories, chariot and horse racing and animal combats feature strongly in the repertoire. Some of the mythological scenes relate so specifically to stories taken from Homer and other Greek poets that they would have had a resonance only with Greeks familiar with their heritage and folk tradition. Scenes taken from the Trojan Wars and from Odysseus' adventures were common themes.

A particularly animated example (fig. 32), found at Megara Hyblaia, comes straight from Homer's *Odyssey*.[39] As explained earlier, Odysseus and his companions are trapped in the Cyclops Polyphemos' cave, along with their captor's flock of sheep. Odysseus cleverly devises an escape plan involving hiding beneath the bellies of the sheep, which the Cyclops would release to pasture at daybreak.

> *So three beasts to bear each man, but as for myself?*
> *There was one bellwether ram, the prize of all the flock*
> *and clutching him by his back, tucked up under*
> *his shaggy belly, there I hung, face upward,*
> *both hands locked in his marvellous deep fleece,*
> *clinging for dear life…*
> HOMER, *ODYSSEY*, BOOK 9, 481–6[40]

The scene on the altar shows two men clutching the bellies or rams. Both men cling on to the animals: the foremost escapee has his head beneath that of the ram's head, while the poor unfortunate man escaping under the second animal has a raw deal – his face is directly below the ram's rear end.

Fig. 32
Terracotta altar (*arula*) showing a scene from the *Odyssey*. Found at Megara Hyblaia. Made *c*.550 BC. L 43 cm.
Museo Archeologico Regionale Paolo Orsi di Siracusa.

Other *arulae* show scenes of one animal dominating and devouring another. These animal battles, known as *zoomachies*, featured on the sculptural decoration of some of the earliest Archaic monumental temples on the Athenian Acropolis, in some cases carved on a colossal scale.[41] The closest inspiration for the altar scenes are architectural friezes, the best parallels coming from the temple of Athena at Assos in Turkey, carved *c*.540 BC, with its numerous scenes of animal attacks.[42] The subjects might have referenced literary works. In Homer's *Iliad*, lion attacks on domesticated animals are occasionally used as similes for powerful warriors attacking and defeating others with uncompromising precision.

> *Then he took down two of the sons of King Priam Echémmon and Chrómius, caught in one*
> *chariot. As a lion charges into a herd of grazing cattle, and leaping onto one, breaks its neck:*
> *just so Diomedes knocked them out of their car brutally…*
> HOMER, *ILIAD*, BOOK 5, 152–7[43]

The metaphor can be taken further by claiming one city or one nation's subjugation of another. A fine example of the theme is from a terracotta altar from Centuripe, which shows a powerfully built lion bringing down a bull (fig. 33).[44] The lion grips on to the bull's belly with his mighty paws, his jaw wide open, exposing a row of extremely sharp teeth, which he uses to chew on the bull's back. The bull swishes his tail in desperation. But, unlike the lion's, his tail is beginning to drop – a mark of defeat – while his lower legs have crumpled beneath the lion's considerable mass, one leg overhanging the architectural frame of the relief. A similar scene (fig. 39) crowns the upper tier of a large terracotta altar from Gela, in which a lioness or panther devours a fallen bull. Certainly similarities in design and technique demonstrate that the same coroplasts (terracotta makers) produced large and small altars alike.

Returning to the city of Megara Hyblaia, the archaeological remains provide us with some significant insights into early Sicilian Greek funerary practices. Two distinct groups of elaborately decorated and richly furnished tombs were discovered at strategic positions on the roads leading from the north and the south of the town. The cemeteries also provide us with a rare glimpse into the sculptural commissions of the community. The majority of the sculptures have probably disappeared, but those that survive are of high quality and, in the case of a few marble *kouroi* (young men) and a head of a *kore* (maiden), were carved from

Fig. 33
Terracotta altar (*arula*) with a lion mauling a bull. From Centuripe. *c*.520– 500 BC. L 51.5 cm.
Museo Archeologico Regionale Paolo Orsi di Siracusa.

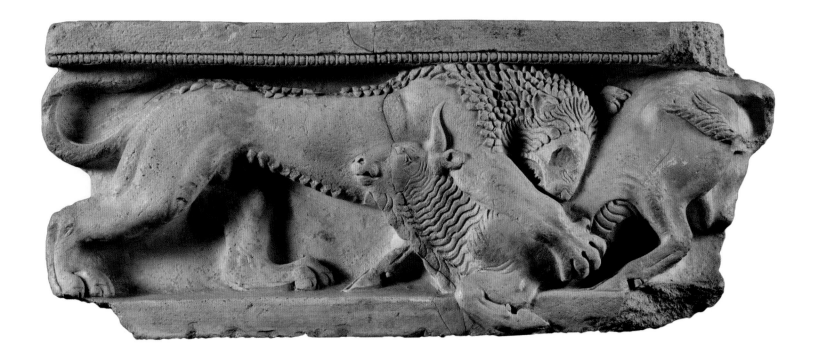

expensive imported marble. At least one of the tombs from the north cemetery had a small shrine erected over it which was richly ornate in its architectural decoration, dated to the end of the sixth century BC. Part of the upper section of the structure survives, consisting of a Doric frieze with a central triglyph and two metopes exquisitely carved with stylized floral patterns (fig. 34; see also temple plan, fig. 61).[45] The shrine housed a rare marble statue of a young man, a *kouros*, now sadly fragmentary. Fortunately, a better-preserved example (fig. 36) was discovered in the southern necropolis at Megara Hyblaia; this is one of the few surviving examples of marble sculpture from the Archaic period on Sicily. The figure, dating to about 550 BC, follows the canonical type prevalent in East Greek workshops, but unusually has a dedicatory inscription carved into its thigh.[46] The text, in the Megarian Greek alphabet, tells us that the figure was a representation of doctor 'Sombrotidas', son of 'Mandrokles'. The rare use of marble and the style point to the possibility of this statue being an import, commissioned by 'Sombrotidas' or his family to serve as a memorial of his life.

Fig. 34 Limestone Doric frieze from tomb at Megara Hyblaia. *c.*500 BC. W 1.22 m.

Museo Archeologico Regionale Paolo Orsi di Siracusa.

Parallels for the sculptures from Megara Hyblaia can be found on the Greek mainland and islands and it is clear that some are specially commissioned imports, while others are locally made and of a hybrid style. To the latter category belongs a statue carved from local white limestone, probably sourced from the quarries at nearby Melilli.[47] It was discovered in over 900 fragments, in the north cemetery at Megara Hyblaia, where a selection of rich monumental burials were located, with graves for the elite amongst many others of modest means. It is an enigmatic yet touching statue of a woman nursing two infants (fig. 35), a type of image known as a *kourotrophos* (literally 'nurturer of boys'). *Kourotrophoi* were associated with the cults of Hermes or Artemis, where the protection of the young was paramount, but this statue shows an idea personified into a matronly and nurturing woman, who some scholars have suggested is Night suckling Sleep and Death. Such a protective and bountiful figure would have been entirely appropriate as a guardian tomb sculpture, ensuring eternal life and abundance after death. The figure, made in about 550 BC, is carved with simplicity of form and design that recalls sculptures in the more commonly used terracotta. The influences it draws on are plentiful, ranging from Asia Minor and Cyprus to Etruria, but all are blended with the local traditions for expressing the human form.

Megara Hyblaia continued to prosper and develop through the sixth and into the early fifth centuries BC, yet surprisingly it minted no coins. The town's downfall came with the Syracusan tyrant Gelon, who defeated Megara Hyblaia in 483 BC (see p. 76). After this catastrophe the town recovered, albeit on a smaller scale. Its 'sub-colony' Selinous, however, thrived and eventually came to overshadow Megara Hyblaia in terms of its monumental public buildings. The primary reason why many of the newly established Greek settlements thrived was because of the climate and the fertility of the soil, which supported agriculture and the rearing of livestock. Cults and sanctuaries of the goddesses Demeter and Persephone, and other deities associated with fertility, rose spectacularly, and through them people gave thanks to the earth. We shall see how those in charge of religious affairs sometimes ascended to prominent ranks, from priests to tyrants.

Fig. 35 (left)
Limestone statue of a woman nursing two infants (*kourotrophos*). From Megara Hyblaia, *c.*550 BC. H 78 cm.
Museo Archeologico Regionale Paolo Orsi di Siracusa.

Fig. 36 (right)
Marble statue of a young man (*kouros*) inscribed with a dedication by 'Sombrotidas'. From Megara Hyblaia, *c.*550 BC. H 1.19 m.
Museo Archeologico Regionale Paolo Orsi di Siracusa.

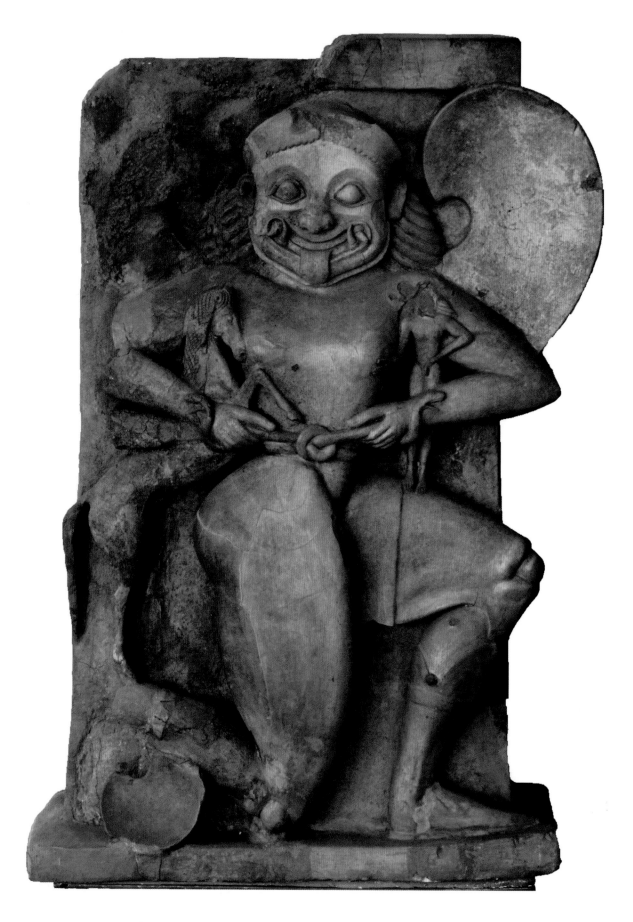

Fertile Sicily: the Island of Persephone

In 1999 three large terracotta altars were discovered in a structure at Bosco Littorio, a coastal sector of the ancient city of Gela, thought to be an *emporion* (trading centre).[48] The buildings at the site date from the sixth to early fifth centuries BC, and housed products related to trade, including vessels imported from Attica and Chalcis on the Greek mainland, and transport amphorae. The *emporion* seems to have been abandoned shortly after 480 BC, when it was violently damaged. The three altars are among the latest datable objects found during the excavations, and might have been made not long before, then stored ready for shipment abroad.

The three altars are stylistically and technically similar, suggesting that they were produced in the same workshop in Gela, for fragmentary but comparable altars were found during excavations there. All three preserve extensive painted decoration, notably red for the backgrounds and a yellow pigment that the firing process has almost vitrified. Two of the altars feature scenes from mythology. One portrays the terrifying gorgon Medusa, poised as to move swiftly forwards (fig. 37). The story goes that when Perseus beheaded Medusa, out sprung Pegasos, the winged horse, and Khrysaor, a golden giant, both of whom she

Fig. 37 (opposite)
Terracotta altar with the gorgon Medusa. From the trading centre (*emporion*) at Gela, *c*.500–480 BC. H 1.16 m.
Museo Archeologico Regionale di Gela.

Fig. 38 (left)
Terracotta altar with Eos abducting Kephalos. From the *emporion* at Gela, *c*.480–460 BC. H 53 cm.
Museo Archeologico Regionale di Gela.

clutches affectionately in the image on the altar. As was customary in representations of the theme, the gorgon's head has miraculously reattached itself. Another, smaller, altar shows the winged goddess of the dawn, Eos, her pose echoing that of Medusa, whisking away a sleeping Kephalos (fig. 38). As a punishment for sleeping with Aphrodite's lover Ares, Eos was cursed with an insatiable sexual appetite by the goddess of love, resulting in her abducting many young mortal men – in this instance Kephalos.

The third altar (fig. 39) has two layers of decoration, its upper tier decorated with a *zoomachy*, here a ravenous feline savaging a bull. As life pours out of the mighty bull, it unknowingly supports new life, for the feline's engorged teats, filled with milk, will feed her young cubs: the cycle of life goes on. The offering of a bull was man's greatest sacrifice, but here it is a wild animal, not a priest, who is killing the prize beast. In contrast, the main scene below shows three women, who when initially observed appear alike, but are subtly different. The figures of the two outermost women were probably made in the same mould, then added to the background before firing took place. The women are dressed identically in sleeved *peploi*, long tubular garments, characteristic of the Archaic and early Classical periods. Each holds an object in their hand, identified as either wreaths or garlands. The women wear *poloi* (crowns) that nestle into their formally arranged hair, the stylized locks tied in a band behind the ears, then falling in long spirals behind the shoulders. This type was commonly found in early Greek Sicilian art, ranging in scale from small terracotta and even wooden figures and larger sculptures.[49] The central figure, however, is distinct from the other two. Her falling locks of hair are braided and flow down in front of her shoulders, where her hands grasp them. She also wears a cloak over her shoulders, a garment not worn by her companions, the material of which falls on either side of her body. On the side walls of the altar are the barely visible remains of painted lotus flowers, picked out in brown and black pigment. In antiquity lotus flowers represented female sexual power and fertility as well as birth and rebirth. Like poppies, their narcotic quality made them the perfect drug to enhance the state of meditation and then forgetfulness that might have been required for the participants in the secretive Mystery cults of Persephone and Demeter. Persephone was often shown holding either lotus flowers or poppies.[50] Lotus flowers might have been ingested to enhance a state of meditation while witnessing or performing the Mysteries that surrounded the cult of the goddesses. So perhaps we are looking at images of these two goddesses, but there is no clue as to the identity of the third, who has been variously identified as Hekate, Aphrodite or even Artemis, all of them goddesses who have associations with the natural world, childbirth and fertility. The central figure may possibly also have been intended as a priestess, raising her hands in prayer, flanked by the goddesses whom she serves. An interesting idea, but perhaps unlikely as she is modelled on the same scale as her companions and wears a *polos*, regalia routinely associated with deities.

A clue might be discovered in another sculpture, in this instance a limestone metope (fig. 40).[51] This was found along with other similar metopes and architectural elements reused in a later context at Selinous, commonly attributed to the decoration of a now unidentified building, labelled by the archaeologists as Temple Y. The metope depicts three women, perhaps the same goddesses as those shown on the altar from Gela, but here in more animated poses. The women raise their hands to display offerings that appear to be short-stemmed flowers. The central goddess could even be wearing a cloak like that of her counterpart on the Gela altar. Although the limestone metope dates to around 550 BC, earlier than the terracotta altar, the iconographic comparisons between the two scenes are considerable. The goddesses on the metope have been variously identified as Demeter, Persephone and Hekate (making up the chthonic triad); or the Horai, goddesses of the Seasons, worshipped especially by farmers; or even the Charites, sometimes known as the Three Graces. An intriguing identification has

Fig. 39 (opposite)
Terracotta altar with
three goddesses. From
the *emporion* at Gela,
c.500 BC. H 1.13 m.
Museo Archeologico Regionale
di Gela.

Fig. 40 (above)
Limestone metope showing
a triad of goddesses. From an
unknown temple at Selinous,
c.550 BC. H 83 cm.
Museo Archeologico Regionale
Antonio Salinas, Palermo.

been proposed more recently, claiming that the central figure is Persephone, picking flowers in a meadow, while her companions, the Okeanides (sea nymphs), or possibly Athena and Artemis, attend. If this identification is correct, then the scene would illustrate the moment just before Persephone's violent abduction by Hades. It might never be possible to explain the intended narrative, but all the commentators agree that the goddesses are associated with fertility.

It is not immediately apparent which deities were served by each of the three altars from Gela. One depicts three goddesses and has an assumed connection with fertility cults. The other two are less obvious. Despite her gruesome appearance, Medusa was also connected with fertility. On the altar she is a shown as a mother; the children, Pegasos and Khrysaor, the result of her sexual encounter with the god Poseidon.[52] Even in death, Medusa's blood retained its magical power. The Roman poet Ovid describes Perseus flying over the land of Libya, with drops of blood falling from the gorgon's severed head. So potent was this blood that it spawned serpents in the earth: the serpent was a symbol of the cycles of life and death, rebirth and the seasons.

> *While Perseus was flying on whirring wings through the yielding air, bearing his famous trophy, the snake-headed gorgon; and as he triumphantly hovered over the Libyan desert, some drops of blood from the Gorgon's neck, fell down to the sand, where the earth received them and gave them life as a medley of serpents.*
> OVID, *METAMORPHOSES*, BOOK 4, 615–19[53]

Ultimately Medusa's death brought life, so a connection with the fertile earth is not as astounding as it may initially have seemed. The smaller altar with Eos cannot so immediately be associated with fertility, but as a goddess of dawn she heralded the start of each new day, bringing light and renewal; all features associated with rebirth and regeneration.

Gela was home to several major sanctuaries dedicated to Demeter and Persephone, including the shrines at Predio Sola and Bitalemi.[54] At Bitalemi the sanctuary was dedicated to Demeter Thesmophoros, giver of laws. Demeter's cult was as significant in the development of politics and civic life in urban areas as it was to the agro-pastoral communities in the countryside. Although festivities and rituals carried on throughout the year, the ceremonies were practised on a larger scale during planting, which corresponded in Greek legend with the return of Persephone (and therefore of life) from the underworld, and then again during the harvest. The clandestine rituals that occurred during these nocturnal festivals were attended by women only, in secret locations far from the settlements, and involved intoxication and wantonness; elements that were not normally permitted within the female sphere of civilized Greek society. The large number of clay oil lamps found at some of these locations bears witness to the practical requirements of the festivals' participants. The rites culminated in the sacrifice of a piglet.

The formal adoption of the Greek rites integral to the cult of Demeter and Persephone was a gradual process in Greek and mixed communities.[55] Indigenous peoples had their own fertility deities to appease and rituals to perform, many of which were based around springs and rivers. Prehistoric sites in Sicily reveal the existence of elaborate fertility cults based in caves. Painted symbols of ritualistic hunts found in the Addaura (see p. 30) and Niscemi caves appeared to promote the fertility of domestic animals, plants and humans, which might have alluded to a belief in rebirth or an afterlife in another world, perhaps subterranean. This idea was not unique to early Sicilian cultures but, realizing that their island was particularly rich in natural resources, the people practised such rites with great vigour.

The settlers' awareness of and dependency on the land and sea was further transmitted through early coinage.[56] Coins minted in Greek settlements on the island reveal a particular affection for symbols of the natural world: for instance, a crab for Akragas, parsley for Selinous, a dolphin for Zankle and a cockerel for Himera (figs 41–4). The latter might have been intended as a pun of the city's name, as the cockerel heralds the dawn of the day – *hemera* in Greek.[57]

Although the exact nature of worship in non-Greek communities is still unknown, veneration of both chthonic and heavenly deities was practised. Unsurprisingly there was an emphasis on the pastoral and agricultural landscape, with ceremonial activity centred on small shrines: hence the frequency of models of sacred huts during the seventh and sixth centuries BC, as shown by the example surmounted by a bull (fig. 45) from ancient Iaitas.[58] Rituals were also probably practised in the open air.

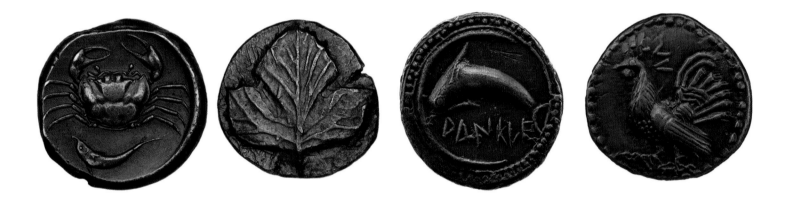

Fig. 41
Silver *didrachm* of Akragas showing a crab. *c*.464 BC. Diam. 2.5 cm.
British Museum, London.

Fig. 42
Silver *didrachm* of Selinous showing a sprig of parsley. *c*.530 BC. Diam. 2.3 cm.
British Museum, London.

Fig. 43
Silver *didrachm* of Zankle showing a dolphin. *c*.510 BC. Diam. 2.3 cm.
British Museum, London.

Fig. 44
Silver *didrachm* of Himera showing a cockerel. *c*.500 BC. Diam. 2.0 cm.
British Museum, London.

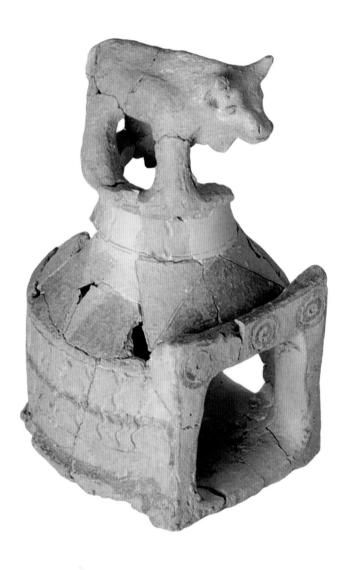

Fig. 45
Terracotta sacred-hut model.
From ancient Iaitas (Monte
Iato), c.575–525 BC. H 28.5
cm. Parco Archeologico di
Monte Iato.

The Phoenicians on Sicily were also conscious of the land's importance and introduced the worship of Baal-Hammon, a fertility god, to the island. The assimilation of traditional cult practices and deities with their Greek counterparts has made it difficult to identify some of the locally produced images of gods and goddesses. Modern research has demonstrated how 'indigenous' communities started to absorb elements of Greek ritual, from architectural features of shrines (for example, the terracotta model from Sabucina in Caltanissetta; fig. 62), to the types of offerings given to the deities, who themselves were sometimes amalgams of local and Greek gods. The chthonic nature of the cult of Demeter and Persephone had a natural affinity with the agro-pastoral religious practice that was popular in non-Greek settlements from an early period, but the change to more organized rites was manipulated by aristocratic groups. The rites were then eventually adopted by early tyrants, such as the Deinomenids of Syracuse, for political and propaganda reasons. Herodotus tells us that Telines (a historical king of Gela) and his descendants became the priests of the goddesses of the underworld, which reinforces the connection between high-ranking religious officials and the rise of powerful autocratic rulers.[59] Control of the city's most important cults could and did lead to dominion over the people by unelected rulers.[60]

At Selinous, the most important cult of Demeter was that of Demeter Malophoros, bearer of fruit, and sometimes the goddess is known by just her epithet.[61] Persephone was not ignored at Selinous, however, and might be the goddess mentioned in inscriptions as 'Pasikrateia' (all-ruling), Queen of the Underworld. Above all other things, food was, and still is, the most significant commodity for humankind, and in all societies the production of food provokes intense superstitious reactions and practices, with the hope that divine beings will look kindly on the harvests. In good years, and particularly in richly fertile lands such as Sicily, surpluses provided a commodity for trade and could lead to great wealth, which in turn led to patronage of sanctuaries and cults, and to temple building. At an individual level, the rise in personal wealth often manifested itself in luxurious lifestyles for the lucky few, and led to richer grave goods.

The significance of the cult and the devotion of its followers was demonstrated by the huge number of offerings found by archaeologists, the vast majority of them in the form of terracotta figurines (fig. 46).[62] It is not always clear whether these images represent worshippers or priestesses holding offerings, or the goddesses themselves receiving them. The figures wearing a *polos* (crown) are likely to be images of the goddesses; those holding a pomegranate are almost definitely Persephone; while those holding a pig could be either mother or daughter. Depending on the quality of the workmanship, terracotta figures would have been relatively affordable, and therefore a popular gift to the goddesses from the less wealthy classes. Sanctuaries and shrines would quickly have filled up with terracotta figures, pottery, lamps and actual foodstuffs, not to mention the more expensive dedications. The sanctuary custodians periodically cleared the cheaper offerings, throwing them into large pits or sometimes more carefully re-depositing them into *bothroi* (sunken chambers). Occasionally such figures have been discovered in domestic or funerary contexts. The popularity of the

Fig. 46
Terracotta figures and clay lamps found in sanctuaries at Gela, Kamarina, Akragas and Selinous. 600–400 BC.
H of tallest figure 38.3 cm.
British Museum, London.

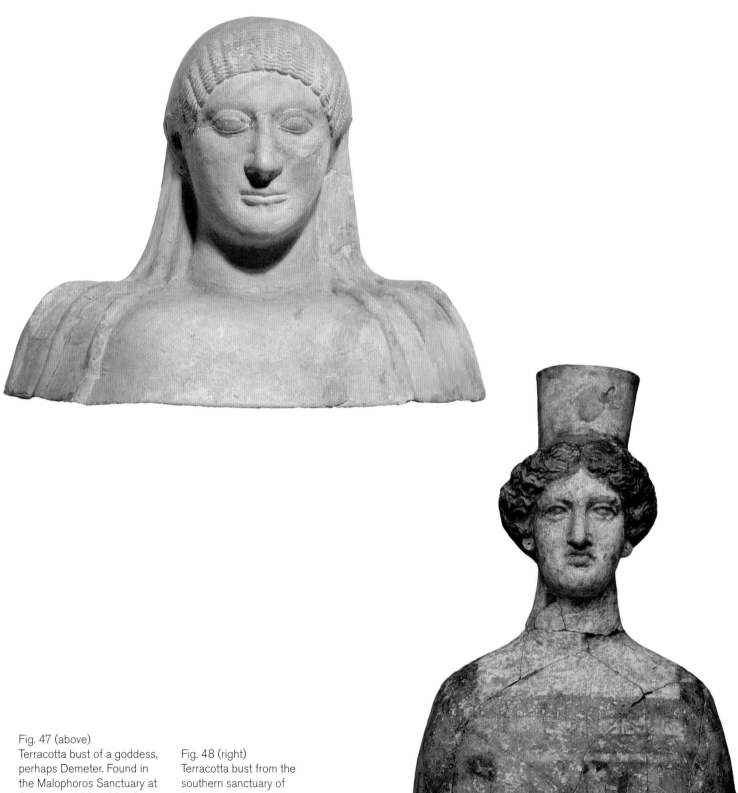

Fig. 47 (above)
Terracotta bust of a goddess,
perhaps Demeter. Found in
the Malophoros Sanctuary at
Selinous. *c.*480–460 BC.
H 38.8 cm.

Museo Archeologico Regionale
Antonio Salinas, Palermo.

Fig. 48 (right)
Terracotta bust from the
southern sanctuary of
Demeter at Morgantina.
*c.*330–300 BC. H 34 cm.

Museo Archeologico Regionale,
Aidone.

terracotta dedications is testified by their export to other Greek settlements in southern Italy, such as Lokri in Calabria, and to the Phoenician settlement at Tharros on Sardinia.

Another significant form of offering to Demeter and Persephone were terracotta busts. During the sixth and fifth centuries BC these usually took the form of heads alone, but they were later modelled as far down as the breasts. Quite how they were displayed in sanctuaries is unclear, but some have holes by which they were either suspended or attached to walls. One of the largest and most dramatic of its type (fig. 47) was found with over 12,000 terracotta statuettes and busts in the sanctuary of Malophoros at Selinous.[63] Its large, bulbous eyes, neatly arranged formal hairstyle and severe countenance resemble Sicilian Greek sculpture in stone. The modelling is highly detailed, from the sharp eyelids and tear ducts to the locks of hair, which show a great contrast between the formal arrangement over the brow and the luscious, long locks that fall from behind the ears then gently undulate over the shoulders and high chest. Behind the hair is a plain band or diadem and there is a fixing hole drilled into the top of the head. Remarkably, on this bust the ears are pierced to accommodate real metal earrings, while on most other busts the earrings are modelled in the clay, usually in the form of simple discs. With its original painted detail, this must have been a particularly striking example. It recalls the series of Archaic Greek marble statues of *korai* (maidens), well-known from the Athenian Acropolis but also occasionally found in the Greek settlements of southern Italy, Sicily and Cyrenaica (Libya), either imported ready-made or carved by local or migrant sculptors to meet local demand.[64]

The votive bust had a long life, with later examples being produced in the south-eastern cities of Morgantina, Syracuse and Grammichele. One of the finest (fig. 48) was found at Morgantina and dates to the late fourth century BC.[65] A tall *polos* crowns the elegantly arranged hair, while the front of the bust serves as a canvas for a painted design on a pink ground. It has been proposed that the scenes imitate actual woven designs in real textiles. Only rarely does enough of the painted scene remain to enable identification of the subject. On this example several women appear, one of whom has a large *tympanon* (drum), while on another, now headless bust, the abduction of Persephone is represented.

While the busts were important offerings, the cult images of the chthonic deities were the focus of the rituals. These were sometimes produced on a monumental scale. The city of Morgantina gives us a unique insight into such religious images. Morgantina, near modern Aidone, was an island settlement in the modern province of Enna, situated on a key route between eastern and southern Sicily. By the later sixth century BC the town had a mixed population of Greeks and Sicels, and as such played a vital role in the struggles between 'indigenous' peoples and Greek settlers. Sources tell of a Sicel ruler, Duketios from Enna, who attempted to form a Sicel federation to rid central Sicily of Greek control, and during his widespread campaign attacked the Greeks at Morgantina in 459 BC.[66] Duketios was eventually defeated and exiled by the combined forces of Akragas and Syracuse, his action being the last real rebellion by the island's non-Greeks before the Roman period. Later the town was ceded to Kamarina, perhaps to buffer the territorial aspirations of Syracuse, to whom it finally fell, under the control of the tyrant Dionysios I, in 396 BC. Thereafter, the town thrived, and was particularly active in cultural and artistic affairs, as we shall discover later. The town's fertile lands stimulated the cult of Demeter and Persephone. Several shrines of the goddesses have been unearthed, but one of the most significant is the sanctuary complex at San Francesco Bisconti, located outside the city walls near the cemetery and natural springs.[67] Regrettably this sanctuary was the site of widespread illegal excavations during the 1970s and many unique and valuable finds were smuggled out of Sicily to be sold on the art market. Happily, however, during recent years many of these great discoveries

have been returned to Sicily and now grace the archaeological museum at Aidone. They include three major cult images.

These three important sculptures provide us with a rare glimpse into the techniques used by sculptors on Sicily in carving and assembling large-scale statues from stone and other materials. The technique, known as acrolithic, was used on the Greek mainland and islands, but was more common in places where the Greeks settled but lacked usable marble sources, such as Cyrenaica in Libya, southern Italy and Sicily. Marble, terracotta, limestone, wood and bronze could be combined in various different ways to create large and realistic statues. From the sanctuary at Morgantina came a pair of over-life-sized statues, with preserved heads, but with only three hands and three feet between them (fig. 49).[68] The flesh parts were made of marble, while hair and clothes were made from different materials. It is unclear whether their bodies were made of stone, perhaps limestone, or of wood, with painted drapery, or even real clothes, as in the modern reconstruction in the museum at Aidone where the statues reside. Thought to have been illicitly dug up in Building A in the sanctuary at San Francesco Bisconiti, the statues are likely to represent Demeter and Persephone and, because of the position of the feet, are usually restored as seated. The statues date from the period 530–520 BC when the

Fig. 49
The two Archaic acrolithic marble statues reconstructed in the Museo Archeologico Regionale, Aidone, with clothes by the designer Marella Ferrara. c. 530–520 BC. H of heads only: left, Acrolith A, 33 cm; right, Acrolith B, 30 cm.

so-called Archaic Greek 'smile' was prevalent, and the style blends local with East Greek, Ionian influences, so it not certain whether the sculptor might have been from the Greek East or native to Sicily: the marble was imported from the Greek island of Thasos. The missing hair could have been made of painted or gilded wood or bronze, or a wig of real hair, and either one or both of the figures might have been veiled, in accordance with other surviving representations of the two goddesses. Whatever the precise combination of materials, the two images when complete would have appeared imposing, if not somewhat eerie, in the dimly lit interior of the sanctuary building in which they were displayed.

Even better preserved is the so-called Morgantina Goddess (fig. 50), a rare surviving example of a sculpture made from both limestone and marble, a technique also found on the metopes from Temple E at Selinous (fig. 76; see pp. 105–6).[69] The Morgantina Goddess stands over two metres tall, her body carved from limestone quarried from the region of Ragusa in south-eastern Sicily; her face, arms and feet made from imported marble from the island of Paros in the Cyclades. Carved in about 420–410 BC, the statue displays the great skill of the sculptor in working limestone to appear crisp and fresh, and as fine as marble. The goddess stands confidently, her weight balanced, the right arm outstretched, the left arm probably also extended but perhaps less than the right. She wears two garments, one a short-sleeved *chiton* (dress), over which is a thin *himation* (cloak). Different carving textures and paint would have helped to distinguish one garment from the other. The resolute swing of the woman's voluptuous body sends a ripple through the fabric of her two garments, mirroring a taste for tranlucent drapery developed by sculptors in Athens and the Peloponnese. Originally the cloak might have covered the goddess's head, over hair made of another material, perhaps cast in bronze and gilded. The statue may also have been crowned by a *polos* under the cloak, as suggested by comparisons with terracotta figures found at Morgantina and elsewhere on Sicily.[70] Such a speculative reconstruction would allow for the rich use of different materials to create a very lifelike image, which would have been further enhanced by the original colour, now indicated only by traces of the red pigment cinnabar.

Scholars are not in agreement about the identity of the woman, although they do concur that it is a goddess rather than a mortal subject. Because of the sensuality of the figure, Aphrodite, goddess of love, has been proposed

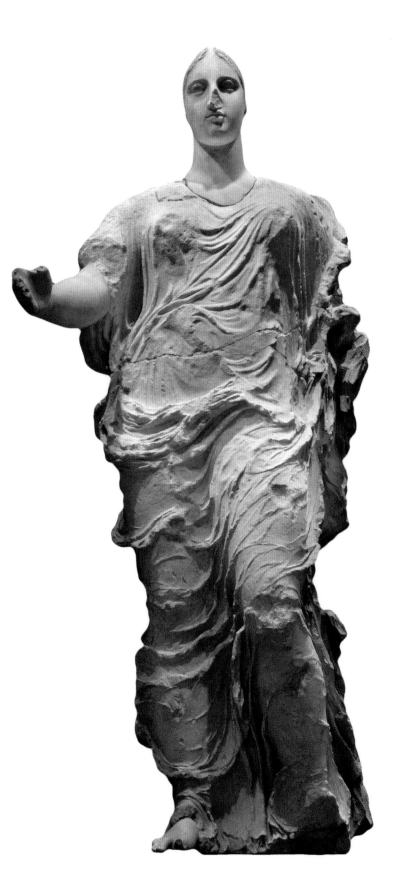

Fig. 50
Marble and limestone statue of a goddess from Morgantina. *c.*420 BC. H 2.20 m.
Museo Archeologico Regionale, Aidone.

– an appropriate subject for a dedication in the sanctuary, for she and her son Eros were instrumental in the story of Persephone's abduction. According to some versions of the tale, Eros fired his love-charged arrow at Hades, inducing him to fall in love with Persephone.[71] If not Aphrodite, then the statue may be Hera, shown here as the bride of Zeus, her veil drawn up in a gesture of modesty. Nonetheless, the most convincing identifications see the figure as Demeter or Persephone, the hands holding attributes denoting their ceremonial function, perhaps a torch, a sheath of corn, or a pomegranate.

Despite his villainous role in the myth of Persephone, Hades was still worshipped as a deity integral to the chthonic rites, as god of the underworld. At Morgantina there were several representations of the god. An almost life-sized terracotta head (fig. 51), dating from about 350 BC, broken from a bust or full-length statue, was reputedly discovered in the sanctuary at San Francesco Bisconti.[72] On this sculpture, each curl of the god's generous hair and voluminous beard was made separately and then attached before firing. Red pigment survives in the hair, and blue in the beard, possibly both mixed to create shades of brown. The deep grooves that highlight the eyes might have held metal eyelashes, suggesting that the head might have been inspired by contemporary bronze sculpture.

Judging from the magnificent sculptural remains at the site of Morgantina dating from the sixth century BC down to the third century BC, the city was attracting and producing highly skilled craftsmen, who created imaginative and exceptional sculptures from a variety of materials, often mixed together.

The vast array of archaeological material relating to the different fertility cults on Sicily shows how its inhabitants did not take the fecundity of the island for granted. Those who increased their wealth through selling agricultural produce internally and from exporting it to other parts of the Mediterranean would have been all too aware of the unpredictable behaviour of the elements. Ritual mechanisms were established for people to make offerings back to the earth. As noted already, these most popular of cults were closely monitored by civic institutions and their leaders, who themselves benefited politically by promoting and controlling them.

Fig. 51
Terracotta head of Hades, from Morgantina. c.350 BC.
H 27 cm.
Museo Archeologico Regionale, Aidone.

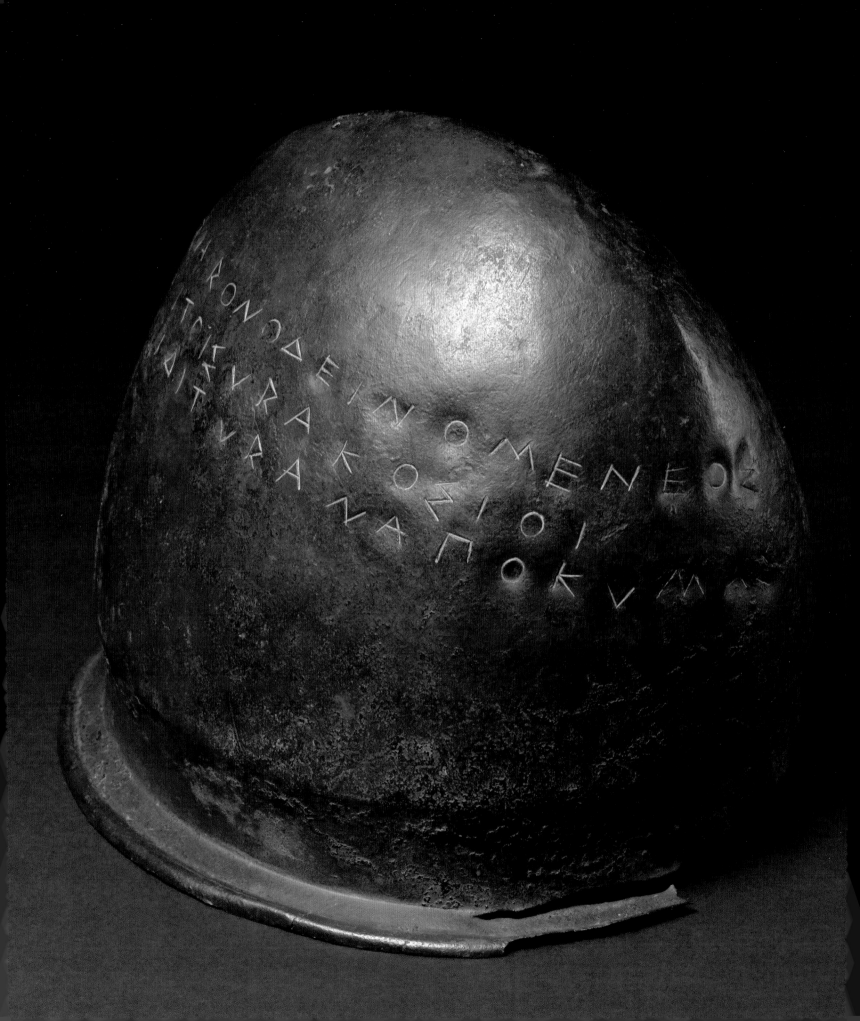

Hieron holds the sceptre of justice in sheep-rich Sicily,
Where he chooses for himself the finest fruits
Of every kind of excellence ...

PINDAR (*c*.52–443 BC), GREEK POET, *ODES, OLYMPIAN 1*

2
The Rise of the Tyrants

Sicily under the early tyrants

The history of Sicily's Archaic and Classical periods is derived from several sources, notably Herodotus, Thucydides and the much later Diodorus Siculus. All of the ancient sources are either brief or biased towards a particular city or state. For instance, Thucydides' report is solely based on the Athenian expedition to Sicily. Their narratives revolve closely around the rise of the tyrants, or *Tyrannoi*, the Greek word for authoritarian, sole rulers, without the negative connotations of the modern word 'tyrant'. Tyrants were not an exclusively Sicilian phenomenon; they were found in many Greek cities during the sixth century BC.[1] They seized power from the oligarchies, the small groups of aristocrats who held political power. One of the earliest and most notorious tyrants on Sicily was Phalaris, who took control of the city of Akragas in 570 BC, only a decade after its formation. Sources differ regarding his rise to power; one account claims that he held an important office in the city, but having misappropriated the funds he was given to construct a temple of Zeus he seized power with the help of his workforce.[2] We do not know how close to the truth this version is: it shares fundamental similarities with the tales behind the rise to power of later tyrants. In many cases we learn that tyrants used a position of power and exploited the existing social conflicts between the wealthy aristocrats or landowners (*gamiroi*) and the ordinary folk to overthrow an unpopular regime. Usually the 'liberating' rulers were far worse than those being supplanted and Phalaris of Akragas was said by some sources to have been clever but cruel (see p. 74).[3]

Historical sources are also condemnatory about the tyrants who ruled Gela and Syracuse from the later sixth into the fourth centuries BC. The Deinomenids of Gela and Syracuse were descendants of Deinomenes and were to become the most ambitious and powerful rulers in Greek Sicily. Deinomenes was a citizen of Gela, a priest of Demeter and according to Herodotus a descendant of Telines, mentioned earlier.[4] Deinomenes is said to have consulted an oracle and been told that his sons were destined to become tyrants. The oracle's prophecy was fulfilled, as Deinomenes' son Gelon I became tyrant of Gela by 491 BC. Gelon was an ambitious individual who immediately set his sights on expanding his territories. His greatest rival was the tyrant Theron of Akragas, but by shrewdly arranging to marry Theron's daughter, Gelon forged an alliance with his rival. He then turned his attention towards Syracuse, with its great wealth and strategic location. At that time, Syracuse was in political turmoil, the wealthy *gamiroi* having been evicted from the city by the lower classes. Gelon sided with the *gamiroi* and took control of the city, declaring himself ruler. To reinforce his power, Gelon practised a ruthless policy of population movement and territorial expansion. In the process he destroyed Kamarina and forcibly transferred all of its inhabitants and half of the population of Gela, his

Fig. 52
From 478 to 467 Hieron I ruled the Greek settlements on Sicily from a magnificent court at Syracuse. In 474 BC he led the fleets of Cumae and Syracuse to defeat the Etruscans from central Italy and Carthaginians in a battle at Cumae, near Naples. Hieron dedicated this bronze Etruscan helmet to Zeus at Olympia, to remind all Greeks of the victory. The inscription reads 'Hieron, son of Deinomenes, and the Syracusans [dedicated] to Zeus Etruscan [spoils] from Cumae.' Made in Etruria, Italy, *c*.475 BC. Found in Olympia, Greece.
H 20 cm.
British Museum, London.

THE BRAZEN BULL

Phalaris is most famous for commissioning the execution device known as the Brazen Bull, forged by the metalworker Perilaos. This marvellous, yet barbarous, feat of engineering was designed to roast its victims alive, with the bull's nostrils incorporating acoustic pipes that ingeniously transmuted the screams of the agonized victim into the sound of a bellowing bull. Remarkably Perilaos was tricked by Phalaris into being the first casualty of the cruel device.[5] This barbaric tale might sound like a story fabricated to discredit the tyrant, but ancient sources as early as Pindar, writing in the early fifth century BC, give it some credence.[6] The tradition continues into the Roman period, as noted by Cicero in the first century BC, while commenting about the return of looted artworks:

> [. . .] some things were restored to the Gelans, some to the Acragantines; among
> which was that noble bull, which that most cruel of all tyrants, Phalaris, is said to have
> had, into which he was accustomed to put men for punishment, and to put fire under.
> And when Scipio restored that bull to the Acragantines, he is reported to have said,
> that he thought it reasonable for them to consider whether it was more advantageous
> to the Sicilians to be subject to their own princes, or to be under the dominion of the
> Roman people, when they had the same thing as a monument of the cruelty of their
> domestic masters, and of our liberality
> (CICERO, *VERRINE ORATIONS*, 4.73)[7]

Despite Phalaris' brutality, the cultural life of Akragas seems to have prospered during his tyranny, while building projects began to transform the city into a physical power to be reckoned with.[8] Phalaris' demise seems like a predictable conclusion from a revenge tale, for he is said by some to have been overthrown by the general Telemachos during an uprising in the city and met his fate being roasted alive in the Brazen Bull.

Fig. 53
Perilaos condemned to the
Brazen Bull by Phalaris. After
Baldassare Peruzzi. Print by
Pierre Woeiriot (1555–62).
H 21cm.
British Museum, London.

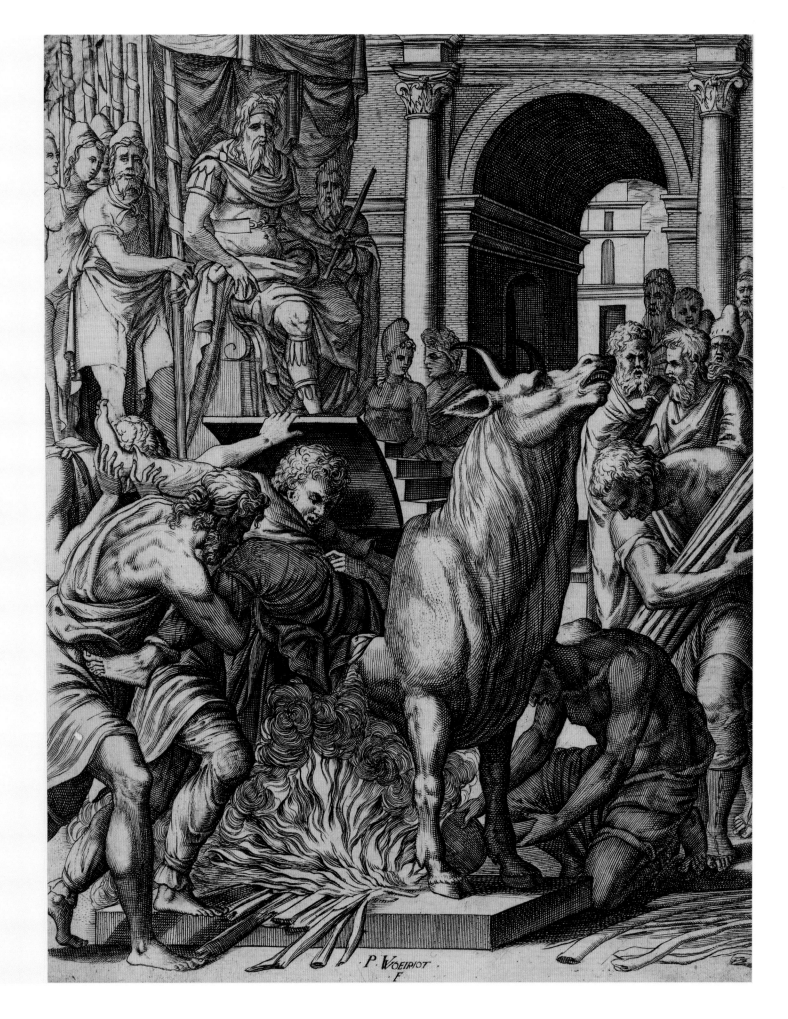

P. WOEIRIOT
F

hometown, to Syracuse. Next he conquered the towns of Euboia and Megara Hyblaia, taking the aristocrats to Syracuse but selling the poor into slavery. According to Herodotus, Gelon revealed his true aristocratic roots when he 'was motivated by the belief that living with the people was most difficult and unpleasant'.[9]

Despite this ruthlessness and disdain for the masses, Gelon's rule in Syracuse saw a revival of the city's fortunes, with cultural affairs flourishing and an increase in major building projects.[10] But Gelon's reign coincided with the rest of the Greek world preparing to fight a major new enemy: the Persians. Considering Syracuse a major political ally, the Athenians sent an embassy to Gelon requesting military assistance. Gelon, however, was clearly becoming too self-assured, for he offered more than was asked for, with the proviso that he be commander of the army. His offer was refused and no military support was sent. But Persia was not the only threat. Carthage was becoming more ambitious and began to take more interest in Sicily, as it now dominated most of the western Mediterranean and its important trade routes. At the same time, Greek Sicilians began to expand their influence across Sicily, threatening the Phoenician colonies and 'indigenous' communities. This had led to several conflicts during the sixth century BC, but it was all to come to a head during the so-called First Sicilian War, which culminated in the Battle of Himera in 480 BC; a clash that allegedly took place on the same day as either the battle of Salamis or Thermopoylae during the Persian Wars on the Greek mainland.[11] Gelon saw this as an opportunity to manipulate the increasing tensions between the Dorian and Ionian Greek cities on Sicily. These two ethnic groups were separated by their language and specific cultural features, but they were both considered Greek. The settlers from Corinth and elsewhere in the Peloponnese and from the islands of Crete and Rhodes were known as Dorians, while those settlers originating from the Greek Cycladic islands, western Anatolia and Euboea were Ionians. The Athenians were, too, although they did not send so many 'colonists' out to Sicily as other cities. It was the Ionians that Gelon, from Dorian Syracuse, saw as his greatest threat. He viewed the Dorian Greeks' fight for freedom as echoing that of the Greek mainland against Persia. Himera, the Greek settlement on the north coast, had been under the control of the tyrant Terillos who, because of his allegiance to Carthage, had recently been defeated by Theron of Akragas. Terillos pleaded with Carthage to intervene and Hamilcar, the Carthaginian ruler, led his forces to attack. However, the combined Greek forces, commanded by Theron and Gelon, won a resounding victory and, according to two different versions of events, Hamilcar was either shot down by arrows or committed suicide by jumping into the post-battle sacrificial fires. Surprisingly, Gelon did not attempt an attack on Sicily's Phoenician settlements nor an invasion of Carthage itself, but instead promoted a peace treaty that led to Carthage paying 2,000 silver talents (about 52,000 kg of silver) as reparations. Diodorus Siculus tells us that

> *After his victory, Gelon honoured with rich gifts the horsemen who had slain Hamilcar, and bestowed decorations for valour on those others who had displayed outstanding bravery in action. The best of the booty he kept in reserve, desiring to adorn the temples of Syracuse with the spoils; of what remained, he nailed a good deal to the most notable of the Himeran shrines, and the rest, together with the prisoners, he shared out among the allies, proportionately to the number that had served under him.*
> DIODORUS SICULUS, *HISTORIES*, BOOK 11, 25.1[12]

In Syracuse, Gelon commissioned a new temple of Athena, now encased within the city's *duomo* (cathedral), and also new shrines of Demeter and Persephone.[13] At Himera a substantial temple dating to the early fifth century BC has also been attributed to this wave of victory building, but it is uncertain to which deity the temple was dedicated or indeed exactly when

or why the temple was constructed.[14] Such a temple would have been an ostentatious and expensive record of a great victory, but a poignant reminder of the tragedy of war was recently discovered by the archaeologist Stefano Vassallo, who led the excavations at the necropolis near the battlefield at Himera.[15] The archaeologists revealed the mass graves of the soldiers, most of their skeletons bearing physical marks of the trauma that killed them (fig. 54). Some even had the tips of the fatal arrows embedded in their bodies. Accompanying some of the burials are the soldiers' horses with bronze bridle parts attached. This find, although a sad reminder of conflict, is extremely important, for it is rare to find mass graves of the victims who fought in ancient Greek battles.

Sicilian tyrants were mainly military men who reigned through periods of great turmoil, much of which was self-perpetrated. Gelon died in 478 BC, and despite his tyranny and his disdain for the working classes, he was remembered as a saviour, bringer of fortune and peace. He was succeeded by his brother Hieron I, who ruled from 478 to 467 BC and oversaw a period of great patronage of the arts and culture in Syracuse. Much of the ancient city lies buried beneath the modern towns of Ortygia and Syracuse, but there are impressive remains that reveal its prosperity during his reign. It was probably Hieron's infatuation with personal image that caused him to invite famous writers from Athens to compose poems in his honour. Syracuse became an auditorium for pioneering poets such as Pindar, Simonides, Bakkylides and Aeschylus.[16] Pindar celebrated Hieron and Gelon's military and athletic victories in his odes. Pindar's poems and Aeschylus' specially commissioned play *The Women of Aitna* were designed to be delivered to public audiences, so were the ideal springboard for marketing Syracuse as a civic and cultural leader. They were cleverly composed so as to render even the negative aspects of Hieron's military affairs as positive interventions, including the continuation of his brother Gelon's aggressive policy of forcibly moving people from one town to another. Hieron drove the people of Naxos and Katane to Leontinoi, and then repopulated

Fig. 54
Mass grave of the soldiers and war horses from the Battle at Himera, excavated under the direction of Stefano Vassallo. Possibly the graves of the soldiers from cities allied with Himera.

Katane with Dorian Greeks, renaming it Aitna. His major role in military affairs overseas was his assistance to the people of Cumae (in south-west Italy), with the triumph over the Etruscans and Carthaginians at the Battle of Cumae in 474 BC. The victory helped him to forge links with the Greek settlements of Campania that were under threat from the Etruscans. To celebrate the victory Hieron dedicated at least two Etruscan helmets (see below and fig. 52) at the Panhellenic sanctuary of Olympia. Hieron died at Aitna in 467 BC and was given a heroic burial, only for his tomb to be destroyed by the disgruntled exiled Katanians when they returned to their city. Tyranny in Syracuse lasted only another year, under Hieron's youngest brother Thrasyboulos, who was then deposed by other members of the Deinomenid family. Thereafter a form of democracy finally prevailed for much of the rest of the fifth century BC.

Political Players on a World Stage: Sicilian Tyrants at Olympia and Delphi

The Panhellenic sanctuaries of Zeus at Olympia and Apollo at Delphi were the principal venues for city states, kings and rulers to advertise their political, military and athletic achievements.[17] These were the venues for the famous Olympic and Pythian Games, held every four years. The scale and position of dedications within the sanctuary was critical in determining how their donors were perceived by others. For the Sicilian tyrants and rulers of the later sixth and early fifth centuries BC, to whom money was usually no object, Olympia and Delphi provided the settings for some of their most ostentatious displays of power, in monuments made from fine materials and created by some of the most famous Greek sculptors of the day. These monuments celebrated victories on the battlefield as well as on the racecourse. They performed to a world audience, in contrast with Pindar's victory odes, which were originally commissioned by Hieron I to be read to the local populations of Syracuse back on Sicily. Monuments, offerings and spoils of war were accompanied by inscriptions that gave the dedications a public voice, one that could be read and understood for centuries. The tyrants of Akragas, Gela and Syracuse made the most frequent and prominent dedications, which ranged from entire buildings to war trophies. The second-century AD Greek travel writer Pausanias, our main source of evidence for the Panhellenic sanctuaries of ancient Greece, describes numerous dedications by Sicilian rulers.[18]

At Olympia one of the earliest monumental dedications was the Treasury of Gela. Treasuries, found at both Olympia and Delphi, housed a city's sacred offerings to the gods. Raised up on platforms, sited in prominent positions within the sanctuaries, their richly decorated facades resembled small shrines. At Olympia, the largest treasury was built probably by the ruling aristocrats of Gela in about 550 BC.[19] Two further treasuries were built by Sicilian Greek cities, one for Selinous and one for Syracuse, dedicated in honour of Gelon I's victory at the Battle at Himera in 480 BC. Pausanias tells us that the latter contained a statue of Zeus, the patron god of the sanctuary, and war booty in the form of linen breastplates. It is highly significant that the surviving recorded inscriptions on the war spoils from Himera and Cumae at Olympia refer to the victory as being that of Hieron and the Syracusans: no mention is made of their Sicilian Greek allies. Fortunately, evidence of these spoils of war survives, including two bronze helmets dedicated by Hieron I after his victory over the Etruscans and Carthaginians at Cumae in 474 BC.[20] One of these is in the British Museum (fig. 52), the other in the Olympia Archaeological Museum.

To ensure maximum impact and global exposure, the tyrants Gelon I and Hieron I set up victory monuments at Delphi, within sight of the Temple of Apollo. First, according to Diodorus Siculus, Gelon had a one metre-high base installed for a bronze column to support a figure of Nike holding a golden tripod weighing 16 talents (about 400 kilograms).[21] The

Fig. 55
The Delphi Charioteer.
Bronze statue from an
equestrian Victory Monument
in the Sanctuary of Apollo,
Delphi. *c*.478 or 474 BC.
H 1.82 m.
Delphi Archaeological Museum.

THE MOTYA YOUTH

This famous statue of a young man dressed in a diaphanous garment was found in the Phoenician settlement at Motya, the small island very close to Sicily's north-west coast. The statue dates from the brief period when the island had been taken by Theron of Akragas, who dedicated a monument at Olympia financed by the spoils of his victory over Motya. It has usually been interpreted as a statue of a youthful charioteer, originally raising his right hand to adjust his victor's wreath. However, various other identifications have been suggested, including a Phoenician god, a king, a soldier, a seer or even Gelon I dancing as an initiate of a cult of Apollo.[22] This broad range of suggested identities demonstrates just how ambiguous the statue is, with numerous possible interpretations. The head and body were carved in strongly contrasting styles. The stylized face and hair differ greatly from the naturalistic and sensuous rendering of the muscular body, revealed through garments of sheer, clinging material. The lack of established identity cannot, however, diminish the simple beauty of this immaculately conceived and carved statue. As an isolated discovery, the exact identification and the ancient context of the statue remain an enigma. Some believe the statue was looted from a Greek city, Selinous or Himera perhaps, and that any Phoenician connection or identification arises only from its find-spot, not its original origin. Perhaps further excavations on the island might yield more of the group. Nonetheless, the statue remains one of the most admired and celebrated of all ancient Greek or Greek-style marble statues that have survived.

Fig. 56
The Motya Youth.
c.470–460 BC. H 1.82 m.
Museo Giuseppe Whitaker, Motya.

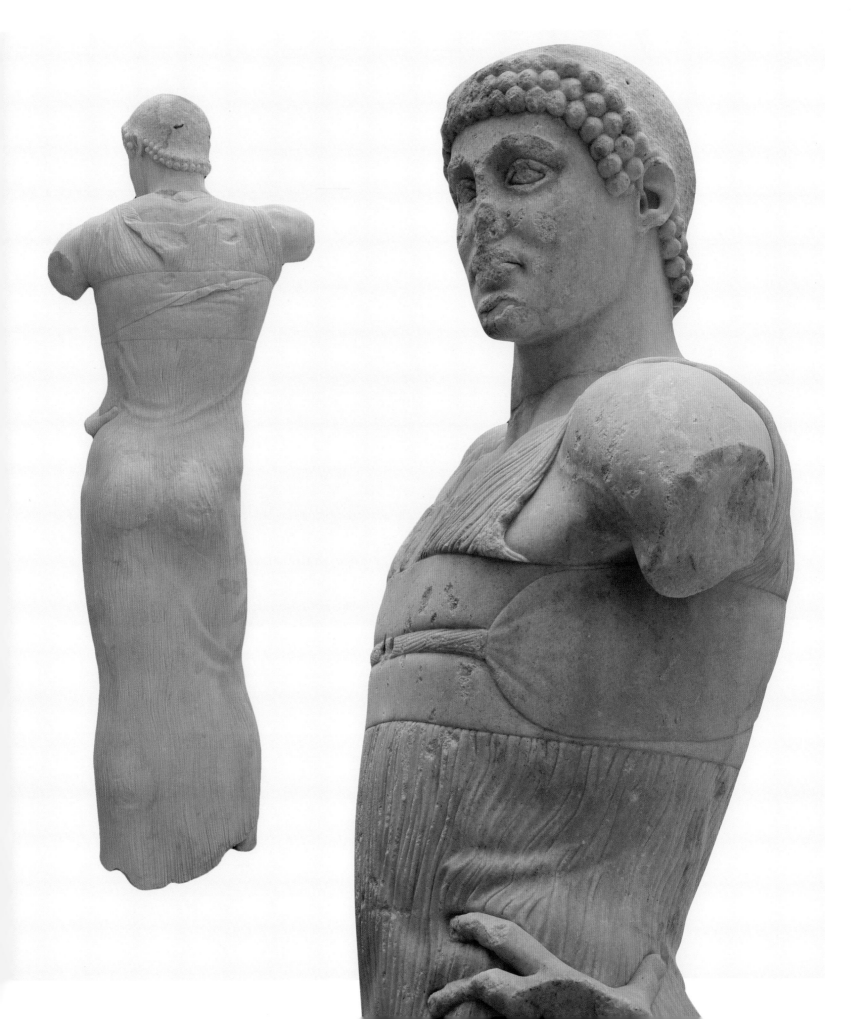

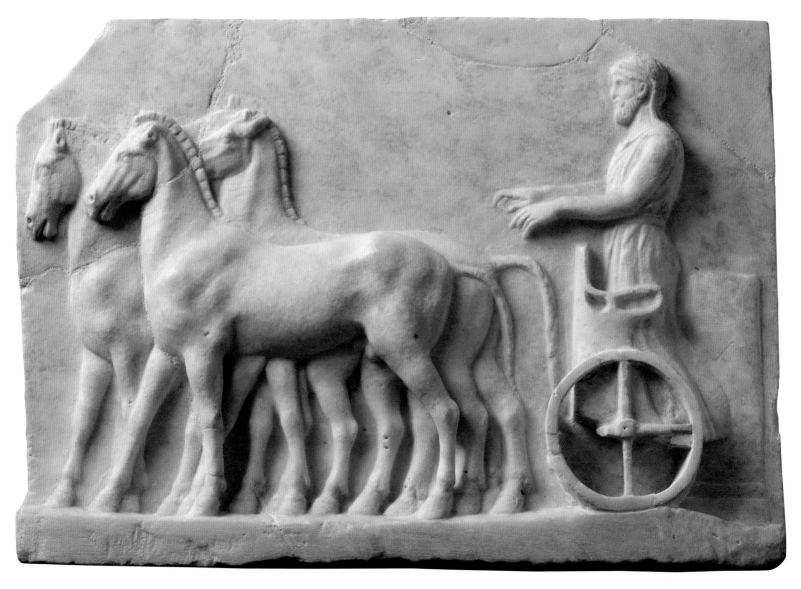

Fig. 57
Greek marble relief of a
quadriga (four-horse chariot)
steered by a charioteer.
*c.*410–400 BC. W 40 cm.
Museo Archeologico Regionale
Antonio Salinas, Palermo.

monument was erected from the spoils of the Battle of Himera and emulated the nearby
bronze serpent column that was erected by all the Greek states who had fought at the Battle
of Plataea, a pivotal event in the Persian Wars. Gelon's tripod served as a reminder of the
role he had played in fighting for the freedom of the Greeks. Hieron I added a second tripod
column, although he reputedly found it more difficult to obtain the necessary refined gold.
The bases of the two monuments with the inscribed dedications survive *in situ*.

Another type of dedication was the victory monument for triumphs in the equestrian
events at the Olympic and Pythian Games, for which the Sicilian Greek rulers were particularly
famous.[23] Chariot races were the most spectacular of all ancient Games, with close to forty
chariots racing around a track, and many pile-ups and crashes occurring during the perilous
turns. The rulers of Greek Sicily financed and entered teams of horses for the chariot race
at the Games from the late sixth into the early fifth centuries BC. They did not actually drive
the chariots – this was done by brave and well-trained charioteers. The surviving victors' lists
from the Games give us the names of the chariot owners and not the charioteer. It is unclear
whether the charioteer figures associated with the recorded monuments represent the intrepid

athletes or the owners in the guise of charioteers (see p. 80). Figures of charioteers might have accompanied those of their patrons in the commemorative statue groups. The famous statue known as the Delphi Charioteer (fig. 55) is associated with the base of an equestrian monument found in the sanctuary of Apollo and dedicated by Polyzalos, the younger brother of Hieron I and Gelon I.[24] Although the inscription was altered at some point, most scholars agree that the monument commemorated a chariot race victory by Polyzalos in the Pythian Games, either in 478 or 474 BC. The statue itself was made by a master sculptor, possibly trained in Athens, rather than a native of Sicily. Sources tell us that Sicilian tyrants commissioned some of the most prestigious sculptors of the day to create their victory monuments.

At Olympia, monumental bronze chariots and equestrian groups were set up to commemorate a series of victories in the chariot and horse races of Gelon I in 488 BC and his brother Hieron in 476, 472 and 468 BC. These were themselves perhaps even accompanied by portrait statues of the tyrants. A similar monument was erected for Theron, ruler of Akragas, for his victory in 476 BC. The Syracusan tradition of dedicating prestigious monuments at Olympia was continued by Hieron II who had two statues of himself installed, made this time by a Sicilian Greek sculptor, Mikon from Syracuse. The portraits, chariots and horsemen are long gone, but ancient sources and parts of inscribed sculpture bases record their presence.

There is no doubt as to the profession of the figure on the marble relief found on Sicily shown in fig. 57. The man is bearded and draped in the garment usually worn by charioteers in such representations, a belted *xystis*, a long, short-sleeved tunic. The horses' reins would have been painted on the marble. Behind the man, a column marks either the turning point or finishing post of the racetrack. Similar votive or dedication reliefs with chariot scenes were found in the western Greek settlement of Cyrene in modern-day Libya.[25]

Sicilian tyrants and civic institutions also displayed their sporting achievements on coins minted at Syracuse, Gela and Akragas from the later sixth century into the third century BC (figs 58–9). From the 460s BC comes a series of high-value silver coins, the so-called Damareteion, showing chariot and horse racing, some with a figure of Nike, goddess of victory, hovering over the scene, crowning either the horses or the charioteer.[26] Scholars mistakenly named it after Damarete, the wife of Gelon I. Diodorus Siculus wrote that Damarete had been instrumental in the peace process after the battle of Himera in 480 BC and the grateful Carthaginians awarded her a gold crown.[27] Damarete then used this gold to issue coins known as Damareteions, worth the equivalent of ten Attic drachmas. Long desiring to find examples of these legendary coins, scholars opted for these large silver coins of Syracuse and then attempted to argue that the jump from gold crown to silver coin was not such a far-fetched idea. Nowadays most believe that these spectacular coins date to the reign of Gelon's successor Hieron I.

Definitely commemorative are the poems of Pindar that were commissioned by Hieron to celebrate his victories at Delphi and his military exploits. Pindar's ode *Pythian 1* overtly connects Hieron's chariot and horse racing victories at Delphi with his military and political achievements. Both words and monuments also served to elevate the status of Syracuse as the primary Greek city on Sicily and Hieron as a hero and the champion of Greek culture over that of Barbarian invaders. Tyrants manipulated their self-images and delivered their propaganda to the largest possible audiences through the monuments seen by all Greeks at the Panhellenic sanctuaries and the poems that were commissioned, probably to be read as part of a victory celebration. However, in Sicily itself aristocrats and tyrants used a further striking method to display their own wealth and power, and that of the cities they ruled, and this was through the building of temples.

Fig. 58
Silver *decadrachm* of Akragas showing a fast-moving four-horse chariot. *c*.400 BC. Diam. 2.7 cm.
British Museum, London.

Fig. 59
Silver coin of Syracuse showing Nike driving a four-horse chariot (reverse of fig. 89). Minted under Hieron II, 275–215 BC. Diam. 2.6 cm.
British Museum, London.

Tyrants and Temples: Building Sicily

The ancient sites of Sicily boast some of the largest and best preserved of all Greek-style temples in the Mediterranean.[28] The motives behind the construction of the monumental Doric temples on Sicily, and other Greek settlements in the western Mediterranean, were varied, although, as we have seen, ancient sources tended to associate their construction with major battle victories. This is a plausible assumption, as war booty would have supplied funds for such building and even a slave-labour workforce in the form of war prisoners. Other theories see the colossal temples as products of a fierce sense of Greek identity, one that was intended to ward off the Phoenician and other possible threats to the Greeks living in Sicily.[29] This theory might hold some weight, but it is perhaps more likely that temples were constructed by groups of high-status individuals or families to display their disposable wealth and to glorify both the gods and themselves, or by civic authorities eager to enhance the status of their particular city. Furthermore, rather than acting as warnings to foreign powers, some of the first large temples, such as those at Gela and Syracuse, might instead have acted as beacons, their architectural styles and decorative sculptures affording those Greeks who arrived at their ports a familiar glimpse of a home away from home. A final motive behind this programme of temple building was simply that building temples is what the Greeks did. Not all were massive in scale, but they were often the largest buildings in any settlement and constructed in prominent positions in the urban landscape, serving the people's ritual and cultural needs. Neither were they all large, peristyle structures; some communities settled for more modest shrines such as they could afford. Early temple building on Sicily demonstrates experimentation of technique and design indicative of the innovative and hybrid culture of the Greek settlers on the island. The cities of Syracuse and Gela provide us with invaluable information about early temple building on a monumental scale. Architectural sculpture from massive temples can be documented from the sixth to fifth centuries BC, particularly from the cities of Selinous and Akragas on the south coast.

A visitor to Sicily today might be drawn into thinking that temple building was the exclusive activity of Akragas and Selinous, where some of the largest Greek temples ever constructed are still visible. In reality, most major Greek towns would have had temples erected in honour of their gods. At Gela, Himera, Akrai and Megara Hyblaia temples survive only as foundations, but some of their architectural decoration and sculpture have been discovered.[30] At Syracuse, however, the colonnades of the Doric temple of Athena are still standing, although now cleverly incorporated in the outer walls of the *Duomo*, the cathedral at Ortygia: more of the ancient Greek temple can be seen inside the building.

One of the earliest temples to be built on Sicily was that of Apollo at Ortygia in Syracuse, the survival of which was due to its transformation into a church, then a mosque and then its incorporation into a private residence.[31] This was the first recorded colonnaded temple in Sicily, built in about 590–580 BC, in the Doric order and measuring 21.5 by 54.9 metres (see fig. 61). This ambitious temple posed an extraordinary challenge for its architect and was a mammoth task for the city, requiring vast funds, not least to ship the stone for its monolithic columns from a distant limestone quarry. The building was an experiment in design and

Fig. 60
Part of the north facade of the Duomo of Syracuse, with the Doric colonnade and frieze of the Temple of Athena, built *c.*475–470 BC, incorporated into its walls.

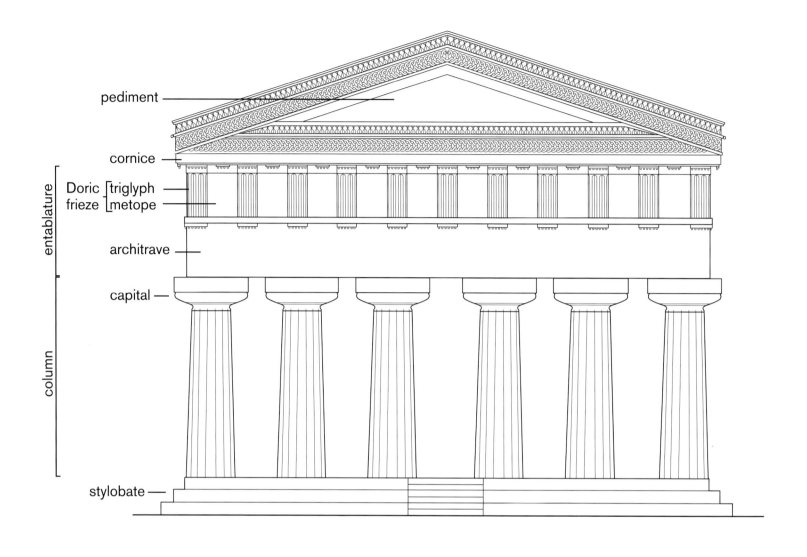

pediment

cornice

entablature

Doric frieze — triglyph / metope

architrave

capital

column

stylobate

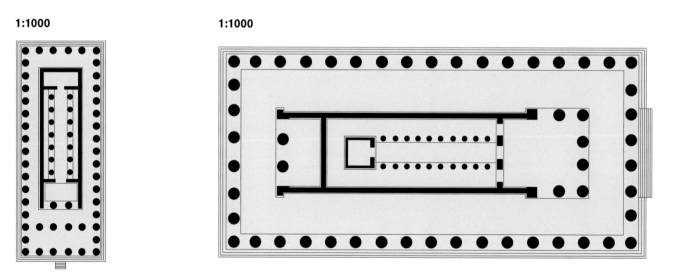

1:1000

1:1000

engineering. Its architect strove to construct a fine colonnade, but we see hints of his hesitation and nervousness in the fact that the columns were positioned extremely close to one another, with a heavy and overbearing upper layer, as is evident in a reconstruction (see opposite). These top-heavy proportions, however, echo those of Etruscan temples, but the imbalance is somewhat redressed by the placing of brightly painted terracotta architectural decorative elements and sculptures at its upper levels. The city honoured the project with an inscription carved into the temple platform, naming one 'Kleiomenes', probably the patron or the dedicator of the temple in honour of Apollo. The inscription in fact specifically refers to the columns as a architectural feat in themselves, a matter of great pride, particularly as building on such a vast scale in heavy stone was still at an early stage across the entire Greek world.

Despite the problems encountered during the build, this new-found confidence in the construction of colonnaded structures led to another, practically identical, temple being built at Syracuse a generation later, in about 550 BC, this time in honour of Zeus.[32] Although it is a ruin today, we know from ancient sources that this and other Syracusan temples were embellished both outside and inside. Rarely do we learn how the interiors of ancient Greek temples were decorated, but a tantalizing hint at the astonishing artworks held inside the Temples of Athena and Zeus at Syracuse can be found in later texts. Cicero, as we shall discover in chapter 3 (see p. 137), describes the plundering of temples and private homes by the infamous and voracious Roman governor Verres in the first century BC. Statues, tapestries, gold rings, fine metal vessels and furniture all found their way to Verres' treasure house. But one of his worst acts of vandalism was the removal of the painted panels from the interior of the Temple of Athena at Syracuse which showed the tyrant Agathokles in battle with the Carthaginians.[33] The story of the plundering of Sicily by outsiders is an unfortunate one, but the sources that inform us of it provide invaluable information about the wealth of offerings held within the temple treasuries. Fortunately, we know much about the decoration of the exteriors of Greek temples on Sicily from the elaborate architectural elements in terracotta and stone that have been found among their ruins. Before the most important of these are discussed, it is useful to consider one of the earliest clues as to the appearance of some of the Greek hybrid-style shrines on Sicily.

A unique terracotta model of a temple (fig. 62) was discovered during excavations at ancient Sabucina,[34] a Sicel settlement but within the sphere of influence of the Greek cities of Akragas and Gela. The model embodies, albeit in a rather unsophisticated form, a rich selection of architectural decorative elements that architect and patron might have required for a typical Greek Sicilian shrine. Two robust, fluted, Doric columns stand in front of an enclosed room (cella), capped by an arching, tiled roof. Ridge tiles and a ridge pole seal the joints between tiles on the roof. The walls of the cella are decorated with mouldings and have thin piercings, like slit windows, at the sides. The simplicity of form of the lower building is contrasted by the sheer volume of decoration at roof level. In the pediment are two prominent faces, a gorgon and a satyr, their faces bulging with energy. Rosette antefixes mark the lower corners of the pediment. Over the main pediment a figure of a horseman emerges from the roof, while at the rear is another horse, perhaps originally with a rider or simply a winged Pegasos. A third figure might have marked the centre of the ridge pole. Mounted on a circular moulded base, the model might have had a ritual function.

Gorgons and satyrs, equestrian groups, figures of Pegasos and floral decoration are all features of known architectural sculpture. Terracotta was the primary material for architectural decoration during the Archaic period on Sicily. Starting from the roof and moving down the building, here is a selection of some of the chief sculptures from temples in Sicily from the Archaic to Classical periods. The most complete example of the equestrian *kalypter* (ridge tile)

Fig. 61

(opposite, above)
Reconstruction of the front facade of the Temple of Apollo at Ortygia, Syracuse.

(opposite, below left)
Plan of the Temple of Apollo at Ortygia, Syracuse, showing its elongated narrow footprint and closely packed columns.

(opposite, below right)
Plan of Temple G at ancient Selinous: one of the largest temples built on Sicily.

monument comes from Kamarina (fig. 63).[35] Like the smaller examples on the model, this group was shown as if emerging from the building, rather than being complete as we might expect. Sitting proudly astride his elegant horse, the Kamarina rider surveyed the territory around the temple, drawing the gaze of worshippers from the ground to the sky.

Slightly later in date are fragments of similar architectural groups from Gela.[36] The realistic and energetically modelled terracotta head of a horse (fig. 64) was found in a cistern at Gela, but has been associated with similar fragments, along with sphinxes, found on the Acropolis at Gela.[37] In all probability they are parts of two *akroteria* from an unknown building

Fig. 62
Terracotta model of a shrine from Sabucina. *c.*525–500 BC. H 51 cm.
Museo Archeologico Regionale, Caltanisetta.

Fig. 63 (opposite)
Equestrian *kalypter* ornament in terracotta from the roof of an unknown building at Kamarina. *c.*550–510 BC. H 1.05 m.
Museo Archeologico Regionale Paolo Orsi di Siracusa.

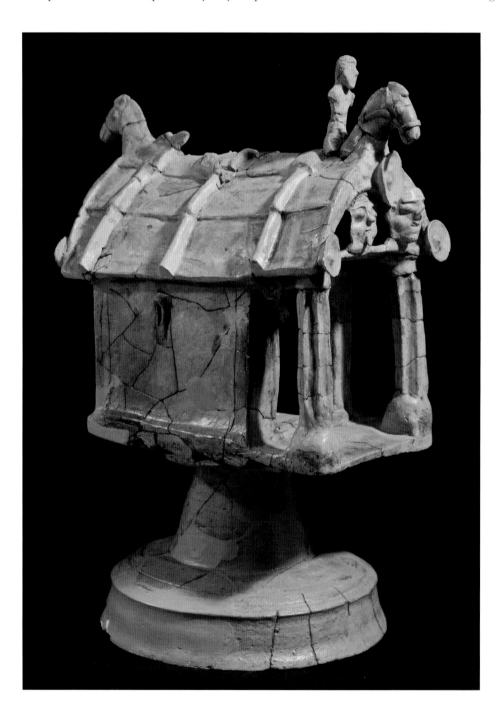

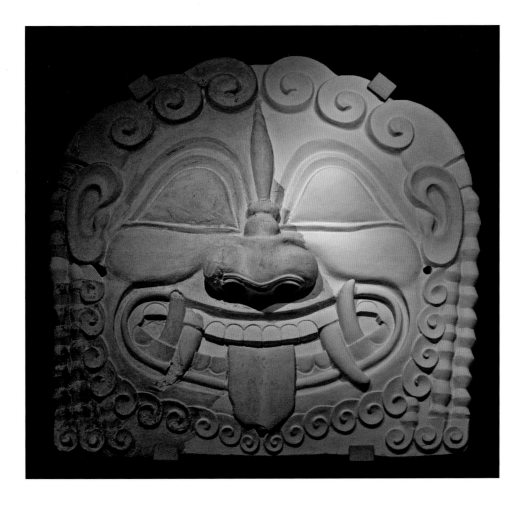

showing horsemen. Standing about 1.4 metres in height, the riders probably had sphinxes supporting the horses' bellies, features found on more complete architectural groups made in southern Italy. Terracotta equestrian groups are almost entirely absent from buildings in the Greek mainland and islands, although marble horsemen were popular subjects for free-standing dedications in sanctuaries. Rooftop equestrian sculptures were popular in Sicily and the West during the sixth century BC and, judging from the frequency of finds, probably emerged in workshops in Syracuse and Gela. But who did the horsemen represent? One obvious suggestion for their identity are the divine twin horsemen, the Dioskouroi, whose mother Leda was seduced by Zeus in the guise of a swan. From the eggs sprang Helen (later of Troy) and Klytemnestra, and Kastor and Polydeukes, the Dioskouroi, although, curiously, the boys had different fathers: one the mortal Tyndareos and the other Zeus. The Dioskouroi enjoyed particular veneration in the western Greek settlements, where they functioned not only as protectors of sailors and soldiers but also of houses. At coastal sites their cult was connected with the protection of harbours and, by extension, of trade and sea commerce. But Sicily was also famous for its horses and therefore two divine horsemen would have been suitable protectors for the religious structures on the island in both rural and coastal areas. An alternative identification is a hero in Athens called *Epitegios* (meaning 'on the roof') and it might be this less well-known figure who is represented here instead.[38]

Fig. 64 (opposite)
Terracotta head of a horse from the Acropolis of Gela. *c.*480–460 BC. L 42.5 cm.
Museo Archeologico Regionale di Gela.

Fig. 65 (left)
Terracotta gorgon mask from the area of Temple B, Gela. Much of its proper left side is restored. *c.*600–580 BC. H 1.05 m.
Museo Archeologico Regionale Paolo Orsi di Siracusa.

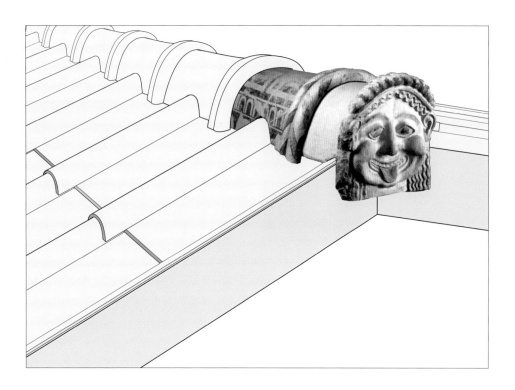

Fig. 66
Terracotta *kalypter* ornament
in the form of a gorgon.
From building VI on
the Acropolis at Gela.
*c.*500–480 BC. H 38.5 cm.
Museo Archeologico Regionale
di Gela.

The drawing shows how
It would have sat over the
triangular gable end of
the building.

The most prominent protective symbols used on temples in Sicily were gorgons; those wide-eyed, grotesque, snarling monsters that we encountered earlier. Formed from a series of stylized elements to form a schematic face, the design was more animal-like than the milder human images of the gorgons from later Greek contexts. The earliest representations of gorgons served as apotropaic images in the pediments of temples at various Greek settlements. To some extent similar in function to the gargoyles of a medieval cathedral, the gorgon masks were intended both to scare away evil spirits and to warn potential worshippers not to violate the sanctity of the shrine. One example, a metre in height, comes from a pediment of an early sixth century BC temple from the Acropolis at Gela (fig. 65), while larger still is a more fragmentary gorgon from the pediment of Temple C at Selinous.[39]

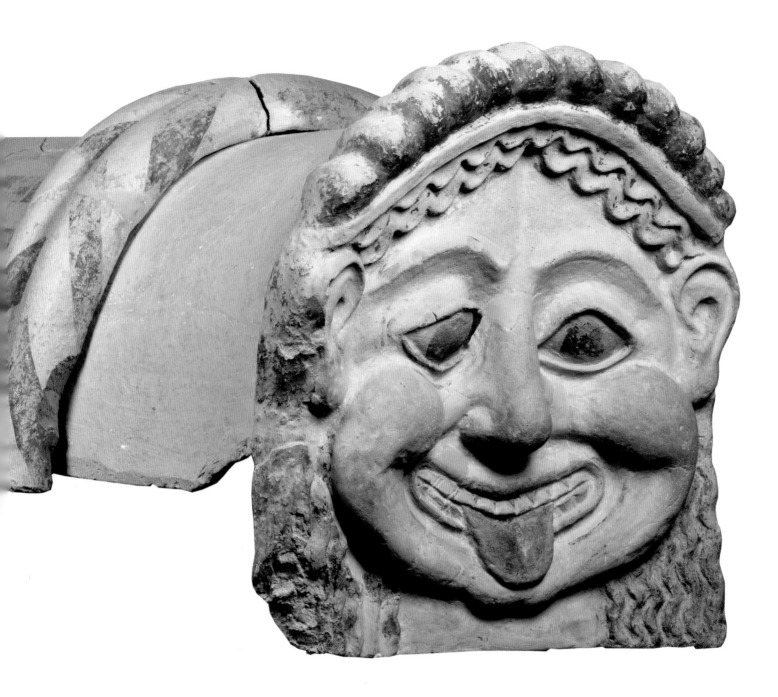

Gorgon masks were also a common feature of roof decoration. One striking example was a *kalypter* ornament (fig. 66) found in the ruins of a small shrine known as Building VI on the Acropolis at Gela.[40] A whole series of smaller but similar terracotta antefixes with gorgon masks were discovered where they had fallen from the building, while this piece came from its western end. The ornament is designed as if it were Medusa's freshly severed head, its features menacing and confrontational, but to modern eyes looking almost playful. The face is enhanced by colour and powerful modelling: the eyes are outlined in black, with dark irises and pupils, accompanying a purple tongue and orange-painted face. The large opened eyes, bulbous nose, puffy cheeks, wide mouth, mocking toothy smile and lolling tongue all combine to grasp attention. Unlike earlier gorgon images of the Archaic period, the gorgon

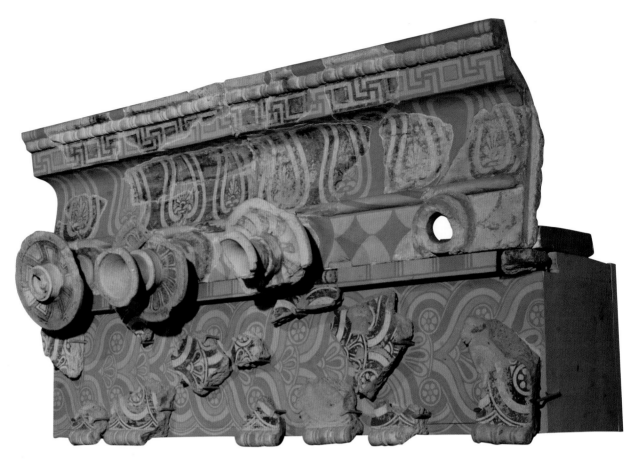

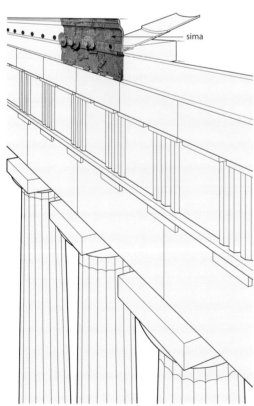

sima

Fig. 67
Terracotta revetment
from a temple at Monte
san Mauro, near Caltagirone.
550–500 BC.

Museo Archeologico Regionale Paolo
Orsi di Siracusa.

The drawing shows the
position of the revetment
on a Doric building.

from Building VI lacks sharp tusks. Behind the gorgon mask another element covered the actual ridge pole of the building. The *imbrex* (saddle over the roof tiles) is painted with black and red *ovoli* (tongue-shaped decoration) on a cream background. On Greek Sicily, the gorgon type was possibly influenced by East Greek, particularly Rhodian representations or those from Etruria and Campania. Gorgon masks are also found on Athenian painted pottery and emblazoned on shields. Perhaps the type was introduced by Rhodian settlers at Gela, or came via Italy, from where it spread to other Greek settlements.

To further enliven the cornices of limestone buildings during the Archaic period, brightly painted terracotta panels were added. These were not exclusive to Sicilian buildings, as they occurred throughout the Greek world and southern Italy too, but Sicilian craftsmen appear to have adapted and then enhanced existing designs, quickly establishing themselves as leaders in the field. Commonly found are brightly painted revetments that covered the stone or wooden overhanging cornices of buildings, protecting the walls and columns, and allowing for the flow of rainwater through tubular spouts. The example illustrated in fig. 67 was discovered at the site of a sixth-century temple at Monte San Mauro, near Caltagirone, along with fragments of terracotta architectural sculpture.[41] The decorative scheme of the revetment follows those produced at Gela, and might have been made by an itinerant Geloan craftsman. The complex design is composed of eight horizontal zones, punctuated by trumpet-shaped spouts for draining water from the roof. It is all too easy to misunderstand the complex nature of the construction of ancient Greek buildings, particularly those surviving temples that remain only as stone shells. These ornamental panels, however, provided a decorative junction between the roof and the walls of buildings. The terracotta sculptures and elements concealed joints between tiles, ends of wooden beams and the voids where tiles overhung the roof. At first Sicily relied on influence from mainland Greece for its terracotta ornaments, but by the first half of the sixth century BC it had developed its own unique approach, known by specialists today as the Geloan *sima*, after the innovative samples produced at Gela.

The first monumental temples at the earliest 'colonial' Greek settlements on Sicily, at Syracuse, Megara Hyblaia and Gela, naturally continued using the iconography of old Greece and Etruria for their decoration. Gorgons dominated the pediments, and antefixes and bronze and terracotta plaques bearing their fierce visages were perhaps also attached to walls. Equestrian groups rode across tile ridges and mythical and heraldic beasts, such as sphinxes and lions, probably sat at the corners of the gabled roofs. The next generation of 'sub-colonies', notably Akragas and Selinous, carried on with these traditions but also transformed them throughout the later sixth and fifth centuries BC. At Akragas the 'telamon' (support in the form of a male figure; see p. 107) was invented, while at Selinous the Doric temples made use of sculptured metopes. The types and styles of the sculptures echoed those being produced in the rest of the Greek world, but made more use of the materials readily available, such as terracotta and limestone, with imported marble only used when it could be afforded and put to best dramatic use.

The Metopes from the Temples at Selinous

In 1822 two young English architects, Samuel Angell and William Harris, travelled to Sicily to examine its Greek remains. They were following in the tradition of the Grand Tour, of which Sicily was an integral part.[42] Early travellers, during the eighteenth and early nineteenth centuries, had the chance to explore the legacy of ancient Greece through the archaeological and architectural remains in Sicily and southern Italy, rather than on the Greek mainland or islands, which were less accessible to western Europeans. In the winter of 1823 Angell and Harris started examining the two ruinous heaps of stone located on the hills flanking the great harbour at Selinous, south-west Sicily. The two temples are known as Temple C, a Doric building with an elongated plan and a peristyle of 6 by 17 columns, and Temple F, slightly smaller at 6 by 14 columns. Modern scholars strongly disagree about exactly when the structures were built, but the majority opts for the middle decades of the sixth century BC.

Among the ruins of both temples were fragments of sculptured metopes carved in high relief, some of which were reconstructed on site, and were immediately recognized as rivalling the finest examples of early Greek architectural sculpture. Angell and Harris's desire was for the sculptures to be sent to the British Museum, but the Sicilian authorities prevented their export and they were taken to the newly established museum at Palermo, where they remain to this day. Sicily was one of the first regions to legislate against the removal of antiquities by foreign explorers. Tragedy struck when Harris died while in Sicily, but Angell continued their great work by publishing their extraordinary discoveries in a volume with drawings by Harris (fig. 68).[43] Their findings encouraged later generations of archaeologists to explore the ancient city with great enthusiasm.

The programme of temple building at Selinous was so ambitious that one scholar has estimated that between about 600 and 460 BC the seven temples constructed in the city required over 112,000 metric tons of stone.[44] For such an immense engineering programme, huge funds must have been available, but, in turn, it would have also have stimulated the economy by employing a large workforce. Selinous possibly had a population of between seven and ten thousand during the early fifth century BC, and the building projects would have involved those working in the quarrying and transportation of stone, metalworkers, builders, masons and sculptors. Slave owners would have also benefited by hiring out their labourers. The money to finance such projects came primarily from trade in grain and other agricultural produce. The early settlement of Selinous and its relationship with the 'indigenous' peoples was less friendly than allegedly experienced by its own 'mother colony', Megara Hyblaia. The settlers at Selinous almost immediately followed a policy of aggressive expansion into the hinterlands, within the territory of 'indigenous' groups of people. Selinous eventually dominated the fertile agricultural land surrounding the city and controlled trade routes. The money required for such a huge investment in public building must have come from wealthy, land-owning individuals and ruling tyrants, no doubt driven by motives of self-importance. The land-owning Selinountines probably exploited the city's relations with the nearby Phoenician settlements by trading grain with them. The minting of the first coins at Selinous also coincided with the period of construction of some of the largest temples in the mid-sixth century BC (fig. 42). The coins were made of imported silver and were perhaps used, amongst other things, to pay the huge workforce. The temples at Selinous commanded the landscape and transformed the town plan from a domestic to a ritual one, designed to impress mortals and gods alike.

The earliest datable series of sculptured metopes, which might have belonged to a fragmentary structure known as Temple Y, form two distinct groups. Carved in shallow

Fig. 68
Drawing by William Harris of the metope from Temple C at Selinous showing Perseus killing Medusa, while Athena observes.
British Museum, London.

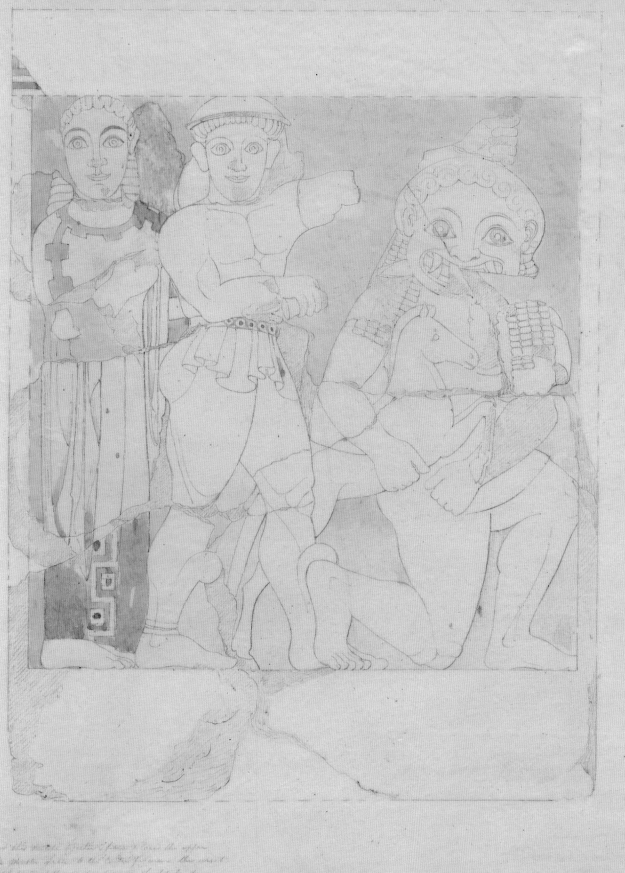

Metope Conical Temple Western Hill
Selinus.

Copied from a drawing made by H. Harris
July 1823

a ject

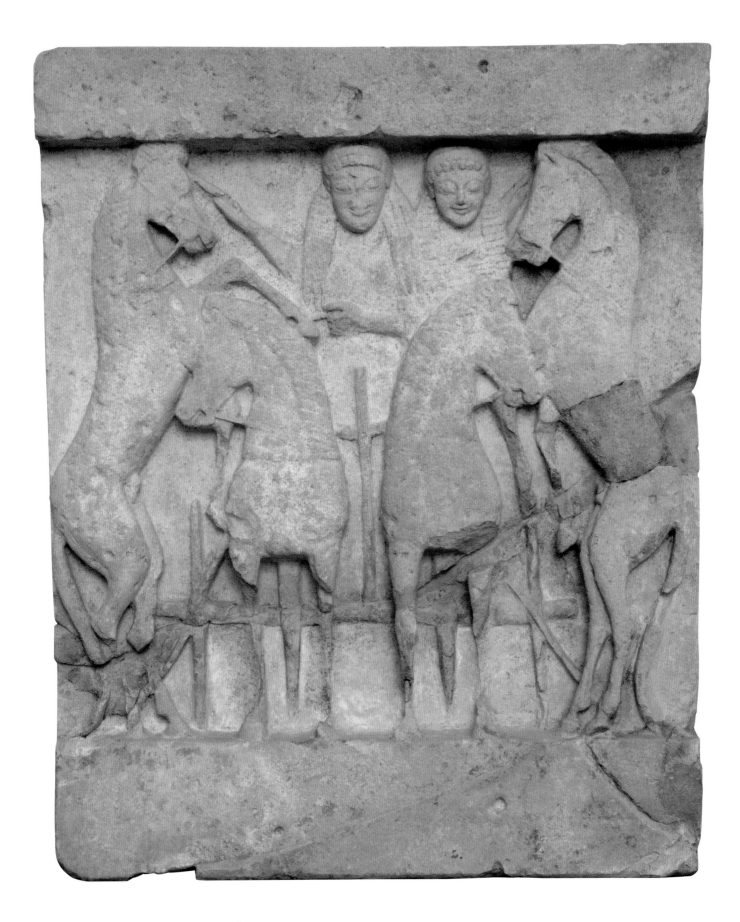

relief and averaging about 85 cm in height, some of the surviving metopes show scenes of 'divine epiphanies', a dramatic appearance of a deity.[45] Characters from Greek myth are also represented, including a sphinx, Europa riding on the bull, and Herakles subduing the Cretan bull. Scenes from the *Iliad* and *Odyssey* might also have been present. One of the metope series, showing three fertility goddesses (fig. 40), has already been discussed (see pp. 60–62). The most powerful composition, however, shows a frontal, four-horse chariot with a charioteer and passenger (fig. 69).[46] The horses are bursting with untamed energy, two turning their heads in anticipation while the other two rear up nervously onto their back legs, turning towards their human companions, who calmly pat them on their foreheads. The scene is one of preparation for departure, the drama enhanced by the poignant relationship between the humans, or deities, and animals. Suggestions for the identity of the riders are confused by the fact that their genders are not immediately apparent, although the charioteer has a more angular face than the passenger and so might be male. Poseidon was the god who controlled horses and he is often shown in Greek art in a chariot accompanied by his wife Amphitrite. But this metope could alternatively represent Hades abducting Persephone; the tension and drama being the cause of the chariot horses' unrest. If both figures are female, then the subjects might be Demeter accompanying her daughter Persephone as she is temporarily released from the underworld. We might never know the exact meaning of the scene, but the relationship between humankind and horses was a particularly significant and popular choice for religious art in Greek Sicily. These early metopes date from about 550 BC and, although conspicuously Sicilian Greek in style, follow the fashions for design and composition in sculpture prevalent in the rest of the Greek world.

A less theatrical version of the same composition appears on a larger metope from Temple C, dating from 540 to 530 BC (fig. 71). Temple C was built on the Acropolis at Selinous, and was of the Doric order with 6 by 17 columns, and measured 23 by 64 metres.[47] The metope, again with the chariot seen from the front, is a masterpiece of carving.[48] Its sculptor has created a sense of depth in the frame by cleverly modelling the horses' front legs completely in the round. This was one of three metopes found near Temple C by Angell and Harris. The other two show equally animated scenes, one with Perseus decapitating the gorgon Medusa, accompanied by Athena. The other shows Herakles and the Kerkopes, a pair of simian-like thieves who in Greek representations are shown trussed up and suspended upside down from a stick carried by Herakles (fig. 70). In one version of the tale Herakles sets the Kerkopes free after they make him laugh by joking about either his genitals or his rear end, which from the captives' position are too close for comfort.

Fragments from some of the damaged metopes of Temple C survive, including several fine heads. The fragment in fig. 74 is a frontal head of a long-haired man wearing a *pilos* helmet.[49] This type of helmet is sometimes shown in images of the god Hermes, but also the hero Odysseus. The details of hair on the drooping moustache and beard would have been completed in paint. When first discovered the helmet revealed traces of red pigment, perhaps to imitate leather rather than metal. The sculptor of this metope succeeded in injecting life into stone through the wide, engaging eyes sinking into the prominent cheekbones over the gentle smile.

The subjects of the Selinous metopes echo those shown on contemporary pottery made at the mother settlement, Megara Hyblaia, where Greek gods and heroes predominate. It is not clear which god the temple served, but it was perhaps Apollo, while the gods and heroes shown on the metopes were ones worshipped in the various shrines at Selinous. According to an important inscription found in the gigantic Temple G, 'The Selinountines are victorious, thanks to the gods Zeus, Phobos, Herakles, Apollo, Poseidon, the Tyndaridai,

Fig.. 69
Limestone metope with a four-horse chariot (*quadriga*) from an unknown building at Selinous.
*c.*560–550 BC. H 84 cm.
Museo Archeologico Regionale Antonio Salinas, Palermo.

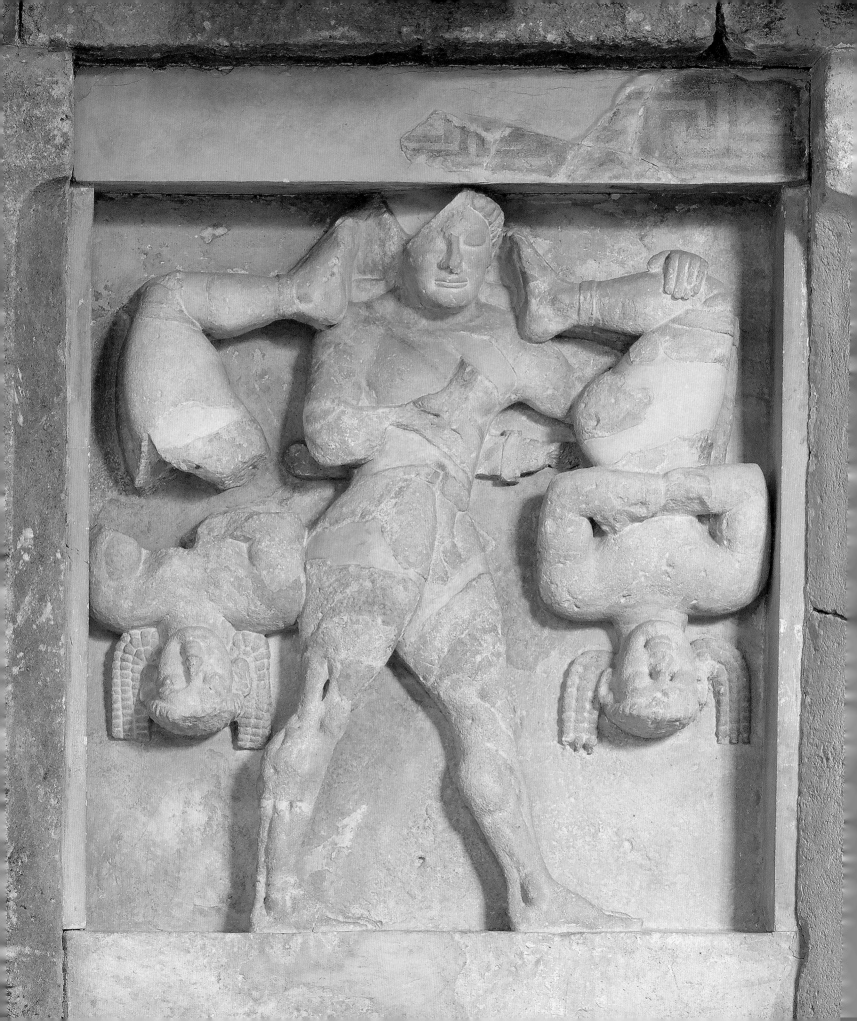

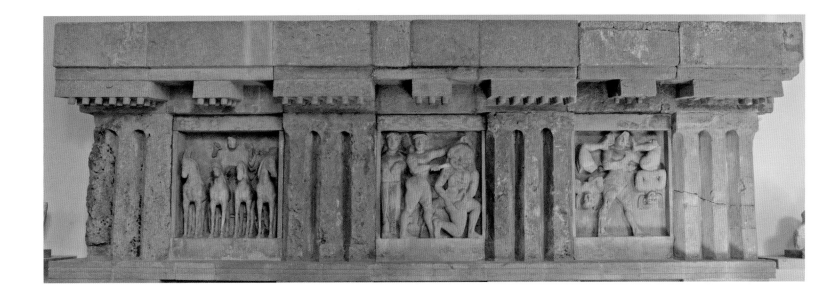

Athena, Demeter, Pasikrateia and other gods, but especially thanks to (Z)eus.'[50] Temple G, its deity again uncertain, measured an impressive 50 by 110 metres (compare the plan of the Temple of Apollo at Ortygia, fig. 61) with some of the column drums alone weighing about 50 metric tonnes.[51] Much of the stone was sourced from the nearby quarry at Cave di Cusa, where some of the stages of the cutting process for column drums can still be seen (fig. 75).[52] Building commenced on Temple G during the late sixth century BC, but work was still in progress when Selinous was sacked by the Carthaginians in 409 BC.

Possibly the last temple at Selinous to receive sculptured metopes was Temple E, dedicated to a deity not listed among the most important cults in the city, but instead to the no less significant goddess Hera.[53] The project began in the early decades of the fifth century BC. The temple was more modestly proportioned than Temple G, at 68 by 25 metres in plan. The temple had porches at either short end, from which came a series of well-preserved metopes and fragments. While continuing the Selinountine tradition for carving figural metopes, Temple E used an innovative technique for architectural sculptures that combined limestone and marble in their construction. (This pseudo-acrolithic technique has already been discussed in relation to the so-called Morgantina Goddess; see pp. 68–9, fig. 50.)

On Temple E's metopes, the human figures and animals were carved from the limestone blocks, but fine marble, imported from the island of Paros, was inserted into the panel to form the parts of heads or faces alone, necks and the exposed limbs of the female figures. One metope shows the cruel punishment of the hunter Aktaion, who accidentally encountered the goddess Artemis while bathing (fig. 76).[54] The virgin goddess transformed Aktaion into a stag and his own hunting dogs devoured him. On this metope Artemis casually stands by while Aktaion is attacked by two dogs that tear and gnash at his flesh. A third, highly spirited, dog leaps up, but is kept at bay by his master. Aktaion's metamorphosis into a stag is alluded to by the head and antlers of the deer emerging from the top of his head.

Aktaion originally held a sword and Artemis a bow cast in bronze so that the marble, limestone and metal combined to create a dramatic, violent and powerfully realistic image. Paint would have enhanced the scene further. This combination of different materials would also have increased the metope's visibility, which was crucial as they were positioned within the dark porches of the temple rather than on the outside. The five metopes found at the

Fig. 70 (opposite)
Metope from above frieze showing Herakes and the Kerkopes.
Museo Archeologico Regionale Antonio Salinas, Palermo.

Fig. 71
Reconstructed Doric frieze from Temple C at Selinous with three of the carved metopes between triglyphs: left to right, chariot; Athena, Perseus and Medusa; and Herakles and the Kerkopes. 540–530 BC. H 1.45m.
Museo Archeologico Regionale Antonio Salinas, Palermo.

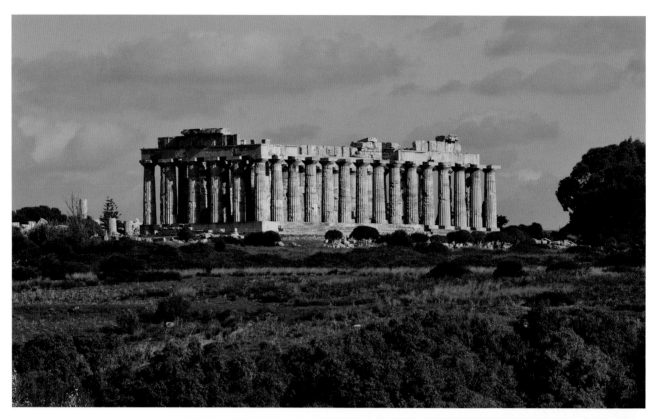

eastern end are relatively complete and continue the use of the acrolithic technique: only the female faces are made of marble, the hair being of limestone. From the western end come some fragments of female marble heads, with evidence of a slightly different technique: on these metopes the entire head is made of marble (see fig. 77).[55] What is clear from the five best-preserved metopes is that they show encounters or combats between a male and female subject. The metopes, divided by architectural triglyphs, were not part of a continuous narrative, but were to be regarded as single episodes from familiar stories.

The other ancient city famous for temple building on a monumental scale was Akragas (modern-day Agrigento), and while there are no surviving sculptured metopes from its temples, equally impressive but different forms of architectural sculptures were employed.

Fig. 72 (opposite, above)
Temple C at Selinous, today.

Fig. 73 (opposite, below)
Computer reconstruction of Temple C at Selinous showing the position of the façade metopes and the Gorgon in the pediment.

Fig. 74
Limestone head of a warrior from a metope of Temple C at Selinous. c.540–530 BC. H 46 cm.
Museo Archeologico Regionale Antonio Salinas, Palermo.

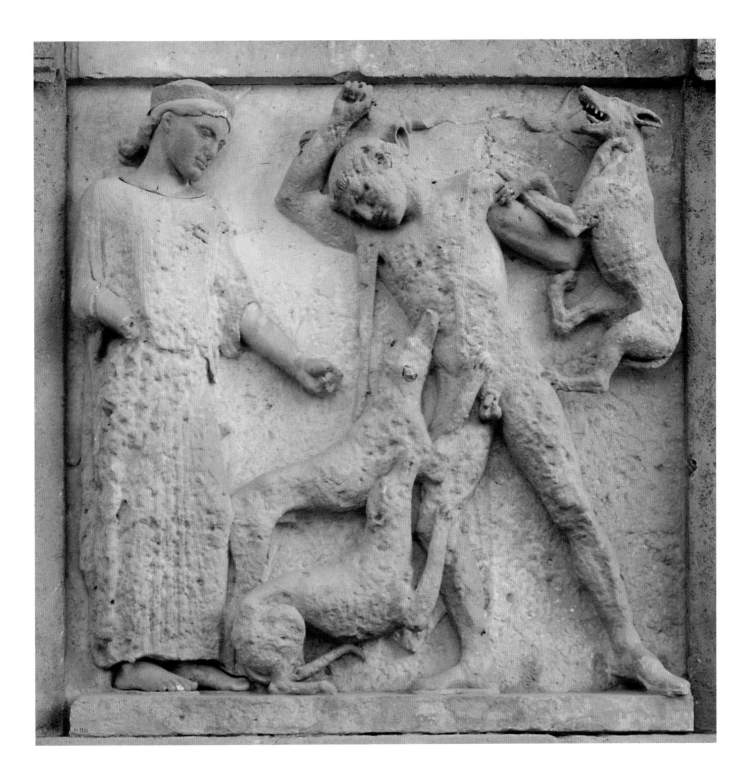

Fig. 75 (opposite)
Aerial view of the quarries at Cave di Cusa
showing different stages in the cutting out
of cylindrical column drums from the quarry.

Fig. 76
Limestone and marble metope from Temple E
at Selinous showing Aktaion being devoured
by his dogs at the instigation of the goddess
Artemis. c.460–450 BC. H 1.62 m.
Museo Archeologico Regionale Antonio Salinas, Palermo.

Fig. 77
Marble head and neck of a
woman from the metopes of
Temple E at Selinous.
*c.*460 –450 BC. H 26 cm.
Museo Archeologico Regionale
Antonio Salinas, Palermo.

The Olympieion, Temple of Zeus

The other temples and porticoes which adorn the city [Akragas] are of great
magnificence, the temple of Olympian Zeus being unfinished but second it seems
to none in Greece in design and dimensions.
POLYBIOS, *THE HISTORIES*, BOOK 9, 27.9

The largest Doric temple ever constructed in antiquity was the Temple of Zeus at Akragas.[56] It measured 110 by 53 metres, while, by comparison, the Parthenon in Athens was only 69 by 30 metres in plan. The Olympieion was thought to have been built as a victory monument after the Battle of Himera in 480 BC, although most scholars now agree that construction began earlier, during the late sixth century BC, and that the temple was never fully finished.[57] The victory at Himera might have provided funds to enhance the building and pay for its colossal architectural statues. Nowadays the site of the temple is strewn with enormous architectural blocks, among which were found many that originally formed colossal, 'Atlas-style' sculptural supports, known as 'telamones'. This term takes its name from the father of Ajax, Telamon, one of the Argonauts, who was the first to break through the walls of Troy.[58] That tenuous link with a built structure was enough, it seems, to have linked the hero with the architectural feature, but Telamon himself rarely appears in Greek art. There is a connection with Troy, however, as according to Diodorus Siculus scenes from the *Iliad* featured in the sculptural groups that adorned one of the temple's pediments;[59] the other pediment had a Gigantomachy, a battle between the Olympian gods and the Titans.

The term 'telamon' was applied to a male statue that supported the architecture on the back of his neck and/or with bent arms.[60] Although not mentioning the sculptures at Akragas, the ancient architectural historian Vitruvius made an early reference to the type: 'if statues of male figures support mutules or cornices, our people call them telamones, and the whys and

Fig. 78 (left)
The best-preserved head of a 'telamon' made from three separate blocks of limestone.
*c.*480–470 BC.
Museo Archeologico Regionale, Agrigento.

Fig. 79 (right)
Reconstructed 'telamon' supporting figure from the Olympeion, Akragas.
*c.*480–470 BC. H 7.65 m.
Museo Archeologico Regionale, Agrigento.

wherefores of that term cannot be found in history books; but the Greeks, in fact, call them ἄτλαντες [atlantes].[61] In reality, the giant figures from the Olympieion, over 7.6 metres in height, have no distinguishing features that allow for a specific identification. Diodorus Siculus tells us that the temple was constructed using slave labour, so some scholars have imaginatively linked each telamon with a Carthaginian prisoner captured from the Battle of Himera: the giant building pressing on their shoulders is a reminder of their defeat. It is uncertain where the sculptures were positioned, with some architects suggesting an exterior position, while others believe the giants faced an interior court.[62] It is clear that the figures varied in details, from bearded to clean-shaven, but were otherwise extremely uniform in design. They acted as supports – semi-engaged pilasters between half-Doric columns – and were constructed in blocks as the courses of the adjacent walls were being laid. They were naked, their legs close together with their hands raised to the back at head level, as if supporting the architrave above. Their simplistic and sharp, angular features suit their vast scale, and they date stylistically to 480–470 BC. They are the earliest known instances of male architectural supports from an ancient Greek context. Their influence on Sicily comes later in the form of similar figures found on fragments of relief ceramics, and on one of the Hellenistic terracotta altars found at Soloeis (fig. 94). Later Hellenistic theatres made use of terracotta and stone satyrs and maenads (see fig. 98) as mock supports in their decoration.

The Olympieion was no doubt intended to impress, and its peculiar plan and decorative scheme rendered it an expensive and extravagant experiment, typical of the Akragantines, who had a reputation for being ostentatious. Akragas was one of the richest cities in the Greek world, earning its wealth from the trading of wool, agricultural produce (including olive oil which was traded with Carthage) and the breeding of horses.[63] Despite there being a prominent stream of fine Greek temples at Akragas, apart from the Olympieion none of them has any architectural sculptures definitely associated with them.

The one possible exception, however, is the enigmatic statue known as the Warrior of Agrigento (Akragas), shown in fig. 81, which has been associated with a small number of fragmentary marble sculptures found in contexts between the Olympieion and the Temple of Herakles.[64] A statue of a helmeted warrior in a dynamic pose has been reconstructed from three pieces, joining a right thigh and a torso and a head that does not join directly onto the body. While some believe that the head never belonged to this statue, but to another figure from the same group, the statue is thought to represent a giant from a Gigantomachy scene. The most recent interpretation is that the figure should be positioned as if falling down. While the exact pose of the statue is debated, one suggestion is that the warrior has fallen onto the shield held in his left hand and is raising his right arm, perhaps brandishing a sword to defend himself. The sculpture was carved during a transitional period in Greek sculpture, about 470 BC, when sculptors were attempting a more realistic interpretation of the human form, but still at an early stage where the flesh and muscles form patterns over the underlying skeleton. The pubic hair is still indicated in an archaic way by a rudimentary simple pattern in the Archaic manner. All was brightly coloured, and hints of polychrome decoration can be traced, including a palmette design on the helmet.

The Temple of Herakles has been cited as being a possible location for the warrior and other fragments of sculpture. If that were the case, they would have been a later addition because that temple was built in about 510–500 BC. An alternative view is that they were from free-standing groups of sculpture showing specific combats, probably mythological rather than historical. Whatever the original context of these figures, they represent a rare and prestigious project extensively embellished with marble sculpture.

Fig. 80
So-called Temple F 'of Concord' at Akragas, built c.450–440 BC. It is one of the best-preserved of all Greek temples. Commonly known as the Temple of Concord after a later Latin inscription referring to Concordia was found inside. One recent idea is that it was a temple to the Dioskouri.

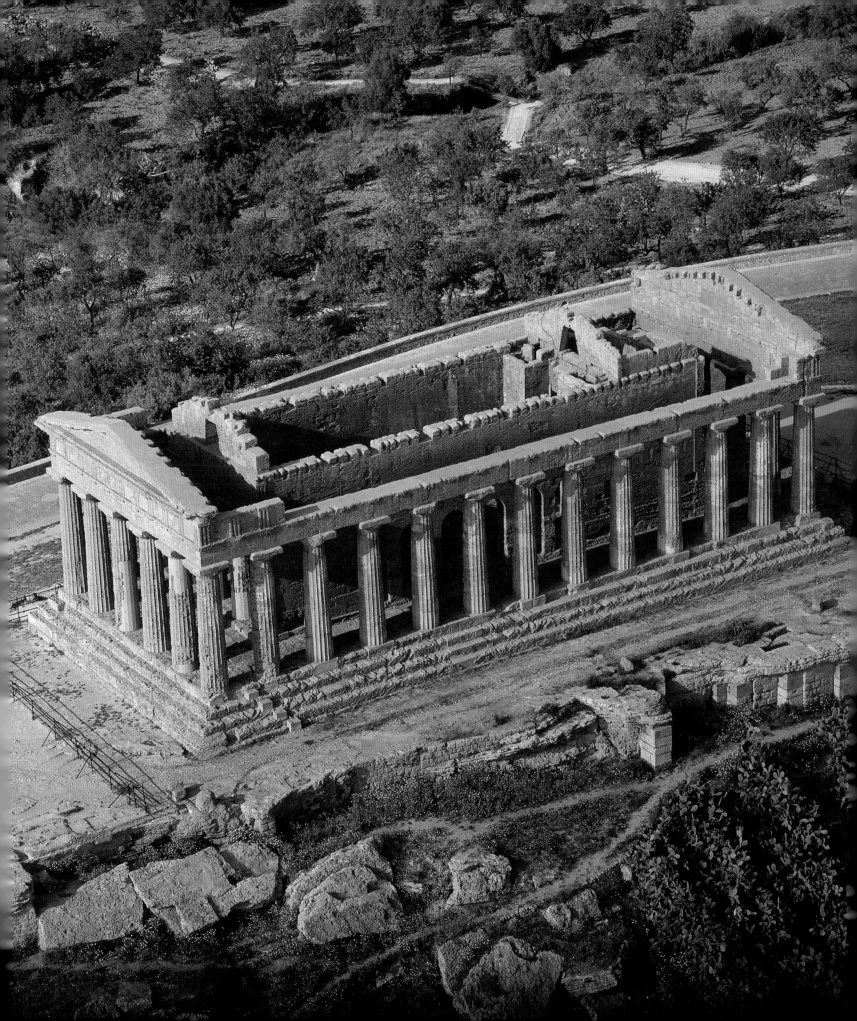

Architectural Tomb Monuments

Greek-style Doric temples on Sicily might now appear relatively uniform in their design, but they have subtleties and innovations that demonstrate the eagerness of Greek Sicilian architects to create something original. Temple design in turn influenced that of funerary structures and monuments. An interesting series of models of tombs were used to crown grave stelai (tall shafts of stone placed over the burial) and demonstrate how the wealthy hoped to be protected by and beneath religious-style buildings. Their desire to be immortalized after death might have been the impetus behind such monumental grave-markers. The majority of examples were discovered at the cities of Gela and Akrai.[65] The example from the necropolis at Capo Soprano at Gela (fig. 82) is the finest and was probably mounted on top of a funerary pillar.

The model building sat upon a tall shaft or stele over a grave. It was carved to emulate the upper part of a Doric temple, but its idiosyncrasies might indicate that it copied an actual structure from Gela that did not follow the canonical design. At each end of the building the pediments contain a column on a stepped base, with Aeolian capitals, an unusual arraignment rarely found in western Greek contexts. Palmette *akroteria* (ornamental elements) straddle the apex of the gabled roof, flanked part way down the slope by horn-shaped decorative features. The roof tiles and covers are carved with great attention to detail. The roof is supported on an architrave and Doric frieze with alternating plain metopes and triglyphs, beneath which are the *guttae* (cylindrical drop-shaped elements), all of which typify a Doric frieze on a larger scale. On one side the raking *geison* is littered with ancient graffiti, naming Greeks but alien to the original object. Having a small temple mounted upon your grave might have been considered conceited by some, but a few wealthy, high-ranking Greeks even managed to have themselves interred in magnificent marble sarcophagi with Doric friezes on the sides and gabled lids like temple pediments. Fine examples of these have been discovered at ancient Akragas.[66]

Fig. 81 (opposite)
The Warrior of Agrigento.
Marble statue of a helmeted
warrior from Akragas, possibly
from a votive dedication. *c.*470
BC. H of head 25 cm; of torso
and thigh, 62 cm.
Museo Archeologico Regionale,
Agrigento.

Fig. 82
Limestone crowning ornament
from a funerary monument in
the form of the upper part of a
shrine. Found in the necropolis
at Gela. *c.*500–470 BC.
H 52 cm.
Museo Archeologico Regionale
Paolo Orsi di Siracusa.

Another interesting type turns the architecture inside out, with polychrome Ionic columns set into the corners of the interior of the gable-lidded sarcophagus. These terracotta sarcophagi were less expensive to commission than marble versions and have plain sides, which might have originally been painted with Doric architectural features. These sarcophagi were relatively popular at Gela and nearby Kamarina.[67]

Rarer still are terracotta sarcophagi in the form of colonnaded temples, such as the large and striking example (fig. 83) from Tomb 26 in the Olimpica necropolis at Monte Saraceno, near Ravanusa.[68] It is uncertain whether the site of Monte Saraceno might be the ancient town of Maktorion or Kakyron. It was originally a Sicani settlement, later gradually settled by Greeks, as shown by the archaeological finds. Despite its size and fragile material, the sarcophagus is well preserved. It was constructed in several sections and then fired and painted. The 3 by 6 Doric columns support an entablature upon which the gabled lid is mounted. The columns are rendered with great skill and accuracy, with the column flutes precisely incised and the anatomy of the capitals expertly translated from stone into clay. An intriguing addition to the sarcophagus is a series of lightly incised designs representing two Corinthian helmets, an amphora and a crescent moon. Their symbolic meaning is denied to us today, but the helmets at least might suggest that the tomb's occupant was a warrior. The sarcophagus contained the remains of a male skeleton, surrounded by mostly imported Athenian and Corinthian pottery dated to the early fifth century BC. The sector of the necropolis in which this tomb was discovered held high-status burials, with mostly Greek and not 'indigenous' pottery, suggesting that the people buried there were more thoroughly Hellenized than those in other parts of the cemetery. The occupant of this grand temple-sarcophagus might have

Fig. 83
Terracotta sarcophagus from Monte Saraceno, near Ravanusa. c.490–480 BC. L 1.80 m.

Museo Archeologico Salvatore Lauricella a Ravanusa.

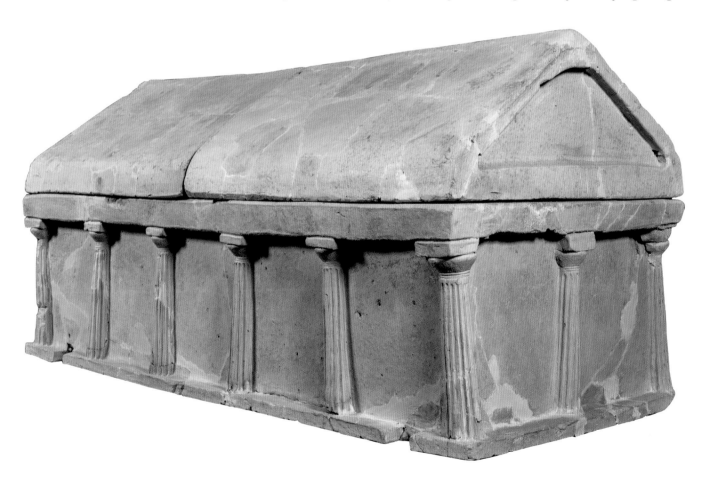

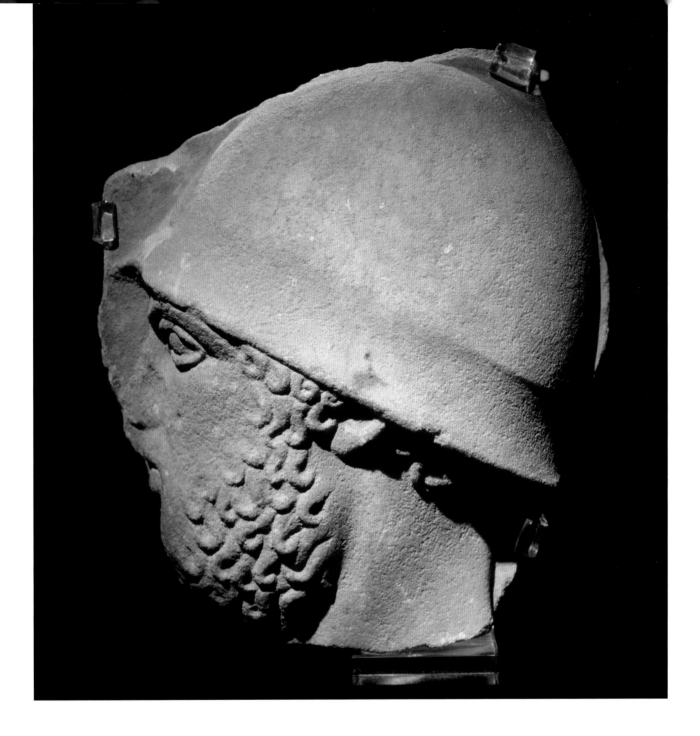

had a stronger cultural affinity with the Greeks of nearby Akragas and not so distant Gela than with the majority of his community.

Tombs also provide us with a few examples of marble sculpture from the fifth century BC. A fragmentary marble relief found on Tomb 1189 of the necropolis at Kamarina demonstrates just how valuable a material marble was to the sculptors in ancient Sicily, as it shows clear evidence of reuse.[69] On one side is a finished sculpture showing a male head wearing a *pilos* helmet (fig. 84), no doubt a representation of the deceased man, a warrior who was buried in the grave beneath. Despite its low relief, the sculptor has achieved a cleverly deceptive three-dimensional sculpture: the helmet appears solid, metallic and rounded, a separate entity from the organic hair and face that it protects. The helmet might have been

Fig. 84
Marble relief from a funerary stele of a warrior, reused from an earlier relief showing a falling man, perhaps a satyr.
*c.*440 BC. H 30 cm.
Museo Archeologico Regionale Paolo Orsi di Siracusa.

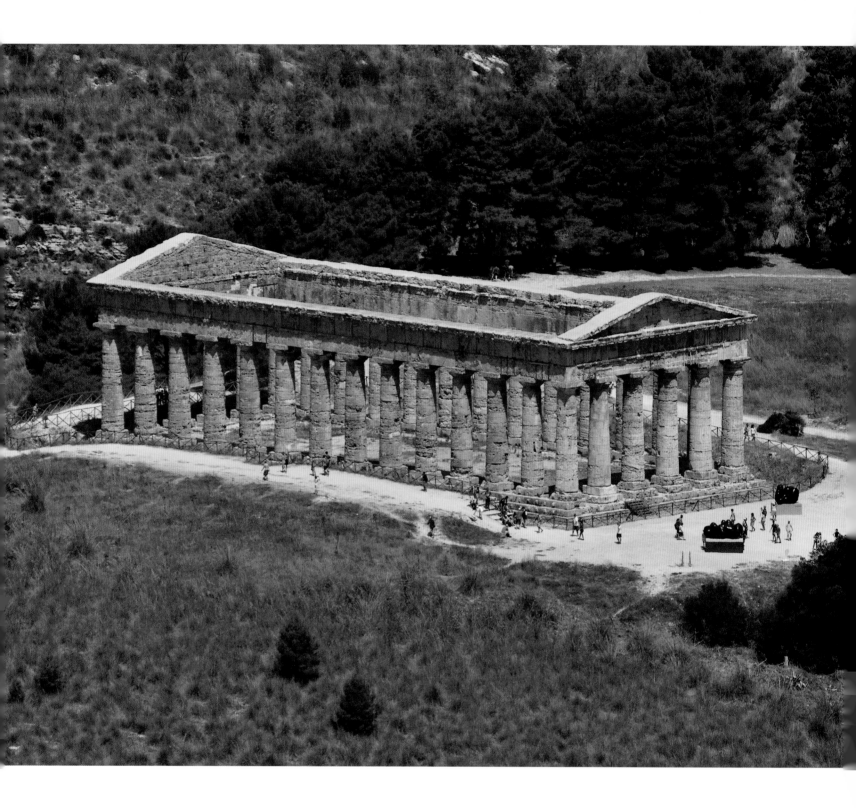

painted with a design, rather like that of the warrior (fig. 81) from Akragas. The head would have been part of a full-length image of a man, but its additional interest lies on its reverse side, which reveals another sculptured relief. This shows a falling or reclining figure, one arm raised over his brow and perhaps part of an arm and hand of another figure on the left. This has been viewed as part of a battle scene, a slab from a frieze perhaps, with the main figure protecting himself from the blow of a weapon. An alternative view is that it shows a drunken satyr, or perhaps a figure of Sileinos, with a thick long beard over the chest, and behind him a tall conical ornament with a flaring mouth, perhaps a column or a *kalathos* (wool basket). Whatever the identification, the scene was definitely not intended to be part of a double-sided relief as it is carved at a different angle from the warrior's head. It appears that the satyr scene was started but abandoned – perhaps it was no longer needed or was a practice piece – but the marble was precious enough to be reused for a funerary stele. The sculpture dates to about 440 BC, a period when Kamarina was in a political alliance with Athens. The style of carving is reminiscent of Athenian works of the same period, not least the heads from the Parthenon frieze.[70] It was a time when Athens was becoming increasingly interested in Sicily, not only in terms of its cultural activity, but also politically. This is demonstrated by some of the alliances and cultural links with certain cities on Sicily.

It was during this period that one of the most famous of all Greek-style temples on the island was built at the site of Egesta (modern-day Segesta), a non-Greek, Elymian settlement. The cult that the temple served is, however, unknown. Today its romantic ruins, dominating the rolling landscape, evoke a sense of isolation and stark beauty, but in antiquity it was not unaccompanied, as archaeologists have discovered the remains of one or maybe two temples nearby. The best-preserved temple, 23 by 58 metres in plan, was built of local limestone, but many features, including the lifting bosses on the steps and its unfluted columns, show that the building was never finished.[71] It is thought to date to about 430–415 BC, a critical period in the history of the Egestan people. The Elymians had major centres in north-west Sicily, occupying the towns of Eryx (Erice), Entella and Iaitas (Monte Iato). Egesta had strong links with Greek communities, especially nearby Selinous, with which it had a turbulent relationship. This temple was built during a period when relations with Selinous were at breaking point, the Egestans perhaps intending the temples to rival those of its neighbour. No doubt it was also intended to remind the Sicilian Greeks of its strengthening relationship with Athens.

Fig. 85
Doric temple at Segesta, ancient Egesta. Built c.430–415 BC. Despite being unfinished, its sophisticated architectural refinements echo those of contemporary temples in Athens.

Sicily: The Envy of the Mediterranean

By the second half of the fifth century BC the Greek cities on Sicily had become wealthy and famous for their monumental architecture. The dedications of the tyrants of Syracuse, Gela and Akragas in Panhellenic sanctuaries were seen by multitudes of dynasts, rulers, diplomats, sculptors, philosophers and writers. Greek Sicily now stood as a formidable economic and political player on the Mediterranean stage. Cultural life on the island flourished under the tyrants and democracies and, while the local communities did not lose their identity completely, Greek culture dominated, in its regionally variable, hybrid form.[72] However, like other parts of the Greek world, the island was not inhabited by a blissfully united Greek population. There was great civil and regional unrest; envies and conflicts continuously simmering. It was only to be a matter of time before external powers began to exploit this in order to gain a slice of the island's prosperity, and it was Sicily's internal political factions that were to kindle the interest of the Athenians, who, in the later decades of the fifth century BC, were embroiled in the bitter and long-lasting Peloponnesian War.

The Athenian Expedition (415–413 BC)

One of the most famous events in Sicilian history was the Athenian expedition of 415 BC, recounted in great detail by Thucydides.[73] Numerous factors led to the Athenians looking west towards Sicily, and in particular Syracuse. Syracuse had been gradually dominating politics on the island, and its aggressive policies so angered the cities of Leontinoi, Naxos and Katane that they requested Athenian assistance against Syracuse in 427 BC, though this had no immediate effect. Internal events were to become more volatile when Syracuse took Selinous' side in their latest war with Egesta. In 415 BC Egesta pleaded with Athens to help and this led to the Athenians sending a fleet of warships and foot soldiers later in that same year.

But the Athenians also had reason to look towards Sicily for their own gains. During the protracted Peloponnesian War, they had been unable to make territorial gains anywhere in Greece. Athens' main adversaries, Sparta and Corinth, depended on getting food supplies from southern Italy and Sicily. Athens therefore began to view Sicily, and in particular Syracuse, as necessary to defeating her enemies back home on the Greek mainland. The historian Thucydides gives a very Athenian account of the events that followed. Two of the most eminent Athenian generals, Nikias and Alkibiades, were given charge of the mission, both of whom had very different personalities and strategies. Alkibiades was to lead the huge force sent to Sicily, which consisted of 134 triremes and 27,000 men, the largest Athens had ever dispatched. Unfortunately for the Athenians, Alkibiades was recalled to Athens to face charges of treason, though he managed to escape trial. Thus the older and less impetuous Nikias took control. Initially the Athenians made great headway, managing to partially blockade the harbour at Ortygia and surround Syracuse, but with Spartan military aid the fortunes of Syracuse reversed. In 413 BC the Athenian fleet was captured and destroyed, and the hoplites on land defeated in battle, with many of them dying of fever contracted in the marshland that surrounded Syracuse. Allegedly, only 700 Athenian soldiers survived the battles and fever, although many of these died of hunger and exposure while imprisoned in the nearby quarries. According to legend, those prisoners who could recite excerpts from the writer Euripides were released, but only a handful ever made it back to Athens. Syracuse had won against all odds and the Athenians had been humiliated. But victory was short-lived, as the ever-present threat from Carthage dealt Sicily another shattering blow.

Fig. 86
The 'Ear of Dionysios', a cave
in the quarries of Syracuse
where the captured Athenian
soldiers were imprisoned.
Watercolour over graphite,
by Phillip Jacob Hackert
and Thomas Hearne,
1777. H 44.3 cm.
British Museum, London.

The ongoing conflict between Selinous and Egesta had continued, leading to Egesta's devastating defeat in 411 BC. The Egestans appealed to Carthage for help, which came in the form of the Carthaginian general Hannibal Mago. He led a force to assist Egesta, which then inflicted an irrevocable defeat on Selinous in 409 BC. Thousands of its inhabitants were slaughtered by Hannibal's men and many of the city's art treasures were reportedly taken as war booty to Carthage. Himera was also destroyed during these hostilities. Encouraged by these victories, Carthage pursued further engagements with the Greek cities on Sicily, and by 405 BC had defeated Akragas, Gela and Kamarina. Only Syracuse remained to be crushed, but the period of Carthaginian conquest saw the emergence of a new dominant individual in the city: the tyrant Dionysios I (r. 405–367 BC).

From Dionysios the Elder to Hieron II, 405–215 BC

Dionysios I, born of an aristocratic family, began his career as a public administrator but rose up to become a military commander. He exploited the power vacuum in Syracuse to eventually declare himself *Tyrannos* in 405 BC, after which he set to work fortifying the city and building up his army reserves with mercenaries who, although effective, were expensive to maintain. Like earlier tyrants, he mercilessly moved populations from city to city, enslaving many. Yet he managed to keep the Carthaginian army from Syracuse's door, forcing them back to the north-west of the island. Now the dominant Greek ruler on Sicily, Dionysios directed his attention to the Greek cities of southern Italy. He conquered Reggio, Lokri and Kroton, and so became the most powerful tyrant of all the Greek settlements in the western Mediterranean.

During these conflicts, Dionysios nonetheless impressively managed to intensify the reputation of Syracuse as a major cultural and artistic hub. His victories in horse racing led to the celebratory dedications of statue groups at Olympia, but he was less successful in the art of poetry. According to Diodorus Siculus, the tyrant invited the poet Philoxenos (435–380) to his court, and on one occasion asked him for an opinion on his own poetry.[74] Philoxenos gave an honest response and was duly dragged to the quarries at Syracuse as a punishment. After his friends entreated with Dionysios for clemency, Philoxenos was released, only to be invited to endure more of the tyrant's poetry. When asked again what he thought of Dionysios' work, he despairingly requested to be taken back to the quarries. Dionysios was notorious for plundering temples for their riches, no doubt to pay for his costly mercenaries. When he died in 367 BC he had acquired the status of king, but his reputation as a ruthless dictator was widespread. Later historical tradition remembers the tyrant, or perhaps his son of the same name, as a Machiavellian ruler. In Dante's *Inferno* (from his *Divine Comedy*) we meet the tyrant as he suffers eternal torment in a river of boiling blood: he is described as having brought long years of grief for Sicily.[75]

The reign of Dionysios' son and successor Dionysios II or the Younger covered the years 367–343 BC and was one of increasing political turmoil. Initially Dionysios ruled under his uncle Dion's watchful eye. Despite his uncle's efforts, the tyrant's extravagant, hedonistic and unpredictable nature led him to make many unpopular decisions. Dion invited Plato to the court at Syracuse to help tame the wild young king and to cast him into a new form as the archetypal philosopher king.[76] Unfortunately, Plato could not accomplish the task and was banished along with Dion.[77] Without any sound guiding counsel, Dionysios became increasingly inept at governing Syracuse and was eventually ousted by Dion when he returned to seize control. Eventually Dion expelled his nephew from Sicily, and Dionysios took refuge at Lokri, only to return in 346 BC to take control again. Dionysios' shambolic rule was finally brought to an abrupt halt by Timoleon, the tyrant of Corinth. Seeing the political chaos that

was prevalent in his city's 'colony', Timoleon had set out initially to crush the threat from the last remaining powerful tyrant, Hiketas of Leontinoi, who now also controlled most of Syracuse apart from Ortygia, Dionysios' last stronghold. Timoleon took Ortygia and Dionysios was exiled to Corinth. Then Timoleon defeated Hiketas, who had allied with but then been abandoned by the Carthaginians. By 343 BC Timoleon was tyrant of all Greek Sicily, and he was credited with allowing the seeds of democracy to germinate again, although with limitations. Timoleon retired from political life in 337 BC as his sight had begun to deteriorate. When he died he was buried with honours by the citizens of Syracuse.

The following years saw a succession of rulers, the most notorious of whom was Agathokles (r. 317–289 BC) who, after several conflicts with the Carthaginians, pronounced his loathing of democracy and proclaimed himself King of Sicily in 304 BC. Ancient authors, particularly Diodorus Siculus, revel in narrating Agathokles' acts of cruelty. He describes one particular event in vivid and gory detail.[78] In 306 BC Agathokles requested that the people of Egesta, his allies, give up their money, no doubt to fund his war campaigns, but they refused and were treated in the most barbaric manner. Many people were so horrified by the torturous devices they had witnessed that they preferred to burn themselves in their own homes rather than suffer a similar fate. Only a few young women and children were spared death, instead to be sold as slaves. Not surprisingly ancient writers do not even applaud the tyrant's patronage

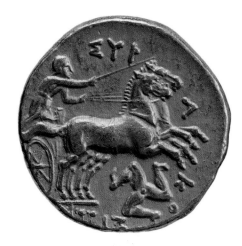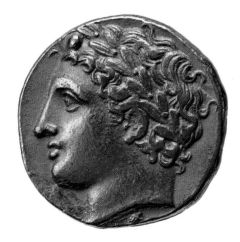

of cultural affairs. Apparently, on his deathbed Agathokles softened, declaring he would rather democracy prevail than for his sons to take over as tyrant rulers. His last wishes were not to be upheld, but fortunately Sicily was to witness a golden age of relative prosperity, if not peace, under the last significant Sicilian tyrant king, Hieron II (r. 270–215 BC).

Hieron II's father claimed descent from the tyrant Gelon I, but Hieron himself gained political influence not only through his lineage, but also as commander of the army. He then consolidated his power by marrying Philistis, daughter of Leptines, a leading and popular citizen of Syracuse. His ousting of the Mamertini, mercenaries brought to Sicily by Agathokles, led to him being declared king, although it was this act that attracted the attention of the emerging superpower that was Rome, as the Mamertini requested the city's aid to retaliate. At first Hieron had surprisingly allied himself with the Carthaginians during the First Punic War, but seeing that the Romans were to defeat Carthage, Hieron's loyalties switched

Fig. 87
Gold coin of Syracuse issued during the reign of Agathokles, first tyrant to proclaim himself a king. The obverse of the coin shows the head of Apollo; the reverse shows a *biga* (two-horse chariot) and a rare glimpse of a *triskelion* beneath the horses. *c.*300 BC. Diam. 1.5 cm. British Museum, London.

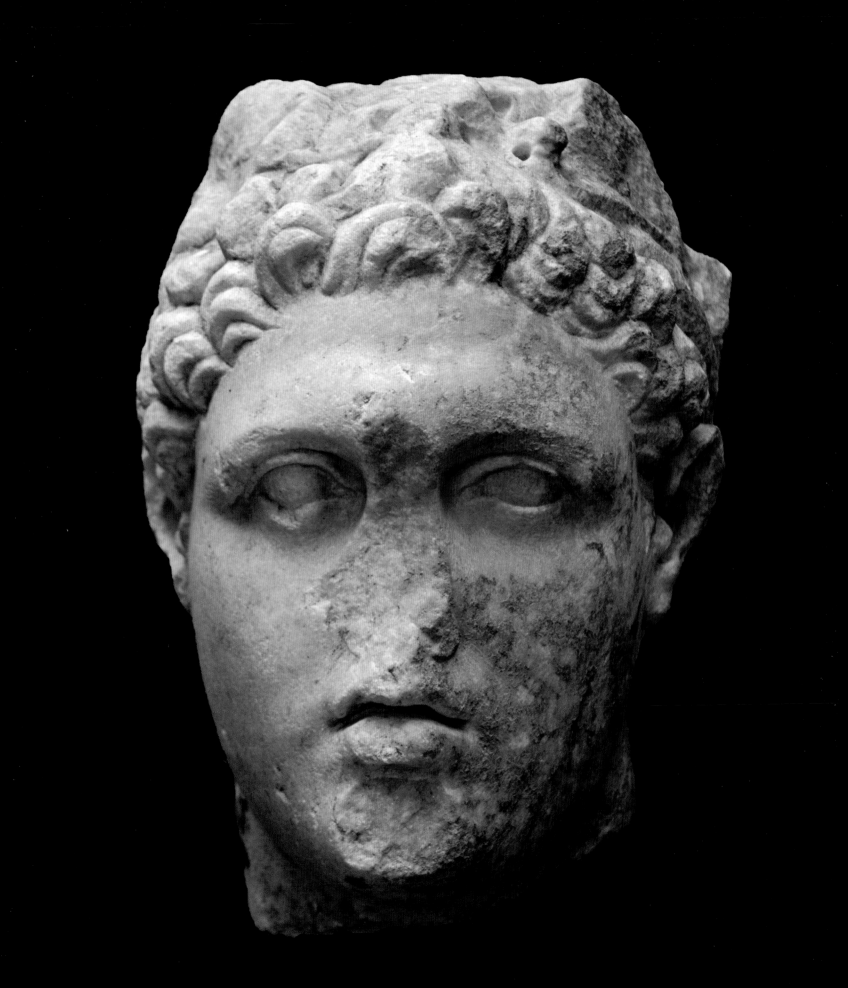

towards the victors. In 263 BC Hieron shrewdly drew up a treaty with the Romans that limited his kingdom to an area from Syracuse to Taormina, along the east coast. Hieron's loyalty to Rome led to a period of relative independence and prosperity. Hieron forged links with other Hellenistic kingdoms, particularly Ptolemaic Egypt, and he famously had a huge ship called the *Syracusia* constructed to deliver Sicilian merchandise to the eastern Mediterranean[79] Designed by Archimedes, the vessel was so immense that only the port of Alexandria in Egypt could accommodate it. Hieron gave Ptolemy IV of Egypt Sicily's finest produce – grain, wool and salted fish – as recorded by the Greek writer Athenaios in the second century AD.[80] This extravagant diplomatic gesture marked a period of history when Sicily was more closely tied with the other Hellenistic kingdoms, although culturally it still retained its own regionally varying identity. Hieron's coin issues are the first to show a living Greek Sicilian ruler, and his portrait appears on some coins, while his wife, Philistis, is shown on silver coins (fig. 89) with the title Basilissa (queen).[81] The introduction of Philistis' portrait on coins and the statues of her and her husband erected in the Panhellenic sanctuaries at Delphi and Olympia marked a rare occurrence of a female Sicilian Greek dynast forging their civic and economic identity in cultural and economic affairs.

Hieron and Philistis encouraged cultural and artistic activities in Syracuse and elsewhere[82] Syracuse was the birthplace and home of the celebrated mathematician Archimedes (287–212 BC), who, sources tell us, planned and executed many of his greatest inventions in the city.[83] His brilliant mind played a crucial role in ancient warfare and the development of military techniques, including, according to some ancient sources, an engine similar to a catapult that threw stones at the enemy and a legendary glass (or, more probably, polished bronze) lens that redirected sun rays to set enemy ships on fire. His name is also attached to the revolutionary 'Archimedean screw', an ingenious device to raise water.

Archimedes and Hieron lived through a period that saw a general increase in the private wealth of the middle and upper classes on Sicily, a phenomenon seen across the Mediterranean following the death of Alexander the Great in 323 BC. The opening up of trade routes, founding of new cities and increase in travel spawned a more cosmopolitan society and a higher level of disposable income for the privileged classes. Private individuals began to decorate their houses in an elaborate style, previously reserved for people of only the highest status, with wall paintings and pebble and tessellated mosaic floors. The ancient cities of Iaitas (Monte Iato), Syracuse, Centuripe and especially Morgantina (which was politically and culturally associated with the court of Hieron II at Syracuse) have yielded fascinating information about the private house during this period.[84]

Fig. 88 (opposite)
Rare marble portrait of a king of Syracuse, modelled in the Hellenistic fashion with a royal diadem, possibly Agathokles or Hieron II. *c.*300–250 BC. H 26.8 cm.
Museo Archeologico Regionale Paolo Orsi di Siracusa.

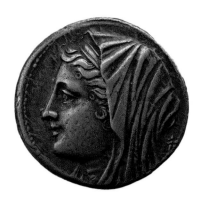

Fig. 89
Silver coin of Syracuse showing Hieron II's wife, Philistis. The style of the portrait is closely related to that of the Ptolemaic queens of Egypt. 275–215 BC. Diam. 2.6 cm.
British Museum, London.

ARCHIMEDES' EUREKA MOMENT

Archimedes is alleged to have achieved this moment of spontaneous comprehension while in the bath, pondering the dilemma of whether a golden crown belonging to the tyrant Hieron II was solid gold or contaminated with silver. Vitruvius, writing two centuries later in the first century BC, picks up the story:

> But afterwards there was a whisper to the effect that some of the gold had been removed and that an equal amount of silver had been mixed in during the making of the crown. Hieron, incensed that he had been made of a fool of and not knowing how to prove fraud, asked Archimedes to consider the matter on his behalf. Then Archimedes, pondering on the problem, happened to go to the baths, and while immersing himself in the bath-tub, noticed that the volume of his body sunk in it equalled the volume of water spilling out of it. Since this showed him a way of resolving the problem, he ecstatically jumped out of the bath without a moment's delay and rushed home, stark naked, announcing at the top of his voice that he had found what he was looking for, since as he ran along, he shouted repeatedly in Greek, Heureka, heureka [I've found it, I've found it].
> (VITRUVIUS, *DE ARCHITECTURA*, BOOK 9.10)[85]

In simple terms, Archimedes discovered and claimed in his writings that a floating body will displace its own volume in fluid, and in the process proved that Hieron's crown was not of pure gold as it should have been!

Archimedes' inventions were allegedly put to the test during the siege of Syracuse by the Roman army between 214 and 212 BC. When the city finally capitulated, the Roman general Marcellus ordered that Archimedes be taken alive, no doubt impressed by his great talents and reputation. Unfortunately, Archimedes was so engrossed in scientific thought that when a Roman soldier found him and attempted to take him captive, he brushed him off, not wanting to be disturbed, and the impatient soldier killed him.

Fig. 90
Drawing by Cosimo Ulivelli showing the death of Archimedes.
AD 1640–1704.
British Museum, London.

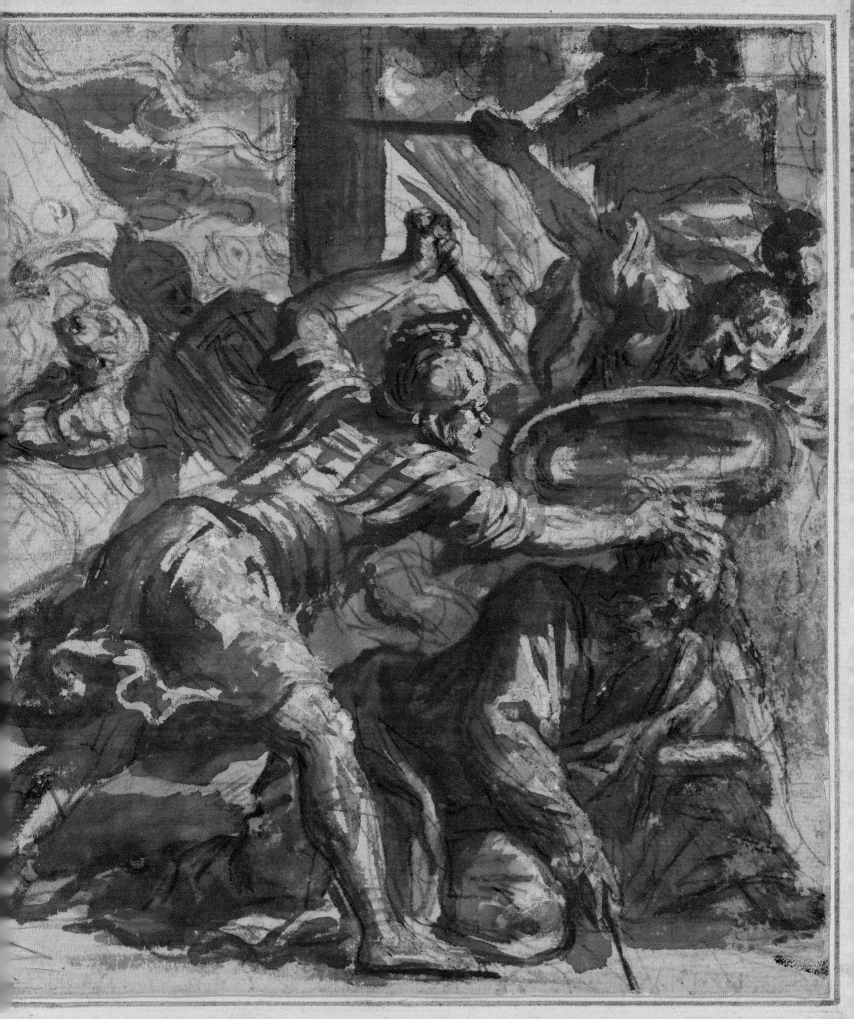

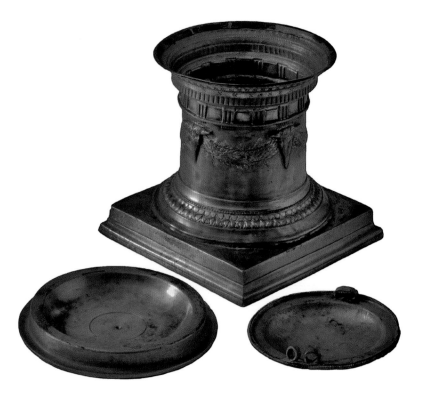

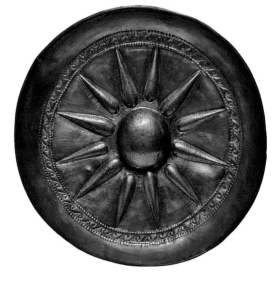

Fig. 91
Silver-gilt vessels from the
the so-called Morgantina
Treasure. 300–350 BC.
See also fig. 7.
Museo Regionale Archeologico,
Aidone.

At Morgantina the houses were designed around central courtyards with designated zones for domestic and private affairs and entertaining.[86] Their occupants were descended from Sicel peoples, but by this period some had adopted Greek names, an indication of a cultural fusion. Morgantina had Greek-style public buildings, but no colonnaded temples. The wealth of Morgantina is revealed by the relatively large numbers of coin hoards and vessels of precious metal found there, most of which were buried during the later third century BC when conflict with Rome was at its height. Morgantina supported Carthage during the Second Punic War (218–201 BC) and was subsequently sacked by the Romans, who then set up a garrison of Spanish mercenaries to keep control. Some of the inhabitants who had anticipated the attack buried their precious possessions to keep them from Roman hands. Those who perished or fled were not able to retrieve their riches, leading to the discovery of some of their hoards in modern times, the most lavish of which is the so-called Morgantina Treasure.[87] This cache of finely made silver and gilded vessels ranges in date from the early to mid-third century BC, revealing that this was a collection built up over time. A coin dated closely to 214–212 BC gives us a date just before the city's capture by the Romans in 211 BC. The hoard was found by illicit treasure hunters in the 1970s in two pits beneath the floor of a house, and some believe that it might have originally belonged to one 'Eupolemos', whose name is inscribed on several of the pieces. Little else survives from Sicily with which to compare such treasure, but the shapes and designs of the vessels do have links with pottery, and so the silver might have been made on the island. There are, however, similar hoards from southern Italy, and so there is a possibility that the vessels were made at Taranto, a Greek city on mainland Italy

famous for its production of lavish metalwork. The roundel with the monster Skylla is one of the hoard's masterpieces (fig. 7), its imposing subject a popular motif with artists on both sides of the Strait of Messina, whether in Sicily or on mainland Italy.[88]

Although gold and silver jewellery, precious metal vessels and fine imported Corinthian and Athenian pottery had made their way into many tombs of the wealthy during the sixth and fifth centuries BC, there was a marked increase in such luxury items during the fourth and third centuries BC. There were no gold or silver resources on the island. Metal was bought in as a raw material to be used in Sicilian workshops, or jewellery and vessels were imported as ready-made goods. Little gold jewellery survives from any ancient period in Sicily. Precious materials must generally have been looted from tombs and melted down or taken elsewhere. A rare survival is the so-called Avola Hoard (fig. 92).[89] This included spectacular items of jewellery, along with over 300 gold coins in an earthenware jar. Some pieces were acquired by the British Museum. The jewellery consists of two gold bracelets, with snake-bodied terminals, one coiling backwards, the other long and sinuous, a box–ring with a frenzied maenad subtly embossed onto its surface, and a gold earring in the form of a figure of Eros. The superb quality of their manufacture points to a Sicilian or Tarentine workshop and, although not a homogeneous group, they reflect the wealth and status of their original owner. The latest date for the coins is about 370 BC, the jewellery also dating to that period.

The importation of red-figured Athenian pottery, so common in rich graves in Greek communities (especially at Akragas and Gela), and the locally produced pottery in the same style, began to dry up during the fourth century BC. Craftsmen in clay-rich areas such as Centuripe were quick to exploit the gap in the market, producing elegantly designed and sumptuously decorated vessels for funerary and ceremonial use.[90] These are some of the most elaborate and ornate of all ancient Sicilian ceramics, with only Canosa in southern Italy producing anything remotely similar.[91] The terracotta lidded vessels were applied with pink,

Fig. 92
Gold jewellery from the Avola Hoard. *c*.390–370 BC. Bracelets diam. 5.5 cm; ring L 2.4 cm; earring H 2.5 cm.
British Museum, London.

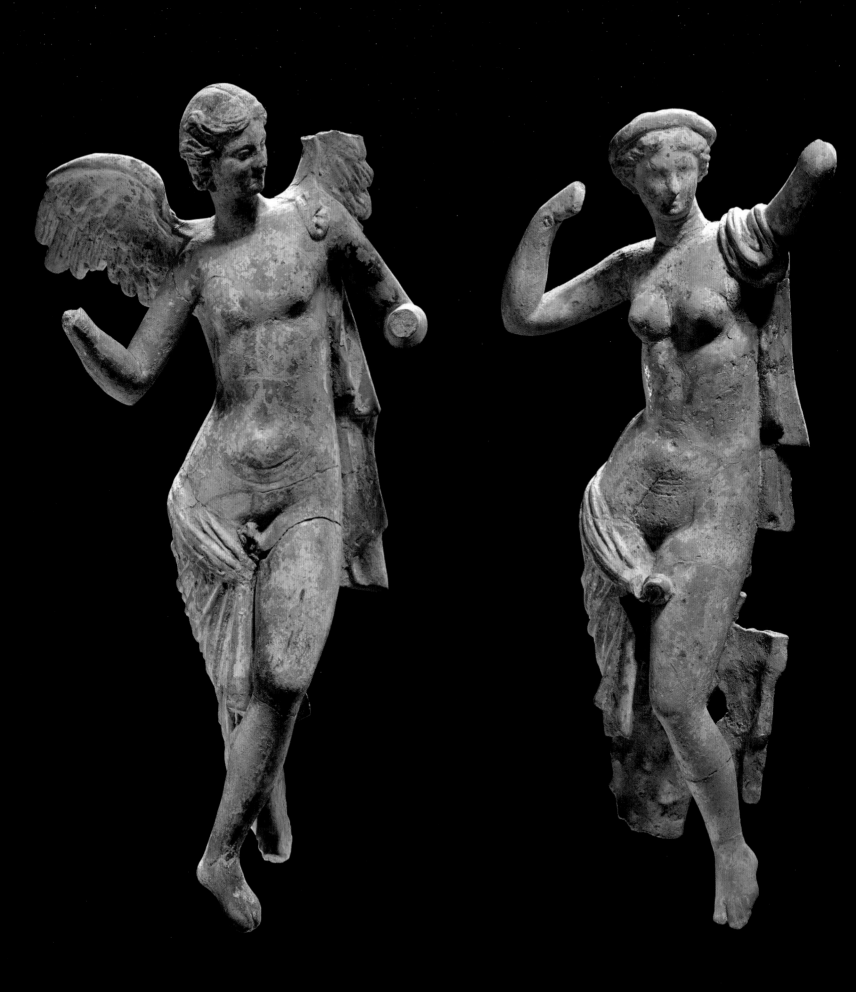

blue and yellow tempera paints after firing. Next, clay appliqué attachments were added to provide further ornament, and then the complete vessels were painted and gilded accordingly. The painted scenes – usually showing women performing wedding rituals perhaps associated with other rites of passage and the afterlife – hint at how the lost repertoire of free panel painting might have looked in Greek Sicily. An example (fig. 95) shows the painted body of the vessel emerging from petals around its base, and crowned by an architectural element, with lion-headed spouts. The scene on the body shows a flying Eros, in front of a figure, perhaps of Aphrodite, and a seated and a standing woman. These elaborate funerary vessels are closely linked with the workshops that produced huge numbers of large and flamboyant terracotta figures, their subjects usually drawn from the hedonistic world of Dionysos and the nymphs or Aphrodite and Eros (see fig. 93).[92]

The relatively large amount of surviving stone sculpture from the Hellenistic period suggests a general increase in production. From the third century BC into the Roman period there are more statues carved completely in marble. The type of sculpture was generally analogous to that being carved in other Greek centres around the Mediterranean. Sculptors were moving around the Mediterranean from commission to commission, influencing styles and absorbing ideas as they travelled. Yet on Sicily some sculptures were produced that continued to employ traditional techniques using mixed materials despite the contemporary styles. These unusual works tend to be products of the mixed indigenous Greek and Punic communities and workshops. One example is the striking and unusual bearded and enthroned statue of Zeus (fig. 96) found during early excavations at Solunto, ancient Soloeis, in north-west Sicily.[93] The colossal statue was carved from locally quarried limestone, apart from the neck, face and upper lip, which were made of imported marble. Recently conserved and restored, the statue exudes magnificence, sitting on an elaborately modelled throne. The statue was no doubt a cult image, worshipped in a temple or sanctuary setting.

Another interesting discovery at ancient Soloeis illustrates the continuing influence of Punic culture on Greek-style religious artefacts in Sicily. Two altars found in a house of the late first century BC are a testimony of the continuation of Punic rituals into the late Hellenistic and early Roman period (fig. 94).[94] Their curved surfaces are covered with symbolic imagery relevant to Greek and Phoenician-Punic Sicily. The symbols modelled in relief include busts of Persephone, *kerykeia* (the travelling wand of Hermes used on Sicily as a symbol of public office), telamones, figures of Melqart (the Phoenician god related to Greek Herakles) and grotesque masks. These images can be paralleled in three-dimensional artefacts from ancient sites in Sicily. The telamones on the altar represent the form of actual architectural sculpture emblematic of ancient Sicily, from the colossal figures on the Olympieion at Akragas of the fifth century BC down into the third century BC.

These figural architectural supports evolved over time into ornaments for theatres. The transformation of theatres from a relatively simple design into complex, near semicircular auditoria with stage buildings, was a common progression throughout Greek sites in the Mediterranean during the fourth to first centuries BC. Sicily led the way in terms of theatre design and revived the telamon as a major form of ornament.[95] The largest Hellenistic telamon-style figures were found at ancient Iaitas, a non-Greek settlement that was influenced by Greek culture but also retained its own identity.[96] Greek-style public buildings were erected there along with a theatre, constructed in several phases from the later fourth century BC onwards. By about 300 BC, a new stage building was constructed incorporating a series of alternating maenads and *Sileinoi*, the mythological retinue of Dionysos, the god of theatre. The sculptures acted as engaged semi-columns, carved in high relief over three blocks, corresponding with the stone courses of the building on each side of them. The Sileinoi

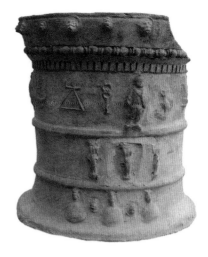

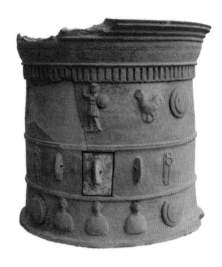

Fig. 93 (opposite)
Terracotta figures of Aphrodite and Eros made at Centuripe. *c.*250–200 BC. Aphrodite H 39.2 cm; Eros H 36 cm.
British Museum, London.

Fig. 94 (above)
Terracotta altars used to burn perfumed oil during religious rites. Found at Solunto, ancient Soloeis. *c.*200–30 BC. H 80 cm.
Solunto Antiquarium.

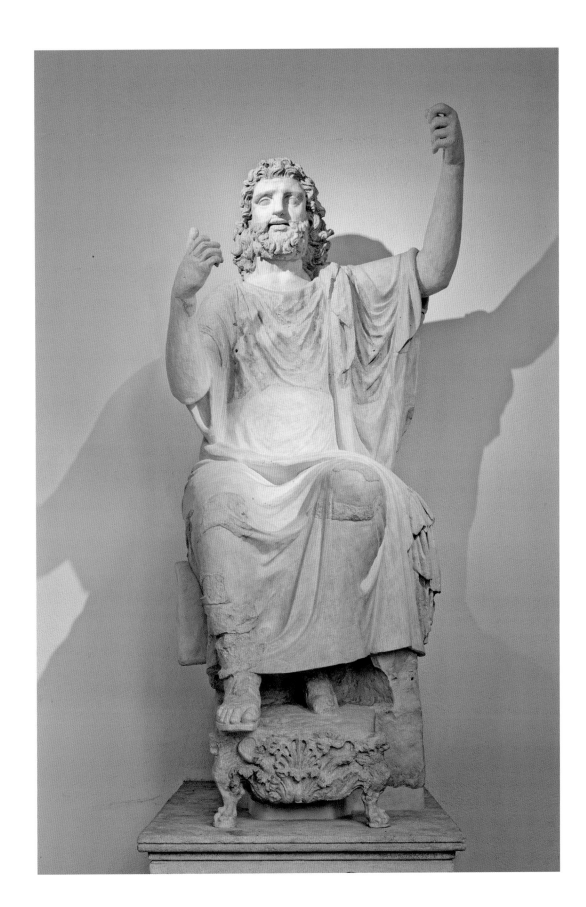

Fig. 95 (opposite)
Funerary vessel
made at Centuripe.
c.200 BC. H 64 cm.
Museo Archeologico Regionale
Paolo Orsi di Siracusa.

Fig. 96 (right)
Limestone, marble and stucco
cult statue of the god Zeus
from ancient Soloeis.
c.150 BC. H 1.65 m.
Museo Archeologico Regionale
Antonio Salinas, Palermo.

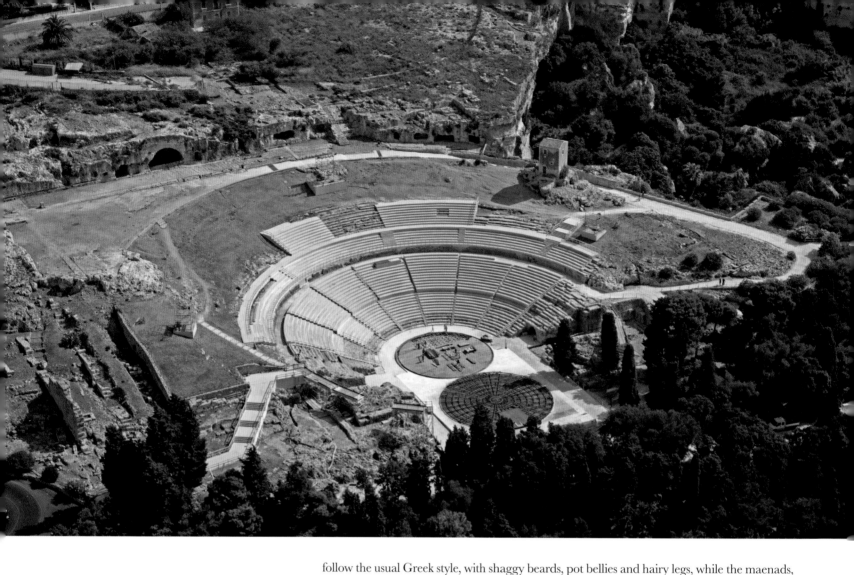

Fig. 97
Theatre at Syracuse, built in
stages between the 5th and
3rd centuries BC. The theatre
is still used for performances
today (the modern removable
seating can be seen here).

follow the usual Greek style, with shaggy beards, pot bellies and hairy legs, while the maenads, altogether more human, wear belted *peploi* (dresses), arranged in an archaizing manner with ivy and berry wreaths and *poloi* (crowns) on their heads. Carved in local limestone then veneered with stucco and painted, the statues follow the general principle of the telamon at the Olympieion at Akragas, but on a much reduced scale. Necks and tense and muscular arms supported the superstructure, the hands of the figures grasping onto the stone cushion behind their necks. Human support figures serving as semi-engaged columns in theatre buildings were probably Sicilian Greek introductions that spread in popularity to other parts of the Greek world. Terracotta examples were found at Centuripe and stone examples have been discovered at the theatre in Syracuse, which was refurbished on a grand scale during the reign of Hieron II.[97] Dedicatory inscriptions of the king, his wife and their son and daughter-in-law are found on the walls of the *cavea*, the theatre's seating sections.[98]

While earlier tyrants had built temples to impress, Hieron II's most conspicuous monument was the immense altar that he erected in honour of Zeus Eleutherios at Neapolis in Syracuse.[99] This monumental altar, no doubt inspired by the great altars being constructed in the Hellenistic East, measured nearly 200 metres in length and could apparently accommodate 450 sacrificial oxen at once. The depredations of time and stone-robbing have reduced the monument to its lower limestone levels, but it might have reached over 11 metres in height when complete. The upper levels of the monument may have also been decorated with a Doric frieze and lions' head water-spouts, fragments of which survive.

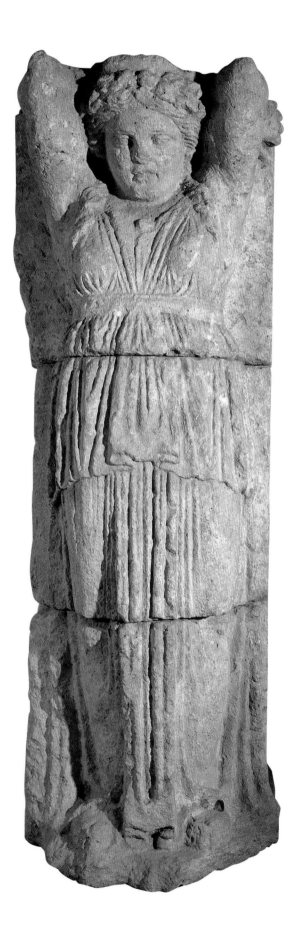

Fig. 98 (left)
Limestone figure of a meanad
from the theatre at Monte Iato.
*c.*300 BC. H 2.0 m.
Parco Archeologico di Monte Iato.

Fig. 99 (above)
Altar of Hieron II at Neapolis,
Syracuse. The feet of a
telamon figure are preserved,
either side of a doorway, on
the right of the picture.

The Roman conquest saw the end of the independent and local systems of government by Greeks on Sicily. During the period of Greek domination each region or city had been governed by an oligarch, tyrant or elected ruler who was most probably born and bred on the island. The states and cities were by no means unified, but they were ruled from home. The eventual Roman annexation meant that governors were put in place and the country administered under a unified system, but from an overseas governing body. Despite this dramatic change in the system of government, Greek and Phoenician-Punic cultural activity continued throughout the early centuries of Roman rule.

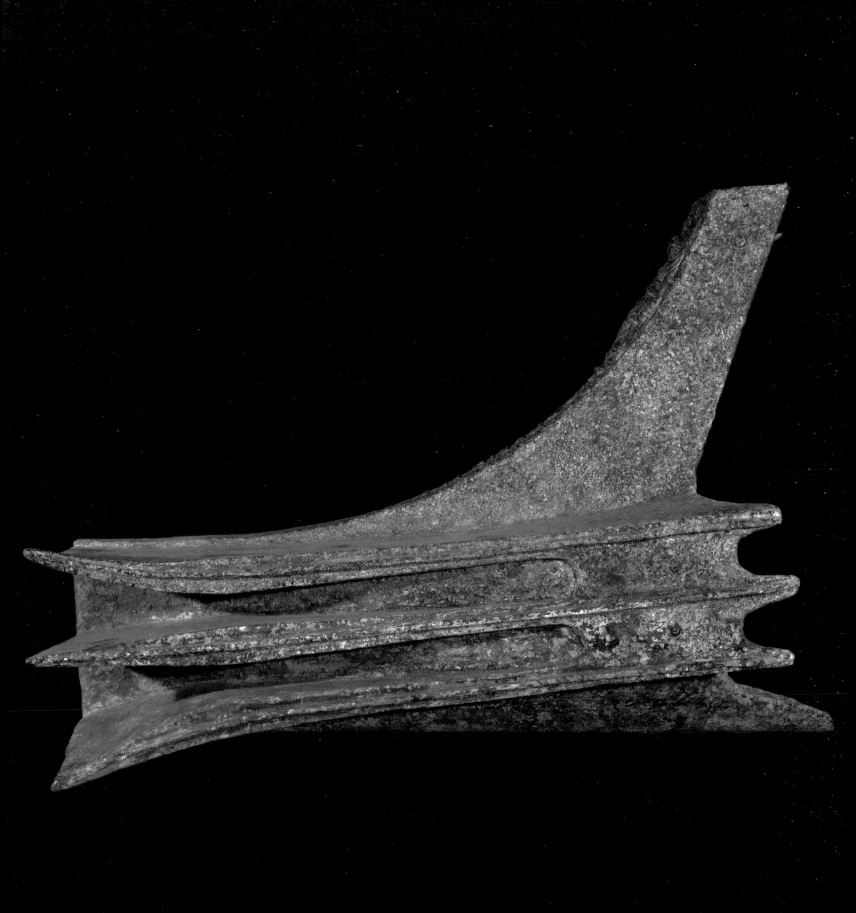

[...] I should say a little of the nobility of that province, of its antiquity, and of its advantages [...] Sicily was the first of all foreign nations to join with the friendship and trust of the Roman people. She was the first to be named a province, which are the jewels of the Empire. She was the first to teach our ancestors what a fine thing it is to rule over foreign peoples.

CICERO, *IN VERREM*, II.2.2

Roman Sicily: The Rebel Island

On 10 March 241 BC the final battle of the First Punic War between Romans and Carthaginians was fought around the Egadi (Aegadian) Islands off the west coast of Sicily. Tensions had been mounting slowly between these two superpowers, who both wanted control over the Mediterranean, and a relatively minor conflict on Sicily was taken as a cause for a Roman invasion in 264 BC. Over the next twenty years several battles took place, mostly at sea, drastically depleting the Roman fleet and treasury. In 243 BC an appeal was made for private wealthy citizens to fund a new fleet, for which the Carthaginians proved unprepared. The Battle of the Egadi Islands saw most of their navy destroyed, after which they had neither the manpower nor the funds to build another one. Rome, the new, and now only, naval superpower in the Mediterranean, offered treaty terms, which included a return of all Roman prisoners of war, a heavy annual tribute, and the withdrawal from Sicily and its smaller islands.

Because they [the Carthaginians] never expected the Romans to dispute the sea with them again, they had [...] neglected their naval force. Therefore, immediately on engaging, they suffered the worst in many parts of the battle and were soon routed, with fifty ships sunk and seventy captured with their crews.

POLYBIOS, *THE HISTORIES*, 61.5–6

Since 2004, ongoing underwater excavations near the island of Levanzo have discovered the remains of several of the ships that took part in this final battle. Most dramatically, the best-surviving parts are the *rostra* (fig. 100), bronze battering rams that were fitted to the front of the warships to drive into enemy ships. Several of them, from both sides of the fight, carry inscriptions either in Latin or Punic, the language of Carthage. The Roman ones mention the magistrates in charge of the works, such as quaestors Lucius Quinctius, Marcus Publicius and Caius Papirius, and also aptly show victory symbols, such as plumed battle helmets and winged personifications of Victory holding a wreath (fig. 101). The most interesting fact is that

Fig. 100 (opposite)
Bronze *rostrum* ('Egadi 4'), excavated from the seabed by the Egadi Islands. 260–242 BC. L 93.5 cm.
Soprintendenza del Mare, Palermo.

Fig. 101
Detail of the *rostrum*, showing Victory holding a wreath, and an inscription naming magistrates in charge of the works.

through these inscriptions some of the Roman ships can be dated earlier than the new fleet of 242 BC, seemingly at odds with the literary sources, which say the Romans built their latest fleet from scratch. However, it was common to reuse ships captured from the enemy, which explains the presence of older ships at this battle. Therefore, it is most likely that the Roman vessels that are being excavated are those that were seized and reused by the Carthaginians, who later of course suffered the heaviest losses.[1]

After a brief initial alliance with the Carthaginians, the city of Syracuse and its king Hieron II had become loyal to Rome. In return, the city and its territory were treated differently by the Romans from the rest of Sicily and given the status of ally, which allowed a certain independence when the island became the first official province of the expanding Roman Empire. However, less than thirty years later, Hieron II's grandson, Hieronymus, opposed Rome and in a bid to gain complete autonomy sided with the newly warring Carthaginians during the Second Punic War. The subsequent Roman siege of the city lasted almost three years, from 213 to 211 BC, during which Syracuse was defended by the ingenious inventions of Archimedes: only when he was killed was the city finally taken by the Roman general Marcellus. Syracuse lost its autonomous status, the whole island now belonging to Rome.

Rome's Granary

Sicily was called the Republic's granary, the wet nurse of the Roman people.
CICERO, *IN VERREM*, II.2.5, QUOTING CATO THE ELDER

For grain, honey, saffron and some other things one could claim it is superior [. . .] In fact, it is called the storehouse of Rome, because except for a few things, everything it produces is brought here. . . STRABO, VI.2.7

It is no accident that one description of the island dominates Roman literary sources for centuries, even into the Byzantine period: that of Sicily as 'nurse of the Roman people', 'granary', or 'breadbasket'.[2] During the 700 years of Roman rule, the island presented only two interests for the conquerors: as a strategically positioned military base for war and further conquest, and as a supplier of grain for the capital and its armies.

As would become standard for all subsequent parts of the Greek world that had been absorbed by Rome, the conquerors did not actively try to change local customs, culture or government. As long as Sicily paid its taxes, mainly in tithes of grain, Rome took a back seat, but still installed an official presence on the island in the form of a governor, and two magistrates for financial administration (including the receipt of taxes) in the form of quaestors. These were based on opposite sides of the island – one in Syracuse and the other in Lilybaeum (modern Marsala). The Romans' lax attitude towards daily life on Sicily meant that Greek culture and local administration continued, and Greek remained the dominant spoken language throughout the entire Roman period.[3] In addition, predominantly on the western side of the island, there was still a large Punic element in the population, with its own distinct culture, religion and language. Although this Punic Sicilian culture diminished and eventually disappeared, traces of it survived until at least the second century AD, when Apuleius, the North African Roman playwright, made reference to the 'three-tongued Sicilians' (*Siculi trilingues*).[4] There is no doubt that Apuleius had in mind Latin, Greek and Punic, the three languages that he, as a North African Berber, spoke himself. Material evidence for this hybrid culture, with its constant interplay of symbols and languages, is visible, for example, in the *aediculae* (tombs) from western Sicily (fig. 102). On these, the deceased is shown at a Greek-style funerary banquet, with a Greek name written in Greek, yet with Punic religious symbols, most

Fig. 102
A tufa stuccoed and painted tomb *aedicula* from Marsala, showing the deceased at a funerary banquet, his Greek name and Punic religious symbols. 200 BC–0.
Museo Archeologico Regionale Lilibeo Baglio Anselmi, Marsala.

distinctively the *caduceus* (*kerukeion*) and the symbol for Tanit, chief goddess of the Phoenicians. Consequences of a multilingual and multicultural society are apparent, in a more subtle way, in a bilingual shop sign (fig. 103) found in Palermo. The inscription, dated to some point between 100 BC and AD 50, advertised inscription-carving in both Greek and Latin. Yet, some of the Latin spelling is archaic (such as *heic* for *hic*, *aidibus sacreis* for *aedibus sacris*, and *qum* for *cum*) and both languages contain grammatical errors. This has prompted the belief that although the composer of the text spoke and understood Greek and Latin, neither was his native language. Instead, it may be that he was Punic-speaking and the mistakes in grammar (such as the preposition and case not matching, or a preposition used as a conjunction) can be explained through influences from Punic, a language devoid of inflection.[5] Such a hypothesis is all the more believable since the shop was in Palermo, originally the Phoenician city Ziz.

In Sicily, however, the troubles got worse. . .
DIODORUS SICULUS, *HISTORIES*, BOOKS 34/35.2.20

The lack of interest and *laissez-faire* attitude[6] towards the province by the new rulers paved the way for local exploitation, and fuelled personal ambitions. During the first centuries of Roman rule a new type of enormous agricultural estate sprang up, called the *latifundium*, where mostly wheat, grapes and olives were cultivated by large numbers of slaves. Although members of the wealthy Sicilian elite owned some of these estates themselves, the fertility of the island and the associated richness of course also attracted the attention of Roman entrepreneurs, often in the shape of absentee senators or consuls who left the running of the estates to others. In those centuries, cheap slave labour was supported through the wars Rome

Fig. 103
Marble slab with an inscription in Greek and Latin advertising inscription-carving. From Palermo. 100 BC–AD 50. W 24.5 cm.
Museo Archeologico Regionale Antonio Salinas, Palermo.

Fig. 104
Silver *denarius* of Manius
Aquillius, minted in Rome
in 71 BC: Manius Aquilius
was the Roman consul who
quelled the second Servile
War (slave revolt) in 101 BC,
for which he received honours
in Rome. When his grandson
Manius was moneyer in
71 BC, the starting post of
Roman officials, he used
his illustrious ancestry as
propaganda on his coins. The
coin shows a soldier subduing
a female representation of the
island of Sicily, as indicated by
the inscription SICIL.
British Museum, London.

Fig. 105
Silver *denarius* of Sextus
Pompey, minted on Sicily
in 42–40 BC, showing the
lighthouse at Messina and
the sea monster Skylla.
British Museum, London.

waged in Italy itself (Third Samnite War), the Punic Wars with Carthage, and wars in the east (such as the sack of Epirus in 167 BC), as well as slaves from Sicily itself.[7] As Pliny the Elder reports, this remained the norm for these estates throughout the Republic and early Empire.[8] The living and working conditions of these slaves were appalling. They were branded and chained together, while being over-worked, ill-fed and repeatedly beaten.[9] It is therefore no coincidence that the only events that took place on Sicily before 70 BC that historiographers found worthy of recording were two major slave revolts. Twice, during 135–132 BC and 104–100 BC, disgruntled slaves managed to rally tens of thousands of others to try and take over parts of the island and claim independence from Rome. Laying waste to cities, countryside and of course the *latifundia*, these episodes were disastrous for Sicily's economy and Rome's grain supply. However, both rebellions were violently quashed by Rome (fig. 104) and the fertile soil meant that the island recovered quickly each time. For the Romans, who were heavily dependent on slave labour in almost every aspect of life, these revolts were eye-openers, alerting them not only to the actual numbers of slaves (which far outweighed Roman citizens) but, to some, also to the awful conditions in which these slaves lived. It is possible to detect hints of compassion for the slaves in later writings,[10] an indication of how gruesomely some of them must have been treated, not dissimilar to slavery on the large plantations of eighteenth- and nineteenth-century North America.

Regardless of the slave revolts, instances of exploitation continued, Roman governors frequently taking advantage of farmers and landowners. None was as bad or exploitative as Gaius Verres (see p. 137), who was put on trial in Rome for misgovernment when in office from 73 to 70 BC.

In addition to magistrates and governors, on several occasions military commanders used Sicily's agricultural significance and its relative isolation to advance their own ambitions, often in order to establish kingdoms independent from Rome. In the early 40s BC the Roman Republic was in great turmoil due to the civil wars between Caesar and the Senate. In 44 BC Caesar was murdered and his adopted son Octavian (the later Emperor Augustus), with Mark Antony and Lepidus, created a triumvirate to take control of the situation. Sextus Pompey, son of Pompey the Great, the former champion of the Senate, sensing the danger he was in, succeeded in occupying Sicily with an army and fleet composed of soldiers loyal to his late father, adventurers, pirates and, of course, angry runaway slaves. Once again, the island became a battleground, both on land and on sea. Sextus managed to bring Octavian to his knees after defeating him twice in naval battles off the Sicilian coast and blocked the export of grain to Rome until it recognized him as ruler. Octavian begrudgingly agreed. As ruler of Sicily, Sextus minted his own coins that incorporated Sicilian symbols such as the lighthouse at Messina, his protective deity Poseidon, and the sea monster Skylla, based on one side of the Strait of Messina (fig. 105) Sextus was finally defeated and killed without trial in 35 BC. A similar turn of events repeated itself under the emperor Nero, when in AD 68 the provincial governor in Carthage, Lucius Clodius Macer, seized Sicily and blocked the export of grain to Rome. His intent was to succeed Nero as emperor: his coins included the phrase *S(enatus) C(onsultum)* (by order of the Senate), implying that his revolt was against only the emperor, not the Senate. The coins also show the Sicilian *triskeles* with sheaves of wheat (fig. 107) highlighting the position of power that came with control of the grain supply.[11]

Once again, and characteristic of the island's history in general, the Sicilian cities did not form a united front: some sided with Sextus, while others continued to support Octavian. Octavian came down hard on the rebelling Sicilians: payment of indemnities was high, 6,000 rebellious slaves whose owners could not be found were impaled, and whole city populations were deported. Octavian's punishment of several cities left large parts of Sicily unpopulated

THE TRIAL OF THE CENTURY

Gaius Verres was a Roman magistrate who in 73 BC secured the governorship of Sicily. Once there, he shamelessly abused his power to enrich himself in any way that he could, applying extortionate taxes, cancelling contracts unless bribes were paid, selling condemned prisoners as slaves, or making unfounded accusations of rebellion against slaves and even their owners – understandably a touchy topic after two slave revolts, and during the uprising of the slave Spartacus in Italy – all against Sicilians and Romans alike. In addition, he ordered the robbing of Greek works of art from private houses and temples, which he put on display in his own residence or sent to Rome. In one famous story, Verres' soldiers were raiding one of Agrigento's temples of its cult statue in the middle of the night, when the townspeople banded together and drove them off.

Upon Verres' return to Rome in 70 BC, the Sicilian people hired Marcus Tullius Cicero, a young up-and-coming orator whom they knew as honourable and trustworthy from his time as quaestor in Lilybaeum (Marsala) in 75 BC. While in office, Cicero even claimed to have rediscovered the tomb of Archimedes, long since forgotten by the Syracusans themselves, even though Archimedes had died only 137 years previously.[12] Cicero immediately left for Sicily to collect evidence and testimonies about Verres' administration and succeeded in bringing him to trial. He originally planned to deliver two speeches at the trial, on two different days. The first one, however, caused such a commotion that Verres' own lawyer, the famous Quintus Hortensius, advised his client to flee the city immediately. Cicero's career was secured, and he became one of Rome's most famous politicians and orators. In later life he would often describe his longing for Sicily, his 'second home', in his writings.[13]

While this man was praetor, the Sicilians enjoyed neither their own laws, nor the decrees of our senate, nor any common rights. Everyone in Sicily only retains that which either escaped the notice or survived the satiation of that most avaricious and licentious man. [. . .] This same man while praetor plundered and stripped those most ancient monuments, some of which were built by wealthy kings and intended by them as embellishment for their cities; some were moreover the work of our own generals, which they either gave or restored as conquerors to the different cities in Sicily. And not only did he do this to public statues and decorations, but he also plundered all the temples consecrated to the most sacred religions of the people. In short, he left not one god to the Sicilians ...

CICERO, *IN VERREM (AGAINST VERRES)*, I.4–5

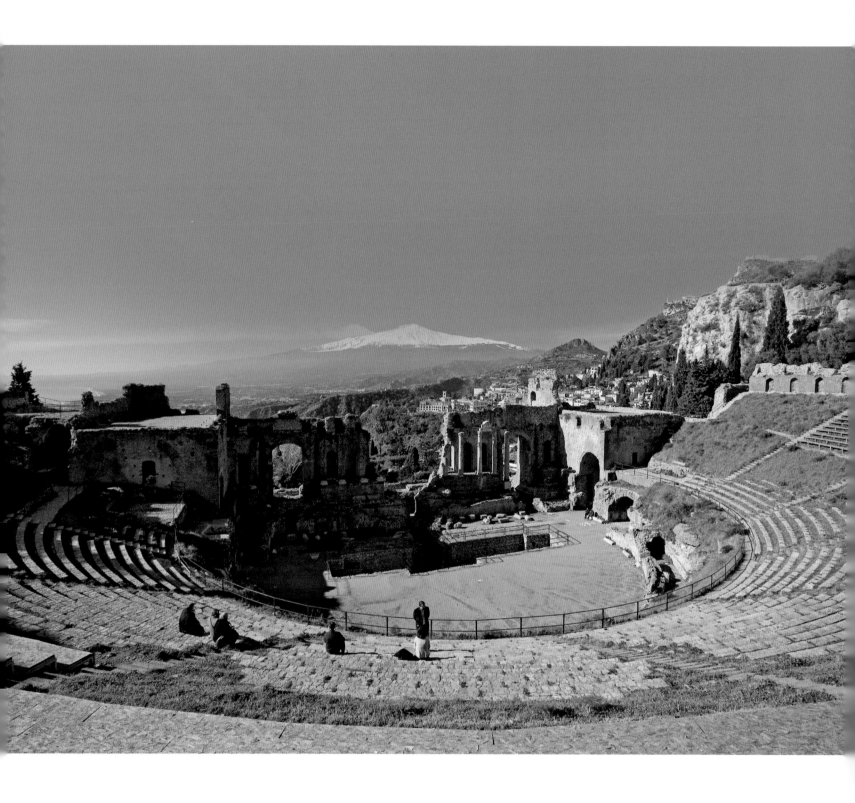

so the State imported new settlers in the shape of thousands of loyal, discharged Italian veterans, who brought with them Roman customs and the Latin language.[14] This was a turning point, after which Sicily was to know a prolonged period of tranquillity under the Pax Romana (Roman Peace). Six major cities – Taormina, Catania, Syracuse, Tyndaris (Tindari), Thermae (Termini Imerese) and Palermo – received the status of colonia, indicating that they probably took the bulk of the veterans.[15] Not surprisingly, these are the cities where the most impressive Roman buildings still stand: for example, the monumental baths at Thermae, the theatre at Taormina (fig. 106) or the theatre at Catania. With the new peace and new settlers, agriculture prospered again and profits were high. Furthermore, with the conquest of Egypt and its subsequent role as most important grain supplier, the pressure on Sicily slightly diminished, opening up new avenues for trade, although wheat and grain still remained the prime produce and main interest for Rome.[16] This is one of the underlying messages of a marble head, found on Sicily, depicting the empress Livia, wife of Augustus, as Ceres, the Roman incarnation of the Greek goddess Demeter (fig. 109). Here she sports a floral wreath on her head, while other similar depictions of her often show her holding the cornucopia (horn of plenty). The cult of the empress as Ceres, a mother whose fertility benefited the whole Empire, became widespread, but was of course all the more significant on Sicily, where Demeter had been worshipped since time immemorial; now Rome, in the guise of its rulers, was responsible for Sicily's prosperity, not just grain, but all produce.[17] This included wine, for which the island had an impressive reputation, its 'sweet, light, and rigorous' Mamertine wine (vinum Mamertinum) from the north-east being considered 'the rival of the best Italian wines', Julius Caesar's personal favourite and widely exported.[18] In addition, vessels that held vinum Mesopotamium, from the area of Kamarina, have been found in Pompeii, Carthage, and as far away as Switzerland.[19]

Fig. 106 (opposite)
The Roman theatre at Taormina, 2nd century AD, is the best-preserved Roman building on Sicily, and one of the best-preserved Roman theatres in the world. With Etna rising majestically in the background, Goethe, who visited in 1787, wrote: 'Never did any audience, in any theatre, have such a spectacle!'

Fig. 107 (above)
Silver *denarius* of Clodius Macer, minted in Carthage in AD 68, showing *triskeles* with ears of wheat, and legend SICILIA.
British Museum, London.

Fig. 108 (left)
Fragment of a sardonyx cameo depicting the empress Livia as the goddess Ceres, seated in a cornucopia. AD 40–50. H 3.1 cm.
British Museum, London.

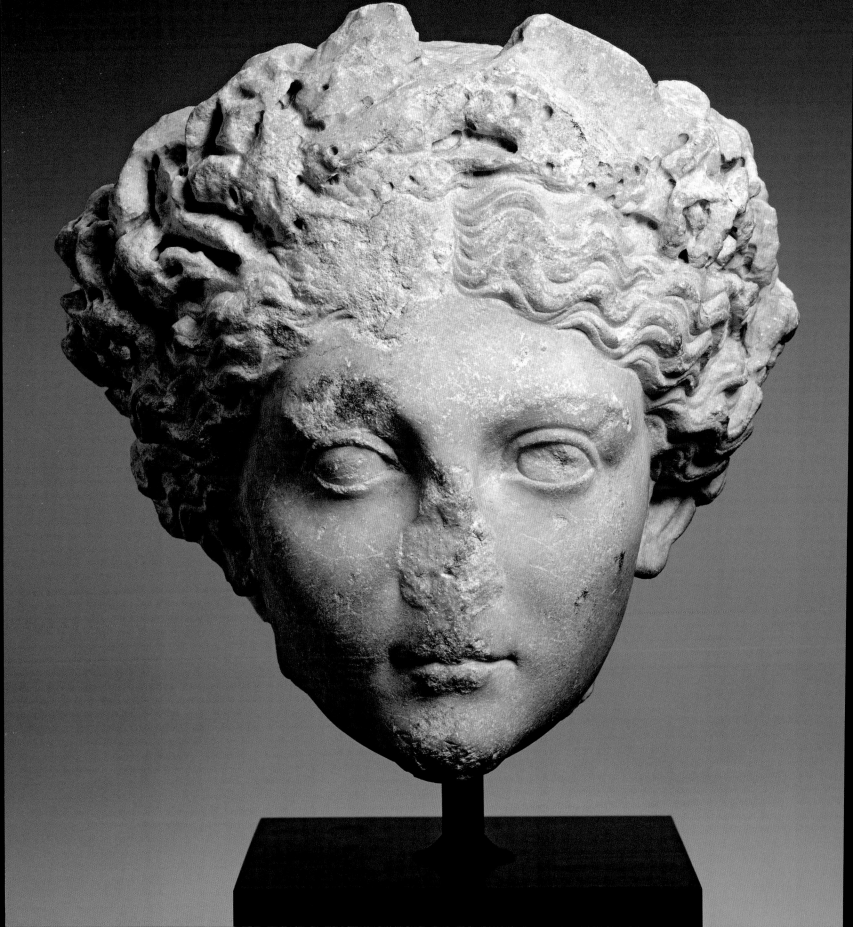

Imperial Prosperity

During his journey through Sicily, after he [Caligula] made fun of the miracles in various places, he suddenly fled from Messina by night, scared by the smoke and the roaring from Etna's crater.
SUETONIUS, *CALIGULA*, 51.1

He [Hadrian] sailed to Sicily, where he climbed Mount Etna to see the sunrise, which they say is many-coloured, like a rainbow.
HISTORIA AUGUSTA, *VITA HADRIANI*, 13.3

Under its newly found peace and regained prosperity, Sicily now became a place to enjoy. This stability meant that there was less compulsion to write about the island, and thus Sicily barely features in contemporary writings. Etna and Syracuse – Cicero's 'fairest of all cities',[20] even though robbed of much artwork by Marcellus, the 'hero' of 211 BC, and Verres – were visited as tourist attractions, and the city's beauty was of such renown that emperors took great care to maintain it.[21] Augustus even named an isolated part of his palace in Rome 'Syracuse', a place to which he withdrew when he wanted to be alone, in analogy, without doubt, to the peninsula of Ortygia, Syracuse's 'Old Town'.[22] Hadrian visited Sicily on his official travels at some point between AD 125 and 127, an event commemorated in two coin issues, both of which show the province represented by a female, clearly identifiable through the *triskeles* on her head (fig. 110).[23] The *triskeles* symbol became much more widespread in Roman times, appearing on coins, pottery, mosaics and so on, used always in order to identify the island (fig. 111).

Another important site was Eryx (Erice), an originally Elymian hilltop bulwark in the west of the island. Like the Romans, the Elymians were considered descendants of the Trojans, the

Fig. 109 (opposite)
Marble head of the empress Livia as the goddess Ceres. Said to be from Sicily, AD 30–50. H 31 cm.
British Museum, London.

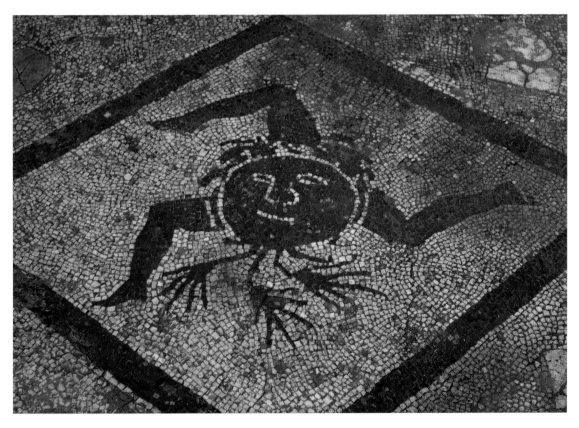

Fig. 110 (above)
Brass *sestertius*, minted in Rome in AD 134–8, showing the emperor Hadrian symbolically raising Sicily from her knees. Sicily is represented as a woman with a *triskeles* of three legs protruding from her head.
British Museum, London.

Fig. 111
Mosaic from a bath-house in Tyndaris, *c.* AD 200, showing *triskeles* with three ears of wheat.

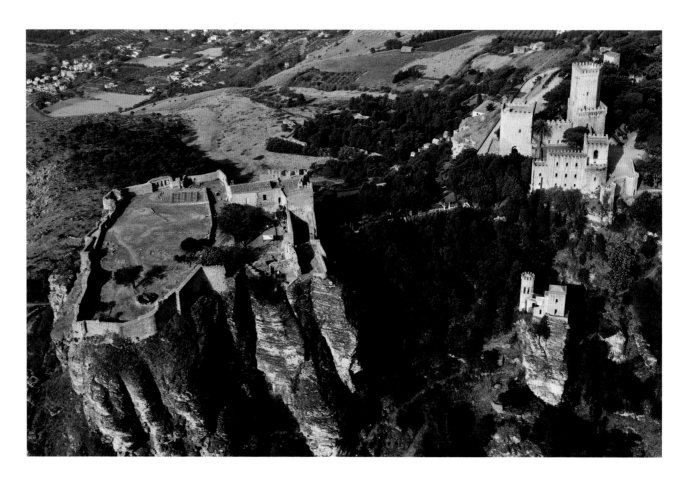

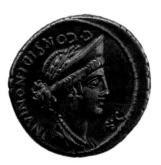

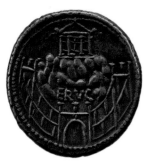

legendary king Eryx was said to have fought with Hercules, and Aeneas, legendary founder of the Roman people, visited (or founded, in some versions of the story) the temple there.[24] The Roman fascination with this temple to Venus Erycina only increased during their rule, and the cult spread throughout the Empire. The original temple must have been a site for pilgrimage, its popularity undoubtedly enhanced by its practice of temple prostitution, a Phoenician custom linked to Astarte, the 'Phoenician Venus' (figs 112 and 113).[25]

Latifundia remained characteristic of the economic landscape until Late Antiquity, when the diversion of the grain from Egypt to the Empire's new capital Constantinople had Italy looking once again to Sicily as supplier. From the early Empire onwards, they were no longer worked by slaves but by free tenant farmers (*coloni*), whose conditions were nevertheless only marginally better than those of slaves, as they were badly paid, extorted, and had to pay rent and taxes. Gradually, they became serfs, tied to the land they worked. The profits of these estates went to the tenants-in-chief and the landowners, still the senators or other elites from Rome. At the same time, their estates on Sicily became favourite country retreats for seasonal escapes from the capital, a custom already mentioned by Cicero, who wrote that 'one takes the greatest delight in estates close by, so the suburban character of this province [Sicily] is a joy to the people of Rome'.[26] It is no accident that, contrary to other provinces, senators were able to visit Sicily without specifically asking permission of the emperor, exactly because many of them owned estates there.[27]

The residential villas tied to the agricultural estates are some of the most expensively and lavishly decorated in the entire Empire. Today the most famous and best preserved is the Villa del Casale near Piazza Armerina, with around 3,500 square metres of surviving mosaic floor

decoration spread over 45 rooms, and dating to the fourth century AD (fig. 114). Extremely luxurious and long thought to be unique and to belong to the imperial family, in recent decades many more of these senatorial villas – such as the Villa del Tellaro near Noto and the villa near Patti, all dating from the same period – have been discovered. The topics of the Villa del Casale's mosaics range from scenes of nature to those of aristocratic daily life, such as forest hunting scenes and chariot races in the Circus Maximus in Rome. The grandest and most impressive of the mosaics is the so-called Great Hunt Mosaic, a 60-metre-long depiction of a hunt for exotic animals, extending geographically from west to east. It includes panthers in Mauretania (modern Morocco) and lions in Africa Proconsularis (modern Tunisia), rhinoceros in Egypt, and elephants and tigers in India. At the centre of the composition the animals are depicted being unloaded at one of Rome's harbours. It is more than likely that the mosaic represents one particular hunt, sponsored by the unknown owner of this lavish villa. The funding of spectacular, staged hunts (*venationes*) in Rome became the duty of high officials, such as city prefects and senators, who often had to save for years to pay for them. These were the highlights of their careers, events worthy of recording and remembering. Therefore, in this case we must be looking at the country estate of a member of the senatorial class, someone from the emperor's sphere, but not necessarily the emperor himself. Furthermore, it is tempting to link some of the daily-life scenes, such as the chariot race or a mosaic of an athletic competition between nine girls in bikinis (and one female judge), such events also being

Fig. 112 (opposite above)
The site of the original temple of Venus at Eryx was later incorporated in a Norman castle, its bulwark making it an easily defendable place.

Fig. 113 (opposite below)
Silver *denarius*, minted in Rome in 57 BC, showing a bust of Venus, possibly modelled on the cult statue at Eryx, and the temple on a rock or mountain with legend ERVC.
British Museum, London.

Fig. 114
Aerial view of the 4th-century Villa del Casale at Piazza Armerina, one of the best-preserved Roman villa complexes on Sicily, with c.3,500 square metres of preserved mosaic floors.

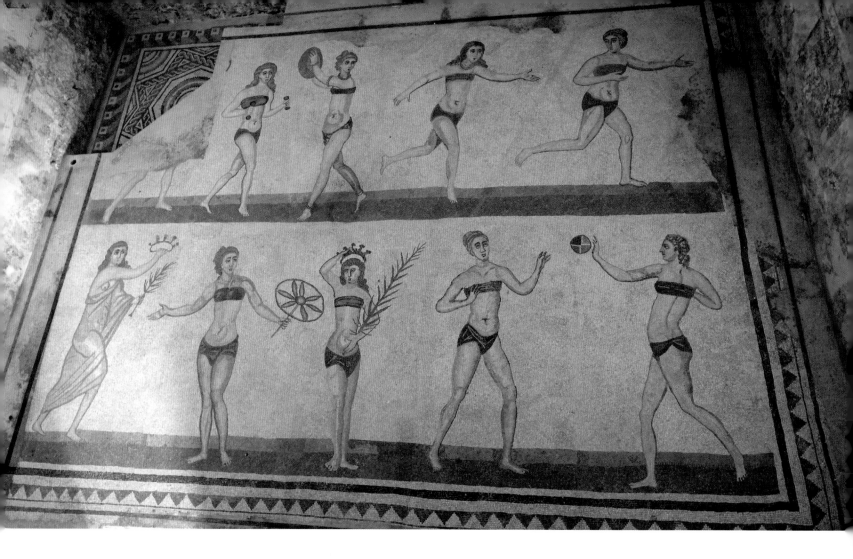

Fig. 115
One of the mosaics
in the Villa del Casale shows
an athletic competition
between girls in bikinis.

known from literary sources, to particular events in the lives of the master and mistress of the villa (fig. 115).[28] Other mosaics show mythological scenes, such as the Labours of Hercules and Odysseus offering the wineskin to the Cyclops Polyphemos (fig. 4). One cannot help but wonder whether these scenes were deliberately chosen for their connections to the island: Polyphemos was said to have lived on Sicily, and Hercules' Labour with the Cattle of Geryon took place on the island. Those mythological connotations were well known to the Roman elite, for whom these classic stories were part of their education, and one of the aristocracy's favourite pastimes was debating mythology over dinner.[29] Discussing mythological stories while looking at depictions of them, in the places they were supposed to have taken place, must have been considered by peers as being quite an impressive achievement for a wealthy Roman.

Detailed studies of the mosaics have revealed that they were laid by mosaicists from North Africa, where in the fourth century large and influential workshops were based, and the styles are those that we find elsewhere in the Empire.[30] This exemplifies the underlying feeling one has when looking at Roman Sicily: namely, the artistic poverty of the island throughout 700 years of Roman rule. Hellenistic times saw local innovations and originality in arts, crafts and science, but as the great scholar of Roman history Moses Finley wrote, 'Roman Sicily developed no identifiable culture of its own.'[31] Statues were copies of original Greek ones, and mosaics were laid by foreign craftsmen; in short, Roman material culture on Sicily was generic, no different from what could be found on the Italian mainland or in North Africa.

The End of Rome

Towards the final decades of the Roman Empire, when its capital had moved to Constantinople and Sicily was left vulnerable, the island's wealth and position once again attracted the attention of foreign peoples, rivals to Roman rule. Over the next 600 years, the island would be fought over by Vandals, Goths, Byzantines and Arabs, passing hands back and forth, with at times different parts of the island under the control of different peoples.

The Vandals, a Germanic tribe that had conquered North Africa in AD 429, repeatedly raided and invaded Sicily, but did not successfully take complete control until AD 468, only to leave the island, in exchange for annual payment, first to the usurper King of Italy Odoacer (r. AD 476–93) and later to Theoderic and the Ostrogoths, another Germanic tribe, which in AD 493 took Rome and most of Italy.[32] None of these peoples left any lasting imprint on the culture or societies of the island, or anywhere else they ruled, a sign of the strength of the continuing Roman legacy.

In AD 535, however, the island became the first territory of Italy that the famed general Belisarius of the now strongly established Byzantine Empire reconquered from the Goths. After the initial division of the Roman Empire in AD 395, officially Sicily had been made part of the Western Roman Empire, though the legacies of many centuries of Greek culture and language meant that it had much more in common with the Eastern Empire commonly called Byzantine, based in the eastern Greek provinces. This and its strategic location were the main reasons why the Byzantines were to invest so much effort in reconquering it over the next 500 years. The Byzantine emperor Justinian (r. AD 527–65) pursued the dream of reuniting the Roman Empire; for this, the reconquest of Italy and Sicily from the Goths was essential. In the end, Byzantium never managed to completely retake the entire peninsula of Italy, which after the Goths was conquered by the Lombards, yet another Germanic tribe. However, Sicily and southern Italy did become theirs, and acted as perfect military bases during their endless attempts to reconquer the rest of Italy. In the 660s the Lombard threat from the north was at another peak and a new menace had emerged in the south in the Islamic conquerors of North Africa. So the emperor Constans II decided, in a desperate bid, to move the Byzantine capital and court from Constantinople to Syracuse, shifting the centre of the empire to the west. It was an isolated moment of genuine imperial attention to the province, rather than as a military base or grain-provider. However, the prestige accorded to Syracuse was short-lived. On the one hand, the court was increasingly unhappy with Constans, not just because of the move, but also due to his religious views, in particular his indifference to Monothelitism. On the other, a small provincial city like Syracuse, although capital of a province, was financially and mentally unable to deal with housing an imperial court. To the large acclaim of populace, clergy, court and army alike, in AD 668 Constans II was assassinated with a soap dish in the Baths of Daphne in Syracuse (which tour guides pointing at meagre remains of a private bathroom will tell you still survive; they do not). Constantinople regained its status of capital.

For the average Sicilian these conquests and politics probably meant little to nothing. Compared to previous wars over the island, the fighting was not very destructive or disruptive. There is barely any evidence for an economic impact: rather, especially after the Vandals took North Africa, an economic boom is visible, as Italy was relying once again on Sicily as its primary source for grain and produce.[33] Before the Byzantines, the Ostrogoth king Theoderic had aimed at restoring the glory of the Roman Empire, including its culture and forms of government, and so a Latin governor of the province of Sicily is recorded for as late as AD 526.[34] From the 530s the Byzantines sought to restore the same glorious empire. They fortified harbours and coastal cities to promote intense trade with other parts of the reconquered

empire, and this bolstered the wealth of the island. Later Arab accounts report that around AD 750 'the Rūm made Sicily secure, reconstructed it everywhere, and rebuilt the castles and they did not even leave a mountain without a fort on top.'[35] The minting of gold and bronze coinage, signs of wealth and prosperity, was reintroduced in Catania and Syracuse.[36]

By the time the Vandals and the Goths were occupiers, Sicily had already been thoroughly Christianized, although some rural areas still adhered to pagan Roman religion until the end of the sixth century.[37] Under subsequent Byzantine rule, the island drifted into a Greek-Eastern sphere of influence, also in its religion, and by the seventh century the Church of the island was Eastern in every respect. A Byzantine system of government operated through a Byzantine governor placed on the island, and also the economy was intrinsically linked to that of the Byzantine world. Sicily traded heavily with North Africa, but when that region was captured by the Arabs in AD 642 imports of goods and ceramics sharply declined and by the early ninth century had stopped altogether. Sicily continued to trade, however, with the rest of the Mediterranean, and we find evidence of imports of ceramics from Constantinople as well as Rome and Central Italy.[38] As had happened in the Roman imperial period, Sicily quite happily took on the artistic influence and culture of their faraway rulers, so that what we find on Sicily in this period can generally be labelled as Byzantine, rather than displaying any distinctive Sicilian aspect. The wealth that accompanied the stabilization of agricultural production and trade is visible to us through the Byzantine jewellery found on the island. High-quality imports indicate that fashions from the court in Constantinople were popular with the island's wealthy elite. One hoard of fifteen pieces of jewellery and hundreds of coins was found in 1903 in a bronze chalice buried under a stone slab in the ruins of a house in Pantalica, near Syracuse. Most of the coins, though catalogued, quickly and mysteriously disappeared, while the rest of the hoard was sold on the antiquities market. Several pieces eventually found their way to different museums, including a gold bracelet now at the Metropolitan Museum of Art, New York (fig. 117). This elegant piece is made in what is called *opus interrasile*, a technique by which a pattern was created by punching out the background with differently shaped holes, which was in vogue between the third and seventh centuries AD. Although local workshops must have been active on Sicily, the high quality of the work suggests that it was imported

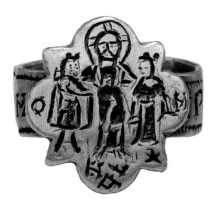

Fig. 116
Byzantine gold wedding ring, showing Christ blessing and uniting bride and groom. Originally with niello inlay, now lost. AD 500–700. H c.2 cm.
British Museum, London.

Fig. 117
Byzantine gold bracelet in *opus interrasile*, from a hoard found in Pantalica. c. AD 650. Diam. 5 cm.
Metropolitan Museum of Art, New York.

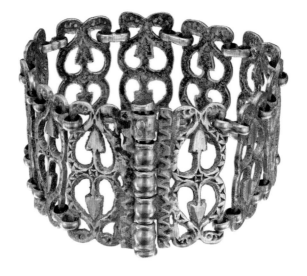

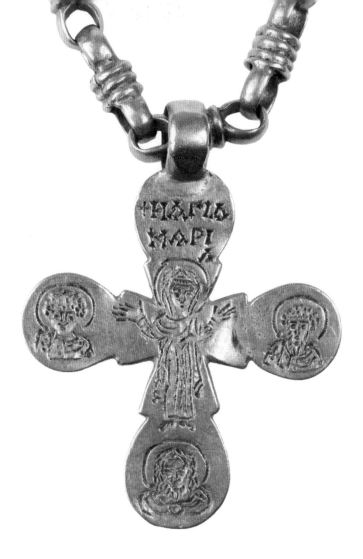

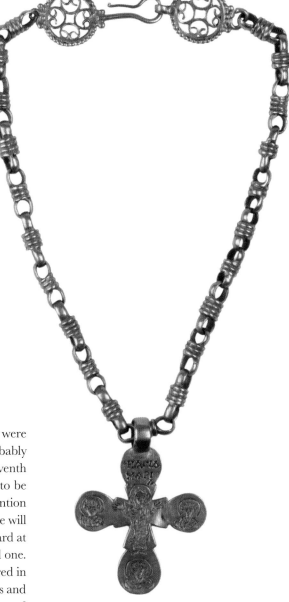

from a metropolis such as Constantinople or Alexandria in Egypt.[39] The coins that were found with the jewellery were dated to AD 641–85, indicating that the bracelet was probably made in the sixth or seventh century and that the hoard was buried in the very late seventh or early eighth century. An Arab raid on Syracuse is recorded for AD 668, too early to be a cause for the hiding of this particular hoard, but contemporary literary sources mention how on that occasion the people of Syracuse fled into the mountains.[40] Arab raids, as we will see later, were frequent, and it is not unimaginable that the burial of this particular hoard at Pantalica, located in the mountains near Syracuse, was the result of an undocumented one. On the other side of the island, at Campobello di Mazara, another hoard was discovered in 1878, this one comprising a pair of gold earrings, a gold purse, a diadem, three necklaces and 150 gold coins, dating to between AD 695 and 775. In this case, Antonio Salinas, director of the Archaeological Museum in Palermo, managed to secure several of the items, including a gold necklace made of twenty-one cylindrical pieces, ending in two circles with fine filigree volute decoration and a heavy gold pendant depicting the Virgin praying and three haloed saints (fig. 118). Once again, the quality of the necklace, as well as comparison to other known pieces, identifies it as a likely import from the capital.[41] Mazara is the closest point on Sicily to the North African coast and several Arab raids there are recorded for the eighth century, making it likely that the hoard was buried to hide it from the invaders. Mazara was also the landing point from which the eventual Arab conquest of the island would begin.

Fig. 118
Byzantine gold necklace, found in a hoard at Campobello di Mazara.
AD 600–800. L 31.2 cm.
Museo Archeologico Regionale Antonio Salinas, Palermo.

Arab Sicily: The Profitable Island

Sicily is an island, extensive and important. The Muslims have no island more splendid, more prosperous or with more cities.

[...]

Sicily, the profitable island, of which the inhabitants are continually engaged in jihad. Wealth here is on a solid base, and cities comparable to Basra are many. The people seek what is good; the ruler is just, wise, and well respected. This region adjoins the sea, the very best of neighbours! The inhabitants are gracious towards everyone who traverses the region.

AL-MUQADDASI, GEOGRAPHER FROM PALESTINE, 10TH CENTURY, *AHSAN AL-TAQASIM FI MARIFAT AL-AQALIM*[42]

Arab Conquest

Muslim Arabs had started taking control of North Africa (Egypt and the Maghreb) from the Byzantines and indigenous Berbers since AD 642 (the capitulation of Alexandria), and by AD 709 had a clear hold on the territory from Egypt to Tangier. One of the three established provinces was Ifriqiya, largely the area of modern-day Tunisia, with Qayrawan (Kairouan) as its capital. From here, after 150 years of hit-and-run raids as well as intermittent peace treaties with Sicily, events in the early ninth century, mainly connected with internal unrest rather than a conscious drive for expansion,[43] led to invasion and eventually conquest of the entire island by the Arab leaders.

In a pattern recognizable from previous centuries, the isolated island, once colonized by a greater empire, was ruled by men who grew too confident and powerful. In some cases they believed they could rebel, secede and become autonomous. This had previously been the case with Hieronymus, client king of Syracuse for Rome; the Roman governor Verres; Sextus Pompey, usurper under Augustus; and was repeated in AD 826/7. A popular medieval story gives a romantic 'disagreement' as the catalyst for the upheaval: the powerful Byzantine naval commander Euphemius, a Sicilian, had abducted and married a nun against her will and in clear violation of the law. When the Byzantine emperor ordered his arrest, Euphemius organized a revolt against imperial command on the island. Other sources claim that when the emperor dispatched emissaries to Sicily on a diplomatic mission, probably to demand more taxes after a series of military defeats in the East, this sparked a new rebellion (the island had rebelled against Byzantine taxes previously).[44] Whatever the cause, Euphemius took it on himself to conquer the entire island and was even proclaimed 'Emperor' in Syracuse. However, certain district governors of Sicily remained loyal to Constantinople and marched against him. Clearly needing help, Euphemius turned to the Aghlabids, the ruling dynasty in Ifriqiya.

Reluctant at first, especially since a peace treaty with the Byzantines was in place, Ziyadat Allah I, third Aghlabid emir of Ifriqiya, put the question to his council. Although most of his advisers warned against it, Asad ibn al-Furat, the most prestigious jurist and theologian of the time, proposed taking advantage of the opportunity, and soon preparations were made for the *jund* (army) to invade Siqiliya (Sicily), with Asad himself as commander. This was the start of the very slow Arab conquest of the island. On 18 June 827, the emir's forces arrived in Mazara and quickly captured the town. They besieged Syracuse, but after a year Asad had died and the diseased army was close to starvation. Under successive commanders and with assistance from reinforcements from Spain, the now determined Arabs turned their attention to other parts of the island, capturing Mineo, Agrigento, Caltanissetta, and eventually Palermo

in AD 831. They made Palermo the new capital, replacing Syracuse after almost 1,500 years. A Muslim governor was installed, implying that the Aghlabids saw themselves as rulers of the entire island, even though only part of the western side had been conquered. Their determination is even more apparent from the first coins that they minted on the island, actually during the first, unsuccessful siege of Enna in AD 829. These named the whole island (Siqiliya) as the mint, even though they were not to conquer Palermo for another two years.[45] The invaders slowly made their way eastwards, with every town falling to them except for a few strongholds in the centre and the east that managed to remain independent or Byzantine: Enna (Castrogiovanni) only fell in AD 859, during the siege of which Euphemius was killed as a traitor by the Byzantine defenders; Syracuse was besieged again and fell in AD 878 (fig. 121; also see p. 152); and Taormina, usually seen as the final step in the Arab conquest, capitulated in AD 902, although some Byzantine bulwarks near Messina still held out until the last one, Rometta, fell in AD 965 after a two-year siege (fig. 120).

From the start, immigrants moved into Sicily in enormous numbers, fleeing political unrest and famine in North Africa, as well as seeing the potential of the fertile land and seeking new opportunities.[46] Generally, Arab Muslim colonists made up the new elite of the island, while North African Berbers, Jews and indigenous Sicilians became the lower classes and farmers. Not much more than one generation after the first conquests, many of these immigrants had completely renounced their North African origins and considered themselves Sicilian. Conflicts close to civil war between the profoundly different 'Sicilian-Arab' elite, 'Sicilian-Berber' subjects and Aghlabid rulers from Ifriqiya resulted in continuous fighting, most notably between Arab Balarm (the Arabic name for Palermo) and Berber Kirkent (the Arabic name for Agrigento), who would only put up a united front against rule from the motherland.[47]

In recent years the Muslim conquest of Sicily has been seen more as a series of random and patchy ventures rather than a well-thought-out deliberate scheme for conquering the island. The faltering start under the guidance of a religious scholar rather than a general; the sometimes surprising unpreparedness of the army; conflicts between Arab and Berber soldiers; the very slow progress; continuing rebellions of the Byzantine cities on the eastern side, closest to Italy; the wars between Muslim cities themselves and the rebellions against the emirate in Ifriqiya; the apparent impossibility of establishing some form of stability on the island, as governors were changed almost yearly; all these factors are seen as signs that not every emir was convinced of the worth and effort of the project.[48] At the same time, the Aghlabid dynasty in Ifriqiya had probably not foreseen the autonomy that new settlers would desire and fight them for. In the end, it was Emir Ibrahim II (r. 875–902), reported to be the cruellest of rulers of Aghlabid Ifriqiya, who personally took it upon himself to put an end to internal conflicts on Sicily and complete the conquest by taking Taormina in AD 902. He continued the jihad into Italy, where he died. Rule passed to his grandson Ziyadat Allah III, who could not hold out against the up-and-coming rival Islamic dynasty of the Fatimids that was slowly conquering North Africa with the help of the indigenous Berber tribes.

What did the conquest mean for the peoples of Sicily? The Muslim conquerors encountered a functioning multi-ethnic and multi-confessional society of Greek-Byzantine Sicilians, Jews, Lombards and Latin peoples, and further diversified it with Arabs, Berbers and Andalusians (settlers from Islamic Spain). They were tolerant towards the Christian and Jewish populations, even though these were encouraged to convert, which many did, as under Islamic law the *dhimmi* (non-Muslim citizens of an Islamic state) are required to pay the *jizya*, an extra tax. Byzantium, which still held the south of Italy, signed several peace treaties with the Aghlabids so that trade could continue with Italy and the East. After all, Sicily was still a prosperous island, and would only remain wealthy if trade were continued. Nevertheless, the

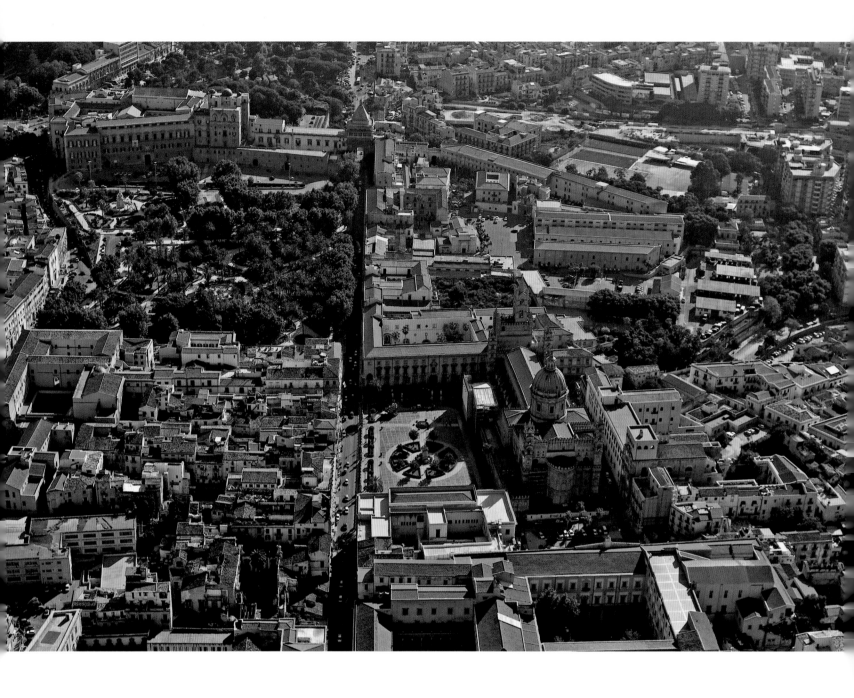

Fig. 119
Aerial view of Palermo
towards the west, with
the Norman palace in the
background and cathedral
in front. The irregular street
pattern sill reflects that of
the old city, grown around
its central east–west
thoroughfare. See also the
plans on p. 161.

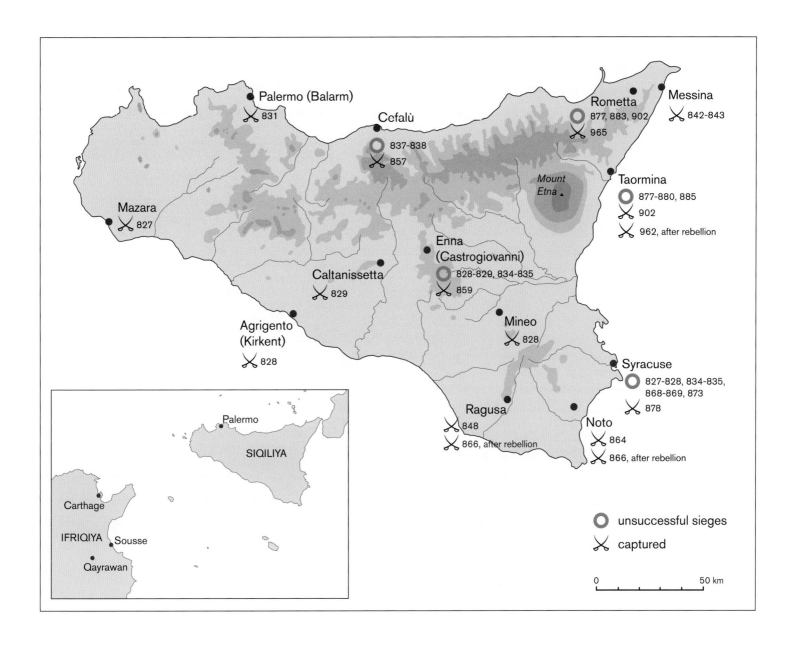

Palermo (Balarm)
✕ 831

Cefalù
◯ 837–838
✕ 857

Rometta
◯ 877, 883, 902
✕ 965

Messina
✕ 842–843

Mount
Etna ▲

Taormina
◯ 877–880, 885
✕ 902
✕ 962, after rebellion

Mazara
✕ 827

Enna
(Castrogiovanni)
◯ 828–829, 834–835
✕ 859

Caltanissetta
✕ 829

Mineo
✕ 828

Agrigento
(Kirkent)
✕ 828

Syracuse
◯ 827–828, 834–835,
868–869, 873
✕ 878

Ragusa
✕ 848
✕ 866, after rebellion

Noto
✕ 864
✕ 866, after rebellion

◯ unsuccessful sieges

✕ captured

0 _____ 50 km

Palermo

SIQILIYA

Carthage

IFRIQIYA Sousse

Qayrawan

Fig. 120
Map of the Arab conquest of
Siqiliya, showing the sieges
and conquests of the
major cities.

THE SIEGE OF SYRACUSE IN AD 878: AN EYE-WITNESS ACCOUNT

The monk Theodosius, who was in Syracuse during the siege, wrote:

We were taken captive after we had suffered hunger long, feeding upon herbs, after having thrust into our mouths in our extreme need even filthy things, after men had even devoured their children – a frightful deed, that should be passed in silence, although we had before abhorred human flesh – oh! Hideous spectacle – but who, for his own dignity's sake, could weep such deeds in tragic strain? We did not abstain from eating leather and the skins of oxen, nor from any other things so-ever which seemed capable of relieving men exhausted by hunger, and we spared not even dry bones, but dressed them to make ourselves a cheerful meal – a new sort of food abhorrent to the custom of mortal men. What will not unceasing hunger force men to do? [. . .] The fountain of Arethusa supplied us abundantly with water for such uses. [. . .] No sort of domestic bird or fowl was left, and oil and all sorts of salt provisions had long been eaten up, even such things which [. . .] are usually the food of the poor; no cheese, no vegetables, no fish. [. . .] Now this thing came to pass, by far the most terrible thing; a most grievous pestilence, alas, followed upon famine, and some were tormented by the disease called lock-jaw, so named from the contraction of the nerves; apoplexy dried up half of the bodies of some others, it killed others instantly, but many who were attacked by the same disease could only move half their bodies or were altogether deprived of the power of motion; others, their bodies inflated like bladders, presented a horrid spectacle to the beholder, and though death was always hanging over them, it hardly set those wretched creatures free. [. . .]

They ascended without opposition and took possession of the place, and they spread through the city like a river in the sight of those who were gathering together to defend it. First they slew to the last man those who were drawn up in line against them at the porch of the Church of the Saviour, and with a great rush they opened the doors and entered the temple with drawn swords, as they panted for breath, to emit fire from their nostrils and eyes. Then indeed people of all ages fell in a moment by the edge of the sword, princes and judges of the earth, as we sing in the psalms, young men and maidens, old men and children, both monks and those joined in matrimony, the priests and the people, the slave and the free man, and even sick persons who had lain a long time in bed. Merciful God, the butchers could not even spare these; for the soul that thirsts for human blood is not easily satisfied by the death of those who first face it in anger. [. . .]

The barbarians took those whom they had made prisoners [. . .], all born in Syracuse, and of high station, and some other captives also, and led them out of the city, and made them stand together within a circle; and they fell upon them with a rush, like wild dogs, and slew them, some with stones, some with clubs, some with the spears they had in their hands, and others with such weapons as they found by accident, pressing upon them most cruelly; and furiously raging in their hearts, they consumed their bodies with fire. I cannot pass over with silence the barbarous cruelties they perpetrated upon Nicetas. This man was of a Tarsian family, most wise and brave in war, and during the siege he used daily

to heap many curses upon Mohammad, who is held by that nation to be the greatest of the prophets. So they separated him from the number of those who were to be slain, and they stretched him upon the ground on his back, and they flayed him alive from his breast downward, and they tore to pieces his protruding vitals with spears; and, moreover, with their hands they tore the heart out of the man while he yet breathed, and lacerated it with their teeth, most monstrously, and dashed it upon the earth and stoned it, and then at last were satiated, and left it. [. . .]

We entered the extremely famous and populous city of Palermo; and as we went into the city, the people came out to meet us. They thronged out in great joy, and they sang songs of triumph, and as they saw the victors carrying the spoils into the city we at length saw the multitude of the citizens and of the strangers who had assembled, and that the number of the citizens, as compared with all accounts, had in our opinion not been overrated; for you would have thought that the whole race of the Saracens had come together there, from the rising up of the sun even to its going down, from the north and from the sea, according to the accustomed speech of the most blessed David.[49]

Fig. 121
Detail from an illuminated manuscript, the Synopsis of Histories by John Skylitzes, showing the Arab siege of Syracuse in AD 878. Created in Palermo, AD 1150–1175.
Biblioteca Nacional de España, Madrid.

Fig. 122
Marble Byzantine-style relief
from an ambo or the front
of an altar, from a church in
the Valley of the Temples,
Agrigento. AD 800–900.
H 77 cm.

Museo Archeologico Regionale Pietro
Griffo, Agrigento.

economy was often disrupted by the ongoing conquest (which with cities sacked and fields burned and exhausted was as destructive in terms of scale as the Punic Wars had been), as well as by the ongoing jihad in the Italian mainland and by internal conflicts between Arabs and Berbers. Messina and Taormina on the eastern side of the island, although conquered, were never fully converted and citizens continually turned to rebellion as they saw themselves part of Byzantium rather than the Arab world.[50] Over and over again, the Arab emirs had to take intervene and assert authority.

Barely any material trace of the Aghlabid period survives on Sicily, perhaps because of the slow and haphazard nature of the conquest, because Byzantine material culture surely endured among the diverse peoples of the island, and because whatever might have been built was reused, destroyed or overbuilt in later times. A chance survival of a fragment (fig. 122) of a ninth-century church in Agrigento, one of the earliest and most thoroughly converted cities, reveals that Christians were allowed to practise their faith. The marble relief, part of the front of an altar or an ambo, shows the Tree of Life surrounded by a myriad of animals and flowers: lilies and lotus flowers, two deer (male and female), two adult lions (male and female) and one cub, and a rabbit. The Tree of Life was an old Near Eastern symbol, but was used during the Byzantine period to symbolize the Cross of Christ, as well as victory over death.[51] It is no coincidence that the tree is a palm tree, abundant on Sicily and equally representing resurrection and immortality, cornerstones of the Christian faith. More interestingly, however, especially for the dating, is that the tree can be identified as a date palm, which was reintroduced on Sicily by Arab settlers.[52] Furthermore, the mirrored composition of lions and deer around the Tree of Life is a motif originating in Sasanian/Persian Middle Eastern textiles, which were hugely prestigious and heavily traded in the Late Antique Roman

and Byzantine world, subsequently adapted to suit a Christian context.[53] As with the jewellery (figs 116–18), this clearly shows that the Byzantine Christians on Sicily were familiar with the repertoire of symbols and decoration that was common in the Mediterranean at the time. Other examples of similarly decorated church furniture, possibly even carved by the same workshops coming from the East, have been found in Naples and Sorrento.[54]

The Arab Agricultural Revolution

A land so fertile, rich in cereals, cattle and slaves as to surpass by far
every other Muslim kingdom bathed by the sea.
AL ISTAKHRI, PERSIAN GEOGRAPHER, 10TH CENTURY[55]

If Sicily had been prosperous before, from the Arab domination onwards it would reach even new crop records, during what has popularly been called, in relation to all Muslim lands, the 'Arab Agricultural Revolution'.[56] The Arabs introduced on Sicily, as they did elsewhere, many new fruits, vegetables and plants that they brought from Asia and the Middle East: lemons and oranges (citrons were cultivated already in the southern Mediterranean), rice, cotton plants, mulberries (for the manufacture of silk), watermelons, spinach, probably aubergines, and possibly bananas and saffron (although the Greeks and Romans had known of the latter).[57] For many others – such as carob beans, almonds, date palms and pistachios (all known from Greek and Phoenician times) – they intensified the growing and the distribution.

For many of these products their introduction into Sicily also secured an introduction into Europe (some travelled through Spain as well), either at the same time or later in the Middle Ages. Perhaps the most important introduction to European cuisine was, however, the sugar cane and ways of refining sugar to make the host of sweets and desserts, such as marzipan and candied fruits, for which the Arabs were already well known.[58]

Intrinsically linked to the introduction of these new crops, and the reason for their success on Sicily, were new techniques of irrigation that the Arabs and Berbers imported, and which changed the landscape significantly. For the Greeks and Romans winter had traditionally been the sowing season on Sicily, with harvesting done in the early summer,[59] but with the introduction of these new crops the growing season was extended, which created the need for more water, especially for aubergines, rice and sugar cane, and especially during the scorching months of July and August.[60] Elevation machines, such as small well poles and enormous Persian waterwheels, were required to draw water from the ground, as well as large networks of irrigation channels, both above and underground, which included the very typical *qanat* – sloping underground channels with several access shafts. A tenth-century traveller specifically mentioned that the people of Palermo drew their water from wells (the shafts of *qanats*), sometimes located in their houses. In Palermo and its fertile plain, many such systems remained active for centuries and made up entire underground networks, which can still be visited today.[61]

The prosperity that these innovations brought with them is apparent through the changes in the Arab monetary system. As mentioned, the first silver coins with the legend Siqiliya were already minted during the earliest conquest phase by the Aghlabid emir Ziyadat Allah I. During the next fifty years, however, silver coinage was only minted sporadically and without any clear system, while no gold coins can be confidently proven to have been minted on the island until the capture of Syracuse in AD 878, when the Arabs turned the Byzantine mint into an Aghlabid one.[62] However, as the Byzantines did not use silver coinage, the minting of gold became necessary for continuing trade in the Mediterranean, while Byzantine gold

continued to circulate on the island, even in the already conquered areas. It was soon apparent that the island's changed economy, though prosperous, was too small-scale for the Arab gold *dinar* (theoretically 4.25 grams) and the silver *dirham* (theoretically 2.97 grams) to be much use. Ibrahim II reorganized the monetary system into a rigid system of quarter *dinars* (*c.*1.05 grams) and *kharruba*, a $\frac{1}{10}$ of the silver *dirham*. They became so useful and widespread that the quarter *dinar*, under the name *tari*, was to become the dominant currency in the Mediterranean (Arab as well as Byzantine, Lombard, Venetian and Genoese) for the next 400 years. The use of the *kharruba* also continued, but devalued to $\frac{1}{16}$ of a *dirham*. Ibrahim's system was retained by the Fatimid successors to the Aghlabids, and coins in their name with indication of the mint 'Siqiliya' were minted.[63]

A key source of information about agriculture and food storage, transport and preparation is Arab pottery, omnipresent in excavations. Imported ceramics moved across the island from west to east with the phases of conquest, and until the first half of the tenth century, after the fall of Taormina, there is no evidence for local production. Instead, we find Islamic pottery from North Africa, such as highly recognizable oil lamps, imported with the army and the new settlers. However, this does not mean that all trade with and influence from Byzantine territories stopped immediately: certain types of amphora and glazed wares also found in Rome continued to exist in those areas, such as Taormina, that resisted longer, or those more connected and susceptible to outside influence, such as the capital and major harbour of Palermo. New forms and innovations occurred in the first half of the tenth century, when ceramic workshops that started producing their own lead-glazed pottery were founded on Sicily. Almost simultaneously the import of ceramics ceased completely. Interestingly, these workshops show no evidence of having had any experimental phase or evolution of specific types, which indicates that the knowledge and techniques came directly from mainland Ifriqiya, undoubtedly together with the North African craftsmen that settled on Sicily. The new products are completely different from what was made before and linked directly to North African lifestyles and innovations: we find predominantly products for lighting, such as a new type of oil lamp (*a coupelle*, or 'domed'), plus objects for the preparation of food and

Fig. 123
Lead-glazed ceramic oil lamps from various excavations in Palermo. AD 900–1000.
L *c.*10 cm.

Soprintendenza di Palermo.

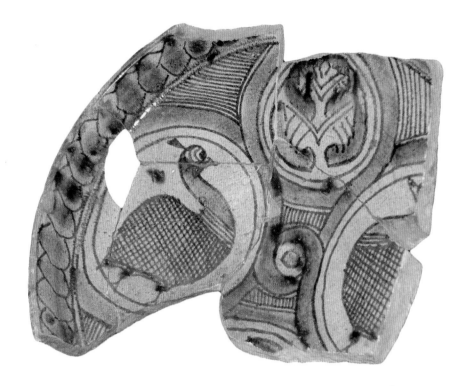

for agricultural activities, such as new types of amphora, as well as the *vasi da noria*, the vessels attached to treadmills for field irrigation. The production techniques as well as the shapes and forms and types of decoration are completely uniform throughout the island, whether in the cities or in the countryside. Typical of the period are lamps, plates and cooking vessels painted in green (through the use of copper oxide), yellow (iron oxide and hydroxide) and brown (manganese) colours (fig. 123). While lead-glazing had existed in Roman times, it had declined during Late Antiquity and the Byzantine period, but was now reintroduced by the North Africans and Arabs. However, Islamic-period lead-glazing used a different process: the unglazed clay body was fired a first time, then painted and glazed, then fired a second time. While the ceramics produced on Sicily look like those from Ifriqiya in terms of form and colour, they were produced using a different technique, using quartz instead of tin oxide to achieve the opaque glaze. One very typical western Sicilian product from the end of the tenth century and throughout the eleventh century was the 'lapwing bowl' (fig. 124), so-called because of the identification of the birds they depict.[64] The reintroduction of glazing in Mediterranean pottery would eventually have far-ranging consequences. When, in the early thirteenth century, tin instead of lead was added to the glaze, proto-maiolica emerged, a predecessor to the maiolica of the Renaissance that would be renowned and exported all over the world.

Fig. 124
Fragment of a lead-glazed ceramic bowl, decorated with lapwings. From Palermo, AD 950–1050. W 22.5 cm.
Galleria Interdisciplinare Regionale della Sicilia di Palazzo Abatellis, Palermo.

Culture Under Prosperous Fatimid/Kalbid Dynasties

When the Fatimid dynasty conquered Ifriqiya from the Aghlabids in AD 909, Sicily automatically came under their rule. Just as in Roman times, Sicily found itself the host of different peoples with very different languages. A large part of the island's population was by now a people that shared Arab, Berber and Christian ancestry, that had adopted a definite Sicilian identity and that considered itself indigenous. As well as converting to Islam, many Greek-speaking Christians probably took Arabic as their native language after a generation or two (apart from the north-east of the island where Greek and Latin persisted), just as many Muslims must have learned at least some Greek. A sense of independence became strong, especially for many who retained the Sunni faith of the Aghlabids, in contrast to the Shi'i Fatimids.[65] Over the next forty years these Sicilians fought and rebelled against the Fatimid caliphs and their representatives on the island, until, in AD 948, Hassan al-Kalbi was appointed Emir of Sicily, and in AD 970, the Fatimids moved their capital from Ifriqiya to Egypt, where a Sicilian general, Jawahr al-Siqili ('the Sicilian'), had founded what is now Cairo. Sicily theoretically remained under Fatimid domination from faraway Egypt, but received a large degree of independence (and similarly, the province of Ifriqiya was left to the Zirid dynasty, also subject to the Fatimid caliph). Hence, in Sicilian history the period is known as the Kalbid rather than as the Fatimid period.

Life on Sicily under the Kalbids became fairly tranquil, stable and prosperous. Al-Kalbi, though not an indigenous Sicilian, managed to gain the support of the people, put down rebellions, re-establish peace, fight off Byzantines, and conduct incessant and successful raids on the Italian mainland for booty and slaves. His son succeeded him and followed the same path. It is therefore not surprising that we are mostly informed about the architecture and material culture of this period, rather than of the tumultuous century before. Many Sicilian cities had mosques, suqs and casbahs, or urban forts. Those of Palermo, as capital, are the best known, both archaeologically and from literary sources.

Although foreign, and mostly Fatimid, Muslims praised Sicily for its wealth, prosperity and beauty, the island was still considered a marginal province, where the inhabitants had been corrupted by the previous dynasties and contact with the 'infidels'. One of the most important Arabic sources for our understanding of Muslim societies on Sicily is the travel writings of Ibn Hawqal, a Shi'i Fatimid geographer from Baghdad, who visited in AD 973. Part of his account is written subjectively and emotionally, through the eyes of an outsider, who considered himself to be a true Muslim from the heart of the Muslim world. To him, Sicily is 'provincial', and he appears disappointed at its alien character. There is contempt in his tone for the Sicilian Muslims – different from the Arab elite in the East – and their expression of Islam:

> *They do not pray, do not perform ritual ablutions, they do not pay the alms tax nor do they go on pilgrimage to Mecca [. . .] the disposition of the country folk is like that of non-Arabic-speaking regions: incoherent deaf mutes. Its inhabitants, who are not classified in any scriptures, are worse than simple beasts in their understanding, their indifference to their rights and duties and to the state of their affairs [. . .] There is in that town not a right-minded person, nor a man of refinement, nor in fact a scholar in any aspect of the scholarly arts, nor anyone of virtue, nor pious men. Most of the town are riffraff and most of its inhabitants have disreputable manners and have neither understanding nor genuine faith.*[66]

The effects of their 'contamination' shone through mostly in language and religion, of which Ibn Hawqal wrote: 'Most people are converts and think it is acceptable to marry Christians on the basis that their male child follows the father by being a convert, while the female child becomes a Christian like her mother.' Nevertheless, his rebukes become almost childish when describing the strange pronunciation of Arabic by one of the Friday sermon speakers, and his contempt for the Sicilians is clear when they reply that they 'would not reject him for something like this!'[67]

Fig. 125
The Conca d'Oro or 'Golden Basin', the fertile plain around Palermo.

IBN HAWQAL

Ibn Hawqal travelled extensively throughout the world and eventually published a record of his travels as the *Surat al-Ard* (The Portrait of the World), in which especially Muslim Spain and Sicily received much attention. He arrived on Sicily in April AD 973, and left an invaluable portrayal of Palermo under Muslim rule, at the peak of its prosperity.

> *Included among places which are in the best of circumstances and which are in the possession of the people of Islam, is Sicily (Siqiliya), an island in the shape of a triangle with two equal sides, its acute angle being on the west of the island. Its length is seven by four days' [travel]. [. . .] Most of it consists of mountains, strongholds, and forts, and most of its land is settled (populated) and cultivated. [. . .]*
>
> *Its only famous town is that known as Palermo, the capital of Sicily and which is on the coast. It has five districts next to one another which are not separated by any great distance although their boundaries appear to be obvious. They are part of the great city called Balarm around which is a huge, high and impregnable stone wall. Merchants live there and it has a great congregational mosque which used to be a Byzantine church before the conquest. [. . .]*
>
> *Facing it [the mosque] is a city known as al-Khalisa which has a stone wall although it is not like Palermo's wall. The ruler and his retinue live there. It has two bath-houses, but no markets nor rest-houses. There is a small, cheaply-built, congregational mosque, and the ruler's army, naval arsenal and administration are there too. It has four gates. [. . .]*
>
> *Most of the markets are there [. . .] for example, the olive market, all the flour merchants, the money-changers, pharmacists, blacksmiths, burnishers, the grain markets, embroiderers, fish-sellers, spice-sellers, a section of butchers, greengrocers, guilds of fruits, herbs, potters, bakers, rope-makers, a section for perfume-sellers, slaughter-men, shoe-makers, tanners, carpenters, joiners and wood-workers. Outside the town and Palermo there are also sections for butchers, potters and rope-makers. The butchers there have almost 200 shops for selling meat.*[68]

Palermo had always been a fairly small city, entirely surrounded by two rivers. However, Ibn Hawqal's account indicates that in just over a century, and clearly linked to its economic success under the Fatimids/Kalbids, it had grown extensively, with four additional quarters (*harat*). Only the original city between the rivers was now called Balarm, of which Ibn Hawqal describes in minute detail the nine gates, such as Shantaghath (meaning 'by the church of Saint Agatha'). One of the new districts was the area around the Khalisa, the new palace built by the Fatimid caliphs in AD 937/8. These descriptions and names are of great interest to historians, as they enable them to compare with Palermo under later Norman rule and map the urban growth in some detail (fig. 126).[69] The Islamic-period development of Palermo left such a lasting legacy that even today some areas and districts are still referred to by their Arabic names, such as the Kalsa (from 'Khalisa') and the Cassaro (from 'Qasr', the other palace, and another name for the old town within the walls).

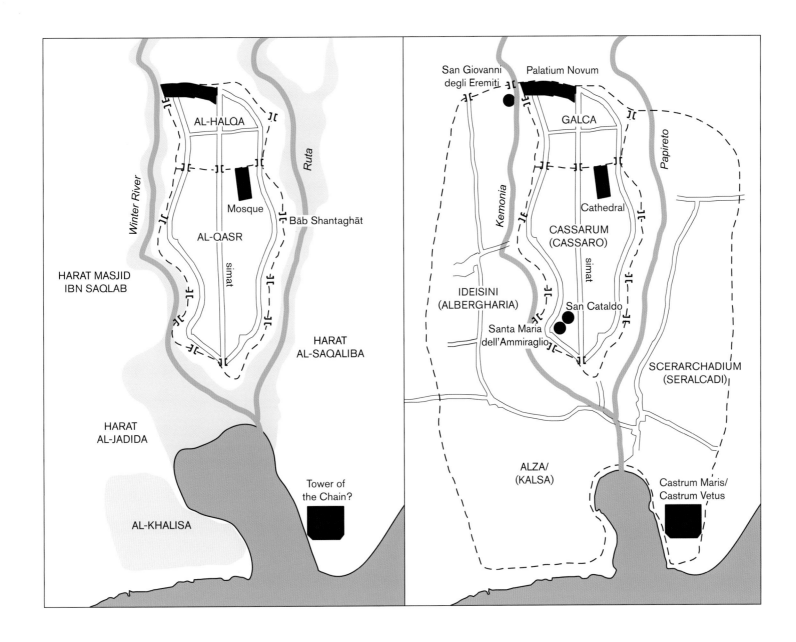

Fig. 126 (left)
Map of Palermo in the Kalbid period
(late 10th–11th century).

(right)
Palermo at the end of the Norman period
(late 12th century). Indicated are the different
districts and buildings discussed in the text
(modern names in brackets). In light blue,
the early floodplains of Palermo's two rivers,
the Papireto and the Kemonia. Dotted lines
indicate city walls (it is as yet unknown
whether the wall around the suburbs was
built at the very end of the Kalbid period,
possibly during the Norman invasion, or
early under Norman rule).
(See also, pp. 222–3.)

In 2000, an Arabic illuminated manuscript of a then unknown cosmographical text was discovered: *Kitab Gharaib al-funun wa-mulah al-uyun* (Book of Curiosities of the Sciences and Marvels for the Eyes) (fig. 129). The original, of which this is a copy from around AD 1200, can be dated to between AD 1021 and 1050, and was most probably made in Egypt, as the anonymous author clearly displays Fatimid sympathies and frequently uses terminology current there. Two of the originally five books survive in this manuscript, the first one dealing with celestial matters and the second with the earth. Both are richly illustrated with maps and diagrams, all of which are accompanied by texts taken from different Muslim sources and authors, including astronomers, travellers and historians. The work includes the earliest rectangular world map as well as the earliest surviving map of Sicily. The latter is accompanied by a text based on Ibn Hawqal's account of Sicily, but edited, updated and expanded. In fact, the texts dealing with the Mediterranean trading ports, especially the islands of Sicily and Cyprus, are much more detailed and accurate than other parts of the text.[70] This is in sharp contrast to the map itself, which is confusing and highly inaccurate, not least because of the round shape given to Sicily. North is at the top, contrary to Islamic mapping practice. There are a few recognizable features, such as Etna (*jabal al-nar*, meaning 'Mountain of Fire'), the walled town of Palermo with eleven gates (updated from the nine in Ibn Hawqal's time) and Palermo's harbour guarded by two castles. The Khalisa is visible to the east of walled Palermo. Other than those buildings, the interior of the island is taken up by place names, two rivers and a few mountain peaks. The peaks are those that make up the mountains around the Conca d'Oro, the 'Golden Basin' encircling Palermo (fig. 125), an extremely fertile plain surrounded by these natural defences, meaning that almost eighty per cent of the map is taken up by the mere 100 square kilometres around Palermo.[71] The Conca d'Oro was a distinct entity in the Sicilian landscape from the earliest times, even if we do not know when exactly it received this name: it obviously refers to its fertility, and in particular to the golden colour of the myriad of orange and lemon groves that existed there from the Middle Ages until as late as the 1950s, when an aggressive building programme was started (nowadays almost the entire Conca d'Oro area is urbanized). The representation of the coastline is another problem on the map. Several of the important cities of the time are mentioned, such as Atranish (Atrabanish = Trapani), Ra's Maran (Ra's Mazar = the headland of Mazara), al-Shama (al-Shaqqa = Sciacca), Siraquniya (Siraqusa = Syracuse), Tabarmin (Taormina), Tusamma (Massini = Messina), Halfunat al-kabira (Jafludha = Cefalù) and Jabal Thirma (The mountain of Termini), sometimes with distances in Arabic miles noted between them.[72] However, Reggio Calabria (actually at the tip of the 'boot' of Italy) is mistakenly positioned on the coast of Sicily, and Etna is shown in the south-west corner of the island, as are Taormina and Syracuse, the latter of which is located immediately next to Sciacca on the map, revealing that most of the southern coastline of Sicily is missing altogether (figs 127–8). A hint of what might have gone wrong lies within the fact that the total Arabic miles of coastline given on the map is considerably less than the total of 500 miles given in the accompanying text.[73] It seems possible that the original map consisted of several leaves, and that in the process of copying it one or more leaves must have gone astray. The copyist, who perhaps had never even been to Sicily, ignored the inconsistencies, whether deliberately or not. We can only guess at the accuracy of the original map from which this one, the earliest surviving map of the island, was copied.

Fig. 127 (opposite above)
Map of Sicily from the 'Book of Curiosities', with major cities highlighted. Made in Egypt *c.* AD 1200, after an original of *c.*1021–1050.
Bodleian Libraries, University of Oxford.

Fig. 128 (opposite below)
Map of Sicily showing the same cities in their accurate locations.

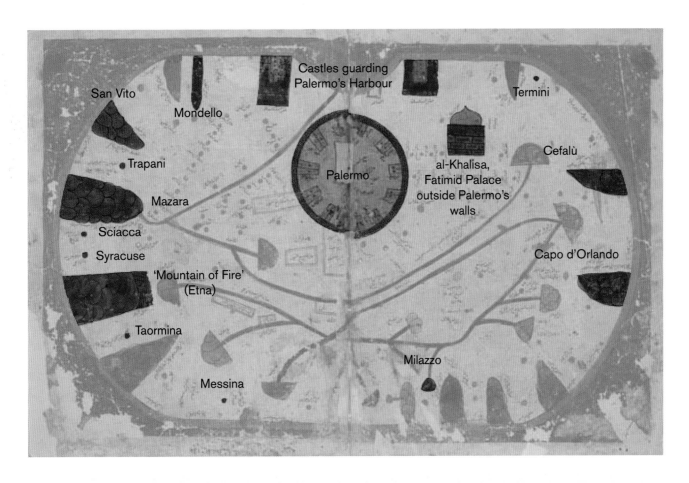

Castles guarding
Palermo's Harbour

Termini

San Vito

Mondello

Cefalù

Palermo

al-Khalisa,
Fatimid Palace
outside Palermo's
walls

Trapani

Mazara

Capo d'Orlando

Sciacca

Syracuse

'Mountain of Fire'
(Etna)

Taormina

Milazzo

Messina

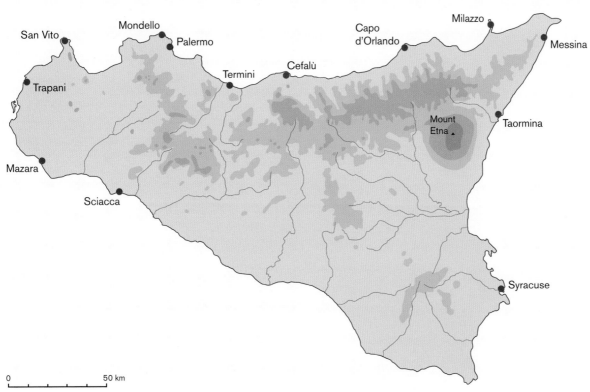

Mondello

Milazzo

San Vito

Palermo

Capo
d'Orlando

Messina

Trapani

Termini

Cefalù

Mount
Etna

Taormina

Mazara

Sciacca

Syracuse

0 50 km

Fig. 129
Map of Sicily from the
'Book of Curiosities'. Made in
Egypt *c.* AD 1200, after an
original of *c.*1021–1050.
H 32.4 cm.

Contrary to the view of some travellers, who in any case were mostly describing the lower and middle classes rather than the court or Arab elite, peace, political stability and economic prosperity logically brought a flourishing of the intellectual landscape. Muslim Sicily became equal in every respect to the cultures of Ifriqiya, the Maghreb and Islamic Spain (al-Andalus). It produced renowned scholars in religious sciences, jurisprudence, grammar and the physical sciences, but it was especially in poetry, patronaged by the Kalbid court, that the island excelled, as it had done in Hellenistic times. No fewer than 170 poets are recorded for the eleventh century, some native, some from abroad, and from most of whom nothing survives other than a few fragments collected in later anthologies. Themes common to Arabic poetry, such as nostalgia, love, longing, courting and abandonment, were also central here.[74] Scholars also believe that, given the continuing importance of cities such as Syracuse and Catania throughout the Byzantine period, Sicilian libraries still contained many of the most famous Greek classical works. Indeed, there are several surviving references to Arab poets and scholars who either owned Greek works, or were well versed in Greek, and knew the works of Aristotle.[75] Later, under the Norman kings, these Greek works formed the basis of translations into Latin.

One of the most important written document to come from Islamic Sicily is the so-called Palermo Qur'an (fig. 130). This Qur'an, written and painted in Palermo in AD 982–3, is made up of 29 quires (units of 8 leaves) of parchment and oriented horizontally. These characteristics are both indications of the conservative nature of the western Islamic world, as paper had been used for vertical manuscripts and Qur'ans in the East since the ninth century. By the time of its creation, most Qur'ans had the core of the text in black ink, with green, blue and yellow for vocalizations, and this one is no exception, showing beautiful and colourful markers in the margins. Gold is used in the verse markers and chapter headings on each page. The second page displays the *shahada*, the profession of faith, but with a specific addition: 'There is no god except God. Muhammad is the Messenger of God. The Qur'an is the Word of God, and is not created.' This explicit profession of the doctrine of the Uncreatedness of the Qur'an is remarkable, and informs us of the cultural milieu of the Muslim elite of Sicily at that time. The doctrine of the Uncreated nature of the Qur'an, that it is eternal and coexistent with God, was upheld by several Muslim groups including the Maliki school of religious law, a Sunni group prominent in the Maghreb in the ninth and tenth centuries

Fig. 130
So-called 'Palermo Qur'an', a Qur'an made in Palermo in AD 982–3. Vellum, ink and pigment. H 17.6 cm.
Nasser D. Khalili Collection of Islamic Art, London.

and still present there today. At the time of this Qur'an's production, the debate between the Created and Uncreated nature of the Qur'an was a source of conflict in Ifriqiya, between various religious schools, some of whom espoused the notion that the Qur'an was created by God's will and not co-eternal with Him. This expression of the *shahada* implies that the debate was far from over on Sicily, where the majority of the population was Sunni, yet under Shi'i rule. It is therefore assumed that this Qur'an was commissioned by one of the Sunni middle-class citizens for personal use, rather than the emir himself, who presumably would not have openly professed his Sunni leanings against his caliph. The relatively modest quality of the Qur'an also points in this direction: the distribution of the quires has made it possible to calculate that 'only' 140 sheepskins were needed for the entire Qur'an, and while gold was used there is no overall extravagantly lavish decoration. Striking is Ibn Hawqal's description, written only ten years before this Qur'an was made, of the type of vain middle-class citizen we imagine to have commissioned such works for private use in a private mosque:[76]

> *I saw about ten other mosques come into my view within the range of an arrow's flight, one opposite the other, separated only by the width of the road. I asked about this and I was informed that, in order to show off, people used to like to have a small mosque each for themselves and to share it with no one but their family and servants. Sometimes, there used to be two brothers whose houses were next door and their walls adjacent, but each one of them had built a mosque for himself to sit in on his own.[77]*

Internal Strife

The political stability of the Kalbid dynasty started to decline around AD 1000. After the brother of the Kalbid Emir Jafar (r. 998–1019) unsuccessfully rebelled with the help of the Berber population of the island, Jafar banished the Berbers, including soldiers, leaving a weakened army, just when the Zirid rulers of Ifriqiya were sizing up Sicily and independence from the Fatimids. At the same time, rebellions followed the attempted introduction of a new tax system, and ethnic difficulties continued between immigrant 'Ifriqiyans' and 'native Sicilians'. As a result, different factions within the Kalbid ruling family allied themselves variously with the Byzantines and with the Zirids for help. Both powers made several invasion attempts on the island, fighting the Sicilians and fighting each other, and the island was once again in intense conflict.

A last Kalbid emir ruled nominally until AD 1053, but during his rule the island fragmented into several autonomous entities under the control of local military leaders. In a move reminiscent of the catalyst for the Arab conquest more than 200 years earlier, one of those strongmen fighting for dominance over the entire island asked the help of Robert Guiscard de Hauteville and his brother Roger, Norman mercenaries who were making a name for themselves in southern Italy. The Normans did not need much persuading, and in AD 1061 invaded the island with supposedly around 450 knights.[78] In AD 1072 they took Palermo; by AD 1091 the entire island was theirs.

GEORGE MANIAKES

In AD 1038 a Byzantine army under general George Maniakes invaded Sicily. The troops were mainly composed of mercenaries, such as Italian Lombards, Normans from France, Normans from Russia (Varangians) and Scandinavians, including the later King of Norway, Harald Hardrada, who in AD 1066 invaded England independently from William the Conqueror to claim the throne. The eastern part of the island around Messina and Taormina, which had never been fully Islamized, was quickly 'conquered'. Maniakes was popular and competent, but a dispute over spoils resulted in the Norman contingents returning to Italy, while a dispute with the commander of the Byzantine fleet had the Byzantine emperor imprison Maniakes back in Constantinople. His replacements, utterly incompetent, lost all conquered territories and were forced to return to Italy.

Fig. 131
Detail from an illuminated manuscript, the *Synopsis of Histories* by John Skylitzes, showing George Maniakes, 'the Roman', landing on Sicily in AD 1038. Created in Palermo, AD 1150–75.
Biblioteca Nacional de España, Madrid.

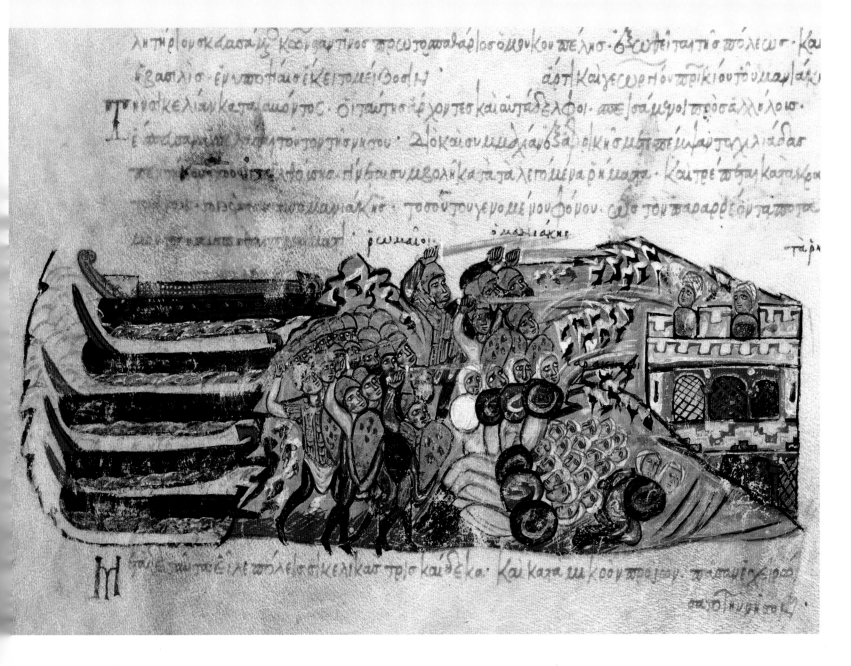

Muslim Legacy

Even though Sicily remained a provincial backwater in the eyes of its rulers in Ifriqiya and Egypt, the local Muslim population loved the land, they loved life on the island, they loved the wealth, the trees, the fruits, and they especially loved writing about it. When the Normans invaded, many of the Muslim elite, including the poets, left the island for other Muslim countries. The greatest poet of Arab Sicily, Ibn Hamdis, was born in Syracuse in AD 1056. He left Palermo when it was conquered, settling first in al-Andalus and then in Ifriqiya. Even in old age his heart longed for Sicily:

Oh my Sicily. In memory
A desperate longing for you and
For the follies of my youth returns. Again I see
The lost happiness and the splendid friends,
Oh Paradise from which I was expelled!
What is the point of recalling your splendour?[79]

Similarly, the poet Abd al-Halim ibn Abd al-Wahid wrote:

I loved Sicily in my early childhood:
it seemed to me a garden of eternal happiness.
I have not had time to grow to maturity,
when, look, the country has become a fiery hell.[80]

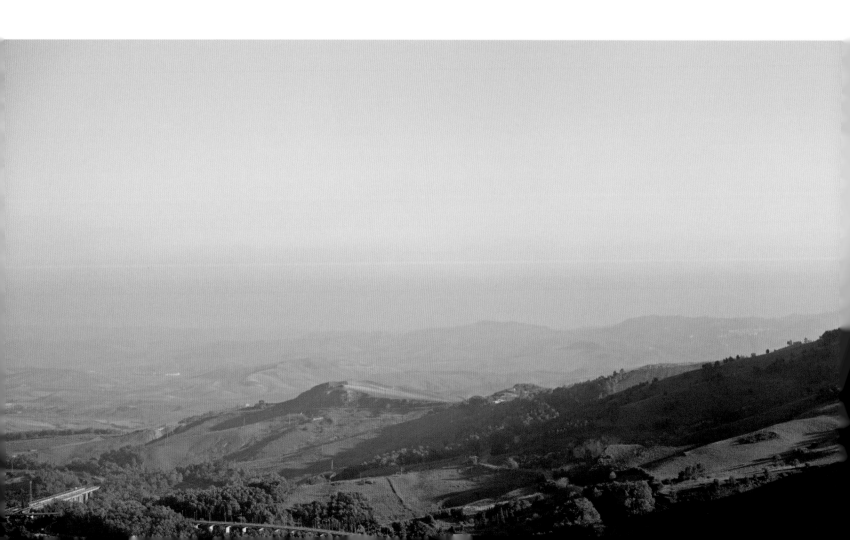

The Arabs and Berbers left a lasting legacy on Sicily that can still be felt today. Their three administrative districts, the Val Demone, Val di Mazara, and Val di Noto, retained their function and boundaries until the nineteenth century, and are still used today as indications of location. The lives of the people of the island are still enriched by the foodstuffs brought from the Islamic world. Sugar (sukkar) was probably the most influential in the Middle Ages, but many other products that have become central to European diets were introduced through Sicily, as their names, derived from Arabic, indicate: 'orange' comes from the Arabic *naranj* (based on Sanskrit), the Italian 'zagara' for orange blossom comes from *zahr*, 'carob' from *kharrub* (hence also the silver coins, small as carob beans), 'saffron' from *zafaran*, 'jasmine' from *yasmin*, 'marzipan' possibly from *mawthaban*, 'cotton' from *qutun*, and so on. Couscous remains the traditional dish of the west of Sicily and specifically Trapani. The Sicilian dialect itself also retains hundreds of words of Arabic origin, unknown in other parts of Italy. Significantly a lot of them relate to water management and measurements, which is unsurprising given the profound transformation the Arabs brought to agriculture: *gebbia* from *jayb* (water tank); *giarra* from *jarrah* (water tower); *senia* from *saniya* (bucket); and so forth.[81] Many Sicilian cities retain their Arabic names, including those with the prefix *calta-* (from *qala*, castle): Caltagirone, Caltanissetta; and *marsa-* (harbour): Marsala (from *Marsa Allah*, 'harbour of God') and Marzamemi (*Marsa Muhammad*, 'harbour of Muhammad').[82]

The start of Norman rule was hardly the end of Islamic culture. Although the new rulers were quite aggressive during the first years of conquest, especially the thirty years it took them to gain control of the entire island, Arab culture was to flourish once again under the rule of the first Norman king Roger II and his immediate successors.

Fig. 132
View of Enna, a natural bulwark with its own source of water that proved to be among the most difficult cities to conquer. The Arabs besieged it three times before capturing it in AD 859 by sneaking in through the city's sewers. After an unsuccessful siege in AD 1061, the Normans only succeeded in taking the city in AD 1087.

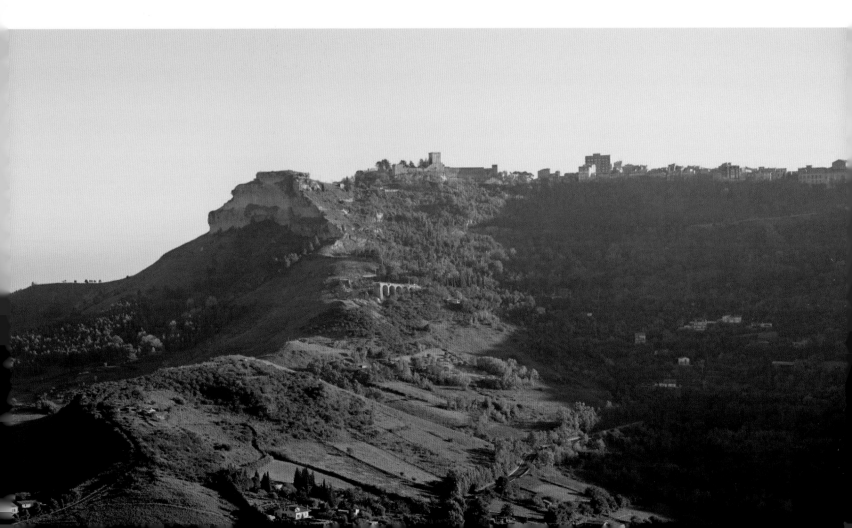

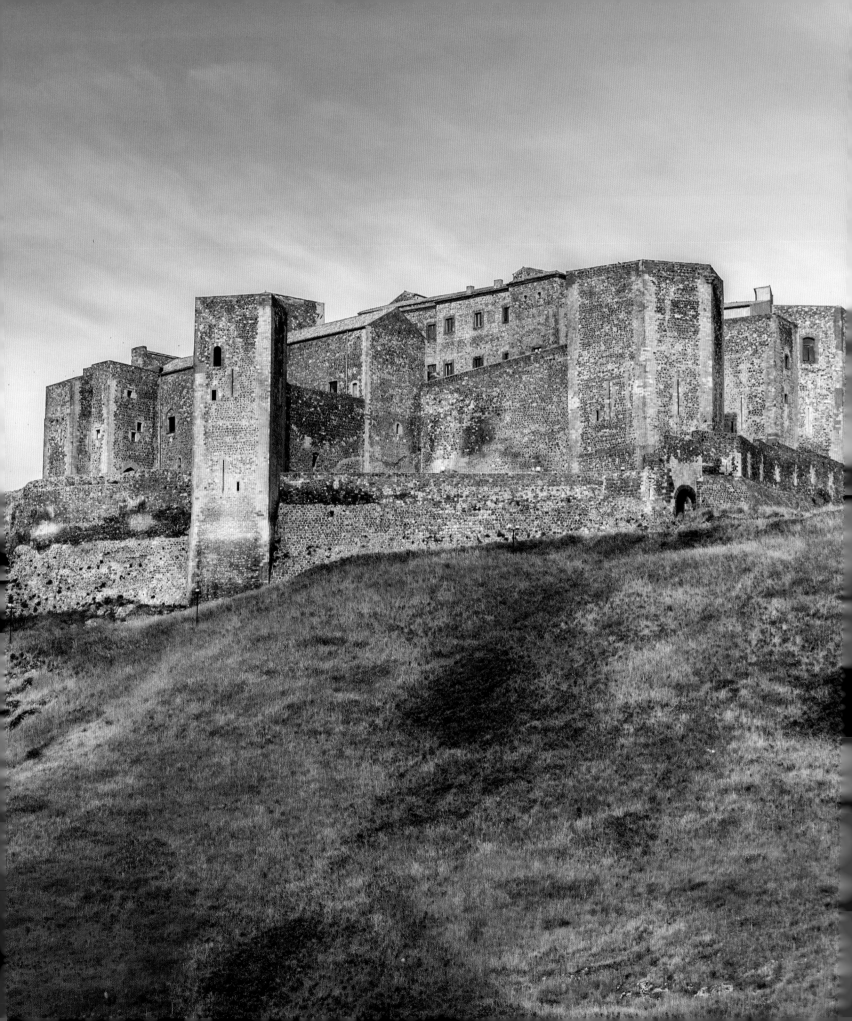

The Conquest

Seeing it [Sicily] from close at hand with only a short stretch of sea lying in between, [Count Roger] was seized by the desire to capture it, for he was always eager for conquest.

GEOFFREY MALATERRA, *THE DEEDS OF COUNT ROGER OF SICILY*, 2.1[1]

From around the same time that the Arabs conquered Sicily, 'Norsemen' (commonly known as Vikings) had first raided and plundered, then settled in the region of northern France to which they gave their name: Normandy. Adapting to farming, turning to Christianity, and mixing with the local Frankish and Gallic populations, they became 'Normans'. War and a constant drive for expansion nonetheless remained in their blood, and Normans were known both as extremely pious pilgrims and infamous mercenaries. The first documented appearance of the Normans in the Mediterranean is in Salerno, in Campania, in the year 999, as pilgrims returning from visiting the Holy Sepulchre in Jerusalem. (Although Jerusalem was then under Fatimid rule, conquered in 969 from the Abbasid dynasty by the same general Jawahr, 'the Sicilian', who had founded Cairo, it allowed Christian and Jewish pilgrims and worship.) According to one story, the city of Salerno was attacked by Arab raiders while the Normans were staying with the local Lombard ruler of Salerno. The Lombards cowered and started collecting the tribute demanded by the raiders, while the Normans held true to their reputation and drove the Arabs away. Not long after, Norman pilgrims, this time at Monte Gargano in Apulia, were approached by another Lombard, asking for their help in rebelling against Byzantine rule in Bari. Whether or not these legends are true, these moments were later said to have planted the seed for more Normans to come to southern Italy as mercenaries in the service of local lords, and used as legitimization for their settling. More and more Norman mercenaries started to make the trip south, quickly turning from upstarts into conquerors, lords and rulers, through alliances, marriages and the distinctive Norman ability to quickly adapt to unfamiliar environments (a characteristic already clear from their earlier settlement in France, and their subsequent conquest of and settlement in England). Melfi (in modern Basilicata) became their leading base (fig. 133), and twelve of the most powerful Norman warlords were established as counts in its territory.[2]

One family of immigrants was eventually to dominate the history of southern Italy and Sicily, namely the de Hautevilles, sons of Tancred de Hauteville, a minor noble from Normandy (see fig. 184). Realizing the limited possibilities that the no less than twelve of them would have in Normandy, they joined many young nobles from France and set out for Italy. The two eldest of them, William 'Iron Arm' and Drogo, are recorded among the Norman mercenaries in George Maniakes's Byzantine expedition to Sicily of 1038 (see p. 169), which they abandoned after disagreement over the distribution of the booty. After settling on the mainland, William was given the title Count of Apulia by the local Lombard prince, a title that was passed on to three of his brothers as well. However, it was William's half-brother Robert Guiscard 'the Resourceful' and the youngest of the brothers, Roger, who set their minds on Sicily, and initiated the conquest in 1061.

Fig. 133
The castle at Melfi, centre of Norman power in the south of Italy.

Fig. 134
A Qur'an verse on one of the reused marble columns of Palermo Cathedral, which was probably already reused when the Byzantine basilica on the site was turned into a mosque in the 9th century. It reads: 'He covers the night with the day, [another night] chasing it rapidly; and [He created] the sun, the moon, and the stars, subjected by His command. Unquestionably, His is the creation and the command; blessed is Allah, Lord of the worlds.' (Sura al-Araf, 7. 54.)

The richness of the land certainly encouraged the Norman drive for conquest; even without the excuse of a request for help by one of the Sicilian Muslim warlords, there is no doubt the Normans would eventually have set out for the island. Although thoroughly Christian, the Norman conquest was not a crusade, as the de Hautevilles did not set out to take the island *because* it was under Muslim rule.[3] Nevertheless, they found an enthusiastic partner in the pope, who himself longed for domination in the south of Italy, and saw the Norman eagerness as an opportunity to take Sicily from both the Arabs and the Byzantines. Already, in 1050, Pope Leo IX had appointed a 'theoretical' archbishop of the island and, in 1058, Pope Nicholas II had made Robert Guiscard 'the future Duke of Sicily'.[4] It was the perfect marriage: for the Normans, the support of the pope added spiritual blessing and legitimacy to their thirst for conquest and rule.[5]

Roger made early reconnaissances to the island in 1060 and the following March with small numbers of knights, raiding the cities of Milazzo, Rometta and especially Messina, where extreme violence, plunder and slaughter of citizens was recorded. The full-scale conquest, however, started in May 1061, when Robert and Roger landed near Messina with around 450 knights.[6] The enterprise would eventually take about thirty years to complete, despite many problems: Roger fell ill for a long time; this particular war was a seasonal event, as ships could not make the crossing during winter; but most importantly, Robert and Roger simultaneously had to deal with uprisings against their rule in Calabria and Apulia.[7] Obviously, garrisons and settlers stayed behind on Sicily, in the already conquered villages, but Robert and Roger constantly went back to Calabria, which remained their base until their deaths. While the conquest was reasonably slow (though not as slow as that of the Aghlabids), the Normans were helped greatly by their Sicilian Muslim allies, who were tired of the turmoil the island had been left in after the rule of the last Kalbid emir. Contemporary sources speak of thousands of Muslims in the Norman army, even constituting the majority.[8] It should not be forgotten that there were still many, though localized, Latin Christians, Greeks and Jews on the island as well, and many cities capitulated without a fight. Palermo was besieged for five months before it fell in January 1072, and this had only been possible after Robert was able to join Roger on Sicily, after finally having recaptured Bari, the last stronghold of the Byzantines in Italy. After Palermo, Robert focused more on removing the Lombards and Byzantines from southern Italy and further east (he died on campaign on Corfu in 1085), while Roger became the enduring driving force behind the Sicilian venture. He received the title Count of Sicily from his brother, now Duke of Apulia, Calabria and Sicily.[9]

To contemporary, decidedly pro-Norman, writers, Roger was the ideal medieval knight: 'very handsome, tall, well proportioned, most eloquent, clever in decision-making, far-sighted in his plans, friendly and pleasant to everyone, strong and brave, and furious in battle'.[10] Although the Muslim capital was now taken, some of the larger cities still needed to be conquered, but they often succumbed after only short sieges: Castronuovo in 1077, Syracuse in 1085, Castrogiovanni and Agrigento in 1087. The final pockets of resistance around Syracuse and Noto were finally put down by 1091 (see map, fig. 141).

Roger found himself in a difficult position. Christian by faith and sponsored by the pope, the conquest was a Christian enterprise. Yet, Sicilians who were Latin-speaking Christians as well as Greek-speaking Christians were being killed alongside Muslims if they opposed the conquering army.[11] However, given that Normans and Latins were still very much a minority on the island, and there were thousands of Muslim soldiers in his army, including his personal bodyguards, Roger seems to have understood the need for inclusion and tolerance, rather than separation, not just of Muslims but also of Greeks. Conversions to Christianity was not enforced and remaining mosques were left to operate, although the main mosque of Palermo

was converted back into a church as it had been a Roman basilica, and a Byzantine church before the Muslim conquest (fig. 134).[12] As Alex Metcalfe writes in a seminal work on Muslim presence in Italy, 'preserving essential elements of the religious *status quo ante* was vital for the early Normans' rule over the Muslims'.[13] In this early period, the most telling evidence of the avoidance to affront the still largely Muslim population are the coins minted by Robert and Roger during the conquest, and later coins mandated by Roger and his wife Adelaide del Vasto, which look and feel very much like their predecessors.

The quarter *dinar* was now so established throughout Sicily and the Mediterranean that it would have been a mistake to change the monetary system. From the moment Palermo was captured, Robert started minting quarter *dinars* in his own name, which were now called *tari* (Arabic for 'fresh'). He kept the quarter *dinar* for both economic and ideological reasons, but also modelled the iconography on those of his Fatimid predecessors, keeping the Arabic writing. Just as the coins in the names of the last Fatimid rulers of Sicily, Al-Zahir (r. 1021–36) and Al-Mustansir (r. 1036–94), but minted by the local Kalbid emirs (fig. 135), the fresh Norman coins contained in Kufic script the *shahada* (the Muslim profession of faith: 'There is no God but God, Muhammad is the prophet of God') and a verse from the Qur'an. The reverse referred to Robert by his titles in Arabic – *bi-amr / Ubart al duqa / al-ajall malik / Siqiliyah* (by order of Robert the Duke, the very glorious ruler of Sicily) – the minting place and the Islamic Hijri year (AH 464/AD 1072). Roger had similar coins struck from the same year onwards that identify him as Count (*al-qumis*, a loan translation from Latin *comes*, meaning 'count') and 'Brother of the Duke', indicating his still subject position to Robert until the latter's death.[14]

Until his own death, Roger minted on Sicily new types of *tari* and *kharruba*, both of which show a T-symbol (fig. 136). Many scholars have speculated on the significance of this T. Some think it refers to the word *tari* itself, others that it is a reference to Trinacria, the old name for Sicily, or that it is an imitation of a coin from Tarentum (Taranto) of the fifth century BC, which might or might not have been known to the Normans. Most likely, however, the T represents a particular type of the Christian cross. Although less used at this time, this form was probably seen as less offensive to a Muslim population.[15] The legend on the coin remained in Arabic: a circular Kufic text, barely legible on surviving examples, but likely to be a verse from the Qur'an, and the name and titles of Roger – *bi-amr / al-qumis Rujjar / bi-Siqiliya* (by order of Roger, Count of Sicily). In contrast, the coins Roger struck in Calabria, where he also ruled, were all in Latin script.[16]

When Roger died at the age of seventy-two in Mileto in 1101, his eight-year-old son Simon took his title of Count of Sicily, although his widow Adelaide acted as regent until Simon was of age. As Simon died only four years later, his then nine-year-old brother Roger, who would become known to the world as Roger II, took his place and title, and in 1112, at the age of sixteen, became sole ruler of the island.

Fig. 135
Gold *tari* of the Fatimid ruler al-Zahir with the Muslim profession of faith, the *shahada*. The back reads 'struck in Siqiliya in the year 423' (AD 1031).
Diam. 1.4 cm.
British Museum, London.

Fig. 136
Gold *tari* of Count Roger (Roger I), minted in Messina or Palermo (1085–1101), imitating those of his Arab predecessors. However, the words of the *shahada* have been muddled up, creating a strange reading and indicating that the early Normans might not have understood what exactly they were copying.
Diam. 1.5 cm.
British Museum, London.

ADELAIDE DEL VASTO

*the great lady, the malika [queen] of Sicily and Calabria, the protector of
Christian faith ...*

Adelaide del Vasto (also known as Adelasia) was a noblewoman from Liguria, where her uncle
was marquis. Considered Lombard by contemporary sources, she was actually of Frankish
descent. Adelaide married Roger in 1089 or 90, when he was around sixty and she barely fifteen.
Nevertheless, she became a trusted and capable adviser, and also cleverly orchestrated political
marriages of her sisters and brother to Roger's children of his first marriage.

When Roger died, Adelaide was less than thirty years old. She proved to be a competent and
respected regent for her sons, after she forcefully crushed 'like earthenware dishes' initial rebellions
against her.[17] Although Roger had kept his main seat in mainland Mileto, Adelaide now resided
mostly at Messina, where she probably felt safer from potential threats from the other Norman lords
in Apulia and Calabria, many of whom were related through her brother-in-law Robert Guiscard,
but were keen to take advantage of the temporary power vacuum. She was sensible enough to
ask for assistance in ruling from local Sicilian officials that had been close to her husband.

Several official documents from her regency survive, but none as important or evocative as a
charter from 1109, which is the oldest surviving paper document in Europe (fig. 138). Although
paper had been introduced to Sicily by the Arabs, no documents on paper survive from the
Muslim period on the island, as official or important documents, such as the 'Palermo Qur'an' (fig.
130), continued to be written on parchment. It is interesting to note that already at the start of the
conquest, Roger took immense care with the administration of the newly conquered territory. A
group of specialists travelled with the count to draft and compile not only treaties of surrender, but
also terms for settlement. Land was booty to be distributed, but this did not mean that the workers
of the land were necessarily sent away. Instead, they now worked, often without interruption, as
villeins for new masters, as many of the more affluent Arab nobility had moved away from the island
(see p. 170). Roger needed the local population to continue working their lands, which they knew
intimately, so as not to destroy the agriculture, the wealth of the island. What is more, he clearly
employed Arabic-speaking officials and scribes from the pre-conquest Islamic administration, as
this charter by Adelaide shows. The bilingual decree, in Greek and Arabic, was issued at Messina
on 6 March 1109. In it, Adelaide, described in Arabic as 'the great lady, the *malika* of Sicily and
Calabria, the protector of Christian faith', instructed her local (probably Muslim) officers to protect
the abbey of San Filippo di Fragalà, near Enna.[18] This particular saint and the abbey were of special
significance to the regent, as San Filippo was thought to have cured her son Roger of a serious
ear illness.[19] Interestingly, although the Greek and Arabic texts say the same things, they are not
translations or paraphrases of each other. The official phrases and the clear structure show that
they are the work of professional scribes, who regularly drew up such decrees. For the Arabic, the
only people with such knowledge would have been scribes from the previous court. What is more,
the structure, the different dating systems (Julian and Byzantine calendars) and the terminology
in this early document show the first signs of what would become benchmarks of the perfectly
organized chancery, the royal *diwan*, which was to emerge under Roger II's rule (see p. 206).[20]

Adelaide stepped down as regent when her son Roger turned sixteen, but her political
influence was far from over. King Baldwin of Jerusalem, temporarily out of cash, requested her
hand in marriage in order to have access to a huge dowry as well as military support from wealthy
Sicily. Desperate to make her son a king, Adelaide consented on the condition that should the

Fig. 137
Baldwin renouncing Adelaide.
Detail from an illuminated
manuscript, 1337.
Bibliothèque Nationale de France,
Paris.

marriage be heirless (Baldwin did not have any children with his first wife and was rumoured to favour men), the crown of Jerusalem would pass to Roger. When Baldwin became gravely ill only six years later, the marriage was still childless, yet Roger was robbed of the crown by the vassals and Patriarch of Jerusalem, who (validly) claimed that Baldwin had never legally separated from his first wife. Adelaide was sent back to Sicily in humiliation, where she died a year later (fig. 137). Roger would never forgive the slight and would never support a crusade, nor would his successive son and grandson.[21] However, a King of Sicily did become King of Jerusalem a century later, when Frederick II, Adelaide's great-grandson, was the only crusader to peacefully negotiate the surrender of Jerusalem during a crusade.

Fig. 138
The so-called Letter of Adelaide, a decree from 1109, the oldest surviving paper document in Europe.
Archivio di Stato, Palermo.

Little is known of Roger II's childhood, but it is clear that he prepared for greatness, taught by Greek and Arabic tutors while growing up in the southern Italian courts, which were ridden with politics. Immediately upon his accession he became a force to be reckoned with in the Mediterranean. On Sicily he took control over Church matters, Greek as well as Latin, which greatly angered the then pope; before the age of eighteen he had negotiated peace treaties with emirs in North Africa;[22] and, most importantly, already from this very early age, he had aspirations for a kingship. The original de Hautevilles from Normandy, such as William, Drogo, and even Robert and Roger I, were, in origin and essence, parvenus. But Roger II had never even been to France,[23] and only knew the more cultured ambience of Sicily and southern Italy. Given his importance in and dominance over these parts, a crown seemed the logical next step – but only the pope could grant him that privilege. Already his mother had tried, in vain, to secure him a crown (that of Jerusalem; see pp. 176–7), but now Roger pursued the matter more actively, referring to himself as the 'son of a queen' (Adelaide had been Queen of Jerusalem) and marrying the daughter of a king (Elvira, daughter of Alfonso VI of Castile and Leon). In addition, upon the death of William, his nephew and the grandson of Guiscard, he cleverly and, thought by many, illegally, appropriated territories in southern Italy by right of inheritance, claiming himself to be 'Duke of Apulia, Calabria and Sicily'. The pope, who eyed those territories as well and had become disillusioned with the Normans, excommunicated him. So Roger, since diplomacy had failed, 'would now wrest by force of arms what he could not obtain by humble words'.[24] In the summer of 1128, Roger marched against the pope's forces of allied cities in southern Italy with an army of 2,000 knights, 3,000 infantry and 1,500 archers, so fierce that the pope surrendered without a battle. The conquest of the rest of dissident southern Italy took only another year and a half, although cities continued to rebel.[25] Roger was now even more hungry for a crown, and his right to it was seen by pro-Norman contemporaries as divine providence, as why else would God have allowed him to be so successful in battle? Such divine intervention for Roger's cause came through a contested papal election that led to the schism among the College of Cardinals of February 1130, when upon the death of the last pope some cardinals hastily elected Innocent II while others established Anacletus II. Since Anacletus needed powerful allies, Roger swore fealty to him, but only in return for a crown. As a new monarchy could not just be invented, a court of experts was summoned, who decided 'that kings had once resided in Palermo, who had ruled only over Sicily . . .'[26]

On Christmas Day 1130 Roger was crowned 'King of Sicily' in the Cathedral of Palermo. A monk who was present wrote:

> When the Duke had been led to the archiepiscopal church in royal manner and had there through unction with the Holy Oil assumed the royal dignity, one cannot write down nor indeed even imagine quite how glorious he was, how regal in his dignity, how splendid in his richly adorned apparel. For it seemed to the onlookers that all the riches and honours of this world were present. The whole city was decorated in a stupendous manner, and nowhere was there anything but rejoicing and light. [. . .] When the king went to the church for the ceremony he was surrounded by dignitaries, and the huge number of horses which accompanied them had saddles and bridles decorated with gold and silver.[27]

The concessions ceded by Anacletus II show how desperate he was for Roger's support. The papal bull postulated that Roger

> shall have and hold this kingdom, which shall take its name from the island of Sicily, with all

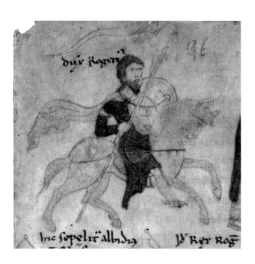

Fig. 139
Roger II on horseback, from the illuminated manuscript *Liber ad honorem Augusti sive de rebus Siculis*, written by Petrus of Eboli at the court in Palermo in 1195–7.

Burgerbibliothek, Bern.

the royal authority and dignity forever. We [the pope] also grant that you and your heirs may be anointed and crowned by the archbishops of your lands whom you choose for that purpose, assisted by such bishops as you desire. We hereby renew all gifts, concessions, and authority conferred upon you and your predecessors, [. . .] give and grant to you and your heirs the principality of Capua, [. . .] the lordship over Naples and its dependencies.[28]

As not all barons and local lords of the South recognized Anacletus as pope, over the next ten years Roger II continued subduing Calabria and Apulia. Eventually, after Anacletus II had died and the schism ended, Roger captured Innocent II in battle, forcing him to confirm his status and the previous edict. This was not the end of conflict between Sicily and the popes – the treaty had to be reconfirmed in 1143 and once more in 1156 by Roger's son and successor, William I.

Roger II's Kingdom

He brought peace to his kingdom that remained unshaken for as long as he lived . . .
SO-CALLED HUGO FALCANDUS, ANONYMOUS HISTORIAN AT THE
NORMAN COURT, PROBABLY 1180s–1190s[29]

Even though kingship was claimed by Roger II to have existed in Palermo before, this new Norman monarchy had to be built from scratch and presented as legitimate.[30] In fact, every aspect of the kingdom was orchestrated and deliberately created, and it appears that Roger knew exactly what he was doing. The new kingship was to be autocratic and dictatorial, and Roger relied closely on a few loyal officials at his court, rather than on local vassal barons. Roger's Kingdom of Sicily was to eventually rival the splendour and military aptitude of the Byzantine Empire, the lustre and administrative competence of the Fatimid Caliphate of Egypt, and the diplomatic skills of northern European courts, such as France and England, which were admired, feared, and/or respected by all. As a new superpower, Sicily managed to bring Constantinople and the Byzantine emperor to their knees in 1149, when they had joined forces with the Holy Roman Emperor to take the kingdom; in addition, Roger conquered parts of Ifriqiya from the ruling Zirids, founding the Norman 'Kingdom of Africa'. Scholars from all over the world and of all religions visited his court at Palermo, which became a centre for learning and invention.

The new kingdom had to appeal and be familiar to the different cultures that had been present on the island for centuries, as well as be approved by the new Norman and Latin elite. Therefore, Roger's apparent complete disinterest in anything but Greek and Byzantine before his coronation is very striking, and one gains the impression that, at first, the Byzantine Empire was the sole model on which he wanted to base his own, perhaps as a response to his continuous trouble with the pope. Arab and Latin/Italian elements only entered his political and visual vocabulary after his coronation, the true reasons for which have never been fully understood. Muslims still comprised the majority of the population and even though they mostly made up the lower and middle classes it was important for the king to have their sympathy. Also, Roger had more and more dealings with the courts in North Africa – Zirid Ifriqiya and particularly Fatimid Egypt – and came to realize the strengths of their institutions, the splendour of their courts, and the learnedness and prestige of their scholars. In the end, Roger deliberately combined elements from the great superpowers of the time – Rome, Constantinople, Fatimid Egypt – to make it clear visually to others that he was, or at

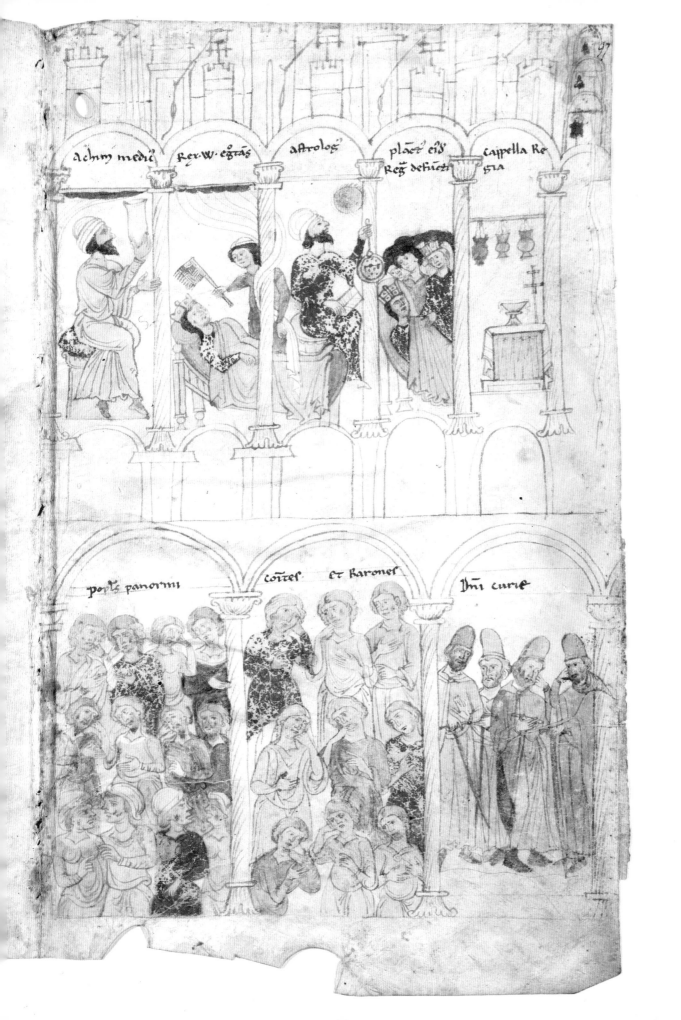

achim medic̄ Rex·W·egͭas astroloḡ placͭ eiſ Cappella Re
 Reḡ deꝼūcͭ gia

poꝑ̄ł panormͤ coͤteſ ᵉͭ Baroneſ ᵭͭi curie

least on his way to being, equal in every respect. The new kingdom was therefore not just a combination of cultural elements already present on the island but a deliberate creation of something new that would both inspire and awe his own subjects as well as foreigners.

This kingdom that Roger II created would survive under his two successors, his son William I, and William's son, William II. At the age of thirty William I inherited a blossoming island that had withstood attacks from Germany, the pope and Byzantium. He was a capable ruler, who had been appointed co-ruler on Easter Day 1151, crowned by Roger himself, without consulting the pope and making use of the privileges granted to him.[31] Once again, the pope, the Holy Roman Emperor Frederick Barbarossa and the Byzantine emperor all saw the change as a new opportunity to try to take Sicily, but William proved to be a capable military leader. Aided by his vizier and supreme commander Maio of Bari, he annihilated the Byzantine fleet in May 1156, and a month later forced the pope to reconfirm his title of king; Barbarossa did not think it worth the trouble any more. A coup by the Sicilian barons in 1160/1, unhappy with Maio's influence and supported by William's eldest son Roger, saw the king captured by the conspirators for a while. The army and the people, loyal to William, however, managed to break him free, after which he came down hard on the rebels. Upon William's death in 1166, his heir and son William II was just eleven years old, and was therefore placed under the regency of his widow Margaret of Navarre, until young William came of age in 1171. William II later received the nickname 'the Good' because of his affable character, his love of luxury and leisure, his general shying away from matters of state, but mostly because of the twenty years of perceived peace under his rule. Yet, he emerged as an able diplomat when it mattered and was not afraid to take drastic measures. When the old feud with Byzantium was taken up again, William's army almost reached Constantinople, but was eventually defeated. A peace treaty was signed only months before his death in November 1189. William was truly loved by the people of Sicily, and at his premature death at the age of thirty-four the whole island was in mourning (figs 140 and 181), not just because their beloved king had died but because there was no immediate heir, and some feared the end of semi-tolerant, multicultural and prosperous Sicily.

Images of Power

Only a few contemporary portraits of Roger II, William I and William II survive today, apart from those on coins and seals, all of which were officially issued by the court itself: they suggest how the kings wanted to be represented. The earliest surviving representation is a small metal inlaid plaque from the baldachin of the Basilica of St Nicholas in Bari, on the Italian mainland (see fig. 142). Byzantine Bari, one of the most important and rich harbour cities of Italy, had been troublesome for the de Hautevilles ever since they set out to conquer the South, having to be reconquered over and over again every time another Norman or Lombard prince rebelled. Its strategic importance was ultimately the reason it was wanted by everyone, and one of the first documented presences of Normans in the South was when they helped a Lombard noble in trying to take Bari from the Byzantines (see p. 173). The basilica itself was founded in 1087, when merchants brought the relics of Saint Nicholas from Myra (south-west Turkey; then in Byzantine territory) – a saint who was also popular in France, so that he personally appealed to the Normans, especially Roger I.[32] Bari became an important place of pilgrimage and a stop for anyone travelling to the eastern Mediterranean, boosting its economy.

Roger dealt with rebellions in Bari in 1129 and 1132, but the city was taken in 1137 by the Holy Roman Emperor Lothair III, who had joined the pope in yet another attempt to capture Sicily. Roger emerged victorious two years later, and this dedicatory plaque to decorate

Fig. 140
Palermo in mourning at the death of King William II, from the illuminated manuscript *Liber ad honorem Augusti sive de rebus Siculis*, written by Petrus of Eboli at the court in Palermo in 1195–7.
Burgerbibliothek, Bern.

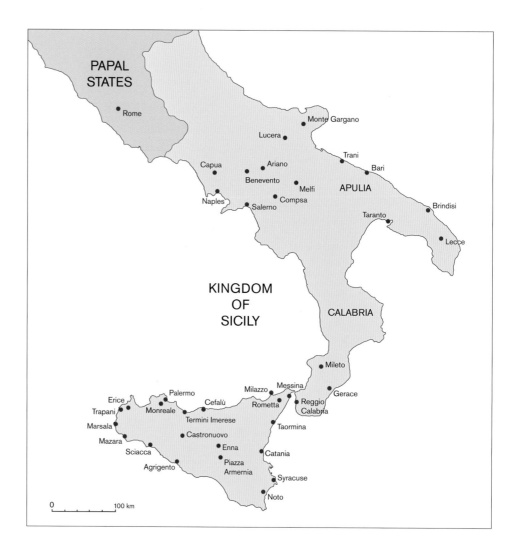

the *ciborium* (baldachin) of the basilica probably dates to just afterwards. The plaque does not necessarily depict a coronation scene, as might at first be thought; instead, Saint Nicholas only holds the crown above Roger's head, a gesture signifying that the king was under the saint's and heaven's protection. Both are identified by accompanying Latin inscriptions. The scene is one commonly found in Byzantine iconography, and shares many of its details: Roger wears the ceremonial Byzantine dress, a *loros* (a type of sash wound around the shoulders, waist and left arm) over a tunic. He holds Byzantine regalia: the orb and the *labarum* (a banner with the cross). In this depiction, Roger could easily be mistaken for a Byzantine emperor. However, the crown has a Western-style diadem, the script is Latin, not Greek, and Roger is depicted with long hair and beard, at a time when this was uncommon for Byzantine emperors.[33] The long hair has been explained in a variety of ways. Roger might have depicted himself resembling Christ, a strong statement emphasizing his elevated position and his protection from God.[34] Or it could be that Roger deliberately kept his hair long to signal his difference from the contemporary Byzantine emperor, with whom relations were tense, especially in a city with a strong Byzantine past. Perhaps he was deliberately showing himself as Frankish, among whom long hair and beard had been common.[35] A more recent hypothesis favours the latter explanation, and links it to a decorative motif on the *loros*: what are usually identified as

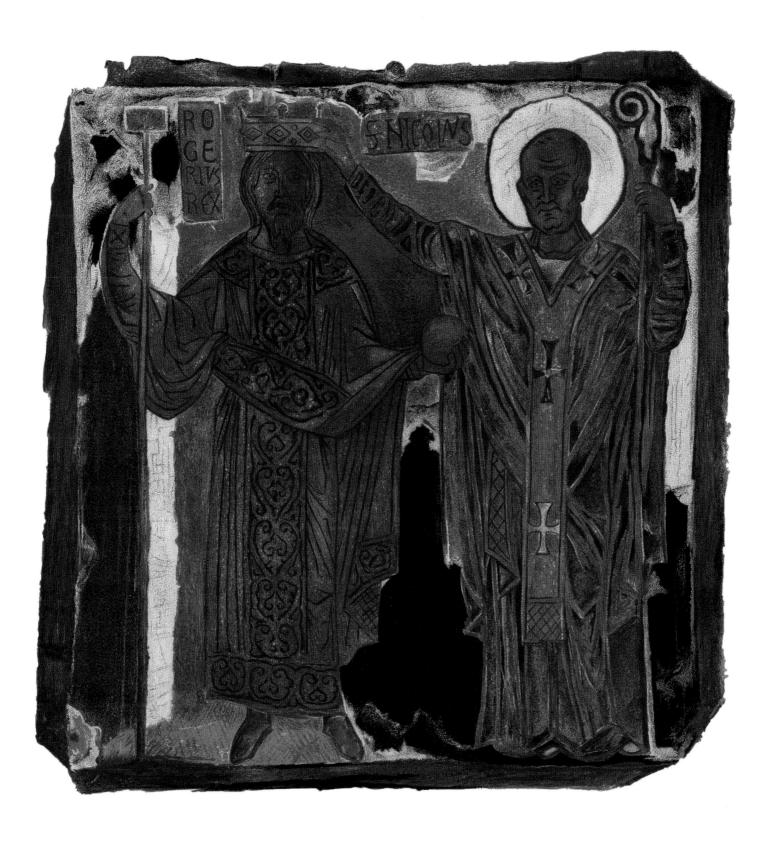

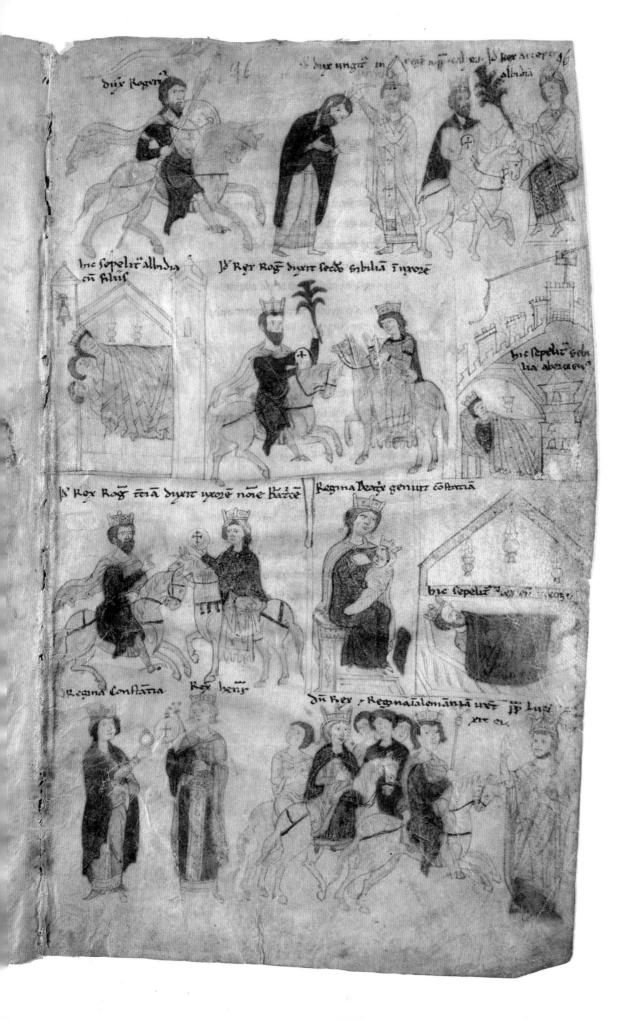

Fig. 143
Page from the illuminated manuscript *Liber ad honorem Augusti sive de rebus Siculis*, written by Petrus of Eboli at the court in Palermo in 1195–7, showing (from left to right and top to bottom) Count Roger (Roger II) on horseback; Roger's coronation; Roger marries Elvira of Castile (his first wife); death of Elvira and children; Roger marries Sibylla of Burgundy (his second wife); death of Sibylla; Roger marries his third wife, Beatrice of Rethel; Beatrice and daughter Constance at death of Roger; marriage of Constance to Henry VI; Henry and Constance with Pope Lucius III.
Burgerbibliothek, Bern.

crosses could be more stylized renderings of the fleur-de-lis, the regal motif used in France since the ninth century, but adopted more prominently by the contemporary King of France.[36] This is an attractive hypothesis, especially since another *loros* on a now-lost mosaic portrait of Roger from the Cathedral at Gerace (Calabria) was described in the sixteenth century as 'bordered with gold lilies'.[37] Even though Roger had never visited his ancestral land, the Norman French dialect was the language spoken mostly by the king,[38] and one contemporary historian recorded that Roger, 'since he derived his own origin from the Normans and knew that the French race excelled all others in the glory of war, he chose to favour and honour those from the north of the Alps particularly' (that is, French-Normans as well as Anglo-Normans).[39] In fact, after his first wife Elvira had died, Roger remarried twice (but only after fifteen years and four of his five sons had died), both times to French noblewomen.[40]

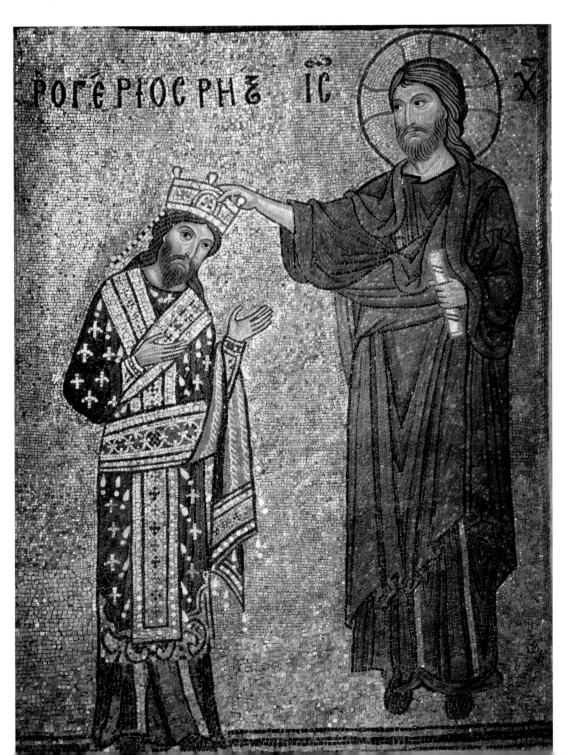

Fig. 144
Roger being crowned by Christ. Mosaic from Santa Maria dell'Ammiraglio, Palermo, 1140s.

Fig. 145 (top)
Gold *tari* of Roger II minted
in Salerno (1130–54), with
Arabic legend 'Roger,
protector of Christianity'.
Diam. 1.8 cm.
British Museum, London.

Fig. 146 (above)
Gold *tari* of Roger II, minted
in Palermo (1130–54),
showing an equal-armed
cross, with legend IC XC /
NI KA (Jesus Christ
Conquers).
Diam. 1.4 cm.
British Museum, London.

The image on the dedicatory plaque is similar to another representation of Roger that survives (fig. 144), from the church of Santa Maria dell'Ammiraglio in Palermo, founded in 1143 by Roger's vizier, George of Antioch. In line with George's own Eastern Orthodox religion, the church was built on a Greek Cross plan, but was later expanded to contain a narthex to house the tombs of George and his wife. Many of the original mosaics dating to 1143–51 survive in and around the dome (see also below), while two dedicatory mosaic panels were taken from their original locations when the church was expanded just after George's death and inserted into the later additions. One of the panels shows George of Antioch himself kneeling before the Virgin Mary, and presenting a petition to her (fig. 148); the other shows George's king, Roger II, crowned by Christ. The messages of these panels are clear: George dedicated the church to the Virgin Mary as an act of personal piety, but at the same time it acted as a political monument to the reign of the king.[41]

At first sight the two representations of Roger – the one in Bari and the one in Palermo – look almost identical. Details, however, indicate inconsistencies with each other and with what one would expect. In the Palermo panel, Roger is identified by an inscription in Greek script, but in Latin language (*Rogerios Rex*). Furthermore, here Christ is crowning Roger rather than just holding the crown above his head, a clear indication that Roger received the kingship with divine approval. However, Roger wears an outdated crown with *pendilia* (in Constantinople at the time, the emperor wore a closed hemispherical bowl-crown) as well as an antiquated style of *loros*, worn over the shoulders, rather than in front. The motif of the *loros* is the same as on the Bari plaque, and could possibly depict lilies rather than crosses. This outdated outfit is often explained as being the work of an artist, local perhaps, unfamiliar with Byzantine iconography and basing himself on older models.[42] But to have two, possibly three (including Gerace), depictions that are similar in style and all show clear divergences from contemporary Byzantine iconography should tell us that there is more to it. In Bari, on mainland Italy and with a strong Byzantine past and present, Roger looks like the contemporary emperor and deviations from the norm are more subtle: the long hair, the Latin script, possibly the fleur-de-lis. But in Palermo, his own capital, and five to ten years later, he clearly distanced himself from the contemporary image of the Byzantine emperor, with whom in the late 1140s tensions were at an all-time high, by the use of antiquated robes and crown, and Latin presented in Greek script. Such subtleties and variations in officially issued portraiture cannot be accidental, or merely the failure of unfamiliar artists, especially since Roger himself had been brought up in the Greek Byzantine milieu of southern Italy and Messina. His tutor Christodoulos had even been awarded the title of *protonobilissimos* by the Byzantine emperor, a title that reflected precise knowledge of Byzantine history and court.[43] Deliberately, rather than just imitating the image and rule of the Byzantine emperor, Roger used these depictions to undermine Byzantine culture and revamp it as something new.[44]

As Count of Sicily, before he became king, Roger continued minting the *tari* and *kharruba* with the T-symbol, which became more and more stylized over time. His titles appearing on the coinage often included the word 'second', written out completely in Arabic (*al-thani*), which he was both as Count and as the second of importance in the family to be named Roger.[45] The coins underwent heavy changes, first after the coronation, and secondly after 1140, the tenth anniversary of his reign. Although coins with Arabic legends continued to be minted, both on the mainland and on Sicily, the visual imagery became much more dominantly Byzantine Christian (fig. 145). One of the new types of gold *tari* no longer showed a stylized T for a cross, but a true cross filling the field of the coin, with the inscription 'IC XC / NI KA' (Jesus Christ Conquers) accompanying it (fig. 146).[46] Roger was no longer 'second' but 'king' (*malik* in Arabic); and the Arabic profession of faith was dropped completely.[47] Silver

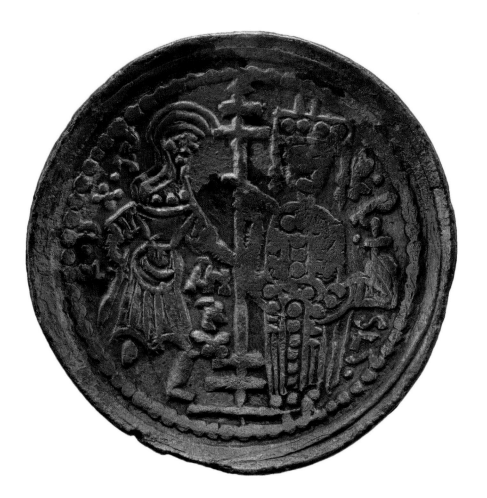

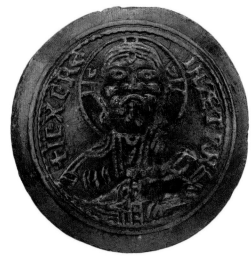

coinage continued to be minted in the form of the *kharruba*, but after 1140 Roger additionally created the *ducalis* (ducat). The *ducalis* was purely Byzantine in design and form, showing a bust of Christ on one side, and Roger himself with his son (also called Roger) on the reverse, in Byzantine dress and regalia (fig. 147).[48] But Roger made the greatest changes in copper coins. Until his reign, copper coinage, in the form of the *follaro*, had been minted only on the mainland. Now, *follari* started to be minted on Sicily as well. Roger was shown again in the same Byzantine dress and crown and holding Byzantine regalia as on the *ducalis*.[49] Clearly, the *follaro* and the *ducalis* were modelled on Byzantine coinage, reflecting the continuing Byzantine presence and influence in trade and economy in the South and on Sicily.

Fig. 147
Silver *ducalis* of Roger II, minted in Palermo. Obverse: a bust of Christ with legend '+IC XC RG' and 'IN ÆTERN', for '*Iesus Christus regnat in aeternum*' (Jesus Christ reigns forever). Reverse: Roger II in Byzantine dress with his son Roger, and legends 'R DVX AP' and 'R R SLS', for '*Rogerius Dux Apulie*' (Roger Duke of Apulia) and '*Rogerius Rex Sicilie*' (Roger King of Sicily), as well as, between the two figures, 'AN [ligatured] R X' for '*anno regni decimo*' (in the tenth year of his reign), i.e. 1140. Eventually the *ducat* was adopted by Venice and became one of the most important currencies of many nations in the later medieval world, up to the twentieth century (see p. 260).
British Museum, London.

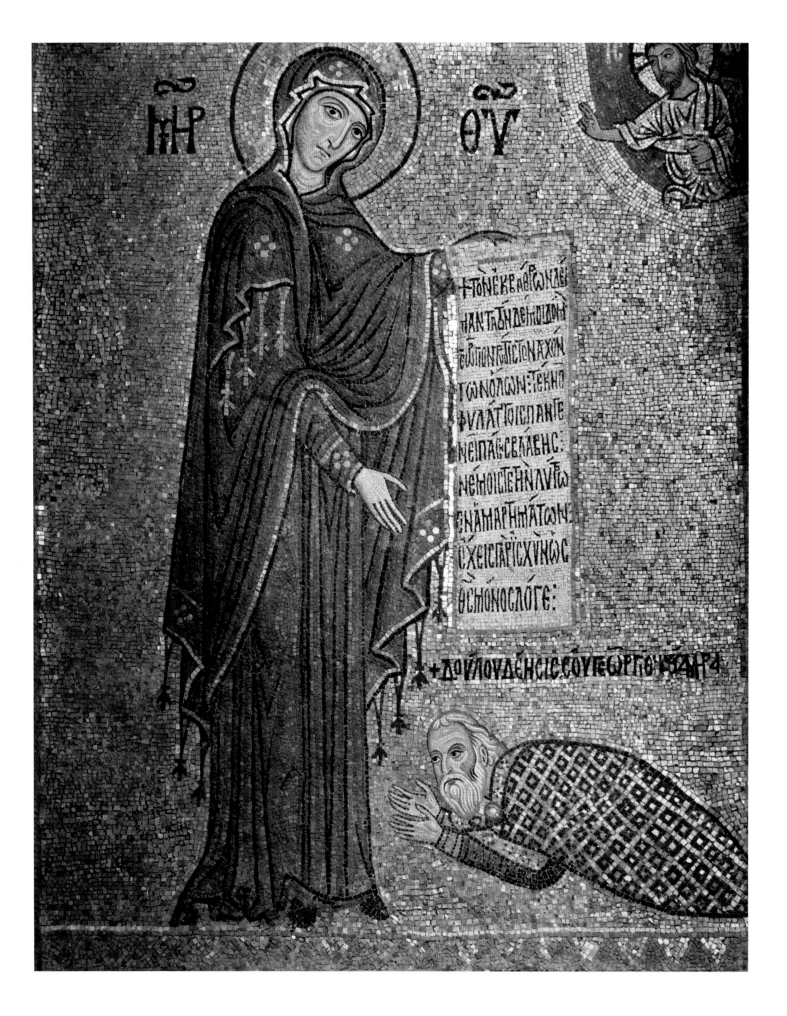

Architecture of Power: Churches and Palace

For its public building programme, the new kingdom also looked to Constantinople, but it mixed those influences with elements from the Islamic world. Instrumental in the introduction of Arab elements to the court was George of Antioch (fig. 148), Roger's most trusted adviser. George, a Greek or Syrian from Antioch, had been a minister at the Zirid court of Ifriqiya, but after a falling-out escaped in secret to Palermo. His Greek-Arabic bilingualism and his diplomatic skills meant he quickly rose in the ranks, and he acted as Roger's ambassador to the Fatimid caliphs in Cairo on several occasions between 1115 and 1125. To George are attributed the introduction of an Arabic system of administration for the new kingdom (see below), as well as the reintroduction of Islamic, mostly Fatimid, artistic influences in art and architecture.[50] In 1124 he was made *amiratus*: in essence the vizier, the greatest authority over the kingdom after the king, the title being a clever Latinization of the Arabic word 'emir' while also evoking the Latin *admirare*, 'to respect', thus meaning 'he who is admired'.[51]

Santa Maria dell'Ammiraglio (commonly called 'La Martorana' after the foundress of an adjacent convent), the church George founded himself, serves as a perfect example of the new hybrid style.[52] As mentioned earlier, it was constructed on a Greek-cross plan (cross-in-

Fig. 148 (opposite)
George of Antioch in front of the Virgin Mary. Mosaic from Santa Maria dell'Ammiraglio, Palermo, 1140s.

Fig. 149
Palermo: in the foreground, the church of San Cataldo, built by William I's *amiratus*, Maio of Bari, *c.*1154–60; behind it, the church of Santa Maria dell'Ammiraglio, *c.*1143–51.

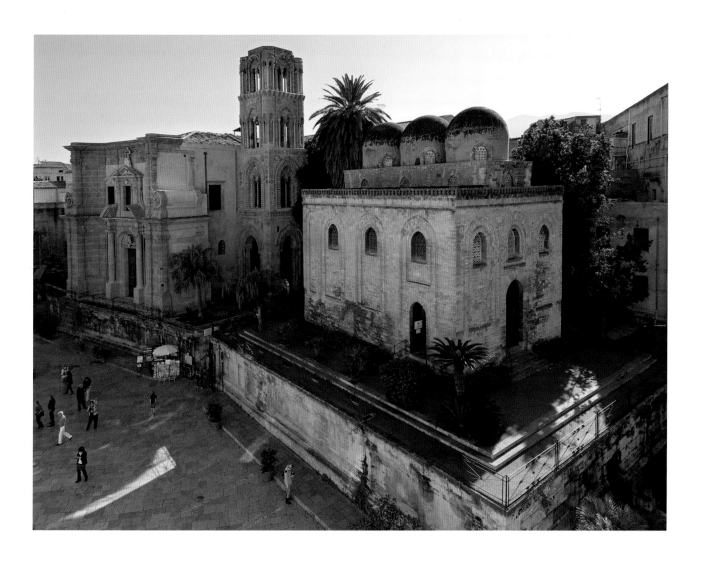

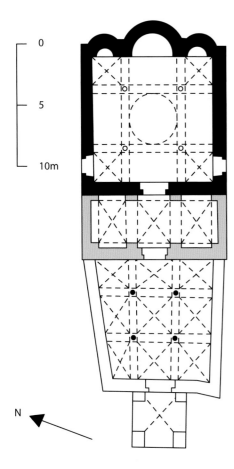

Fig. 150
Plan of Santa Maria dell'Am-
miraglio at the end of the 12th
century: the Byzantine-style
cross-in-square church (black)
with the narthex (grey) that
originally held the founding
mosaics; after George's death
in 1151 an additional atrium
with campanile (bell tower;
both white) was added.

Fig. 151 (opposite)
The monastery and church of
San Giovanni degli Eremiti,
Palermo, were built between
1130 and 1148, incorporating
elements from previous
buildings on the site.

square), common in middle to late Byzantine architecture (fig. 150).[53] The interior decoration is almost entirely preserved, showing marble-clad walls and inlaid marble floors, as well as a spectacular Byzantine-style iconographic programme of mosaics: a Christ Pantocrator in the dome, four archangels underneath, as well as the eight prophets of the Old Testament, four evangelists, a Nativity scene and the Dormition of Mary. Yet, the dome rests on squinches, common in architecture of Islamic lands, and the shallow niches of the exterior walls, framed with concentric arches, also have parallels in Islamic tradition.[54] The pointed, or ogival, arches, which became a common feature of Sicilian architecture under the Normans, was at this time also starting to be used in European Gothic architecture, but had their origins in Islamic architecture, especially used as a non-structural feature.[55] The dedicatory inscription crowning the exterior of the building, while in Greek, in concept and architectural form is identical to such inscriptions from Muslim North Africa. Even more closely referencing Islamic architecture is the campanile (bell tower), which originally had one large central dome and four miniature domes crowning the corner turrets, a feature found on minarets in contemporary Islamic Spain and Ifriqiya,[56] plus the various Arabic inscriptions found within the church, one running along the bottom of the dome (a verse from Byzantine, Greek Orthodox liturgy, but written in Arabic) and others painted on columns, referring to the king and his vizier.[57] It is no surprise then that the building was thus described (in 1189) by a Muslim traveller:

One of the most remarkable works of the infidels that we saw was the church known as the Church of the Antiochian. [. . .] It is beyond dispute the most wonderful edifice in the world. The inner walls are all embellished with gold. There are slabs of coloured marble, the like of which we had never seen, inlaid throughout with gold mosaic and surrounded by branches [formed from] green mosaic. In its upper parts are well-placed windows of gilded glass which steal all looks by the brilliance of their rays, and bewitch the soul. [. . .] We learnt that its founder, after whom it was named, spent hundredweights of gold on it. He had been vizier to the grandfather of this [. . .] king.[58]

Another Palermo church dating to the same period is San Giovanni degli Eremiti (fig. 151), which was built in 1130 on the remains of a sixth-century church and an earlier mosque. This time the ground plan of the church is a Latin cross, Western European rather than Byzantine in style, with a long nave and two aisles ending in three apses, one of which is topped by the belfry. Nothing of the interior decoration survives. The whole church was surmounted by five domes with small windows, in Islamic style. Today, these domes, like almost all these types of domes in Palermo and Sicily (as many similar twelfth-century buildings remain), are painted red, based, however, on an incorrect nineteenth-century interpretation. Instead, these domes were likely to have been left white or a soft beige.[59]

The true marriage of different architectural and decorative styles, however, is best gauged from the one building that was closest to the Norman kings. The royal palace (commonly called the Palazzo dei Normanni today) was built on the *arx*, the highest point of Palermo, which is a rock south-west of the harbour, overlooking the old city that lies in-between. Phoenician walls have been found in the substructures of the palace, and it is generally believed that the Aghlabid emirs also had their primary residence here, although actual architectural remains of it have never been found. The building was completely restructured and rebuilt by the Normans. Afterwards it was altered and added to continuously, and it remained the residence of rulers and viceroys (including French, Spanish and Bourbon) from the later Middle Ages to today; it is still the seat of the Regional Assembly of Sicily and houses the office of the President (fig. 119). Because of their splendour and magnificence, several of the original Norman structures and their decoration were deliberately maintained

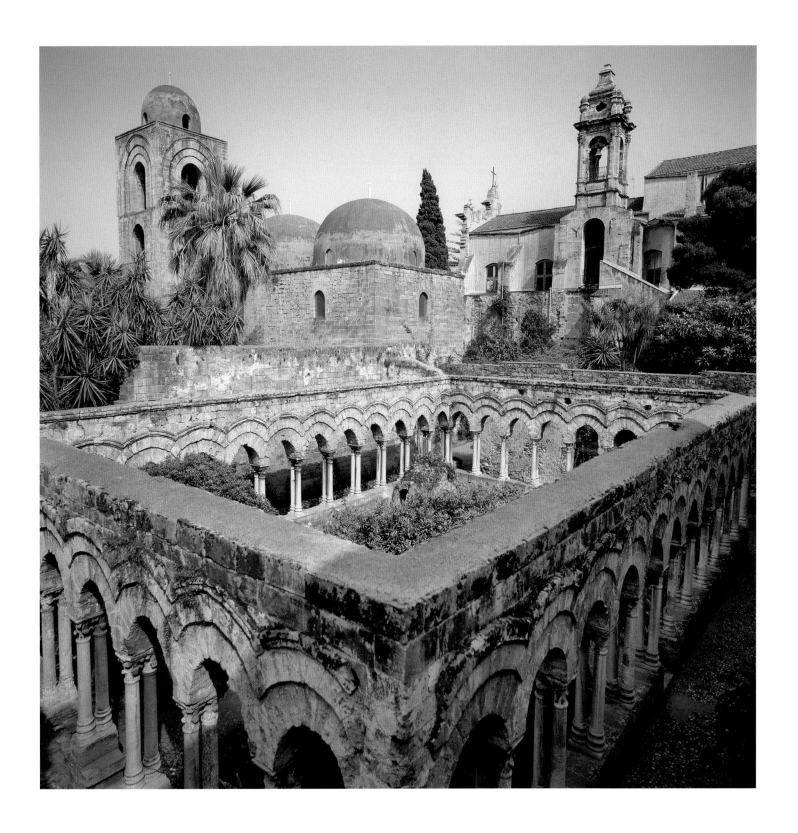

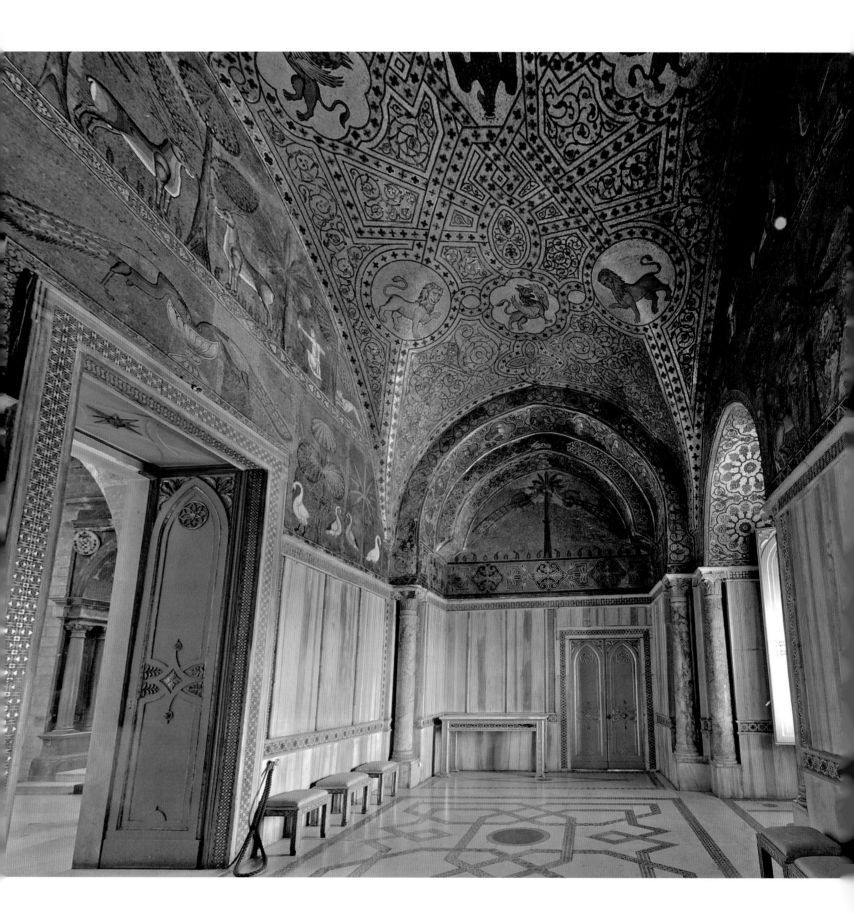

in their original state, but now appear as dismembered components within a more modern building, nevertheless making the palace one of, if not the best, preserved royal residence of the Middle Ages.[60] The palace was also mentioned numerous times in contemporary literature, from which some of the history and details of missing parts can be gained. It appears that immediately upon capturing the city in 1072, Robert Guiscard and Roger I took up residence on the *arx* and built a chapel and a brick tower (the 'Red Tower', which no longer survives).[61] The palace was called 'Castrum Superius' and 'Palatium Novum' (New Palace), seemingly to distinguish it from the Khalisa and the 'Castrum Vetus', the 'Old Fortress' by the harbour, which the Normans also rebuilt (see fig. 126).[62] One description, datable to 1154, the year of Roger II's death, states that

> at the highest point of the Cassaro [see p. 160 and fig. 126] a fortress was recently built for the great King Roger, with enormous blocks of cut stone and covered with mosaics. [. . .] its towers and outlooks are high and well aligned and of very solid construction, like the various mansions and rooms that it contains. These last are decorated with the most beautiful calligraphic motifs and covered with remarkable paintings. All travellers confirm the splendour of Palermo and describe it with exaggerated statements. They claim resolutely that outside Palermo there are no other buildings more magnificent [. . .] or any palace more imposing . . .'[63]

Of course, the buildings and some of the decorations were subsequently modified by William I and William II, who adapted the residence to their own tastes. A later source, probably Hugo Falcandus, writing shortly after the death of William II in 1189, gives even more detail:

> The New Palace [. . .] built with amazing effort and astonishing skill [. . .]; the outer side has walls which wind far and wide, the inner side is remarkable for its great splendour of gems and gold. On one side it has the Pisan Tower, assigned to the protection of the treasury, on the other the Greek Tower [. . .]. The part of the palace called Joharia [from Arabic jawhariya, meaning 'Jewel Room'] glorifies the middle section; it is particularly beautiful, sparkling with the glory of many kinds of adornment, and the king used to spend his time there intimately when he wanted to enjoy peace and quiet. Over the rest of the site there are spread various mansions placed all around for the married ladies, the girls of the harem, and the eunuchs who are assigned to serve the king and queen. There are some other smaller apartments there, shining with great beauty, where the king either discusses the affairs of the state in private with his intimates [familiares], or invites the notables to talk about the great public affairs of the realm.[64]

The surviving parts of the palace attributable to Roger II probably date from after his coronation when he started to spend all his time in Palermo. They include two of the look-outs, the so-called 'Greek' and 'Pisan' Towers (the names are original, but their meanings lost), the latter acting as the treasury on the ground floor, and the former as one of the state rooms on the first floor; and the Joharia, the most luxurious of apartments, where splendid mosaics from the time of William I still survive in the so-called Room of Roger, another state room (fig. 152). These mosaics are among the very rarely surviving secular mosaics of the Middle Ages, and show the common and shared medieval Mediterranean motifs that when put together became so typical of Norman Sicilian art: the Tree of Life, flanked by panthers (fig. 153) and peacocks, hunters and centaurs, all interspersed with lions, which from early on had become the de Hauteville heraldic symbol (Roger specifically was often compared to a lion, the 'strongest of beasts').[65] Depicted here were the enclosed pleasure gardens that bordered the palace to the west, modelled after the gardens of Muslim rulers in the East, particularly Baghdad,[66] considered representations of Paradise on earth (see pp. 222–3).

Fig. 152
The so-called Room of Roger, a state hall at the centre of the Joharia in the Norman palace in Palermo. The mosaics date to the reign of William I (1154–66).

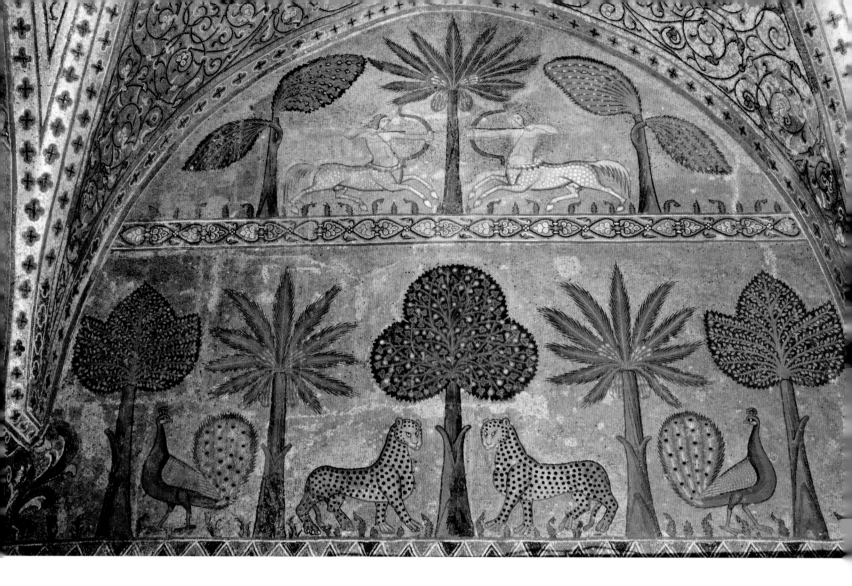

Fig. 153
Detail of a mosaic in the Room of Roger, showing leopards, peacocks and centaurs, around date palms and orange trees.

Fig.154 (opposite)
Wooden inlaid ceiling panel from the Norman palace, Palermo, 1130–1200.
H 1.34 m.
Galleria Interdisciplinare Regionale della Sicilia di Palazzo Abatellis, Palermo.

Apart from the Room of Roger, barely any interior decoration of the residential parts of the palace still survives, with the exception of an inlaid wooden panel, now detached and housed in the Galleria Regionale della Sicilia di Palazzo Abatellis in Palermo, which gives us a real idea of the abundance and the intricate details that the sources describe every surface as displaying (fig. 154). The panel is itself assembled from several individual pieces, creating a complex geometric design by intersecting quadrangles around an eight-pointed star, the Islamic motif of the *girih* (knot), in so-called *Kassettenstil*, a technique developed in the workshops of Fatimid Egypt. Each compartment shows animals usually associated with court circles, either as curiosities or pets, for hunting, or as heraldic symbols: there are hares and deer being hunted by wolves and lions, peacocks on either side of a Tree of Life (which had become a common motif in Sicilian-Norman art, see pp. 215–17) and eagles and double-headed eagles, which, as well as the lion, became a de Hauteville heraldic symbol. There is no consistency in the direction in which the scenes are shown, indicating that this was a ceiling panel designed to be seen from below.[67]

The 'remaining space' between the Pisan and Greek Towers and closest to the Joharia was taken up by the Chirimbi, which, according to Falcandus, were 'mansions for the married ladies, the girls of the harem, and the eunuchs', built by either Roger II or William I,[68] and by what is the most spectacular building of Norman Palermo and Sicily, and one of the most

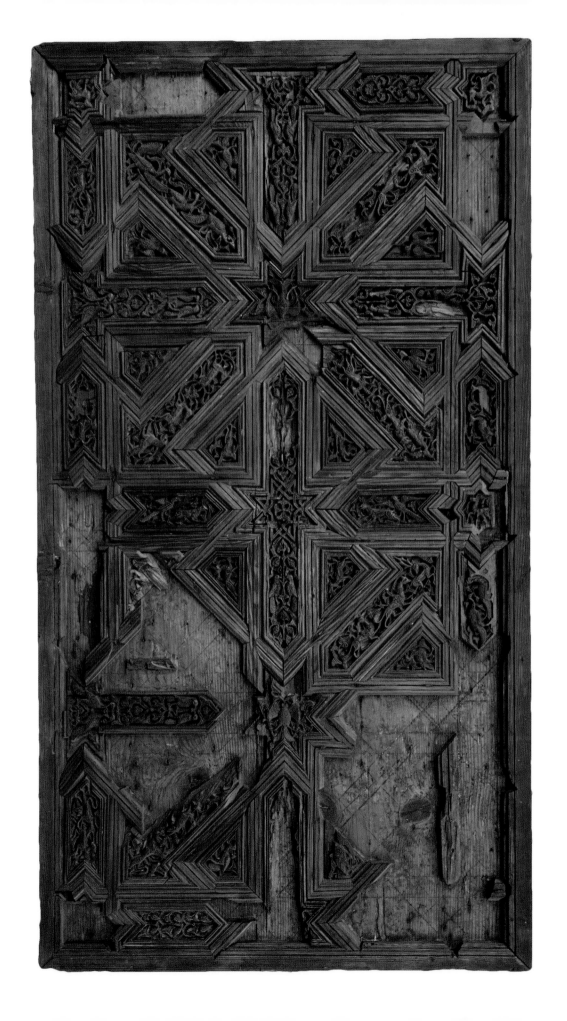

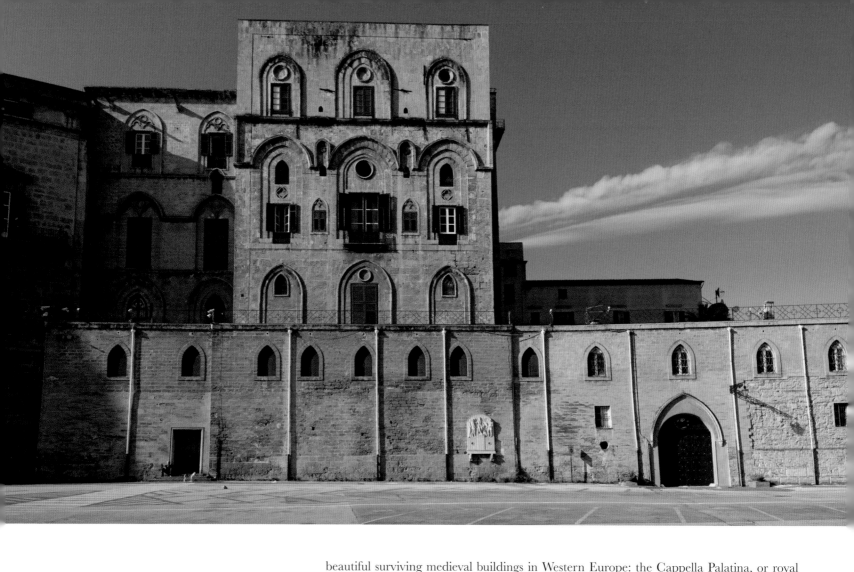

Fig. 155
Outside view of the Joharia
(left) and Pisan Tower (right) of
the palace in Palermo.

beautiful surviving medieval buildings in Western Europe: the Cappella Palatina, or royal chapel. Commissioned by Roger shortly after his coronation and inaugurated in 1143 (not all the mosaics had been completed by this time),[69] the Cappella Palatina stood at the centre of the palace and acted as its focal point, in space as in function. It was built on top of the earlier chapel, which became the new chapel's crypt, Roger II thus symbolically and literally surpassing the glory of his father and uncle, Roger I and Robert, while also honouring their legacy.[70] As designed and executed under Roger, the Cappella was in essence a combination of two buildings. To the east, the domed *naos* served as the church, the setting for the liturgy, an altar set in its apse. It was built on the Byzantine 'domed basilica' plan, similar to the Greek cross-in-square plan, with the choir surmounted by a dome on squinches, and with two side chapels to the north and south, also ending in apses.[71] The decorative programme is thoroughly (Middle-)Byzantine, with a Pantocrator in the dome, underneath which are angels, prophets, evangelists and saints, and scenes from the life of Christ, all brilliantly coloured on a golden background. The whole decorative scheme was executed by Byzantine artists, who were brought from Constantinople to complete the work.[72] Not only is the style of the mosaics thoroughly Byzantine, but a Greek inscription runs along the bottom of the dome, and mosaic figures are identified by Greek inscriptions. The northern chapel of the *naos* was linked to the private royal apartments on a higher level (the Pisan Tower and later the Chirimbi), creating a viewing balcony or 'royal box' from which the king could watch the liturgy and religious festivals celebrated in the church.

To this Greek church, a long hall was joined on its western side, composed of a central nave, flanked by two colonnades of high arches above which was a clerestory, and two side aisles. Against the western wall of this Latin basilica, an enclosed throne platform (the throne itself was probably portable) was installed, and above it mosaics of heraldic lions as well as Christ flanked by Saints Peter and Paul.[73] The walls were clad in marble panelling – mainly white and green marble, and especially purple porphyry, purple being the imperial colour since the Roman Empire. Some sections of the walls, as well as the entire pavement, were in *opus sectile*, decorative geometric designs formed by cut pieces of coloured marble and glass, in a style generally referred to as Cosmatesque, after the most famous family of craftsmen from Rome of the early thirteenth century. *Opus sectile* had been around since Roman times, but these motifs – such as the *quincunx* (four circles around one central one) and the *guilloche* – were inspired by Byzantine art. Alongside these (curvilinear) Byzantine patterns, other motifs were clearly taken from (rectilinear) Islamic art, where the star-pattern was omnipresent, as already seen in the inlaid wooden ceiling panel of the royal palace (fig. 154).[74] Comparisons with *opus sectile* pavements from southern Italy has raised the likelihood that master craftsmen from the area of Salerno, in Campania, were brought to Palermo to construct the floors of the chapel.[75] The wall mosaics of the nave clerestories and side aisles are among the most famous medieval mosaics in the world. The narrative sequence of scenes from the Old Testament in the nave and the lives of Saints Peter and Paul in the aisles, accompanied with captions in Latin, perhaps finds its nearest modern parallel in comic books or graphic novels. The spandrels of the colonnades show important bishops, and the insides of the arches show saints. However, the mosaics of the hall were inserted at a later stage, under William I or William II, thus changing the original function of the space.[76]

To imagine, today, this hall without the mosaics is not an easy task, especially since the original decoration of the walls remains unknown. However, there is ample evidence that under Roger II the gallery functioned as a royal audience hall rather than a church. Seated on the royal throne on a raised dais, Roger would be positioned immediately below Christ, who, of course, gave him royal legitimacy; in front of him, a large empty space could accommodate his subjects and petitioners. From a second balcony, this one into the nave, but connected to the private apartments as well, women and children could follow the ceremonies and receptions. Above all, however, the combination of Greek mosaics and Italian floors with the numerous distinctly Islamic elements in the hall make it a mini-display of his kingdom. Two Arabic inscriptions in marble *opus sectile* survive, which originally framed the hall's doorways but were later reused in other positions. They are obvious examples of what one visitor described as 'wonderful and rare calligraphy' (see above). Even though fragmentary, some of their phrases can be reconstructed. One is of particular interest, as it reads '[. . .] kiss its corner after having embraced it // and contemplate the beauty that it contains [. . .]' (fig. 156). Not only is the

Fig. 156
Marble slab with inlaid Arabic inscription in green and red porphyry, from the Cappella Palatina. 1130s–40s.
W 1.84 m.
Galleria Interdisciplinare Regionale della Sicilia di Palazzo Abatellis, Palermo.

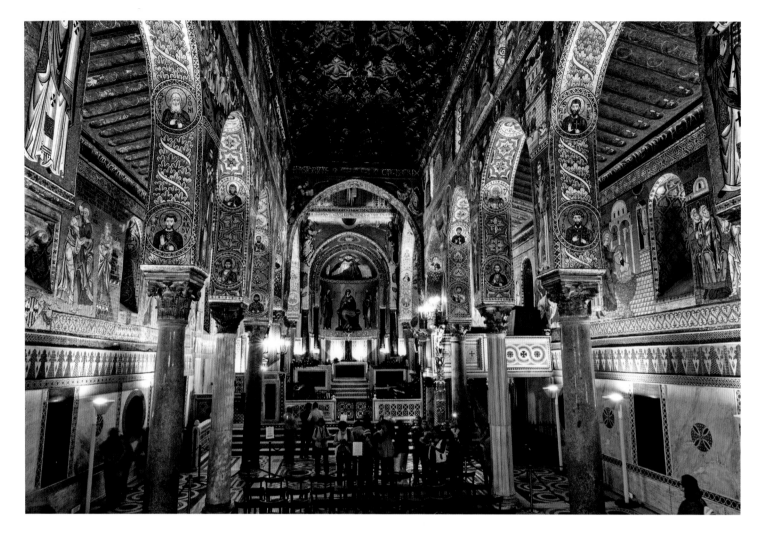

Fig. 157
Interior view of the Cappella
Palatina, looking east towards
the apse.

Fig. 158 (opposite)
The Islamic-style painted
wooden ceiling in the
Cappella Palatina, from below.

reference a clear allusion to the chapel itself and the 'beauty it contains', but to 'kiss its corner' was a custom directly related to the rite of the Hajj, the pilgrimage to Mecca, where Muslim pilgrims kiss the Black Stone after each of seven circuits. These inscriptions indicate that it was the Fatimid court that was used for inspiration, whose own palaces were often compared to the sanctuary in contemporary panegyric.[77] If nothing else, these inscriptions are another of the signs that Roger modelled the Arabic elements of his new kingdom on the Fatimid Caliphate.[78] However, visitors to the chapel throughout its history have been even more amazed by the stunning wooden painted ceiling of the nave, its styles and subject matters (figs 158–60).

At the chapel's inauguration in 1143, the orator Philagathos of Cerami delivered a sermon to praise Roger and his new church, in which he delicately described its various components:

> *[. . .] this delightful church of the Apostles [. . .] brilliant with lights, shining with gold, glittering with mosaics, and bright with paintings. He who has seen it many times, marvels when he sees it again, and is as astonished as if he were seeing it for the first time, his gaze wandering everywhere. [. . .] The most holy floor of the church actually resembles a spring meadow because of the many-coloured marbles of the mosaics, as if it were adorned with flowers; except that flowers wither and change, while this meadow is never-fading and ever-lasting, and within itself maintains eternal spring.*

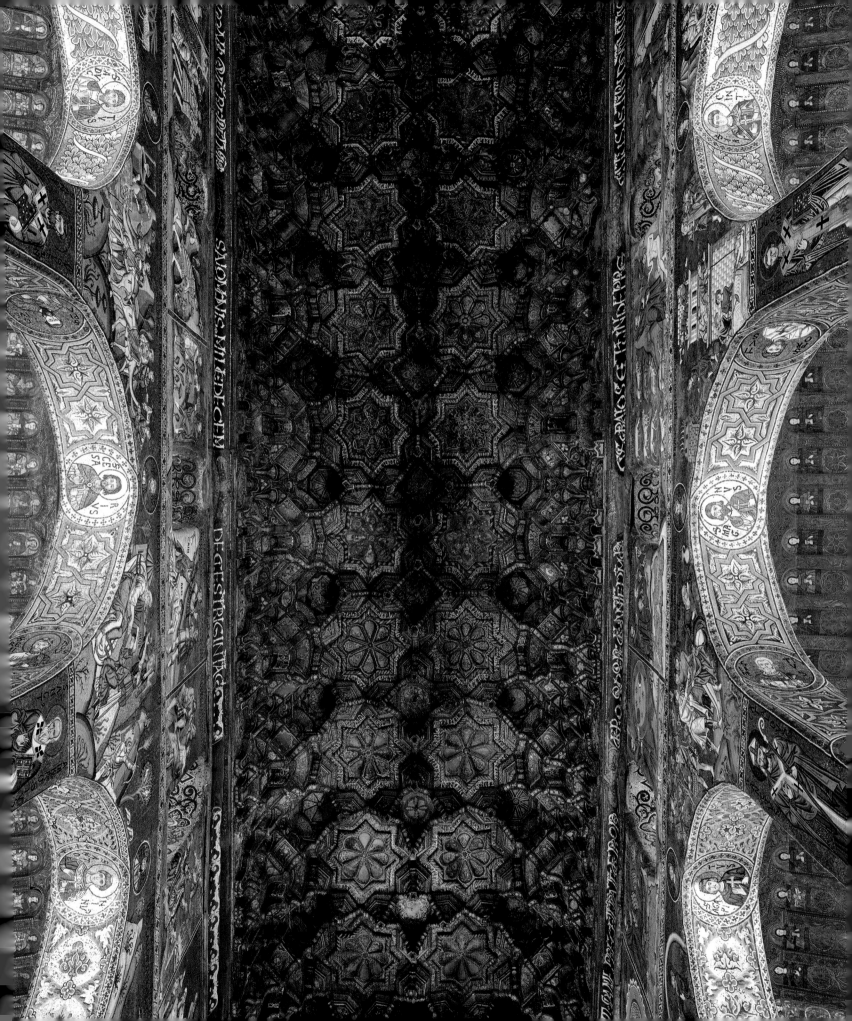

Fig. 159
Detail of the painted ceiling
of the Cappella Palatina:
Roger II in kaftan, sitting
in lotus-position.

And while the floor was thought to imitate gardens and meadows, the ceiling represented the heavens and stars:

> [. . .] one can never see enough of it; it is wonderful to look at and to hear about. It is decorated with delicate carvings, variously formed like little coffers; all flashing with gold, it imitates the heavens, when, through the clear air (of the night), the host of stars shines everywhere. The most beautiful columns support the arches, raising the ceiling to an extraordinary height.[79]

If up to roof height Islamic elements inside the chapel seem perhaps more subtle, limited to the decorative patterns in the floor (and if the inlaid inscriptions were on the outside), the ceiling of the nave was much more openly and obviously Islamic, both in its architectural form and in the styles and subjects of paintings. Entirely made out of wooden panels, it presents a complex stalactite-like structure, creating a star-and-cross pattern in the central area, bosses protruding from their intersections – a purely Islamic version of the Byzantine-influenced patterns of the floor beneath it. It was framed along the sides by *muqarnas* or 'honeycomb' vaulting (fig. 160), typical of prestigious architecture in the Islamic world. Every inch of the woodwork was covered with gesso, which in its turn was painted with a wide variety of decorative motifs, Arabic inscriptions and figurative scenes, in dominating red, blue, black and white colours, with gold for details and backgrounds. The figurative style most closely resembles that of contemporary Fatimid Egypt, which itself had its origins in Central Asia. It is clearly distinguishable through the very defined outlines of forms and the typical human facial features: a round face, large eyes with enormous pupils, a straight nose with a small mouth, and long side-locks falling in front of the ears. The scenes do not seem to convey a clear visual programme *per se*, but generally fall within the realm of a princely court of the

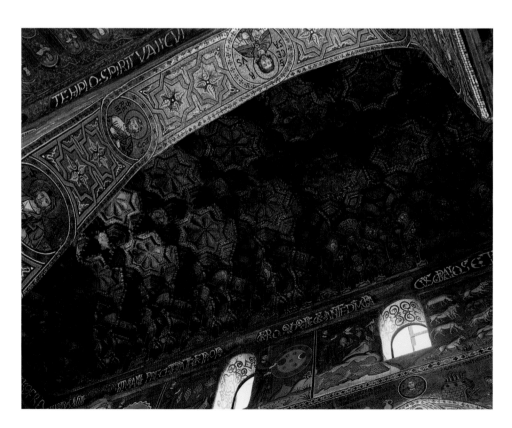

Fig. 160
Detail of the painted ceiling
of the Cappella Palatina,
showing the *muqarnas*
(honeycomb) construction.

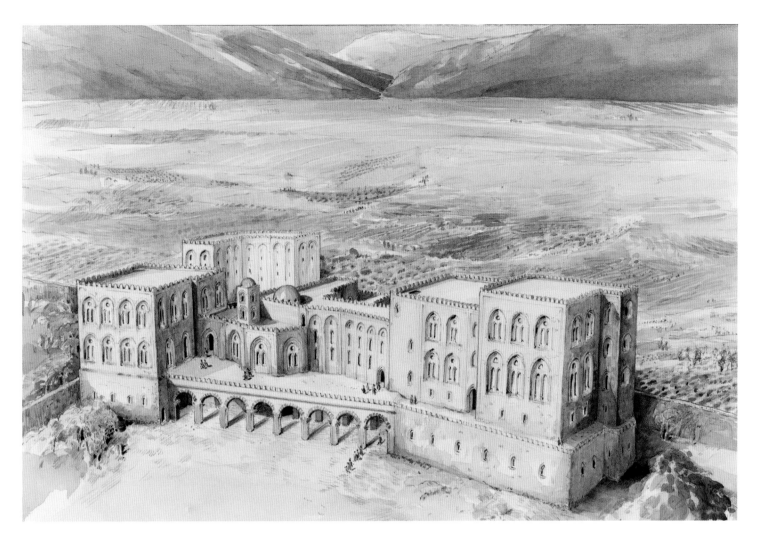

medieval Muslim world. Most of the scenes depict daily life at such a court, such as men playing chess, sitting by a fountain (fig. 168) or hunting; there are dancers, musicians, and people eating and drinking; others are repetitive heraldic symbols of lions, griffins and falcons. The majority focus specifically on the ruler and the kingdom: Roger himself is depicted seven times, presented in the Islamic manner of the 'seated ruler', cross-legged, wearing a kaftan and a three-pointed crown, yet clearly different from the other characters through his Western physiognomy (fig. 159), while historical and mythological figures – such as Alexander the Great or the Sun and Moon chariots – allude to his 'universal' rule.[80] Kufic inscriptions frame the central stars with blessings for and qualities and virtues of the kingdom and Roger's rule, using the same words found on the columns in Santa Maria dell'Ammiraglio: 'good fortune', 'power', 'magnificence', 'prosperity', 'perfection' and so on.[81] Given this blending together of traditions common to Christian and Islamic culture, was the chapel's outside appearance (as much as we are able to reconstruct that truthfully today) as viewed from the city merely a coincidence, when the combination of Byzantine dome and domed bell tower could be mistaken for a domed mosque with minaret (fig. 161)?

As no similar large-scale paintings survive from Norman or earlier Arab Sicily of the same high quality and naturalism, it is assumed by most historians that artists from Fatimid Egypt were invited to Palermo to carry out the project, rather than an existing local workshop.[82]

Fig. 161
Artist's reconstruction of the Norman palace at the end of the 12th century.

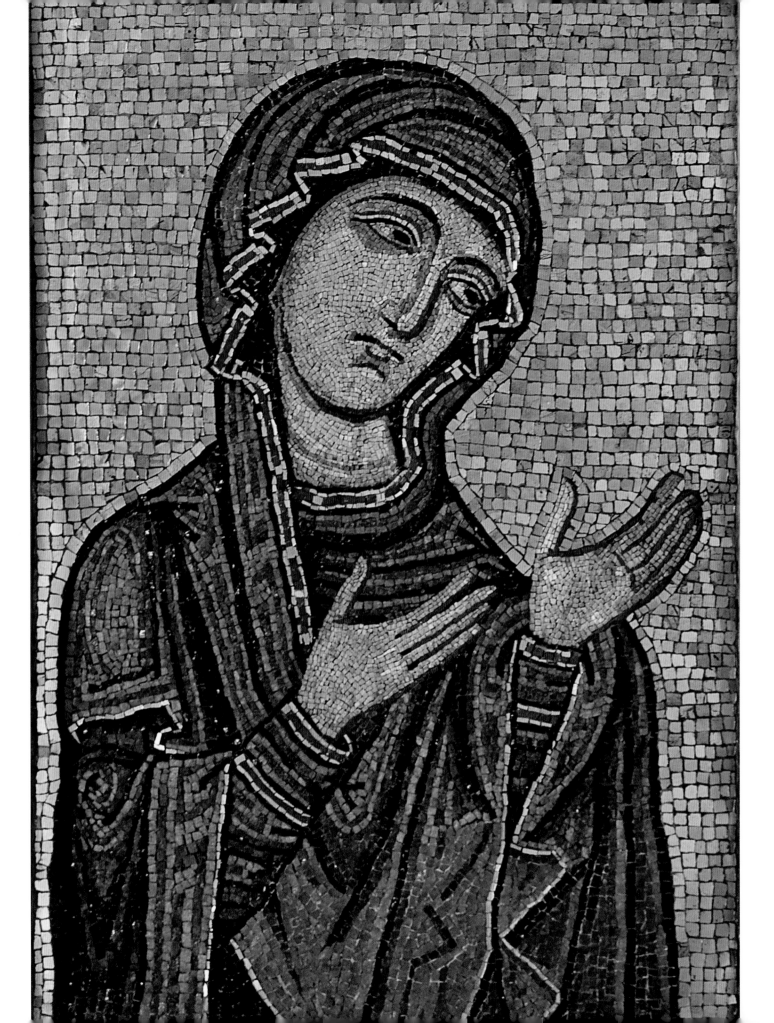

This means that between 1130 and the late 1140s, when the chapel was being finished,[83] floor mosaicists from southern Italy were working side by side with Byzantine wall mosaicists and Muslim craftsmen from Egypt to create this unique monument for a brand-new kingdom. It was the first and the only of its kind, even if none of the individual elements remained unique in Norman Sicily.

Close parallels to the *opus sectile* floors can be found in many churches throughout the entire kingdom, including southern Italy, eventually developing, as mentioned, into the so-called Cosmatesque style, ubiquitous in central Italy. Parallels for the Byzantine mosaics, on the other hand, are scarcer, and remained reserved for the royally founded churches and cathedrals: Santa Maria dell'Ammiraglio; the cathedral at Cefalù, founded by Roger II;[84] the rebuilding of the basilica in Palermo into a cathedral; and the new foundation of Monreale Cathedral under William II.

Very little is known about Palermo Cathedral under Roger II, as it was largely rebuilt under William II and later adapted to the fashions of the Baroque period. There are signs, however, that it too was lavishly decorated in the early Norman phase. After all, it was at the heart of the old city, it was here that Roger had been crowned king, and it was directly connected to the royal palace via a covered marble walkway.[85] All that survives of the Byzantine-style mosaics that once adorned its walls is a small panel showing the so-called 'Virgin Hagiosoritissa', Mary as advocate for the human race, half turned (fig. 162). It shows clear similarities with the mosaics of the *naos* of the Cappella Palatina, and is thus tentatively dated to the time of Roger II, and perhaps even to the same workshop.[86] Also originating from the Cathedral are three recently discovered fragments from the sidewalls of a throne platform, similar to the one in the chapel. The royal cathedrals all included a throne, not as part of any audience hall, but for the ruler to follow the liturgy. The pieces show the same curvilinear *guilloche* design of inlaid marble and glass (fig. 163). It remains impossible to say if these date to the time of Roger or of the rebuilding under William II.

Fig. 162 (opposite)
Mosaic panel showing the
Virgin Hagiosoritissa, from
Palermo Cathedral. Made
c.1130–89.
Museo Diocesano di Palermo.

Fig. 163 (above)
Reused fragment of an
originally rectangular inlaid
marble panel, from a throne
platform in Palermo Cathedral.
Made c.1130–89.
W approx. 2 m.
Museo Diocesano di Palermo.

Fig. 164 (top)
Reconstruction of the panel
from which the fragment
originates.

Only the cathedral at Cefalù was adorned with Fatimid-style Islamic paintings, although in a much more limited way, and, surprisingly, barely noticeable from the ground, as they decorated the sides of the nave's roof rafters, 21 metres above floor level.[87] This building was dedicated in 1131 by Roger, who envisaged it as his personal, elite cathedral, and his final resting place. The types of imagery and the painting style are identical to those of the Cappella Palatina, and represent the princely courts: the images include musicians, courtiers drinking and eating, and dancers, as well as animals, heraldic symbols and vegetal motifs (fig. 165). The paintings are, however, clearly of an inferior quality to those of the Cappella. While some scholars therefore attribute the paintings to local copyists unfamiliar with what they were imitating and only knowing what they could see in the chapel,[88] others think the same Fatimid workshop was responsible for both.[89] The conditions were certainly not the same: while the paintings at the Cappella Palatina were done on gesso, at Cefalù the scenes were painted directly onto the wood, considerably more difficult to do, and probably the reason for the bad state in which most of the paintings are in now.

The depictions of such scenes in two of Roger's elite projects, even showing Roger himself as a Muslim prince, begs the question of whether life at and organization of the Norman court was as Arabicized as these paintings make us believe. Other evidence certainly seems to point to such a conclusion.[90]

Fig. 165
Wooden painted ceiling panel from Cefalù Cathedral, showing a female singer or storyteller and a flower within a mandorla. 1130s–40s. H 33 cm.
Galleria Interdisciplinare Regionale della Sicilia di Palazzo Abatellis, Palermo.

Court Life

He [George of Antioch] veiled Roger from his subjects, and arranged for him to dress in clothes like the Muslims', and not to ride out, nor to show himself in public, except on holidays, when he would process, preceded by horses adorned with saddles of gold and silver; and with horse-trappers studded with gemstones, and by domed litters and gilded banners, with the parasol above him and the crown upon his head.

AL-MAQRIZI, EGYPTIAN HISTORIAN (1364–1442), *KITAB AL-TARIKH AL-KABIR AL-MUQAFFA LI-MIJR*[91]

Several written testimonies describe Roger's behaviour at court and in public, but it is those by Arab writers that refer to the rulers' specific affinity for Islamic culture.[92] Although distrustful of Christian kings ruling Muslims, these writers praised their courts and kingship and their attitude towards Muslim courtiers and servants. The great historian Ibn al-Athir said of Roger II that

[. . .] he followed the way of Muslim rulers with mounted companions, chamberlains, arms-bearers, body-guards, and others of that kind. Thus, he broke with the custom of the Franks, who are not acquainted with such things. He founded a Court of Complaints, to which those [Muslims] who had been unjustly treated brought their grievances, and [the king] would give them justice. [. . .] He treated the Muslims with respect, took them as his companions, and kept the Franks off them, so that they loved him.[93]

The same was still true fifty years later at William II's court, as Ibn Jubayr recounts:

Their king, William, is admirable for his just conduct, and the use he makes of the industry of the Muslims, and for choosing eunuch pages who all, or nearly all, concealing their faith, yet hold firm to the Muslim divine law. He has much confidence in Muslims, relying on them for his affairs, and the most important matters, even the supervisor of his kitchen being a Muslim; and he keeps a band of black Muslim slaves commanded by a leader chosen from among them. His ministers and chamberlains he appoints from his pages, of whom he has a great number and who are his public officials and are described as his courtiers. In them shines the splendour of his realm for the magnificent clothing and fiery horses they display; and there is none of them but has his retinue, his servants, and his followers. [. . .] William is engrossed in the pleasures of his land, the arrangement of its laws, the laying down of procedure, the allocation of the functions of his chief officials, the enlargement of the splendour of the realm, and the display of his pomp, in a manner that resembles the Muslim Kings. [. . .] He pays much attention to his [Muslim] physicians and astrologers, and also takes great care of them. He will even, when told that a physician or astrologer is passing through his land, order his detainment, and then provide him with means of living so that he will forget his native land. [. . .] One of the remarkable things told of him is that he reads and writes Arabic. [. . .] The handmaidens [jawari is also sometimes translated as 'slave girls'] and concubines [hazaya] in his palace are all Muslims. One of the strangest things told us by this servant, Yahya ibn Fityan, the Embroiderer, who embroidered in gold the king's clothes, was that the Frankish Christian women who came to his palace became Muslims, converted by these handmaidens.[94]

As these descriptions make clear, not only did the rulers dress like Muslim rulers and read and speak Arabic, they also kept concubines in their harems, the women's quarters of the palace that contained girls and ladies-in-waiting, servant girls, the women workers of the palace workshops (see p. 214), and the eunuchs, but those quarters were not segregated from the rest of the palace or inaccessible to men.[95] The palace also employed large numbers of Muslims

and ex-Muslims (as well as Greeks and Latins) in both lower and high positions, including among the king's closest advisers.

Although the Normans inherited some of the institutions established by their Muslim predecessors on the island, such as the mint and the fiscal administration or *diwan* (from which comes the modern word *douane*, meaning 'customs duty'), at first the new rulers used Greek officials and Greek administration styles for the running of their island, retaining only a few Arab scribes (see p. 176).[96] However, shortly after Roger's coronation, documents in Arabic emerged frequently and of a professional quality; a new, highly professional script (*diwani*) was used; the rulers signed (or ordered the signing) with a royal Arabic signature,[97] the *alama*; and the *diwan* itself underwent a structural reorganization, so that by 1149 it was split into different sections, all administering different interests of the kings.[98] A similar organization in contemporary Fatimid Egypt existed and it appears Roger used this as the key model for his new administration. That is not to say that all administration was in Arabic from now on. The majority of documents were still either in Greek with only occasional insertions of Arabic, or bilingual. Latin also started to be used increasingly: under Roger, only a single notary was appointed for Latin documents,[99] but under his successors the language eventually surpassed all others in official documents. Yet the *diwan* itself was governed by trusted Arab officials, often one of the 'palace eunuchs' (fig. 166).[100] Known throughout the city as the king's ears and eyes, these eunuchs had been castrated as young boys and forcibly converted to Christianity, then raised to become servants, chamberlains, important administrators and even military commanders. In secret, they may still have practised Islam, which was apparently one of the worst-kept secrets in the kingdom. In fact, they were mostly referred to as the 'Palace Saracens'.

Fig. 166
The royal *diwan* of the palace with Greek, 'Saracen' and Latin notaries, each in their characteristic dress, from the illuminated manuscript *Liber ad honorem Augusti sive de rebus Siculis*, written by Petrus of Eboli at the court in Palermo in AD 1195–7.
Burgerbibliothek, Bern.

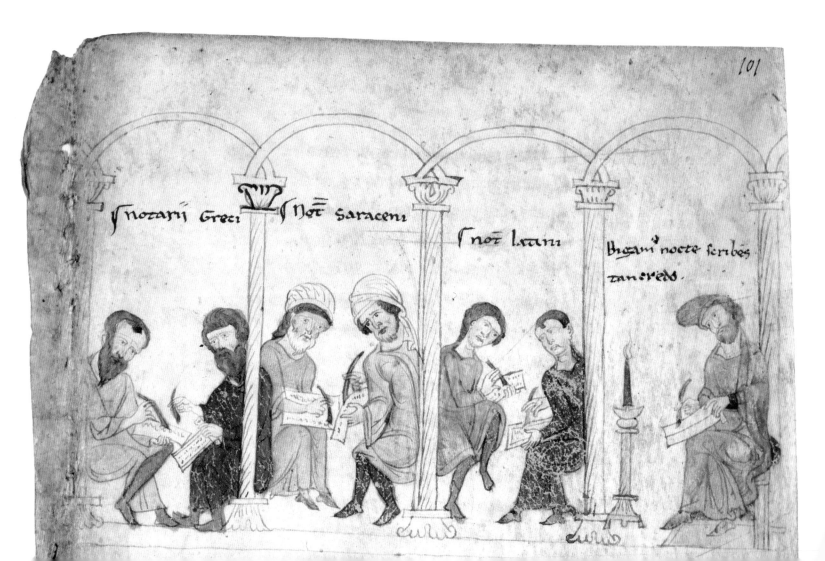

As in Byzantium, but ultimately a Middle Eastern tradition, eunuchs were employed in high positions, and many of the names and details of the lives of these chamberlains to the kings and other officials survive in the records. As close advisers and personal friends of the king, they accumulated a lot of influence as well as prestige and wealth; thus, unsurprisingly, these courtiers were feared and hated by a large part of the population.[101]

Architecture of Leisure

His castles are arranged around the neck of the city like necklaces strung around the throats of voluptuous girls. The king moves around the gardens and courts, between amusing diversions and games. How many palaces and constructions does he have in the city [...], how many watchtowers and belvederes? IBN JUBAYR[102]

If the palace showed more subtle influences from the Islamic world, the private architecture of the kings did so much more openly. The already mentioned gardens, some of which bordered the palace and others that surrounded the city, in the Conca d'Oro, were modelled after the enclosed luxury gardens of the caliphs in the East and in the Maghreb. The one directly connected to the palace was called the Genoardo, from Arabic 'Jannat al-Ard', meaning 'Earthly Paradise' (see fig. 181).[103] However, their primary use, in the Conca d'Oro as well as in Arab lands, was essentially practical, incorporating water canals and *qanat* (see p. 155) throughout, thus making cultivation possible through irrigation. Sugar-cane, various types of palms, oranges, lemons and so forth had all been grown here already under Arab rule, and it appears that under the Normans the farmers remained mostly Arab (both Muslim and converted) and Jewish, who had the agricultural knowledge.[104] At the same time, parts of the luxuriant gardens were used to keep indigenous and exotic wildlife, such as parakeets, falcons, peacocks, ostriches, panthers, lions, and also apes, bears, giraffes and elephants.[105] In these Oriental gardens, the Norman kings had various pavilions built, all in essence miniature palaces. Of six of these suburban palaces considerable remains survive, most famous and representative of which are La Favara Castle, built by Roger II and enlarged with two artificial lakes; La Zisa, built under William I; and La Cuba (fig. 167), built under William II. These were all directly modelled on palaces from Ifriqiya and Fatimid Egypt. Their ground plans and their sober and restrained exterior facades, as well as their lavish interiors with *muqarnas* vaulting, water features such as fountains with lion-spouts and basins within the throne rooms, and marble wainscoting, are all features that can be found in the palaces in Ashur and Bani Hammad (Ifriqiya) and Fustat (Egypt).[106] Arabic inscriptions running along their roofs referred to the glory and magnificence of the kings, to the palaces' symbolic representations of universal peace and order, and of their submission of nature, all very reminiscent of the way the kingdom and its rulers were described on the ceiling of the royal chapel. Certainly, like the central palace, these smaller residences were also manifestations of the ruler's power.[107] Running above the entrance arch to La Zisa, one could read the verses (tentatively reconstructed as they have been partially destroyed):

Whenever you wish, you will see here the loveliest possession of this kingdom, the most splendid of the world and the seas. [You will see] the mountains whose peaks are bursting with the colour of narcissus [...]. You will see the great king of this century in his beautiful dwelling-place, a house of joy and splendour which suits him well. This is the Earthly Paradise [Jannat al-Ard] that opens to view; this king is the Mustaizz *[the Glorious One], this palace the* al-Aziz *['the Magnificent', which in Sicilian vernacular became 'La Zisa'].*[108]

Fig. 167
The palace called La Cuba, in Palermo, built by William II, c.1180.

Fig. 168
Detail of the painted ceiling
of the Cappella Palatina: two
men seated by a lion-headed
fountain.

Benjamin of Tudela, a Jewish visitor to Palermo in 1172, recorded the sight of the lakes at La Favara Castle: 'ornamented with royal vessels, enriched with painting and gilding, in which, for recreation, the king and his women [i.e. concubines] frequently made excursions'.[109] The palaces and gardens were places for hunting, for the court's recreation, and were summer and winter retreats away from the city: La Zisa contained an air-cooling system that distributed draughts between lower and upper floors, and another palace, Uscibene, had underground conduits of cool water for relief during the summer.[110]

Over the centuries, many of these palaces were abandoned and became derelict, so that little of the actual interior decorations survive, with the exception of La Zisa. There, the central throne room still retains its original beautifully carved column capitals with peacocks and some *muqarnas* vaulting, as well as a central, marble-inlaid fountain (fig. 169). The fountain interestingly finds close parallels on the royal chapel ceiling (fig. 168) and in contemporary Arabic Sicilian panegyrics, whose poets often looked to these palaces for inspiration in order to praise the kings and the splendour of their courts. Thus wrote al-Buthayri when describing one of Roger II's palaces, possibly La Favara (Arabic for 'fresh water spring'), and its gardens as a reflection of Paradise and a place of relaxation and harmony:[111]

Fig. 169 (opposite)
Fountain in the central room
of La Zisa, Palermo,
similar to the one depicted
on the painted ceiling of the
Cappella Palatina.

And in the palaces of the victorious state
 joy breaks its journey and settles
How admirable its site:
 the Compassionate Lord has perfected its appearance
And the loggias, more radiant than
 any architectural work
And his gardens of new herbage, where
 earthly existence reverts to splendour
And from the mouths of the lions in his fountain
 the waters of paradise gush forth
And spring dresses the land
 with its beauty in radiant cloaks[112]

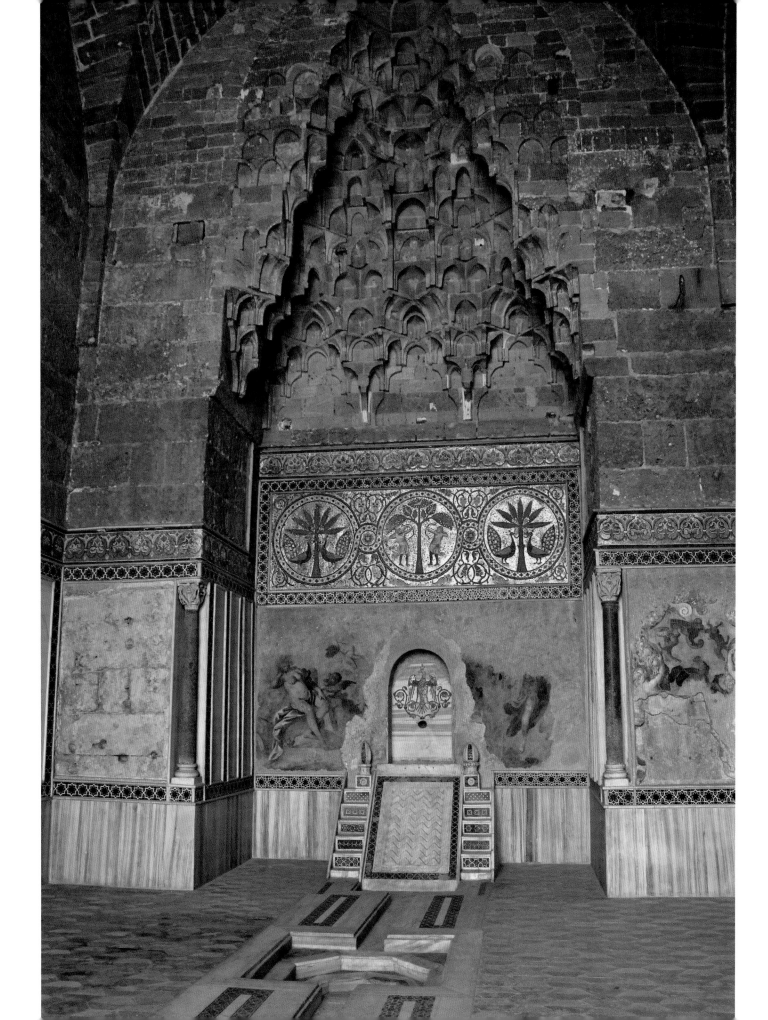

Fig. 170
Artistic reconstruction of
La Zisa, Palermo, by Rocco
Lentini, 1935. Oil on canvas.
Soprintendenza di Palermo.

And what has become perhaps the best-known medieval poem from Sicily, labelled the 'symbol of Muslim Sicily' (even though relating to Norman Sicily) by historians, cultural historians, Orientalists and Arabists,[113] is one by Abd ar-Rahman of Trapani, also describing Roger's Favara palace:

Oh, Favara with the double lake! In you, desires converge!
 In you, life is pleasant, your view is majestic
Your waters are divided into nine streams;
 how lovely their divided flow!
At the convergence of your two seas, a battlefield of love
 and upon your two bays, desire encamps
How glorious is the sea of the two palm trees, and what the sea surrounding it contains:
 it is the greatest of all places
It is as if your waters, where they flow together, in their clarity
 were liquid pearls and the land were dusky skin
And as if the branches of the gardens stretched out
 to gaze on the billowing waters and smile
The fish swim in the clarity of her water
 and the birds of her gardens sing
The oranges of the island when they blossom
 are like fire blazing on branches of emerald
The lemons are like the yellow complexion of a lover
 who, having spent the night in the torment of distance, laments
And the two palm trees like two lovers who choose
 as protection from the enemy, a castle well-fortified against them
Or as if misgivings clings to them, and they draw themselves up
 to frighten suspicion out of the one who suspects them
Oh two palms of the two seas of Palermo, may you always drink
 of the sustaining rain! May it not be cut off!
May you take pleasure in the passage of time, may it grant all your desires,
 and may history lull you to sleep
By God, protect with your shade the people of love,
 for in the safety of your shade love finds protection
This account of an eyewitness is not to be doubted: rather
 distrust the trivial descriptions based on hearsay[114]

Court Art

Located within the Norman palace were also the *khizana*, the royal workshops, in which craftsmen and artists produced objects of the highest quality for the kings themselves, or as diplomatic gifts. Best known to us now are the silk robes that were preserved for centuries and were used repeatedly for the coronations of the Holy Roman Emperors, but the workshops also produced luxury items in precious metals and enamel, or carvings in ivory, rock crystal and glass.[115]

Silkworms and silk production had been introduced to Sicily by the Arabs. At least by the later tenth century raw silk called 'Sicilian', as well as finished silk fabric, was definitely being exported from Palermo, Mazara and Syracuse. Production continued under the Norman rulers, and until the twelfth century all varieties of silk weaves produced on the island had

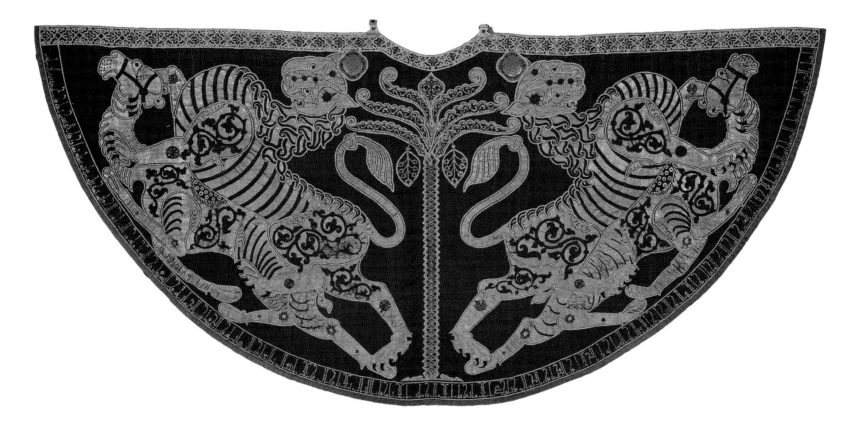

Fig. 171 (above and opposite)
The so-called Robe of Roger,
made in the royal workshops
in Palermo, 1133–4.
W 3.45 m.
Kaiserliche Schatzkammer, Vienna.

Arabic names. Nevertheless, Sicilian fabrics remained far below the quality of those of the Byzantine Empire and its workshops in Constantinople and Greece. The Sicilian kings who, just as at the Byzantine and Islamic courts, used the finest silks for luxury furnishings in the palace,[116] therefore had to import these. However, Sicily's real achievement and international renown in the silk industry was in the embroidery of imported textiles.[117] The best-preserved and most famous example is at the same time the earliest robe to survive from the *khizana* (fig. 171). This cloak, often wrongly called Roger's Coronation Robe (as it was not created until 1133/4), is made of a large semicircular piece of red-dyed heavy Byzantine samite silk, probably imported from Thebes in central Greece, but embroidered at the palace with gold and silk thread and set with hundreds of tiny pearls, enamel plaques, sapphires, garnets and one ruby. Its design shows a central palm tree, on either side of which and symmetrically, lions defeat prostrate camels. The design combines two old Persian and Middle Eastern motifs – the Tree of Life and the dominant lion – both of which we have seen in a variety of contexts already, but which are used here with specific and not-too-subtle symbolic meaning. The Tree of Life, especially in the form of a palm tree, refers to the fertility of the island, but in a Christian context also the victory over death and eternal life. The lion on the other hand was a general symbol of the ruler in many societies, but here stood for Roger himself, while the North African camels represented the subject North Africans, subdued and at the mercy of the (Christian) king. While the shape and colour (similar to the imperial purple) were

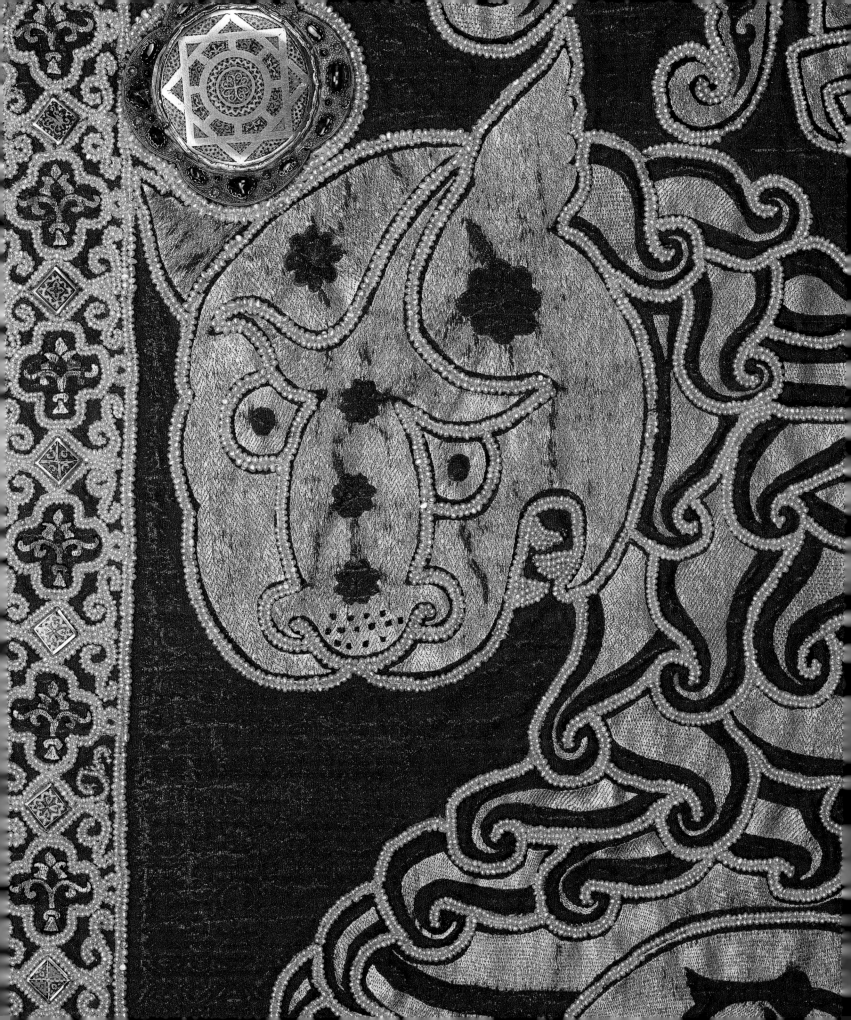

characteristic of Christian rulers, the iconography is clearly Islamic, with direct parallels of the types of lions and camels to be found in the paintings of the Cappella Palatina ceiling, even if they were to the glory of the Christian king. Furthermore, along the seam runs an Arabic inscription in Kufic characters, using the same descriptions for Roger and his reign as the ceiling, and stating that the robe was

> made [i.e. embroidered] in the royal workshops for the good fortune, supreme honour, perfection and power, the betterment, capacity, prosperity, sublimity, glory, beauty, in the increase of his security, fulfilment of his hopes, the goodness of his days and nights without end or interruption, for his power and guard, his defence and protection, good fortune, salvation, victory and excellence. In the capital of Sicily, in the 528th year [of the Hijri; i.e. AD 1133/4].[118]

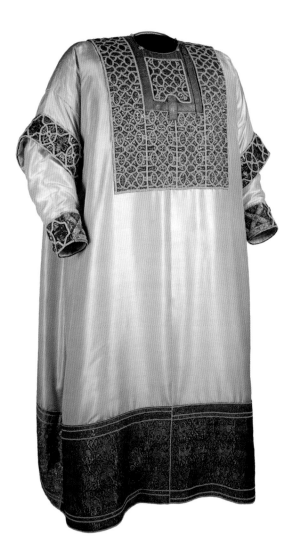

Fig. 172
The so-called Alb of William II,
made in the royal workshops
in Palermo, c.1181–1220.
L 1.54 m.
Kaiserliche Schatzkammer, Vienna.

It is clear that the robe was embroidered at the *khizana*, where the majority of embroiderers were Muslim or ex-Muslims, such as Yahya ibn Fityan mentioned in Ibn Jubayr's description of the court quoted earlier (see p. 205).[119]

Byzantine elements were introduced into the *Khizana* in 1147, after Roger's sack of Thebes and Corinth, centres of the Byzantine silk industry. Roger took Greek, mostly female, weavers (but not embroiderers) captive, transported them to Palermo, settled them in the workshops, and ordered them to train indigenous artists. With them came Byzantine technical knowledge for weaving but also for different types of tools and designs, bringing about a significant improvement in the quality of Sicilian weaves. From then on, Greek names were used for textiles, although mostly Islamic motifs remained to be used, and, if we believe the sources, many of the craftswomen converted to Islam. A Latin description of the *nobiles officinae*, the 'noble workshops' of the *khizana*, dating to c.1190, reflects this change in its vocabulary, and in the second part might as well be talking about Roger's mantle specifically:

> It is not appropriate to pass over those noble workshops which adjoin the palace, where the silk fibres are spun into threads of various colours and then intertwined in many types of weaves, amita, dimita, trimita [. . .] examita [. . .], and diarhodon, which strikes with a fiery splendour.[120] [. . .] The garments are worked in a remarkable way [. . .] and these desire or require greater diligence on the part of the artists and greater richness of materials and consequently they sell for a greater price. And you may see many other things and ornaments of varied colour and type in which gold is woven into the silks and you will see a manifold variety of designs adorned with translucent gems. Pearls also are either included whole in golden settings or are perforated and connected by slender thread, and are turned into a picture . . .[121]

The later silk products of the *hizanat* show more clearly the changes effected by the introduction of Byzantine elements and the growing Latinization/Westernization of the kingdom under William I and William II. The so-called Alb of William II (fig. 172) is the type of tunic that Roger wears on the mosaic from Santa Maria dell'Ammiraglio. The tunic is, however, made up of different pieces of textile that were stitched together, probably shortly before 1220. The cuffs and bands on the upper arms are the earliest fabrics, and show addorsed pairs of lions and griffins in gold embroidery. On the other hand, the samite silk hem of the gown, as well as its similar ornamental border, can be dated precisely through the double inscription, now both in Arabic and Latin, that runs along it. While the Latin only states that the textile was 'made in the fortunate city of Palermo in the 15th year of William II, by the grace of God', and gives his titles and ancestry, the Arabic gives more information, saying it was 'commissioned by the magnificent king Gulyalm [William] the Second, he who is highly honoured by God, [. . . titles . . .], the mainstay of the Imam of Rumiya [pope of Rome], the defender of the

Christian faith, at the time of July the 14th, in the year 1181 in the era of our lord Jesus, the Messiah'.[122] On the ornamental border, pairs of griffins and lions flank a Tree of Life, in a repetitive pattern that fills the entire space.[123] This ornamental border is similar in style, though not in weaving, to a fragment of red and gold lampas silk in the British Museum from the same period, which comes from the tomb of King Henry VI of Sicily (r. 1194–7). On the fragment (fig. 173), in the same *horror vacui* style, horizontal repetitions of pairs of animals around a stylized Tree of Life appear in gold thread, the animals however being parrots (or peacocks) and deer. The style of the animals is still entirely Middle Eastern and Near Eastern in origin, as is the type and technique of gold-threading, while the lampas and the horizontal

Fig. 173
Fragment of the funerary robe of Henry VI, made in the royal workshops in Palermo, 1180–90. H 24 cm.

British Museum, London.

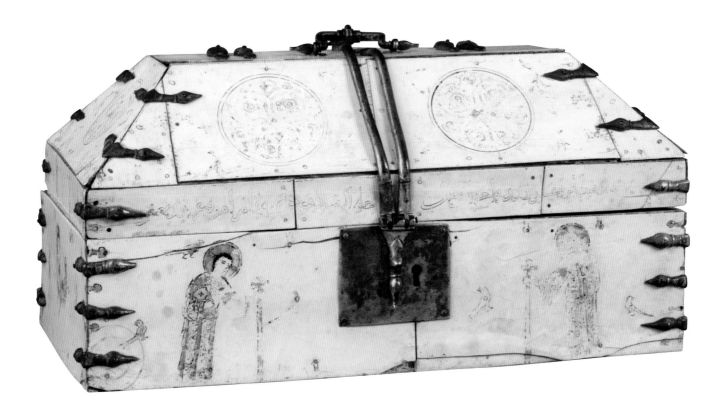

repetition are Western traits.[124] In short, while Eastern motifs persistently survived, the styles of weaving and the cultural context around them became increasingly Westernized.

Most distinctive among the other luxury objects produced by the royal *khizana* are rectangular and round ivory caskets in a variety of sizes, of which more than 200 have survived.[125] Elephant ivory, imported from southern and central Africa,[126] was extremely precious in the Middle Ages, and its usage was almost exclusively limited to the spheres of royalty and the Church.[127] The find-spots of the caskets, however, show that a market for small luxury goods like these clearly existed in medieval Europe: to date, all the caskets for which there are records of provenance have been discovered in Sicily, southern Italy and Northern European contexts. They are thought to have been made originally as diplomatic gifts or even wedding gifts. However, on account of their great value, they entered royal and church treasuries, often as reliquaries, throughout Europe, already in the twelfth and thirteenth centuries, and as far as England.[128] The boxes were made both unpainted and painted, and precisely the painting styles and choice of scenes indicate that they can be attributed to Sicily.[129] A good example is a fairly large casket (fig. 174) that belonged to the treasury of Bari Cathedral. Typical aspects that can be found in many of the caskets are present here, such as the gilded bronze hinges (though these ones are later replacements), the floral motifs and, common for caskets of this size, the fact that the ivory plaques were applied to wooden supports. The subjects include small birds, peacocks, panthers, harpies, a tree and a musician, all identical in painting style to those same subjects on the ceiling of the Cappella Palatina, the mosaics of the Room of Roger and the textiles. However, this particular casket has attracted specific attention because of its unique combination of a long and complex Arabic supplication along the top border with the unusually explicit Christian iconography on its

Fig. 175
Metal enamelled lid of a small
box, showing two peacocks
around a stylized Tree of Life.
Probably Sicily or southern
Italy, 1250–1300. H 9.1 cm.
British Museum, London.

front panel, which shows two men, one young and one old, with haloes bearing crosses and
carrying liturgy books and croziers. Given the importance of the cathedral as episcopal see in
the Norman kingdom, it is thought that the casket was a specific gift or a special commission
for the Cathedral of Bari, and hence that the two figures are two saints venerated there.[130]

The peacocks on the casket are reminiscent of those on a metal enamelled lid of a small
box, the origins of which remain a mystery. Technically, the enamel technique of the plaque
is different from French Limoges enamels of around 1300, but nevertheless close to it, making
a thirteenth-century date likely. This motif of the peacocks (fig. 175), while one common in
the Mediterranean, is extremely close to the same motif in the mosaics in the Room of Roger,
in which the Tree of Life has become stylized, resembling more a thin line with erupting
branches (fig. 176), suggesting a Sicilian origin for the casket.[131]

Fig. 176
Detail of a mosaic in the
Room of Roger, showing two
peacocks around a stylized
Tree of Life.

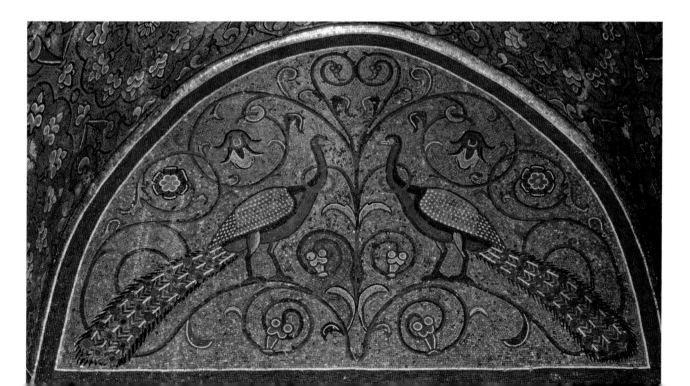

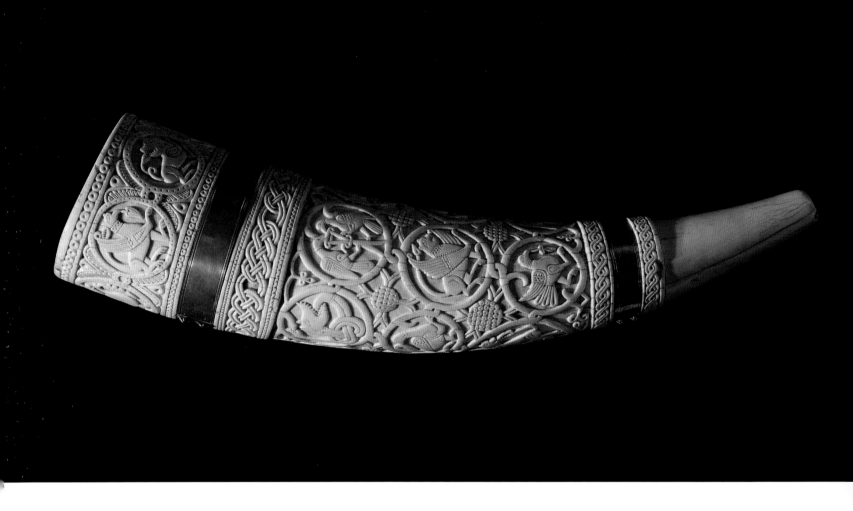

Ivory carving at the workshops was not limited to creating casket panels, however. A type of object that reached extreme popularity in medieval Europe between the eleventh and thirteenth centuries was the oliphant, a hollowed-out elephant tusk, often with decorative carvings, used as a hunting horn. Its popularity was due to its important role in *La Chanson de Roland* (*The Song of Roland*), an epic poem composed in the eleventh century about a historic battle during Charlemagne's invasion of Islamic Spain, which became popular at the time of the crusades. Roland, commander of the rearguard of Charlemagne's army under attack, refused to blow the horn until the battle was already lost; the force it took him to blow it resulted in his heroic death.

Rollant ad mis l'olifan a sa buche,	*Count Roland lifts the horn up to his mouth,*
Empeint le ben, par grant vertut le sunet.	*Then sets his lips and blows it with great force.*
Halt sunt li pui e la voiz est mult lunge,	*The hills are high; the horn's voice loud and long;*
Granz XXX liwes l'oïrent il respundre.	*They hear it echoing full thirty leagues.*[132]

Oliphants were created in various places about the tenth century, with Salerno in southern Italy being a primary production centre in the eleventh century. However, some oliphants show a more angular, exceptionally low, relief carving, which is also found in a few Sicilian ivory caskets of the twelfth century.[133] The same low-relief carvings can be found on the British Museum's 'Borradaile Oliphant' (fig. 177),[134] on which griffins, heraldic eagles, lions, peacocks and snakes are represented in the 'Fatimid' style. Without a doubt, the Borradaile Oliphant was created in a Norman environment – either Norman Salerno or possibly even Sicily.

Fig. 177
The so-called Borradaile Oliphant, an ivory hunting horn. Sicily or southern Italy, 1100–1200. L 52.5 cm.
British Museum, London.

One final object linked to the carving workshops of the palace is also the most controversial: the so-called 'Hedwig Beakers'. Ever since these objects attracted the attention of scholars and collectors, their place of origin has been a matter of debate, and the example at the British Museum itself has variously been attributed to Syria, Sicily and more recently Syria again.[135] The iconography differs between beakers, but the British Museum example has the most varied decoration (figs 178–9). It shows an eagle flanked by a griffin and a lion, with a palm tree behind them. While all these form part of the repertoire of Mediterranean motifs of the twelfth century, we have already seen several unique Sicilian contexts where exactly these same symbols were displayed together, in a similar style: the Cappella Palatina ceiling, the Alb of William II and the Room of Roger mosaics (and even the Borradaile Oliphant). Furthermore, on every surviving beaker, each lion is accompanied by an unexplained triangular motif. Some see the shape as a shield but others read the triangle as the Trinacria (Sicily's emblematic shape), a name and form with which maybe scholars at the time were well acquainted.[136] A Sicilian origin cannot be dismissed altogether.

Fig. 178 (top)
A so-called Hedwig Beaker:
a glass vessel with eagle,
lion and griffin decoration.
Sicily (or Syria?),
1100–1200. H 14 cm.
British Museum, London.

Fig. 179 (above)
Line drawing of the
decoration of the
Hedwig Beaker.

A Multicultural Kingdom

Given the multicultural influences encountered in all these aspects of daily life at the court and royal propaganda, it seems clear that Roger and his successors truly aimed at unifying the diverse peoples of the island into one 'Sicilian people' under the king's cohesive rule.[137] An illuminated manuscript that shows Greek, Latin and Saracen scribes working together at the palace certainly depicts the people as such (fig. 166), elsewhere also referring to Palermo as the '*urbs felix, populo dotata trilingui*' (happy city, endowed with a three-tongued people), in a clear classical reference to Apuleius' *Siculi trilingues* (see p. 134). To this end, or more likely as a message that their policy had succeeded, the king and his ministers ensured that bilingual and trilingual texts were evident for the larger population to see, often strengthened through the architecture in which they were set. We have seen several such examples, not least in their coins, regalia and dress, but also in religious contexts, such as the Cappella Palatina and the cathedral decorations.[138] This policy was also adopted by the courtiers of lower rank, indicating that, at least in Palermo, multilingualism was indeed seen as reflecting multiculturalism, and a key aspect of the monarchy. Most telling are the tombstones of the parents of Grisandus, who was a priest of Roger II. A first inscription, in Latin alone, recorded the burial of Anna, mother of Grisandus, in Palermo Cathedral in 1148. However, a second 'tombstone' (fig. 180), probably one side of her marble sarcophagus, records the transfer by

Fig. 180
Marble inlaid tombstone or sarcophagus slab for Anna, with eulogy in Judeo-Arabic, Latin, Greek and Arabic. Palermo, 1149. H 32 cm.
Soprintendenza di Palermo.

her son of her remains to a private chapel in the Church of St Michael in Palermo in 1149, uniquely in four languages and in four scripts. The marble slab was inlaid with colourful marble *opus sectile*, and four different sections contain texts in Judeo-Arabic (an Arabic dialect written in Hebrew characters, for the largely Arabic-speaking Jewish population) at the top, Latin on the left, Greek on the right, and Arabic at the bottom. At the centre, around the *opus sectile* Greek cross, is engraved 'IC / XC / NI / KA' (Jesus Christ Conquers). Interestingly, the four texts are not literal translations of one another, but each addressed cultural and religious aspects of the distinct group they represented. For example, the date of the transfer (1149) is variously given as the year 4909 in the Judeo-Arabic, calculated from the creation in 3761 BC; AD 1149 in Latin; the year 6657 in Greek, according to the Byzantine era calculated from the creation in 5508 BC; and the year 544 in Arabic, according to the Hijri. As on the Alb of William II, the Arabic refers to the pope as the 'Imam of Rome'. The texts also record that during the transfer of Anna's remains, prayers were said in both Greek and Latin. This bilingualism could be a specific characteristic of Roger's new 'Sicilian' church, of which Grisandus obviously was a priest and advocate. A third tombstone, much plainer than the previous one, but set into the same chapel, records the death and burial of Grisandus' father, Drogo, in 1153, in three languages: Greek, Latin and Arabic. Again, the dates respect the different calendars. These texts do not only convey Roger's official policy, but possibly also represented an actual multicultural family situation: their names suggest that Anna was Greek and Drogo was French, probably Norman. Grisandus, on the other hand, is a Latin name, Latinized from the Greek.[139] However, it might also be the case that these names mask ex-Muslims, their new names conferred upon them after Christian baptism.[140]

Such an overt use of Arabic in these tombstones, as in architecture in general, can of course be considered surprising for what was in essence a Christian kingdom. One should, however, consider that for centuries (and still today) Arabic was a language of Christianity, not just on Sicily, where many Muslims had converted to Christianity and Greek Orthodox Christians still spoke Arabic after century-long domination, but all around the Mediterranean, from the Mozarabs in al-Andalus (Islamic Spain), to the Melkites and other Christian communities in Antioch and the Holy Land, and even further east to the area of modern Iraq.[141] Evidence for Muslim converts at the royal court comes from the presence of a *Kitab tafsir Batir Nustir* (The Book of the Explanation of the Pater Noster) listed among the books kept at the Cappella Palatina.[142] Certainly for use by Arabic-speaking Christians, whether converts or not, is also the trilingual psalter, the Book of Psalms, that was dated at the court of Roger II on 8 January 1153, and probably created not long before that.[143] The psalms are written in narrow columns, three to a page, each in a different language: Greek on the left, Latin in the centre and Arabic on the right, the latter written in the *diwani* script of the kingdom's administration. Interestingly, only the Arabic psalms are annotated, and only with references to the Latin liturgy, as for example 'reading for Tuesday night'.[144] It is tempting to see this psalter used at the Cappella Palatina, which itself shows the influences of the religious spheres of these different languages and where the multilingual and multicultural kings themselves followed the liturgy. It is likely that the Arabic texts were there to act as a translation for converts whose Greek or Latin was not sufficient enough to follow the liturgy. However, in combination with the reference to the bilingual rite performed during the transfer of Anna's remains, some scholars see in these books the evidence for the actual existence of an Arabic rite in Sicilian liturgy under Roger as well, the Rogerian Sicilian Church then being the only church to have a trilingual liturgy, even though short-lived.[145]

IBN JUBAYR

Palermo and other towns in Sicily were visited in 1184–5 by Ibn Jubayr, an Andalusian traveller. It is interesting to compare his description of Palermo with that of Ibn Hawqal (see p. 160), as seemingly it had barely changed from the Muslim city of almost two centuries earlier.

> *The finest town in Sicily and the seat of its sovereign, is known to the Muslims as al-Madina, and to the Christians as Palermo. It has Muslim citizens who possess mosques, and their own markets, in the many suburbs. [. . .]*

> *It is an ancient and elegant city, magnificent and gracious, and seductive to look upon. Proudly set between its open spaces and plains filled with gardens, with broad roads and avenues, it dazzles the eyes with its perfection. It is a wonderful place, built in the Cordova style, entirely from cut stone known as* kadhan *[a soft limestone]. A river splits the town, and four springs gush in its suburbs. The king, to whom it is his world, has embellished it to perfection and taken it as the capital of his Frankish Kingdom – may God destroy it. [. . .]*

> *The Muslims of this city preserve the remaining evidence of the faith. They keep in repair the greater number of their mosques, and come to prayers at the call of the muezzin. In their own suburbs they live apart from the Christians. The markets are full of them, and they are the merchants of the place. They do not congregate for the Friday service, since the* khutba *[public sermon] is forbidden. On feast-days [only may] they recite it with intercessions for the Abbasid caliphs. They have a* qadi *[judge] to whom they refer their law-suits, and a cathedral mosque where, in this holy month, they assemble under its lamps. The ordinary mosques are countless, and most of them are used as schools for Qur'an teachers. But in general these Muslims do not mix with their brethren under infidel patronage, and enjoy no security for their goods, their women, or their children. [. . .]*

> *The Christian women of this city follow the fashion of Muslim women, are fluent of speech, wrap their cloaks about them, and are veiled. They go forth on this Feast Day [Ibn Jubayr visited on Christmas Day] dressed in robes of gold-embroidered silk, wrapped in elegant cloaks, concealed by coloured veils, and shod with gilt slippers. Thus they parade to their churches [. . .], bearing all the adornments of Muslim women, including jewellery, henna on the fingers, and perfumes.*[146]

Ibn Jubayr was mostly interested in describing Muslims and Muslim culture in Sicily and Palermo, and his account remains frustratingly short on detail. However, some interesting conclusions can be drawn from what he recounts. There were still very many Muslims living in Palermo who had kept their own mosques – prayer was allowed, but not the public sermon; however, many of the mosques were now schools. Furthermore, Palermo seems to have had districts segregated by culture/religion, as the Muslims have 'their own suburbs'. This is the same view that we get from Petrus of Eboli's miniature of Palermo (fig. 181), where at the death of William II each district of the city is shown with its own particular inhabitants, clearly recognizable by their dress and attributes: Latins in Cassarum, Greeks in Alza, Arabs and Jews in the Ideisini and the Scerarchadium, all

names Latinized from Arabic predecessors.[147] Perhaps the only truly mixed district of Palermo was the Galca, the area around the palace, in which all the functionaries and dignitaries lived in sumptuous palaces along the main roads.[148] Yet, the legacy of Arab culture was still so strong in the city that Christian women dressed as Muslim women, even to go to church. The Islamic legacy even survives today, when several of Palermo's districts are still known by the same names they had back then (see fig. 126): the Cassaro, the Galca, the Kalsa and Seralcadi (from Scerarchadium).

Fig. 181
Page showing the palace gardens (Genoardo or Jannat al-Ard, Paradise on earth), as well as the different districts of Palermo in mourning at the death of King William II, from the illuminated manuscript *Liber ad honorem Augusti sive de rebus Siculis*, written by Petrus of Eboli at the court in Palermo in 1195–7.
Burgerbibliothek, Bern.

The Growing Latinization

The integration of a visually strong Islamic component in the art and architecture of the new kingdom, including depictions of the king as a Muslim ruler, has in the past persuaded historians that Norman Sicily was a peaceful multicultural society, which it mostly was, in which all peoples were equal, which it certainly was not. It has been described as the 'land without crusades' and 'an example of tolerance'.[149] Such statements could certainly be supported by a document such as the trilingual psalter, as well as a few medieval writers who saw, or wished to see, Sicily through the same eyes: Petrus of Eboli's miniatures of life at the court (see p. 206) and reference to the three-tongued people of Palermo; or the address made by Eugenius, one of William II's ministers, to that same king: 'Do you not harmonize the inharmonious, and mix together the un-mixable [. . .] with wise foresight blending and uniting into a single race disparate and incongruent peoples.'[150] However, the miniatures show only Palermo and it is the Palermitans who are 'three-tongued', while it was only the powerful charisma of the king personally that held the key to Sicily's harmony.

For once, it is not a coincidence that all the most explicit surviving evidence of influence from the Islamic world – written, visual and physical – was only in the immediate surroundings of the king: the palaces and churches of Messina and Palermo (including Cefalù).[151] What is more, it is highly unlikely that people other than those at the court in Palermo would be able to speak more than one language, and even those struggled at times.[152] It is also highly telling that the miniatures of Petrus of Eboli – one depicting notaries at the court and the other the peoples of Palermo – indeed show three *different* peoples, each represented by their stereotypical attributes and dress, and segregated in different parts of the city, a situation also described by Ibn Jubayr (see p. 222).[153] All this suggests that the visual language was meant for only a very select audience, including the Muslims at the court, many of whom had converted to Christianity, or high-status visitors and diplomats, who could marvel at the accomplishment of inclusion on the part of the king.

Muslims who were not at the court were gradually more and more oppressed through the rising Latinization of the kingdom.[154] When during and immediately after the Norman conquest many of the Arab social and intellectual elite emigrated, those that stayed behind either saw themselves as Sicilian rather than Arab or Muslim, sympathetic to the court and thus of strategic importance to Roger,[155] or were those too poor, merchants as well as farmers (villeins) of the west and the south of the island (the north-east always retaining their Byzantine affinities), who, abandoned by their own leaders and elite and by the North African dynasties, had little choice but to submit to the Christian rule.[156] At first, for the villein, little more than their master must have changed, from an Arab to Christian landlord, and Muslim villeins had the same rights/duties as Greek or Latin villeins, with the exception of the extra *jizya*, now a tax that Christians charged Muslims. Increasingly, however, areas previously inhabited by Muslims were gradually filled with Latin settlers, and in some areas Latin-speakers were actively preferred.[157] Such situations and organization of Muslim villeins on agricultural estates can be reconstructed through official bilingual documents, issued by the court, registering land holdings and men that were conceded to landlords.[158] Over time, many of the agricultural estates were donated to churches, and these registers survived in their treasuries.

Even though Roger obviously valued Islamic and Greek culture and respected the religions – what is more, his first wife Elvira was daughter of an ex-Muslim from al-Andalus – he did nothing to limit the consequences for these cultures of the growing Latinization of the kingdom through a continuous stream of Latin-speaking immigrants and settlers from France, England and Italy.[159] Even during his reign Roger seemingly had to 'keep the Franks

'off' the Muslims.[160] However, there are so many references to Roger's changing behaviour towards the end of his life that these are difficult to ignore. Chroniclers mention that he started trying to convert Muslims to Christianity, especially those that had leading roles within the larger Muslim communities,[161] and the execution of one of his most trusted Muslim advisers was seen by one contemporary Arab historian as 'the beginning of the end for the Muslims of Sicily'.[162] Under William I and William II, even though they also highly valued Islamic culture, the kingdom turned firmly towards Western Christianity. The continued hostilities with the Byzantine Empire and the loss of the Norman 'Kingdom of Africa' certainly contributed to this.[163] William I and his wife Margaret became strong supporters of Pope Alexander III, and were followed in this by their son. At the death of William I, the extremely pious Margaret had

Fig. 182
Mosaic from Monreale Cathedral, showing King William II being crowned by an enthroned Christ, 1180s.

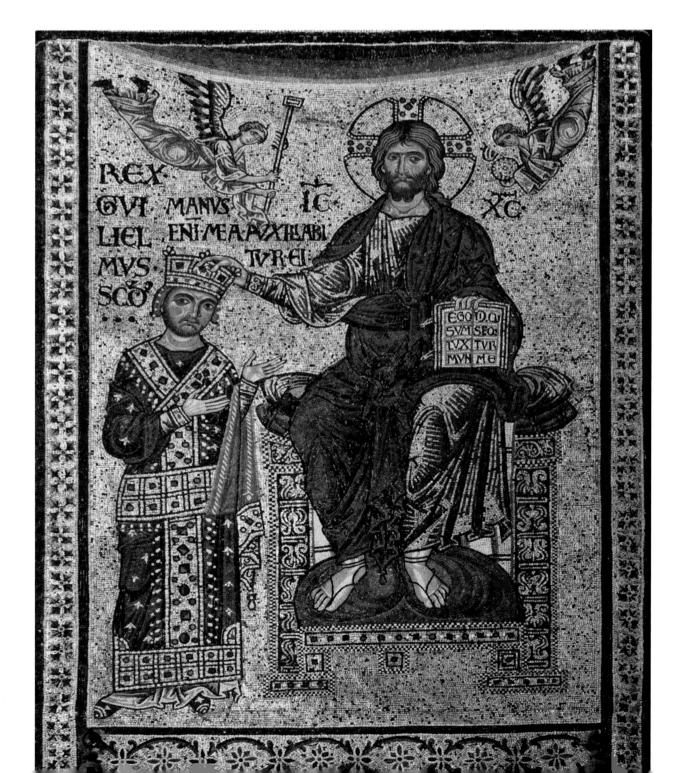

asked her French archbishop cousin for help in governing the kingdom as regent, and to her aid was sent Stephen du Perche, who was, in any case, on his way to join a crusade with a large contingent of Latins. He ended up staying for several years, during which he was appointed Archbishop of Palermo. At once, he wrote to Pope Alexander III asking him to intervene in the excessive tolerance that was shown to Saracens in Sicily, and actively persecuted some of the palace eunuchs,[164] who eventually with the help of others more tolerant successfully plotted against him. William II increasingly used Latin advisers, rather than Arab-speaking ex-Muslims,[165] and turned the secular audience hall of the Cappella Palatina into the nave of the church through the addition of new mosaics, pulpit, font and candelabrum, as well as the removal of the inlaid Arabic inscriptions.[166] He also founded the new monastery and Cathedral of Monreale (fig. 183) in an area inhabited mostly by Muslims. Although considered as an act of personal piety and serving as a dynastic mausoleum (William I and II were both buried in Monreale),[167] the monastery was also strategically placed at the border between the Conca d'Oro and the lands behind it, all of which were donated to the new church, including its Muslim towns, inhabitants and villeins. Muslim and Greek villeins now became serfs, tied to the land, and could be bought, sold and inherited like animals or other possessions.[168] The cathedral, which stood as an icon of Christianity, more Latin than Byzantine, was nothing short of a provocation to the remaining Muslims on the island.[169] Strangely enough, however, the rulers remained thoroughly Islamic influenced in customs, manner and dress, when in private, as the quotations cited earlier make clear, and they still systematically surprised Arab visitors by their learnedness, tolerance and behaviour towards Muslims, albeit only scholars and the elite. Such a contradiction was witnessed by Ibn Jubayr, who when describing the island in general said that 'the Christians treat these Muslims well and have taken them to themselves as friends', but shortly after praising the king's conduct, wrote in connection with Palermo that 'in general these Muslims do not mix with their brethren under infidel patronage, and enjoy no security for their goods, their women, or their children'.[170]

The king was truly the charismatic cohesive power behind the peaceful coexistence. Once that power fell away, however, the Muslims were left on their own.[171] There must have been a general sentiment of resentment, especially from the Latin immigrants, towards the 'infidels'. The 'Palace Saracens' were especially vulnerable, given that their influence depended solely on the king, and that the larger populace saw them as responsible for the unpopular acts and failures of government, foremost among them the taxes.[172] Actual violence against Muslims was rare, but happened at those most critical of times when the power of the king was wanting. In 1161, when the Sicilian barons rebelled against William I, pogroms against Muslims broke out, especially in Palermo. The same also happened during the power vacuum after the death of William II, who had left no heir. William II's rule having taken a firmer turn towards Western Christianity, the latter massacres were more severe and systematic, so that Muslims were forced to flee the cities and withdraw to mountain villages.[173]

The Norman period in the history of Sicily is indeed one of tolerance and coexistence, but not of integration or equality. Four peoples – including the minority of Jews, whose status was as low as that of Muslims – lived side by side, but outside the palace were thoroughly separated by religion, status and language. What Roger truly envisioned at some point, a peaceful prosperous multicultural society of equals, sparkled brightly in the world of the time, but could not survive the constant pressures from outside forces and religions.

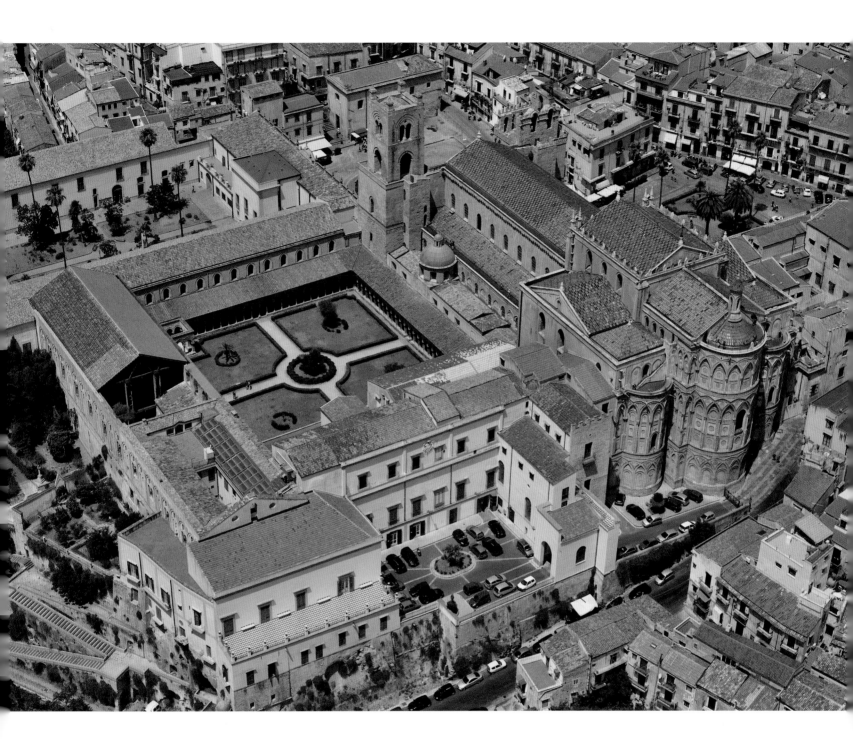

Fig. 183
Aerial view of Monreale
Cathedral, built by William II
between 1174 and 1182.

TANCRED OF HAUTEVILLE

WILLIAM 'IRON ARM'
COUNT OF APULIA
(1042–6)

DROGO
COUNT OF APULIA
(1046–51)

ROBERT 'GUISCARD'
DUKE OF APULIA (1057–85)

ROGER I
COUNT OF SICILY
(1071/2–1101)

Judith of Évreux
Eremburga of Mortain
Adelaide of Vasto
(REGENT 1101–12; D. 1118)

ROGER BORSA
DUKE OF APULIA
(1085–1111)

SIMON
COUNT OF SICILY
(1101–5)

ROGER II
COUNT OF SICILY
(1105–28)
DUKE OF APULIA
(1128–30)
KING OF SICILY
(1130–54)

Elvira of León-Castile
Sybil of Burgundy
Beatrice of Rethel

WILLIAM
DUKE OF APULIA
(1111–27)

ROGER
DUKE OF APULIA
(D. 1148)

WILLIAM I
KING OF
SICILY
(1154–66)

Margaret of Navarre
REGENT (1166–71)

**FREDERICK I
BARBAROSSA**
HOLY ROMAN EMPEROR
(1155–90)

TANCRED
(ILLEG.)
KING OF SICILY
(1190–4)

WILLIAM II
KING OF SICILY
(1166–89)

Joan of England

CONSTANCE
QUEEN OF SICILY
(1194–8)

HENRY VI
HOLY ROMAN
EMPEROR
(1190–7)
KING OF SICILY
(1194–7)

FREDERICK II
KING OF SICILY
(1198–1250)

KING OF GERMANY (1212–50)
HOLY ROMAN EMPEROR (1220–50)
KING OF JERUSALEM (1225–50)

And although the king himself was possessed of great wisdom, intelligence and judgement, he also gathered men of good sense of different classes from the various parts of the earth and made them partners in his decisions.

ARCHBISHOP ROMUALD II OF SALERNO, c.1169–81[1]

5
An Enlightened Kingdom

When in the Maghreb famine and chaos broke out, many of their princes, judges, jurists, writers and poets went to them, and George [of Antioch] and Roger gave them wealth and took them in.

AL-MAQRIZI, EGYPTIAN HISTORIAN (1364–1442),

KITAB AL-TARIKH AL-KABIR AL-MUQAFFA LI-MIŞR[2]

It should not be a surprise that the multicultural and tolerant milieu of the Norman kings – even if only or mainly at the court – was fertile ground for the emergence of what was probably the most enlightened court in all of contemporary Europe. The court of Roger II became one of the first places where scientific advancement was encouraged through collaboration and tolerance, and where the king himself was not just the royal patron but an active participant. The king as a collector of knowledge and an enlightened ruler was a concept that had taken hold in the Mediterranean with the Arab conquest: caliphates in Cairo and al-Andalus used the cultivation of culture to legitimize their rule, and were largely responsible for the survival of Greek and Latin manuscripts that were now being 'rediscovered' in Muslim libraries. In that respect, Roger was once again imitating contemporary Eastern practice.[3] In their turn, William I and William II closely followed Roger's example. As Ibn Jubayr said of William II's court:

> *He pays much attention to his [Muslim] physicians and astrologers, and also takes great care of them. He will even, when told that a physician or astrologer is passing through his land, order his detainment, and then provide him with means of living so that he will forget his native land.*[4]

Twelfth-century Sicily has been described as 'a model state in the Middle Ages', and even an 'early Renaissance' by several scholars;[5] there certainly was a flourishing of the sciences and arts, as there had been in western Europe under Charlemagne in the ninth century.[6] Other historians are more cautious about identifying the Norman kingdom as the start of or even as an early version of the fourteenth-century Italian Renaissance, as the bulk of the Normans' fascinations were still part of a wider and more general interest in humanist advancement during the Middle Ages, including especially astronomy, mathematics and philosophy.[7] However, it cannot be denied that other elements usually associated with the Renaissance, such as a desire to revive the glory of the past as well as an investment in the development of secular law and the move away from feudal code, were already present at the court of Roger II and his immediate successors.

This perception of a 'court before its time' has been even stronger in relation to Frederick II, Roger's grandson, and in everything a worthy member of his line to become King of

Fig. 184
Simplified genealogical tree of the Hauteville dynasty.

Fig. 185
Ivory chess pieces from Sicily, 1100–1200. H of largest 5.3 cm. Chess was invented in the East and reached Europe via the Arab conquests of Spain and Sicily, by crusaders returning from Jerusalem, and through Byzantine contacts with Scandinavia. Its popularity likely increased through the strong ties between the Norman court in Sicily and the courts in France and England.
British Museum, London.

Fig. 186 (opposite)
One of the oldest copies of al-Idrisi's world map, with indication of the seven climates of the world. As on most Arab maps, north is down. The Great Wall of China can be seen in the bottom left; Europe lies in the bottom right. *c.*1300–1500.
Bodleian Libraries, University of Oxford.

Sicily. Inspired by his grandfather and by the glorious Roman Empire of the past, Frederick introduced some of the most influential cultural and humanist changes into the developing nations of what is now Europe. Some early twentieth-century historians have therefore named him a 'forerunner of the Renaissance', or even 'the first modern human on a throne'.[8]

Knowledge Exchange

He made every effort to find out about the customs of other kings and peoples, in order to adopt any of them that seemed particularly admirable and useful.
SO-CALLED HUGO FALCANDUS, ANONYMOUS HISTORIAN AT THE
NORMAN COURT, PROBABLY 1180s–90s[9]

One of Roger's specific interests was geography, and he commissioned an Arab scholar who had travelled extensively to Islamic Spain, Portugal, France, England and Anatolia[10] to write a description of the world, accompanied by maps. At that time, Western scholars had at their disposal only Orosius' description of the earth, written in the fifth century. Ptolemy's work (from the second century AD, but based on Eratosthenes, from the third century BC) was unknown in medieval Europe, but had survived in an Arabic translation and was widely used by Arab geographers as a basis for their maps.[11] Roger studied these, but still,

> *when King Roger had carried out an exhaustive and detailed investigation, he found that these texts had obscured the meaning, and so he summoned to his court learned men well versed in these subjects. However, after discussion with them he discovered that their knowledge was no better than that contained in the aforementioned books. When he realized this, he ordered that men be summoned from all his dominions who knew about these matters and were experienced travellers. He questioned them in groups and also individually, through an intermediary.*[12]

That 'intermediary' was the Arab scholar himself, Muhammad al-Idrisi, who for a period of fifteen years (*c.*1138–54) remained at Roger's court, compiling and comparing the information that he gathered from the myriad of travellers and merchants that stopped in Palermo and other Sicilian ports. The results were set down in the *Kitab nuzhat al-mushtaq fi khtiraq al-afaq*, 'The book of pleasant journeys into faraway lands'.[13] It is more generally known as 'The Book of Roger', to whom al-Idrisi dedicated it in January 1154, only a few weeks before Roger's death. Al-Idrisi's preface to the volume stated that 'he had written record made only of that part of what they told him on which there was a total agreement and seemed credible, excluding what was contradictory. The king continued this work for about fifteen years, without abandoning for a moment verification, inquiry and research, until he had secured what he wanted.'[14] The project would become the most ambitious scholarly work of Roger's reign. It would also survive the ages, with al-Idrisi becoming one of the most important and profound influences on medieval Western geography for the next several centuries,[15] and the book becoming one of the first secular Arabic books to be published in Europe.[16] Although still reliant on Ptolemy, especially for his division of the inhabited world into seven 'climates' or sectors from north to south, al-Idrisi was not afraid to update the work according to newly acquired information. The book's text was accompanied by seventy sectional maps (ten per 'climate'), as well as a circular world map (fig. 186), the latter remaining unmentioned in the text itself.

'The Book of Roger' was not solely a geographical treatise, but also included ethno-geographic descriptions of peoples and their cultures, including architecture, trade, religion,

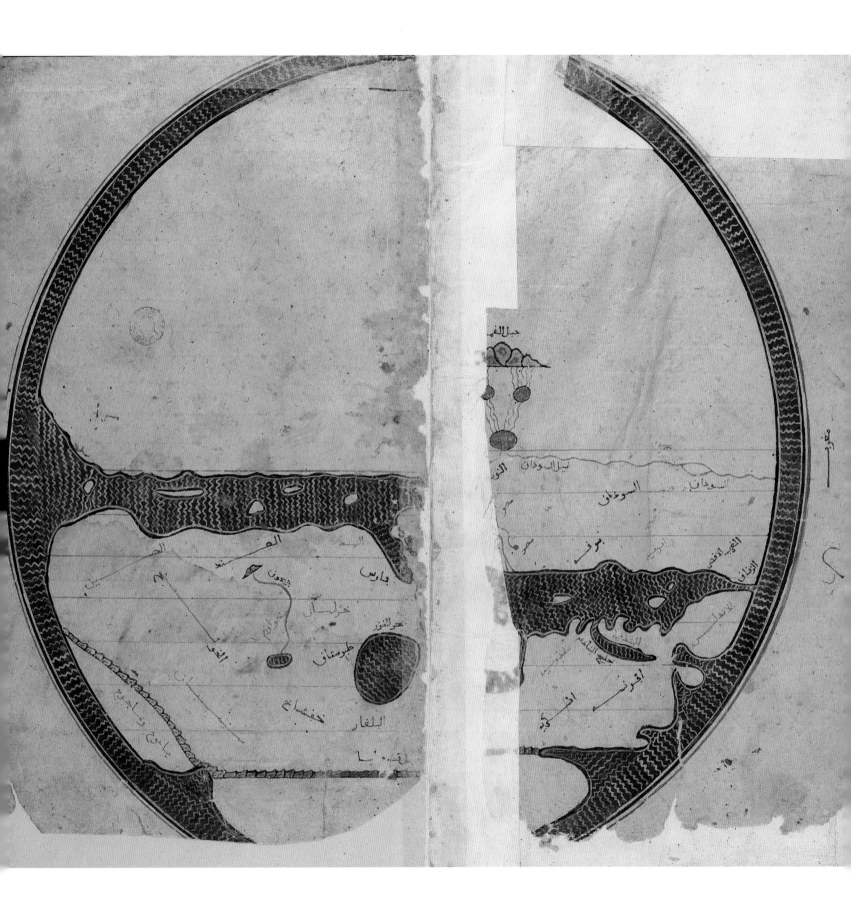

dress and language. Regions as far apart as England and China were discussed, while some scholars even believe they have found a description of the American coast, which is, however, more likely to be that of Bermuda or the Azores. The maps correctly show the Indian Ocean as open to the east, while up to that point it had been considered an enclosed sea.[17] Also depicted is the Great Wall of China, which was well known to Arab geographers, although it was thought to have been built by Alexander the Great and that behind it lay the biblical lands of Gog and Magog.[18] Like most serious scholars of his time, al-Idrisi believed the earth to be round:

> *The earth is round like a sphere, and the waters adhere to it and are maintained on it through natural equilibrium which suffers no variation. It remained stable in space like the yolk in an egg. Air surrounds it on all sides [...]. All creatures are stable on the surface of the earth, the air attracting what is light, the earth what is heavy, as the magnet attracts iron.[19]*

To accompany the book, Roger also ordered the creation of a world map that had to be permanent and durable. After it was laid out on a drawing board, this map was inscribed in accurate detail in a planisphere of pure silver, about 2 metres in diameter and weighing about 134 kilograms. While neither al-Idrisi's original publication nor the planisphere survive (they are thought to have been destroyed when the palace was sacked in 1161, during the reign of William I, a silver disc of this size obviously appealing to looters), several manuscript copies of the seventy-one maps and text still exist (fig. 188).

Apart from encouraging and participating in new research, Roger was also credited by al-Idrisi as having made personal inventions:

> *His knowledge of mathematics and applied science was boundless. He was deeply grounded in every aspect of these two disciplines, studied them comprehensively and himself made new discoveries and wonderful inventions, as no prince before him had. These discoveries were well known to many witnesses. [...] They are so well known, and their reputation has spread everywhere and to every district ...[20]*

Fig. 187
Marble slab with inscription in Latin, Greek and Arabic, recording the dedication of a water clock by Roger II, at the Norman palace in Palermo.

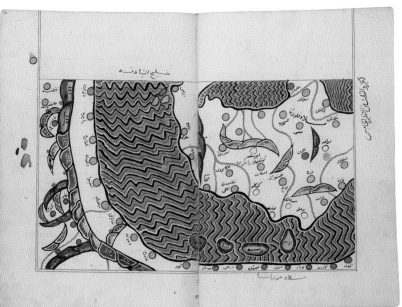
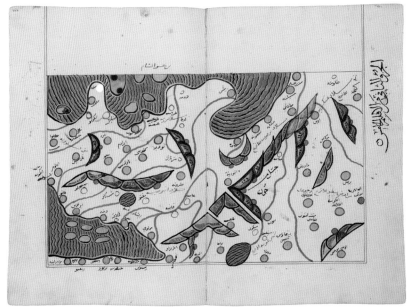

Historians often interpret these inventions as gadgetry or automata, even if ascribing these achievements to Roger personally might rather be idle flattery. Automata, or mechanized devices, were frequently found in Byzantine and Islamic palaces, as well as regarded as highly desirable gifts between friendly rulers, and they certainly brought prestige to their owners. Al-Idrisi's comment is therefore often linked to a trilingual inscription that can still be found in the Norman palace, Palermo, probably not too far from where it was originally set up (fig. 187). The inscription celebrates the construction of an automated clock, by order of Roger, in 1141–2. Rather than being translations of each other, the three texts complement each other and are thus once again indicative of all three languages – Latin, Greek and Arabic – being integrated on an equal level in the court.[21] Nevertheless, while the Latin and Arabic

Fig. 188
Four sectional maps of a copy of al-Idrisi's so-called Book of Roger, together making up the south of France, Italy and Sicily. As on most Arab maps, north is at the bottom. Made in Cairo in 1553.
Bodleian Libraries, University of Oxford.

Fig. 189
Bronze *follaro* of Roger II,
minted in Messina in 1138–9.
The Arabic legend contains
the minting date in the
Islamic Hijri calendar.
British Museum, London.

Fig. 190 (opposite)
A Book of Psalms in Greek,
Latin and Arabic. The Arabic
numerals in the right-hand
margin are those also used on
the coin. A note in Arabic in
the left-hand margin says
'prayer for Tuesday'.
British Library, London.

texts merely talk generally about a clock ('*horologium*' and 'instrument to observe the hours'), only the Greek texts tells us that the clock is a *clepsydra* (water clock): 'Oh new wonder! The mighty lord, king Roger [...] controls the flow of the liquid element, dispensing knowledge of the hours of the year.'[22]

In 1138/9, the same year that al-Idrisi arrived at Roger's court, the king also minted a *follaro* with a unique element. While the reverse showed the legend 'IC XC' around a bust of Christ, very reminiscent of Roger's innovative Pantocrator representation in his cathedral at Cefalù and in the Cappella Palatina,[23] the obverse contained four lines of Arabic, reading *al-malik al-muazzam Rujjar al-mutazz bi-llah* (by order / of King Roger the Magnificent / the powerful through God), and a date, which can be identified as the oldest year-date in Europe in a new Arabic numeral representation (fig. 189).[24] These Indian numerals had been imported with the Arab conquests of North Africa, after which a distinct Western variant of the numerals emerged in the Maghreb and Spain (while the Eastern numerals developed separately and are still used in Arabic today). Through scholarly contacts, first in Spain, then in Sicily, these Western numerals slowly made their way into Europe. The oldest manuscript showing the new numerals was written in 976 (Codex Vigilanus, in the monastery of Albelda, near Logroño),[25] after which they appear only haphazardly in a handful of manuscripts of the eleventh and twelfth centuries, until 1202, when the Pisan scholar Fibonacci published the *Liber Abaci*, his influential treatise about arithmetic:[26]

> As my father was a public official away from our homeland in the Bugia customhouse established for the Pisan merchants who frequently gathered there, he had me in my youth brought to him, looking to find for me a useful and comfortable future; there he wanted me to be in the study of mathematics and to be taught for some days. There from a marvellous instruction in the art of the nine Indian figures, the introduction and knowledge of the art pleased me so much above all else, and I learnt from them, whoever was learned in it, from nearby Egypt, Syria, Greece, Sicily and Provence, and their various methods, to which locations of business I travelled considerably ...[27]

Sicily was one of the places where the new numerals were used and studied before Fibonacci, and Roger himself must have taken an interest in this mathematical innovation, as he was the first to use the new numerals for a date (previously, he had used, only once, his regnal year in Latin numerals to mint a coin; see p. 187). The date, however, was not given as the Christian year AD 1138, but as the year 533 of the Hijri. Interestingly, the same types of numerals are also found accompanying the Arabic text of the trilingual psalter, made before 1153 (see p. 221 and fig. 190), as well as in a few other Sicilian manuscripts. (The Latin text of the trilingual psalter contained Roman numerals and the Greek the traditional alphabetical numeration.) While both these examples from Sicily show the same forms of the numerals, they also show an oddity when compared to other places in the West that used the numerals at the same time: rather than being the usual Western variants, in Sicily the set of numerals are a combination of Eastern forms for 2, 3, 5 and 7, and Western forms for 4, 6 and 8. Although discrepant with other contemporary Western manuscripts, this should hardly be a surprise: the script used in the psalter is the same as that of the *diwan*, which itself was based on the script of Egypt and eastern Mediterranean chanceries (p. 206).[28]

cogitabo pro
peccato meo.
Inimici aut mei uiuent
& confirmati sunt
sup me æmuli
plicati st qui oderunt
me iniq·
Qui retribuunt in
mala p bonis:
detrahebant me
qm sequebar
bonitatem.
Ne derelinqs me
dne ds ms ne discedas
a me intende
in adiutorium meu
dne ds salutis mee. Inf

p... cant... coppha increpat
iudeos qui diuicias habent & nesciunt
cui amittunt. XXXVIII.

Dixi custodiam in
as mea ut n
delinquam in
lingua mea posui
ori meo
custodiam cu
sisteret peccator
aduersum me
Obmutui & hu
miliat sum & silui

An International Court

The Survival of the Antique

At this time, Sicily (that is, Palermo, but also Messina and Syracuse) became one of two principal destinations in Europe (the other being the Iberian peninsula, mainly Toledo) for the rediscovery of 'lost' Western Greek and Roman writings that had survived in Arab libraries, either in their original languages or translated into Arabic. The greatest scholars of the time, from all over Europe, would travel to Sicily specifically in search of these manuscripts, including the most famous writings of Aristotle and Ptolemy, in order to translate them back into their original Greek or Latin, as well as to learn from them for their original treatises.[29] One such scholar was the great Adelard of Bath (*c*.1080–1150), a wandering academic who was eventually to become tutor to the future Plantagenet king, Henry II.[30] His travels around the Mediterranean in search of knowledge eventually took him to Sicily, and he dedicated one of his own works (rather than a translation) to his friend William, bishop of Syracuse, an expert on mathematics.[31] Adelard is also credited with disseminating, at this early date, the first new Indian numerals into Europe. John of Salisbury, secretary at Canterbury and later bishop of Chartres, visited the south of Italy and Sicily on several occasions, his pupil Peter de Blois becoming tutor to the young William II.[32] Most prominent among them all, however, was Henry Aristippus, a native of southern Italy, who rose to prominence at the court of William I and who made the first Latin translation of Ptolemy's *Almagest* from Greek,[33] the first Latin translations of Plato's *Phaedo* and *Meno* and of the fourth book of Aristotle's *Meteorologica*, some at William's own request.[34] Although some of the original books survived in Greek, many of these scholars also learned Arabic in order to read Arabic commentaries on these texts and translate more manuscripts. The true intellectual environment of the Norman court shines through best in Aristippus' own words, when trying to convince a visiting English scholar that there is no better place than Sicily for learning:

> *In Sicily you have the Syracusan and Argolian libraries; there is no lack of Latin philosophy […] You have the* Mechanica *of Hero […] Euclid's* Optica *[…] Aristotle's* Apodictice *[…], the* Philosophica *of Anaxagoras, Aristotle, Themistius, Plutarch, and the other famous philosophers are in your hands […], and I offer you theological, mathematical, and meteorological* theoreumata. *[…] Do you have a King William […], whose court is a school, whose retinue is a* gymnasium, *whose individual words are philosophical* apophthegmata, *whose questions are unanswerable, whose solutions leave nothing undiscussed and whose zeal leaves nothing untried …?*[35]

Perhaps because of shared ancestry, contacts and exchanges between Norman England and Norman Sicily were particularly frequent for such an early period in the Middle Ages, even taking into account that Plantagenet territories stretched to the south of France, and Roger's kingdom incorporated almost all of the Italian mainland up to Rome. As attested by the contemporary chronicler Hugo Falcandus, 'since [Roger] derived his own origin from the Normans and knew that the French race excelled all others in the glory of war, he chose to favour and honour those from the north of the Alps particularly'.[36] This underlines Roger's favouritism towards his French and English cousins. Aristippus' English visitor was just one of many that made the long trip during the twelfth century. Indeed, Englishmen travelled to the new kingdom of Sicily from its very earliest moments, and included not just merchants and pilgrims, but also nobility in search of a court in which to serve, as well as clergymen, who perhaps hoped to 'help' Christianize the new kingdom.[37] Under William II, arguably the most Christian of the Norman kings, four of the highest positions in Sicily's church were

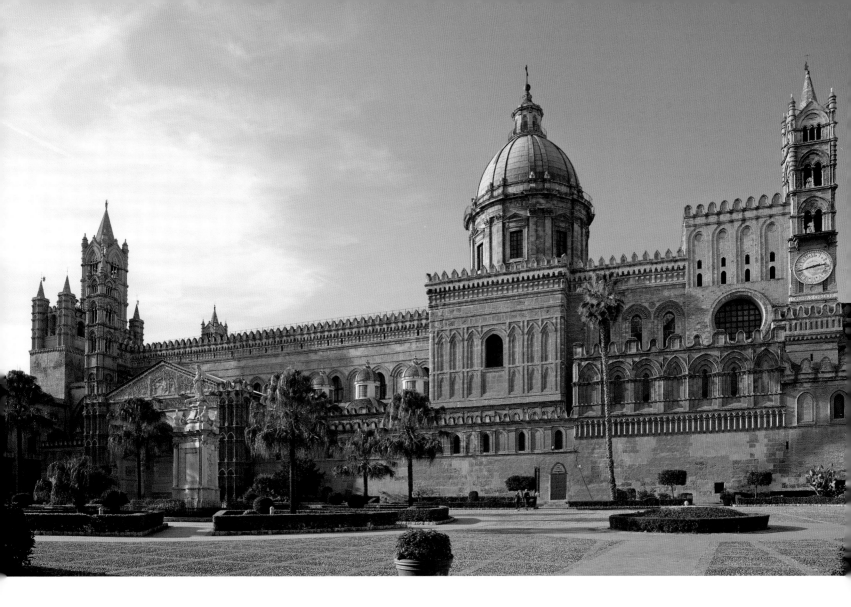

filled by Englishmen: Richard Palmer, bishop of Syracuse and archbishop of Messina (he was probably also a scholar: his tomb inscription proudly imitates Virgil's, as well as betraying his origins: *Anglia me genuit, instruxit Gallia, fovit Trinacris* – England bore me, France taught me, Sicily embraced me);[38] Walter of the Mill, archbishop of Palermo (fig. 191); Bartholomew (Walter's brother), bishop of Agrigento; and Herbert of Middlesex, archbishop of Compsa (near Naples).[39] Perhaps due to the intense exchange of people between England and Sicily, al-Idrisi's description of the other Norman island is generally considered extremely accurate: England is 'set in the Ocean of Darkness. It is a considerable island, whose shape is that of the head of an ostrich, and where there are flourishing towns, high mountains, great rivers and plains. This country is most fertile; its inhabitants are brave, active and enterprising, but all is in the grip of perpetual winter.'[40]

Fig. 191
Palermo Cathedral, started in 1185 by Walter of the Mill, archbishop of Palermo, under King William II. It was enlarged and restyled in later periods, and only a little of the original Norman decoration survives.

The Law of the Land

The most important expatriate to be found on Sicily during the reign of Roger II was the Anglo-Norman Thomas Brown, born Thomas le Brun in England. He became Roger's principal treasurer and is even thought to have drafted the foundation charter for the Cappella Palatina.[41] He left Sicily upon Roger's death in 1154, and arrived at the English court just before the accession of Henry II, who made him Chancellor of the Exchequer.[42] Having been taught the new numerals while on Sicily, Thomas tried to introduce them at the English court, although without success. He is likely, however, to have introduced to Henry other influences that came from the enlightened kingdom,[43] most importantly the new legislation, the so-called Assizes of Ariano, which Roger had issued for the Kingdom of Sicily (which of course at this point incorporated the south of Italy) sometime around 1140.

The Assizes were the most sophisticated body of secular laws at a time when mainly common law or ecclesiastical law were being practised in Europe. However, during the twelfth century – foremost, and almost exclusively, at the University of Bologna – new interest arose in Roman law, specifically the *Corpus Iuris Civilis* (Body of Civil Law) issued by Justinian, the sixth-century emperor. The similarities between several of Justinian's edicts and Roger's Assizes are striking. Seventeen of the sixty-nine Assizes came direct from Roman law, while others were clearly influenced by it; some recent studies indicate that perhaps also law from the Islamic tradition was incorporated.[44] Thus it appears that, once again, Roger was at the forefront of current academic scholarship and must have brought one or more trained jurists from Bologna to set out his new legislation.[45] For Roger, who was having constant trouble with rebellious vassal barons, especially in his territories on the Italian mainland, the Assizes were a first and limited attempt at moving away from feudalism towards more centralization, as well as towards gaining more legalized control over the barons. The king disguised these intentions, however, by stating that these laws were inspired by Divine grace, in return for God's gift of rich Sicily:

> It is right and proper, barons, that we should not be presumptuous either concerning ourselves or about the condition and deserts of our whole kingdom, and that if we have received anything from the generosity which has resulted from Divine grace, then we should repay these Divine benefits through which we have our strength with humble service, lest we be entirely ungrateful for such great favour [...]. We therefore desire and order that you should faithfully and enthusiastically receive the provisions which we make public in the present code whether they have been promulgated by us or [simply] re-enacted.[46]

All the same, Roger was very conscious of the fact that the Assizes could not lay down the law for everything and for everyone. Customary law remained in force as long as it was not contradicted by the Assizes – a system that was recognized as being necessary 'because of the variety of different peoples subject to our rule'.[47] The new laws mainly concerned 'theft, housebreaking, attacks on travellers, violence towards women, duels, murders, judgements of God, criminal calumnies, and arson'.[48] Some of these laws were far ahead of their time, and certainly broke with the common law and superstition that had been practised before: for example, those regarding duels (which Normans had used to settle disputes since their Viking days) and judgments of God. Whereas other contemporary rulers rather put existing common laws in writing, Roger demonstrated investment on the part of the monarch to protect the land and its inhabitants to the best of his abilities, even revealing a nascent notion of human rights. Although there is no direct evidence available, it is thought that the Assizes also influenced the Constitutions of Clarendon made by the reformer Henry II; if so, Thomas le Brun was the most likely source.[49]

The Other Norman Kingdom: The Becket Connection

One of the most prominent episodes demonstrating close ties between the two Norman islands of Sicily and Britain occurred in around 1167–70, during the period when Margaret of Navarre was ruling Sicily on behalf of her infant son, William II. Surviving correspondence between Margaret and Thomas Becket, archbishop of Canterbury, shows that the regent queen had given refuge and support to relatives of Becket after Henry II had banished them and confiscated their properties. Sicily found itself torn between supporting Becket, who was backed by the pope, and Henry II. Margaret and William were close allies of the pope, but on the other hand they had recently sought closer relationships with the English court, and the future political marriage between William II and Joan Plantagenet, Henry II's daughter, had already been discussed. Furthermore, the conflict between Henry and Becket revolved around royal authority over ecclesiastical matters and appointments, and, about forty years earlier on Sicily, Roger had extracted from Pope Anacletus II the royal right to appoint archbishops and bishops for himself and his successors (pp. 178–9). Nevertheless, Becket and Margaret maintained a correspondence that showed deep gratitude from Becket's side: 'Although we have never seen your face, we cannot be ignorant of your renown […] We are obliged to your generosisty, which has given solace to our fellow exiles […] and we now owe you even greater thanks for that kindness, with all the devotion that we can.'[50] Margaret and William seem to have been able to keep a middle ground in the conflict, as friends and intermediaries. What is more, after the murder of Becket in 1170 and his subsequent canonization in 1173, Sicily became one of the first places to introduce the cult of Saint Thomas of Canterbury, and, in 1177, the marriage between William and Joan did take place.

Fig. 192
Genealogical tree showing Henry II, King of England, and his children, including Joan (second from the right). Made in England, c.1300–40.
British Library, London.

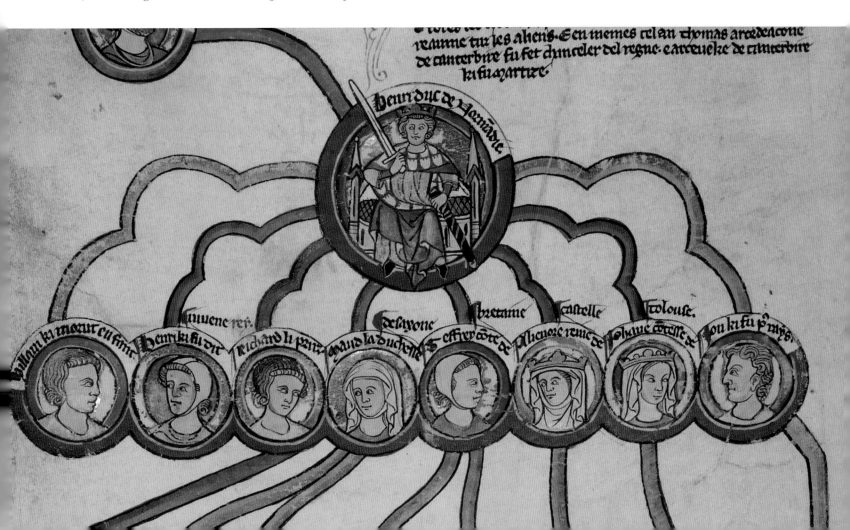

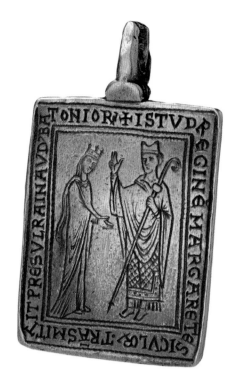

Fig. 193 (right)
Gold reliquary pendant
showing Queen Margaret of
Sicily and bishop Reginald of
Bath, 1174–83. H 5 cm.
Metropolitan Museum of Art, New York.

Fig. 194 (below)
Metal enamelled so-called
Limoges casket, depicting the
murder of Thomas Becket.
Made in Limoges, France,
1180–90. W 21 cm.
Society of Antiquaries, London.

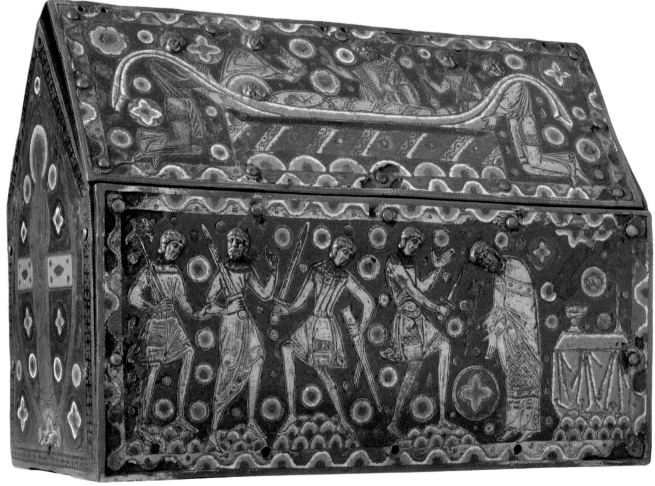

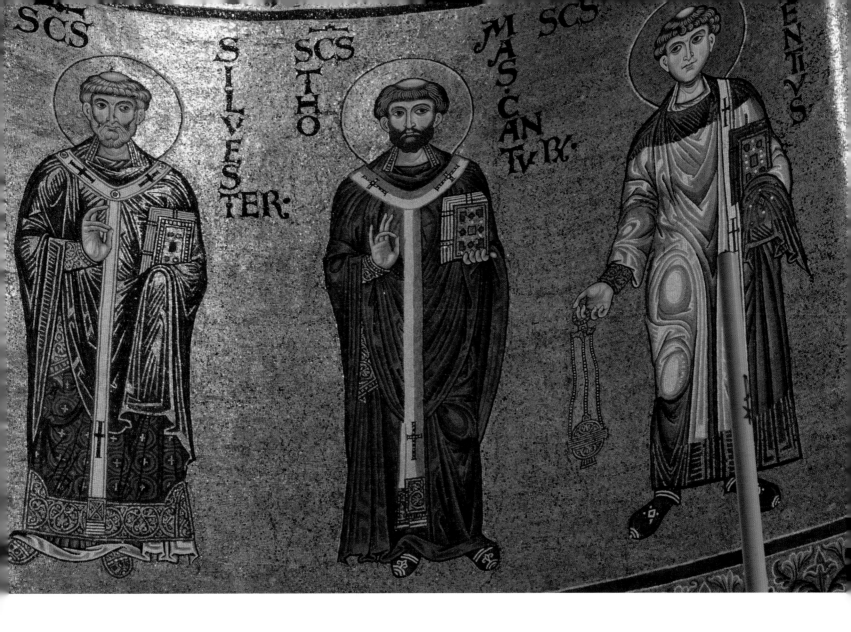

The marriage and the establishment of the cult were undoubtedly linked, as it is known that Joan showed particular devotion to the cult of Becket. At least two churches on Sicily were newly founded and dedicated to Saint Thomas, one in Catania and the other in Marsala, which preserved a reliquary of Becket that had been given by Joan herself.[51] Two other Becket reliquaries can be identified in connection with the Sicilian court. About forty-five so-called 'Limoges caskets' (fig. 194) – enamel inlaid caskets made in Limoges in France in the later twelfth century, which show scenes depicting Becket's murder – were spread around England, France and the rest of Europe. One was bought by diplomat and antiquarian Sir William Hamilton in Naples, while he served there between 1764 and 1800, where it is quite plausibly thought to have been since the Middle Ages.[52] If so, it is possible that it was originally a gift to the Norman court. The second reliquary (fig. 193) can be linked unquestionably to Margaret, as she is depicted on it. The inscription running along the edges of a small pendant reveals that it originally held pieces of the garments in which Becket was murdered (fragments of the cloak, belt, hood, shoe and shirt) and which were stained with his blood. It also states that

Fig. 195
Mosaic from the central apse of Monreale Cathedral, depicting SCS THOMAS CANTVB, Saint Thomas of Canterbury.

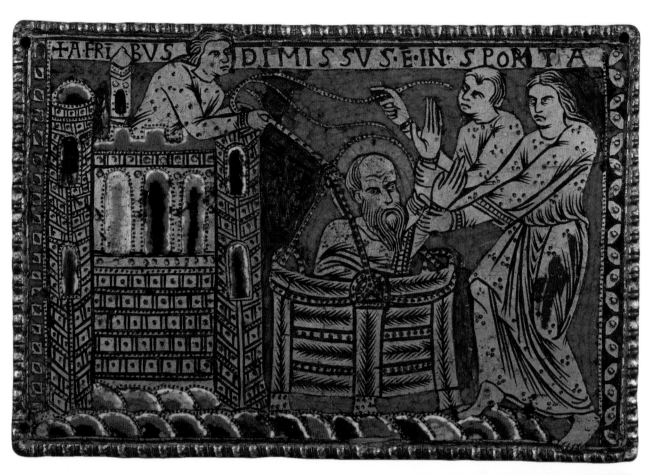

HAFRIBVS DIMISSVS E IN SPORTA

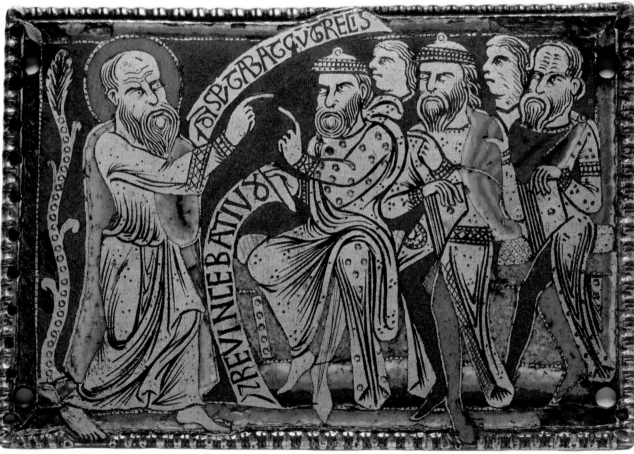

DISP ET BAT GVT GRECS
TREVINCEBATINDII

the pendant was presented to Margaret by Bishop Reginald of Bath – who is also depicted on it – probably on the occasion of the marriage and definitely before Margaret's own death in 1183. Most impressive of all, however, is the very first known effigy of 'Saint Thomas of Canterbury' (fig. 195), which still stands tall in one of the most prominent positions of the central apse of the Cathedral of Monreale, the new foundation created by William II. It is assumed that it was on Joan and Margaret's orders that he was portrayed there at such an early date, barely ten years after his canonization.[53]

Interestingly, through the mosaics of Monreale Cathedral, as well as those of the Cappella Palatina, we can detect hints of artistic contacts between England and Sicily. A series of enamelled plaques (figs 196–7), made in England around the end of the twelfth century (1170–80) are thought to have decorated a prestigious box, perhaps also a reliquary. The scenes depicted are all from the life of Saint Paul, an unusual cycle of images to find on a box as they were usually restricted to manuscript miniatures.[54] No parallels for the scenes are known from contemporary England. In fact, the only known parallels – and they are extremely striking – are found in Monreale Cathedral and in the Cappella Palatina (fig. 198). In both, they occupy prominent positions in the side aisles. It is presumed that artistic ideas such as these were probably being disseminated via illustrated manuscripts, but at the same time the similarities between the scenes hint at a back-and-forth movement of people and ideas between the two islands, as well as an emerging shared image culture. Unfortunately, it remains unknown which are the earlier – the mosaics or the enamel plaques. However, what is known is that they were made by very different craftsmen: Byzantine mosaicists in Monreale, and English metalworkers for the plaques.

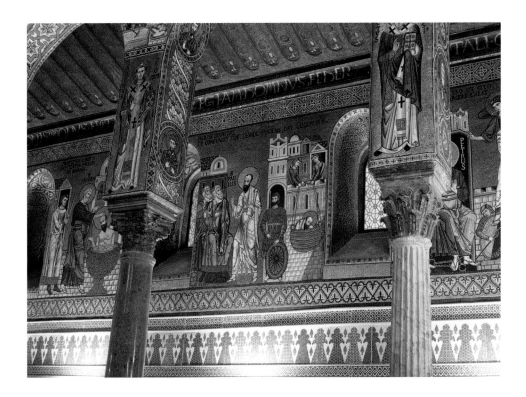

Figs 196–7 (opposite)
Two metal enamelled plaques from a casket, showing scenes of the Life of St Paul: St Paul being lowered from the walls of Damascus (top) and St Paul disputing with the Greeks and Jews (bottom). Made in England, c.1170–80. W 12.8 cm.
Victoria and Albert Museum, London.

Fig. 198
Interior view of the south wall of the Cappella Palatina, depicting the same scenes of the Life of St Paul in mosaic.

The Beginning of the End

Although barely anything is known about Joan during her time as queen of Sicily, she eventually played an important part in the international politics that the island was dragged into when William II died in 1189 without having produced a child. With no direct heir available, Tancred of Lecce, an illegitimate grandson of Roger II, immediately seized power. Tancred had tried to usurp power before: he had been instrumental in the revolt against William I's rule in 1161 and in the accompanying pogroms against the Muslim population. Pardoned after this unsuccessful coup, he remained active within the court. However, this time Tancred was backed by the populace, the pope and some, but not all, of the island's baronial class. The alternative legitimate heir, Constance de Hauteville, was less desirable as queen for the larger population, not because of her parentage (she was the posthumous daughter of Roger II himself) but because of her German husband, the Holy Roman Emperor, Henry VI of Hohenstaufen.

In 1186 the heirless William II had consented to the marriage of his aunt Constance to Henry VI, son of the Holy Roman Emperor Frederick Barbarossa. Barbarossa had previously tried to take Sicily forcefully with the help of the pope (see p. 181), but now resorted to diplomacy and a political marriage.[55] William, for his part, must have seen the plan as a way of keeping the crown in the family, in case he reamained childless. He had already been married for nine years by that point. While the people did not necessarily object to Constance, they did not want the island to fall into German hands:

> *I imagine the disorderly columns of foreigners occupying her [i.e. Sicily] with that impetus with which they are borne forward, destroying with fear wealthy cities and places flourishing as a result of a long period of peace, devastating them with slaughter, wasting them with plunder and sullying them with rape [...]. You are an island whose condition is wretched, and fate damned. [...] For the madness of the Germans has no experience of being ruled by the guidance of reason, or being deflected from its aims by human sympathy, or deterred by religious scruples. Its inborn fury urges it forward, greed goads it, lust drives it on.*[56]
> ANONYMOUS, PROBABLY THE SO-CALLED HUGO FALCANDUS, '*A LETTER CONCERNING THE SICILIAN TRAGEDY*', c.1189–91

Over the next five years, Constance and Henry VI tried to conquer the island and were finally successful in 1194. It was hardly a coincidence that Henry chose to be crowned King of Sicily on Christmas Day of that year, in this way aligning himself to Roger II's rule and coronation (as well as Charlemagne's coronation in Rome on Christmas Day 800). Constance was not able to attend the coronation as she was delayed in Iesi on the Italian mainland, giving birth to their first and only child, Frederick.

Fig. 199
The marriage of Constance de Hauteville and Henry VI Hohenstaufen, from the illuminated manuscript *Liber ad honorem Augusti sive de rebus Siculis*, written by Petrus of Eboli at the court in Palermo in 1195–7.
Burgerbibliothek, Bern.

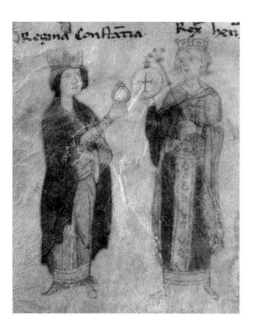

EXCALIBUR ON SICILY

Tancred made the mistake of imprisoning Joan, who obviously supported Constance, and refusing her monetary inheritance, just at the time when Joan's brother, Richard the Lionheart, was sailing the Mediterranean in preparation for a crusade. Although Richard might have felt genuine affection for his sister, the insult was also the perfect excuse to show the extent of his power and to plunder some of the Sicilian cities, Messina in particular. When the situation became untenable to Tancred, he relented, released Joan and offered Richard assistance for his crusade. One medieval chronicler, Roger of Howden, tells the remarkable story that subsequently, on 6 March 1191, Richard gave King Arthur's sword 'Caliburn' (Excalibur) to Tancred as a diplomatic gift, in return for his assistance, but also to forge a closer relation for the future. Richard had no love for the Holy Roman Emperor either (he would be imprisoned by Henry VI on his return from the crusades). Although only Roger of Howden recorded the story, Richard might actually have given a sword to Tancred as a diplomatic gift, claiming that it was Excalibur in order to emphasize its prestige.[57] Interestingly, a manuscript miniature dating from just a few years later, depicting Tancred's entry into Palermo, shows a sword being carried in procession with him.

Fig. 200
King Tancred entering Palermo with his sword carried in front of him. Falcons or eagles decorate his crown, the head of his horse and his standard. Detail from the illuminated manuscript *Liber ad honorem Augusti sive de rebus Siculis*, written by Petrus of Eboli at the court in Palermo in 1195–7.
Burgerbibliothek, Bern.

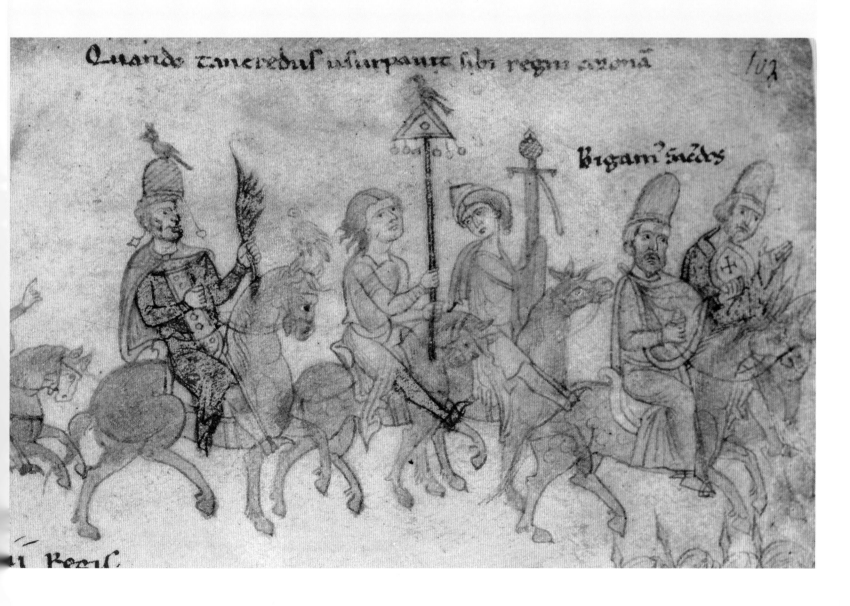

Frederick II, *Stupor Mundi*

One would have to believe that Frederick was destined for greatness. He was, after all, the grandson of two of the most influential rulers in twelfth-century Europe: Holy Roman Emperor Frederick Barbarossa and King of Sicily Roger II. However, both were dead before he was born. Neither did he spend much time with his parents: Henry died in 1197 and Constance in 1198, but not before crowning Frederick King of Sicily, thus guaranteeing the succession. Given the dangers to the young king from other pretenders, both to the throne and to the imperial crown, since Frederick was also destined to be Holy Roman Emperor and thus ruler of most of central Europe, Constance had approached Pope Innocent III, putting aside previous disputes, and had placed Frederick II under his guardianship. The pope, still wanting Sicily among his own domains, and especially now that he was hemmed in between two of the most powerful states under potentially one ruler, agreed. In practice, however, the pope's involvements in both governing Sicily and in Frederick's education were limited. Between 1198 and 1208, Palermo became a battleground between supporters of Constance and Henry, supporters of the pope (such as the future Pope Honorius III), internal pretenders to the throne, and foreign forces such as the Pisans and the Genoese, all of whom managed to hold power for a few years, each time assuming guardianship of the young Frederick.

Although nothing much is known of Frederick's childhood, growing up in Palermo during this period must have been instructive on a political as well as on a cultural level. Apocryphal and probably slightly embellished accounts state that the boy grew up 'on the streets' and was fed by the people of Palermo who took pity on him. It is also believed that this experience, rather than a formal education, taught him fluency in no fewer than six languages: Arabic, Latin, Greek, German, French and, of course, vernacular Sicilian. Frederick survived (perhaps surprisingly so, even though he was under the protection of the pope), declared of age in 1208 (at fourteen years old) and given authority over Sicily. He immediately proved to be a capable and clever ruler, and set out to take back control over his territories in Germany and Italy.

The story of Frederick's accomplishments, while vastly interesting, is also long and complicated and is not the story of Sicily. The island, mainly Palermo, had an important role to play as capital of the new empire Frederick wanted to found, but nothing more than that, as Frederick chose it for purely pragmatic reasons: its centrality, its multiculturalism and its illustrious history. During the almost fifty years of his reign, Frederick would not spend much time on Sicily, being away in Germany, northern Italy or the Holy Land. Even during periods of calm, Frederick preferred Apulia to Sicily, and many of his castles survive there, including the most famous one, Castel del Monte. Furthermore, his entourage, though nominally based in Palermo, travelled with him, becoming an itinerant court. Thus it is problematic to link all his accomplishments only to the island, even though the fact he grew up there meant that they sometimes were identified with it, even at the time. In the brief account that follows, then, the main focus will be on Frederick's policy for Sicily itself, set within the wider context of his rule.

Fig. 201
Sicilian agate bust depicting Constance as a Roman empress. Sicily or southern Italy, 1200–50.
H (without base) 4.5 cm.
Fondazione Dino ed Ernesta Santarelli, Rome (on long-term loan to the Capitoline Museums, Rome).

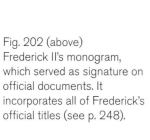

Fig. 202 (above)
Frederick II's monogram,
which served as signature on
official documents. It
incorporates all of Frederick's
official titles (see p. 248).

Fig. 203 (right)
Marble bust of Frederick II
depicted as a Roman emperor,
perhaps Augustus or
Constantine the Great. Found
in Lanuvio, made c.1220–50.
H 49 cm.

Deutsches Archäologisches Institut,
Rome.

Fig. 204
The red porphyry tombs in Palermo Cathedral: in the foreground the tomb of Frederick II (left) and his father Henry VI (right); in the background, the tomb of Roger II (left) and Constance (right). Against the wall on the far right is the white marble reused Roman sarcophagus of Constance of Aragon, wife of Frederick II, who died in 1222.

Frederick was crowned King of the Romans in 1212 and Holy Roman Emperor in 1220. First through marriage, then through a crusade, he also became King of Jerusalem in 1225 (see pp. 177 and 257). Even though he never knew his grandparents, he seems to have taken many of their interests and strategies to heart. His reign is characterized by the pursuit of humanist ideals, in particular a constant search for learning and scientific fact or truth. Like Roger, Barbarossa had also favoured academic learning and had issued special privileges to scholars.[58] Further, Frederick displayed a tolerance towards different cultures and religions, and, most of all, a drive for restoring a peaceful empire, such as that under Charlemagne, or even further back, under the Romans. These earthly sentiments, as well as the fact that Frederick's lands surrounded the Papal States, strained his relationships with successive popes, who obviously felt territorially threatened. During his lifetime, Frederick was to be excommunicated a total of four times; his papal opponents named him 'the Antichrist', 'the Punisher of the World', 'a limb of the devil' and 'a monster emerging from the sea', an ally of demons and magical arts.[59] History, however, has been kinder to him and has focused on the epithets of praise, most famously *Stupor Mundi* (the Wonder of the World), or *Immutator mirabilis* (extraordinary innovator).[60]

Fig. 205
The tomb of Roger II in
Palermo Cathedral, made
of reused Roman red
porphyry slabs.

The Founding of a New Dynasty

There is no doubt that Frederick saw Palermo as the eventual capital of his empire, and that
he intended to found a dynasty that built on the legacies of both his houses. To this effect he
created a dynastic monumental tomb (fig. 204) in the Cathedral of Palermo, when in 1215
he buried his mother and his father alongside his grandfather Roger II, whose remains had
never been transferred to Cefalù Cathedral, where he had wanted to be buried (fig. 229).
Frederick's wish was to be buried with them as well, as he ultimately was after his death in
1250.[61] Around the same time (in 1213), Frederick undertook a similar act in the cathedral in
Speyer in Germany, where he 'brought together the remains of his uncle Philip of Swabia and
his grandmother Beatrix of Burgundy, wife of Frederick Barbarossa'.[62] However, Frederick's
emphasis on his Norman Sicilian heritage did not stop there. He relied heavily on the still-
operating *khizana* of the palace where he had grown up, from which he specially commissioned
garments for his coronation as Holy Roman Emperor in Rome in 1220.[63] These garments
still survive today – the splendid gloves, shoes and the ceremonial sword (figs 206–8) – all
displaying the same techniques of enamel and filigree, as well as identical symbols, including
an eagle with aureole.[64] The gloves and shoes were set with various enamel plaques, as well
as a myriad of precious stones and pearls, similar to the Robe of Roger. The Robe itself (see
p. 212), even though it might have been taken out of Sicily at the same date, was probably not
used for Frederick's coronation in Rome. Instead, a new robe was created, the so-called Metz
Alb, which featured the same eagle with aureole as on the accompanying garments. This and
all the vestments subsequently became part of the insignia of the Holy Roman Empire and
were venerated as relics, displayed or used at every subsequent coronation of a Holy Roman
Emperor until the eighteenth century.[65]

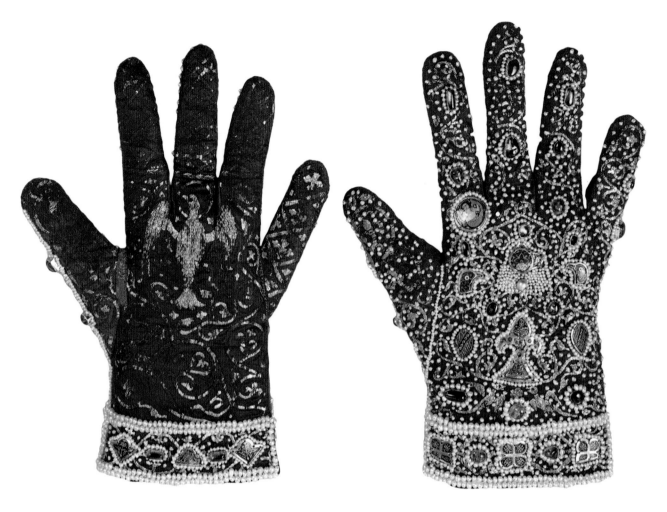

Figs 206–8
The ceremonial garments
made in the royal workshops
in Palermo for the coronation
of Frederick II as Holy Roman
Emperor in 1220: gloves
(L 26.3 and 27.7 cm), shoes
(L 10.8 cm), and sword of
state (L 1.08 m).
Kaiserliche Schatzkammer, Vienna.

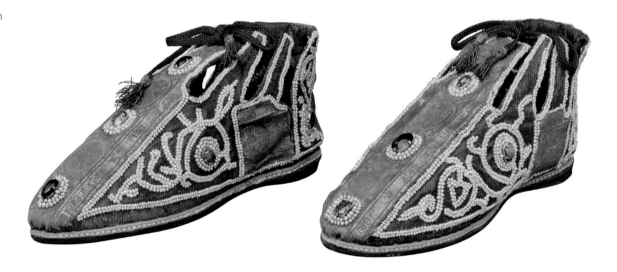

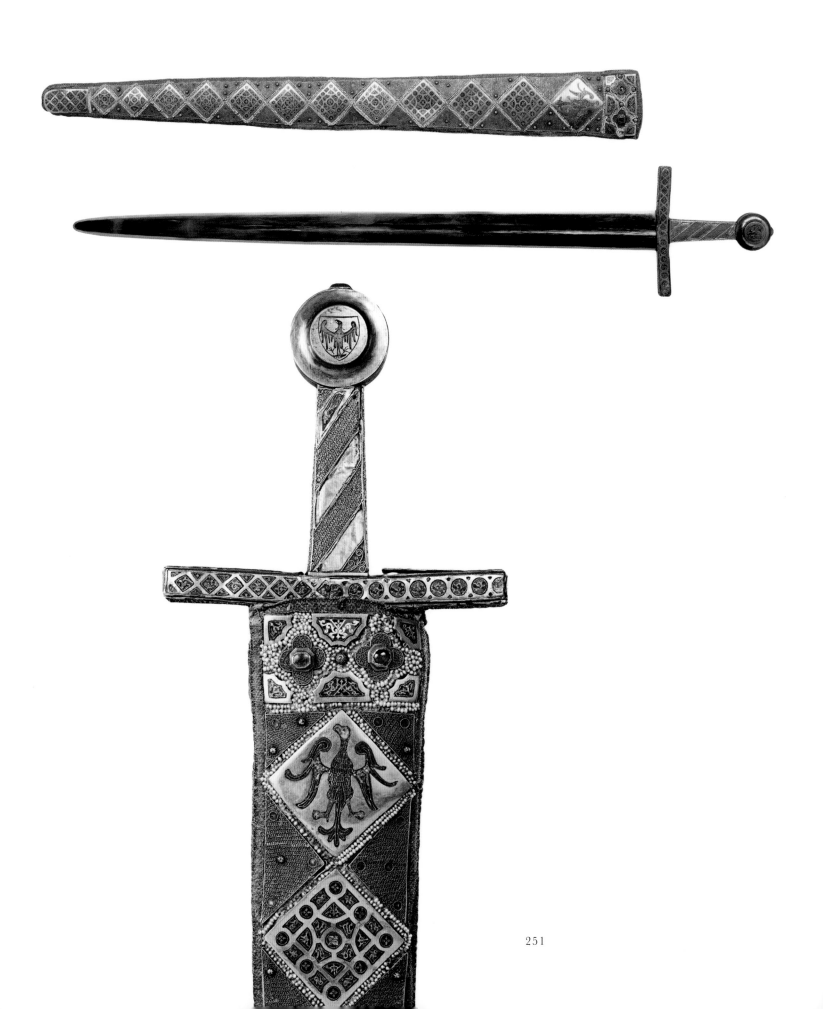

251

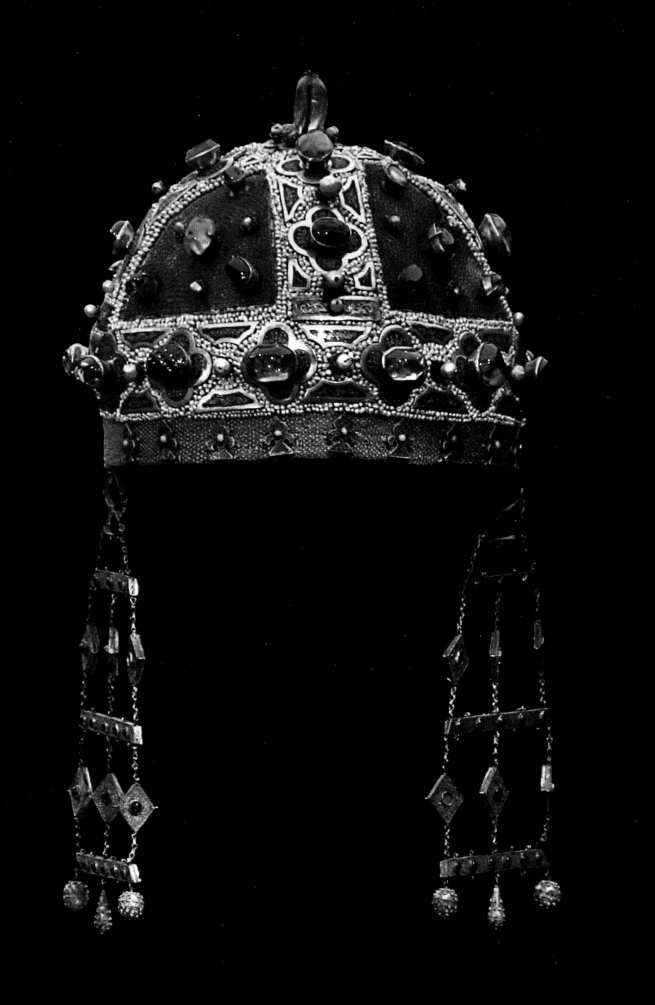

Special mention should be made of a crown that was found in the tomb of Constance of Aragon, Frederick's first wife, who died in 1222 and was also buried in the Cathedral of Palermo. This so-called Crown of Constance (fig. 209) has often been thought to have been a Byzantine-style crown for Frederick himself, which was subsequently buried with his empress. However, its actual reconstruction remains problematic, as at the opening of the sarcophagus in 1491 the only surviving parts of the crown were the decorations in precious metals and the gemstones, and the crown was repaired with new fabric and the decorations rearranged. Nevertheless, in the decoration, we find the same enamel techniques and the same types of gemstones as in Frederick's coronation shoes and gloves. It is clear that the *khizana* was still producing high-quality material during the early reign of Frederick II, even if signs of reuse of materials appear, such as for the so-called Alb of William II (fig. 172), as was the case for the crown: at its front, a garnet bears the Arabic inscription 'In God, Isa ibn Jubayr trusts', which has no apparent connection to Constance or the crown.[66]

An Inquisitive Mind

Intentio vero nostra est manifestare ea quae sunt, sicut sunt.
(It is in fact our intention to show the things that are, exactly as they are.)[67]

Just as the Norman kings had done before him, Frederick encouraged new Latin translations of the classical literature that survived only in Greek or Arabic versions, and took a very keen interest in astrology. To Frederick's court can be attributed the oldest surviving classical text on paper. Paper was only slowly replacing vellum for manuscripts, and in fact, because of its fragility, Frederick forbade its use for official documents; it wasn't to be used in Europe for hundreds of years. This text is not surprisingly a copy of Germanicus' Latin translation of a Greek astrological poem by Aratus, which was the most famous astrological work of the Middle Ages.[68] Frederick's renowned court astrologer, Michael Scotus, or 'the Scot', had come from the north. A wandering scholar like Adelard of Bath, he had studied in Paris and Oxford, and subsequently worked in Toledo, where he learned Arabic. He entered Frederick's court in Palermo in around 1227, shortly before Leonardo Fibonacci, also working at the court, dedicated to him his updated *Liber Abaci* (which Frederick had wished him to update). Frederick commissioned Scotus to write several works on astrology, of which he produced at least four, but Scotus's works equally include astral magic, invocations of demons, and physiognomy, the judgement of a person's mind by their outer appearances (hence his more popular reputation as necromancer and magician). In one of his works, Scotus makes reference to the so-called *Liber Novem Iudicum* (The Book of Nine Judges), a collection of Latin translations of Arabic, Hebrew and Greek astrological treatises by different authorities (the nine judges). These books had been collected together in the twelfth century, possibly to improve astrological observation. One of the surviving manuscript copies of the *Liber*, made in Sicily or southern Italy and datable to the early fourteenth century, interestingly also includes a dedication, which tells us that the book had been sent to Frederick II by the Sultan of Egypt (*soldanus Babilonie*) at the same time that the chalif (*magnus chalif*) in Baghdad had sent him a certain Master Theodore (fig. 210). Master Theodore of Antioch, another wandering scholar, but mostly in the Arab world, did indeed arrive in Palermo, where he replaced Scotus, after his death, as the court astrologer and mathematician. A lot is known about Theodore's activities at court, specifically about the mathematical challenges between him and Fibonacci.[69] Even though the dedication is surely a later addition and the texts of the *Liber* were translated in Spain rather than in Egypt,[70] the dedication reveals an exchange of ideas, scholarship and even scholars between Frederick II and Muslim rulers.

Fig. 209 The so-called Crown of Constance, found in the tomb of Constance of Aragon, wife of Frederick II. c.1220–22. H c.34 cm.
Palermo Cathedral.

Frederick's interest in astrology was deeply rooted in classical and medieval thought, but at the same time he was also actively pursuing original scientific research through personal observations and empirical knowledge. This resulted from the rediscovery of the teachings of Aristotle that entered the world of scholarly learning from around 1200,[71] but also from Roger's earlier efforts to create a new world map based on new reports and observations. This was certainly the initiative behind the *De Arte Venandi cum Avibus* (About the art of hunting with birds), a treatise on ornithology and falconry (fig. 211), the only work that can definitely be attributed to Frederick himself and on which he worked for more than thirty years.[72] Previous books on animals and falconry existed, and Frederick had consulted as many of them as he could: he had Scotus translate Aristotle's *Liber Animalium* from Greek, and Master Theodore a famous ninth-century treatise, the so-called Moamin, from Arabic. However, as the preface of *De Arte Venandi cum Avibus* proclaimed, Frederick wanted to show the things factually, as they are exactly: '*ea quae sunt, sicut sunt*'. The book not only typologically classified the different

Fig. 210
Final page of a 14th-century copy of the *Liber Novem Iudicum*, showing the dedication to Frederick II by the 'Sultan of Egypt'. Made in Naples.

British Library, London.

Fig. 211 (opposite)
Frontispiece of a manuscript of *De Arte Venandi cum Avibus*, a copy commissioned by Frederick's son Manfred, *c.*1240–1258. Made in Sicily or southern Italy.

Biblioteca Apostolica Vaticana.

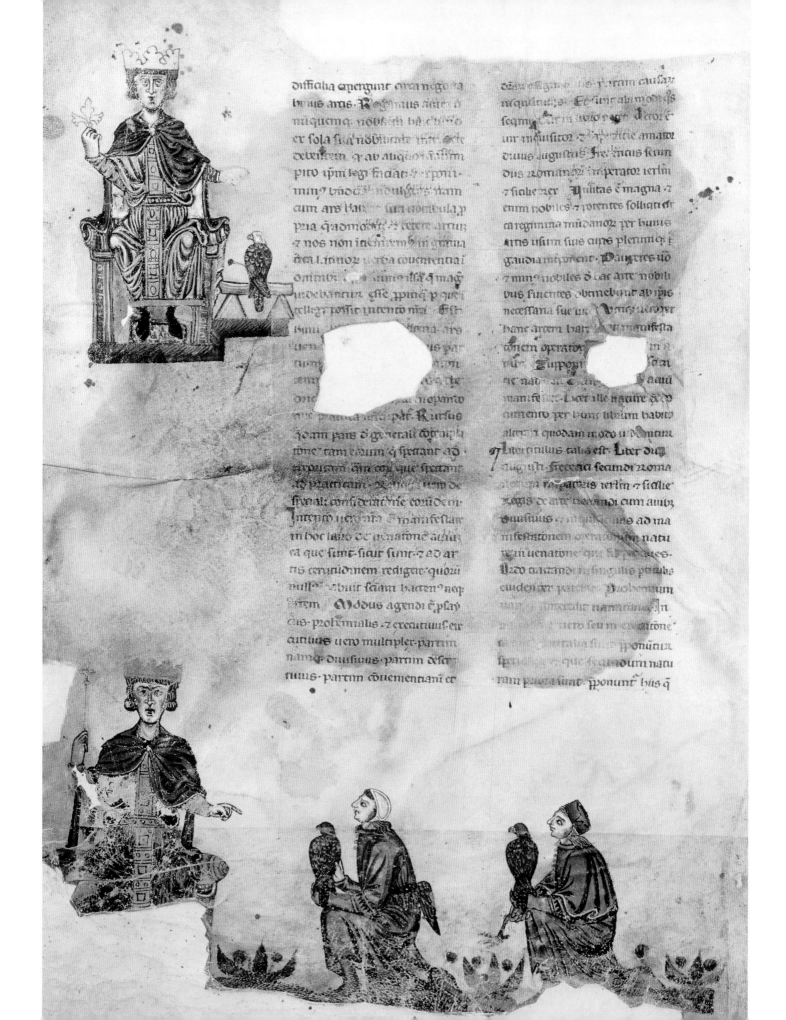

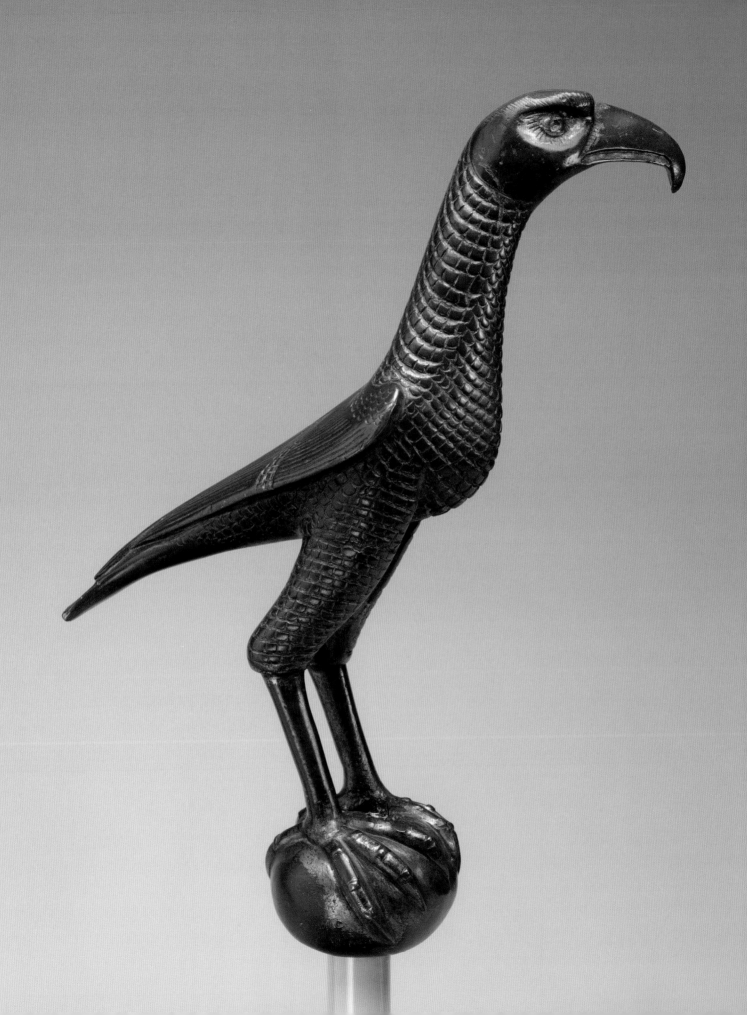

birds known at the time (a novelty in itself), but also listed experiments conducted by and for Frederick, such as on the hatching of eggs and on the senses birds use for hunting, as well as techniques for teaching birds to hunt. Falconry was the privilege of the elite throughout the Middle Ages, and eagles became heraldic symbols of many royal dynasties, including the Hohenstaufen, Frederick's dynasty. They appeared on coins and cameos (see p. 262), as well as in other types of art and on architecture. On the ceiling of the Cappella Palatina, a tent of the ruler is decorated with falcon ornaments (fig. 213), as are the crown and battle standard of Tancred in a contemporary illuminated manuscript (see fig. 200). A surviving example of such decoration (either from a tent or a battle standard), said to come from Sicily, shows a gilded bronze falcon with a relatively long neck and thin body, stylistic elements that can be dated to the reign of Frederick.[73] What is more, the falcon can be identified as a gerfalcon, which Frederick, in his work, lists as the highest-ranking of hunting falcons, and which was specifically reserved for the use of the king only.[74]

Frederick the Islamophile

Frederick's constant search for fact and truth meant that he was frequently in touch with scholars from the Muslim courts in al-Andalus, North Africa and in the East, where study of philosophy had continued uninterrupted during the Middle Ages, including several works of Aristotle, copies of which had not survived in northern Europe. Several instances are recorded, factual as well as imaginary, in which Frederick discussed philosophy, astrology and mathematics with the most famous scholars of the time, sometimes in person, sometimes through letters, sometimes through ambassadors such as Theodore of Antioch.[75] The most famous example of such exchanges is a treatise usually known as the *Sicilian Questions*, an answer to a letter that Frederick (addressed as the 'ruler of Sicily') had purportedly sent to the Islamic world containing four philosophical questions, regarding, for example, the soul and the eternity of the world, and to which the scholar Ibn Sabin at the court in al-Andalus responded. Ibn Sabin's treatise shows a thorough knowledge of the texts of not just the most famous contemporary Muslim philosophers, but even more so of the ancient Greek philosophers and mathematicians Anaxagoras, Diogenes, Euclid, Pythagoras, Socrates and especially Plato and Aristotle. The works of some of them were still unknown in the West at that time, Greek copies on papyrus not having withstood the test of time (see p. 236).[76]

Frederick also retained a lively exchange of letters with Fakhr al-Din, who acted as plenipotentiary in Baghdad for al-Kamil, the Ayyubid sultan of Egypt. The two had met in Jaffa (modern Tel Aviv) in 1228/9, during Frederick's crusade, and it had been Fakhr al-Din with whom he had negotiated the surrender of Jerusalem to the crusaders (with the exception of the sacred area of al-Haram al-Sharif with two mosques. In 1225 Frederick had married Yolande of Brienne, Queen of Jerusalem, who lived in southern Italy while the Holy Land was in Muslim hands, after which Frederick took the title King of Jerusalem. However, Frederick had also promised the pope to undertake a new crusade himself, a promise that he kept delaying until Pope Innocent IX excommunicated him for breaking his vow. Though excommunicated, or perhaps precisely because of it, Frederick then sailed eastwards and became the only crusader to negotiate peacefully the surrender of the Muslims and of Jerusalem.[77] This was an extraordinary and unique event, but it obviously had little to do with the fact that Fakhr al-Din and Frederick found themselves befriending each other and discussed philosophy and mathematics. Rather, al-Kamil realized his forces were vastly outnumbered by the crusader army, while Frederick was anxious to return home, learning of an attack on Sicily by the pope, who had waited to take advantage of Frederick's absence.

Fig. 212 (opposite)
Gilded bronze gerfalcon, originally part of a standard, or a furniture or tent decoration. Sicily or southern Italy, 1200–20. H 27.9 cm.
Metropolitan Museum of Art, New York.

Fig. 213 (above)
Detail of the painted ceiling of the Cappella Palatina, showing a tent with animal decorations, including panthers and falcons.

Fig. 214
One of the oldest dated bronze celestial globes, made for Sultan al-Kamil in Egypt in 1225–6, consisting of two hemispheres with forty-eight constellations, engraved and inlaid in silver. Diam. of globe 22.1 cm.
Museo Nazionale di Capodimonte, Naples.

THE OLDEST SURVIVING POEM IN SICILIAN VERNACULAR

Giacomino Pugliese

Oi resplendiente
stella de albur,
dulce plaçente
dona d'amur,
bella, lu meu cor as in balia:
da voy non si departe, en fidança,
m'ad on'or te renenbra la dya
quando formamo la dulçe amança.

Nevertheless, Frederick reportedly took the time to be shown Jerusalem and other sites in the Holy Land by Fakhr al-Din, all the while, it seems, discussing scholarly topics of philosophy, algebra and mathematics. These discussions, as well as those with al-Kamil himself, continued after Frederick had returned home.[78] In fact, a celestial globe (fig. 214) in the Museo Nazionale di Capodimonte in Naples has an inscription stating that it was made for the same al-Kamil. It is believed that al-Kamil gave this globe to Frederick as a gift, as it is known from literary sources that the 'sultan of Egypt' also sent him an astronomical tent. It was said to be of miraculous construction, with representations of the sun and moon that mechanically rose and set according to the time of day.[79]

Current scholarship interprets Frederick's apparent Islamophilia rather as a well-honed skill for pragmatism and diplomacy. Such a view would be supported by the fact that, during his reign, Frederick undertook the deportation of the remaining Muslims from Sicily to a new colony in Lucera on the Italian mainland. However, it is surely the case that too many references to Frederick's friendly, diplomatic and scholarly contacts with the Muslim world survive, both in Western and in Muslim sources, for us to discount his interests in Islamic culture. Certainly there was an element of pragmatism: the deportation had become necessary, both for the protection of Sicily and for the protection of the Muslim population itself. After the death of William II, the Latinization and Christianization of the island became almost total. The Muslims had withdrawn to small isolated communities or had reverted to violent rebellions against any rule, with the result that the situation on Sicily had become untenable. Most radically, the rebel leader Muhammad ibn Abbad had created a Muslim 'state' within Sicily, with Monte Iato, a mere 40 kilometres from Palermo, as capital. This separate community existed for a few decades, but when it started minting its own coinage, and fighting and attacks on neighbouring lands of Monreale intensified, Frederick besieged Iato, took ibn Abbad captive and put him to death.[80] In Lucera, on the other hand, the deportees were free to live their lives and keep their faith, and Sicily was relieved of tensions. During the deportations of these rebels, however, Frederick still issued a law to protect Jews and Muslims on Sicily against Christians.[81] It is clear that his contacts with the political and academic elite should be judged separately from his measures to defend the peace within his kingdom.

Renaissance Prince?

Moving away from earlier historians' views of Frederick's reign as the clear forerunner, if not the beginning of the Renaissance, current scholarship mainly emphasizes how many of Frederick's accomplishments (as discussed above) were still deeply rooted in medieval thought, a product of the emerging humanism. However, even with this due caution, two developments under Frederick's immediate patronage did indeed herald the coming of the Renaissance, and these can be directly linked to his court on Sicily.

> *Some [literary] inventions … intended to charm the ears of the people, obeyed their own rules. This style, as the story goes, was revived on Sicily not many generations ago, and in a short time spread throughout all of Italy and even beyond.*
> PETRARCH, PREFACE TO *EPISTOLAE FAMILIARES*

> *And since Sicily was the seat of the imperial throne, it came about that whatever our predecessors wrote in the vernacular was called 'Sicilian'. This term is still in use today, and posterity will be able to do nothing to change it.*
> DANTE, *DE VULGARI ELOQUENTIA*, CHAPTER 12[82]

The first development was the use of vernacular Sicilian rather than Latin for literature and poetry. This was the language of the populace, with a Romance base of vulgar Latin, but with influences and borrowed words from Arabic (and Arabic love poetry), Greek, Norman French and Lombard. In fact, an extremely productive 'Sicilian school' of poetry was established at the court in Palermo, which included mainly Sicilian poets, but also troubadours from Provence as well as people from mainland Italy, since the court accompanied Frederick when he travelled. To this 'school' are attributed the inventions of both the sonnet and the canzone, new forms of poetry that would not only dominate Renaissance poetry, but became canons for centuries afterwards. The work of this 'Sicilian school' was closely studied and recognized by Dante and Petrarch as the earliest form of an Italian language, which Dante and his circle subsequently adapted, incorporating Florentine and Latin influences, to create an Italian language very close to that still spoken today.

The most famous of the Sicilian poets were Giacomo da Lentini (to whom the invention of the sonnet is attributed),[83] Cielo d'Alcamo, Giacomino Pugliese and Frederick II himself. Until recently, however, no direct examples of their poetry survived in the original Sicilian, but rather in Tuscan modified versions of the later thirteenth and early fourteenth centuries, and scholars had thus tentatively reconstructed their Sicilian originals. In 2000, however, the earliest surviving thirty-two lines of an original poem by Giacomino Pugliese were discovered

Fig. 215
View of the tombs of Kings William I (front) and II (back) in Monreale Cathedral.

in a manuscript kept in Zurich, written in around 1230 by a northern hand, which indeed shows the phonetic particulars of the Sicilian vernacular, with strong Latin and Provençal influences (see p. 258).[84] Furthermore, in 2013, a manuscript was found in Bergamo that contained fragments of four original poems by the 'Sicilian school', in vernacular Sicilian and dating to 1250–60, indicating that their influence had reached much further north than Tuscany. Among them were the canzone *Donna, eo languisco e no so qua speranza* by Giacomo da Lentini, and *Oi, Lasso! Non pensai* by Ruggerone of Palermo, which is thought to be Frederick's *nom de plume*.[85]

The second, and in this context perhaps even more significant, development was that a clear classical artistic revival started, evidently part of Frederick's desire to renew the Roman Empire and portray himself as successor to the Roman emperors.[86] Such 'borrowing' from the past was in fact not new on Sicily. Roger II, William I and William II all had linked their reigns to the island's glorious history, albeit in a very limited way. Both the sarcophagi of Roger II (in which eventually Frederick himself was to be buried) and of William I were deliberately carved out of purple porphyry, the same material that had been used for the tombs of the Roman and Byzantine emperors, purple being the imperial colour. In this respect, Roger was evidently imitating Pope Innocent II, who had chosen to be buried in a reused Roman porphyry sarcophagus. The Norman tombs were new creations, but most likely carved from ancient columns from Rome (figs 204, 205 and 215).[87] Similarly, William II had coins minted that imitated both Phoenician coins from Palermo and ancient Greek coins from Messina (figs 216–18).[88] Though a millennium old by then, they incorporated what had become two of the most powerful Sicilian symbols: the Norman lion and the 'Arab' date palm (which was found everywhere in contemporary iconography, not least in the palace mosaics; see fig. 153). This way, obvious links were being made between symbols of the past and current signs of dynastic power.[89] Frederick II, however, was to take these associations even further: for the Normans, the links with the past were made in order to glorify their own rule, but Frederick genuinely wanted to create a new Roman Empire. He used similar porphyry for the tombs of his parents, as well as for himself, and his antiquarian enthusiasm and interests were well known. In fact, one medieval chronicler tells us that while Frederick was staying near Ravenna, in 1231, he was told of a 'beautiful chapel', half buried, but with mosaics and three marble sarcophagi, in one of which the emperor Theodosius (r. 379–95) was said to be entombed. Upon visiting it, Frederick immediately ordered the excavation of the monument, which turned out to be the mausoleum of Galla Placidia, actually Theodosius's daughter.[90]

The deliberate link to the Roman Empire is very visible in Frederick's coinage. He initially followed the currency policy introduced by his father, Henry VI, who had continued the minting of gold *tari*, but who had also started, on Sicily, the minting of silver alloy *denari*, a coin known from the mainland and from the northern economic forces, such as Genoa and Pisa, and which replaced the copper *follari*.[91] On the *tari*, the Arabic legend transcribed Western titles, rather than Eastern interpretations of them, such as *Harir Qaysar Awghust* (Henry, *Caesar Augustus*), a title that Frederick retained, adding his own initial 'FE' or 'FR'. On the other hand, the silver alloy *denaro* bore Frederick's official titulature: '+·F··ROM·IP·SEMP' and 'AVG / +·R·IERL·ET SICIL' (*Fredericus Romanorum Imperator Semper Augustus, Rex Ierusalem et Sicilie*).[92] A severe shortage of silver throughout the Mediterranean meant that *denari* were repeatedly debased during Frederick's reign. Gold, however, was plentiful through a constant influx from North Africa, as tribute or through trade for grain,[93] keeping not only the *tari* strong, but also guaranteeing a solid base for the *augustalis* (fig. 219), the coin that Frederick introduced in 1231.[94]

The *augustalis* has received much interest from historians, because it was so different from any coinage before – in terms of concept, elegance and decoration – and proved to be

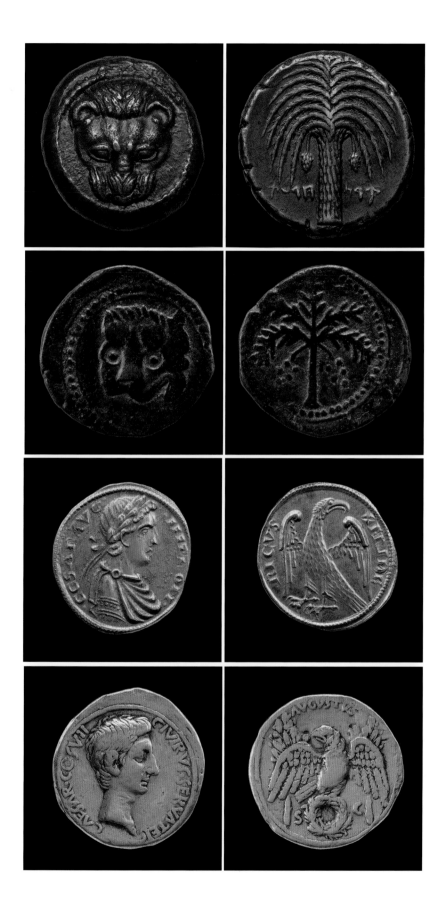

Figs 216–17
Silver Greek coin, minted
in Messina (488–481 BC),
showing a lion mask. Diam.
2.4 cm. Silver Phoenician coin,
minted in Palermo (410–395
BC), showing a date palm.
Diam. 2.6 cm.
British Museum, London.

Fig. 218
Obverse and reverse of a
bronze *follaro* of William II,
minted in Messina (1166–89).
Diam. 2.5 cm.
British Museum, London.

Fig. 219
Obverse and reverse of a
gold *augustalis* of Frederick II,
minted in Palermo or Messina
(1231–50). Diam. 1.7 cm.
British Museum, London.

Fig. 220
Obverse and reverse of a gold
aureus of Augustus, minted in
Rome (27 BC). Diam. 2 cm.
British Museum, London

hugely influential for the next few centuries. Gold coinage, apart from the *tarì*, had virtually disappeared in Europe in the Middle Ages, but after Frederick's death, Florence followed suit by minting the golden florin and Venice the gold ducat, which became standards throughout Europe. However, nothing of the elegance or quality of the *augustalis* would appear until two hundred years later.[95] The Sicilian mints were extremely watchful that the weight of the *augustalis* (ideally 5.31 grams) was kept constant and the coin free from inflation. Most important, however, was that the coin was clearly modelled on classical coinage – specifically the *aureus* of the Roman Empire – in fabric (it was solid and heavy), in design and in name. This was a full century before imitating classical antiquity to this extent became one of the hallmarks of the Renaissance. The coin shows on one side a classical-style bust of Frederick, wreathed as a Roman emperor, and on the reverse an imperial eagle with spread wings. Inscriptions run on both sides, reading 'CESAR AVG IMP ROM' (*Caesar Augustus, Imperator Romanorum*, Emperor of the Romans) around the bust and 'FRIDERICUS' around the eagle. Some historians have thought that the coin specifically imitated an *aureus* of Augustus, the first and most famous of the Roman emperors, and indeed some similarities are apparent (fig. 220).[96]

In fact, Frederick looked to the classical past for inspiration not only in coinage but also in sculptural art and architecture. Most famously, he had a Roman-style triumphal arch built in Capua, in which the sculptures were directly modelled on classical examples. Art historians have also identified the emperor himself in several busts from Italy and Germany that imitated known portrait types of Roman emperors, although whether the craftsmen took inspiration from sculptures, cameos or coins remains unknown. One bust from the area around Rome, is particularly significant, as it was originally thought to have been a Roman sculpture, depicting either Augustus or Constantine. Now firmly dated to the years 1220–50, the similarities between the bust and Frederick's *augustalis* portrait are striking, so that the bust is now generally accepted as being of Frederick II (see fig. 203).[97] The same classical influence is visible in smaller sculptures, namely the cameos and gems that were produced at Frederick's court, again with such skill that until a few decades ago most of them were identified as being actually Roman in date. A whole array of classical and mythological scenes (figs 222–3, which must have been known to the court and the craftsmen from ancient examples, was used and copied, and new scenes were created, sometimes depicting more Christian themes (fig. 224).[98] Others (figs 221 and 225) show the traditional dynastic symbols of lions and especially eagles: about a dozen cameos with an eagle in a pose similar to that on the *augustalis* are attributed to the Norman-Hohenstaufen workshops.[99] One striking little gem shows a veiled woman, elderly, but with an air of power and strength. It is generally identified as Constance, especially since, clearly medieval itself, it imitates imperial portraiture, and more specifically that of the elder Livia, wife of the Roman emperor Augustus (fig. 201).[100] Where the skills originated from is a matter of debate, particularly as the art of gemstone cutting had largely been lost in medieval Europe. However, the tradition had survived in eastern Islamic courts, as well as in the Byzantine Empire, all of which had close contacts with the Norman courts in Sicily, and the *khizana* at the palace. Certainly, Byzantine and Muslim craftsmen working there had experience of cutting hard stones, such as rock crystal and the porphyry of the sarcophagi.[101] Furthermore, it is presumed that after the sack of Constantinople by the Venetians in 1204, former craftsmen of the city were invited by Frederick's court or were attracted by its splendour.[102] We know from literary sources that Frederick himself collected gems, and he must have commissioned the cutting of many new ones for himself and as diplomatic gifts: in 1253, a few years after Frederick's death, the imperial treasure included over five hundred gems and intaglios, and eighty cameos.[103] The Hohenstaufen treasury was

eventually dispersed, parts of it taken to castles in Germany, either during or after Frederick's reign, and others parts lost, especially after certain military defeats, including, in particular, Frederick's rout at Parma in 1248. The imperial treasure was vulnerable since it travelled with the itinerant court; the original manuscript of *De Arte Venandi cum Avibus* was also lost at the Battle of Parma. Several Hohenstaufen cameos eventually found their way into the most important collection of gems of the Renaissance, that of Lorenzo de' Medici, 'il Magnifico', because of their outstanding quality and beauty.[104]

In 1231 – the same year as the launch of the *augustalis* coin and similarly associated with both his revival of the Roman Empire and his dynastic aspirations – Frederick issued the so-called Constitutions of Melfi, or *Liber Augustalis*, a new body of legislation that was based directly on Roger's Assizes. Thirty-nine of Roger's sixty-nine laws were subsumed directly, along with additions based on Roman law. It was certainly not a coincidence that these laws were issued at Melfi, because its castle, which Frederick had enlarged, was the ancestral 'home' of the de Hautevilles (see p. 173). Although Frederick's pursuit of scientific fact hints at his favouring of more worldly than religious views, and although he was almost continuously at odds with the popes, the Constitutions proclaimed that the king was able to rule only as an instrument of God, sanctioned by God, and was not above the law himself, even though he remained the ultimate authority. At the same time, the Constitutions compared his position to that of the Roman emperors, stating that 'the Roman citizens conferred the right and *imperium* of establishing laws on the Roman prince by the *Lex Regia*. Thus the source of justice might proceed from the same person by whom justice is defended, who ruled through the authority established by the emperor.'[105]

The Constitutions of Melfi pertained only to the Kingdom of Sicily – called 'our glorious and precious heritage' by Frederick (*regnum Sicilie, nostre majestatis hereditas pretiosa*) – and they would remain in effect there until the nineteenth century. Yet Frederick probably ultimately envisaged them becoming the law for his entire empire. This, at least, is suggested by the full list of his titles at the start of the laws: *Imperator Fridericus secundus Romanorum Caesar semper Augustus Italicus, Siculus, Hierosolymitanus, Arelatensis, felix, victor ac triumphator* (see also fig. 202).[106]

Figs 221–5
Five sardonyx cameos from the royal workshops under Frederick II, *c.*1200–50.

Fig. 221 (opposite above)
Roman-style eagle.
Diam. 2.8 cm.
Fondazione Dino ed Ernesta Santarelli, Rome (on long-term loan to Capitoline Museums, Rome).

Fig. 222 (opposite centre)
Hercules fighting the Nemean lion. H 4.2 cm.
Metropolitan Museum of Art, New York.

Fig. 223 (opposite below)
Leda and the Swan. H 2.5 cm.
Fondazione Dino ed Ernesta Santarelli, Rome (on long-term loan to Capitoline Museums, Rome).

Figs 224–5 (below)
Noah and his family entering the Ark (W 7.3 cm) and a lion (W 1.8 cm). These two cameos entered the collection of Lorenzo de'Medici, who had them inscribed LAVR.MED.
British Museum, London.

EPILOGUE

Indeed, those illustrious heroes, the Emperor Frederick and his worthy son Manfred, knew how to reveal the nobility and integrity that were in their hearts; and … all that the most gifted individuals in Italy brought forth first came to light in the court of these two great monarchs.

DANTE, *DE VULGARI ELOQUENTIA*, CHAPTER 12[107]

Many commentators today would agree with those who already in the thirteenth century felt that Sicily's golden age of Norman rule ended after just a single century, with the death of William II 'the Good'. Yet Frederick, even though he preferred Apulia, did genuinely care for Sicily, not least because of the remarkable multicultural legacy of his Norman ancestors. He maintained the palace for himself, his courtiers and his harem, whenever they were there. He added his own heraldic symbols to various mosaics and assigned the upkeep of the royal gardens, specifically the date palms, to Arabic-speaking Jews – as no Muslim gardeners who had the necessary knowledge could still be found.[108] As we have seen, the *khizana* was still fully functional and commissioned to produce stunning products. As Frederick II's court was not based permanently in Palermo and instead travelled with him around his empire, Sicily as a physical location cannot take credit for all of his accomplishments. But the capital's cultured and multicultural atmosphere, where everything evoked the glorious period of Norman rule, of which Frederick was the proud descendant, surely contributed to his enlightened character, his thirst for learning, and his ambitions to create a largely secular, centrally governed empire.

At Frederick's sudden death in December 1250, the pope sighed with relief, as this was his chance finally to get his hands on the island – which he thought of as legitimately his anyway, seeing himself as feudal superior of Frederick. Frederick's heirs and supporters, however, were prepared to fight for the emperor's legacy and the Hohenstaufen dynasty. Frederick's son Conrad first took the throne but died in 1254, leaving behind his young son Conradin to be crowned at the age of two. Furthermore, Manfred, an illegitimate son of Frederick, took up arms with the help of many of his father's supporters and his private army of 'Saracens' from the colony at Lucera, to counter threats from the pope. When a false rumour spread that Conradin had died, Manfred was himself crowned King of Sicily in 1258 in Palermo. Manfred, loved by the people and also in fact still loyal to Conradin, was able to defend the kingdom for many years, while successive popes desperately sought loyal European royalty inclined to take on a 'poisoned gift' like the island. After a few unsuccessful approaches to various rulers, Pope Innocent IV had already offered the crown to Richard of Cornwall, brother of Henry III, King of England. Richard aptly replied 'you might as well say, 'I make you a present of the moon – step up to the sky and take it down!'[109] King Henry III, however, was more taken by the offer and accepted it for his son, Prince Edmund 'Crouchback', in 1254. So convinced was he of the potential success of the expedition to wrest it from Conrad and after him, Manfred, that seal-impressions of Edmund as 'King of Sicily' (*Sicilie Rex*) were minted and distributed (fig. 226). However, after the enormous cost of such an undertaking became apparent, Henry III lost the will to pursue it, and Innocent's successor Alexander IV needed to look elsewhere. He found a new champion in the military powerful Count Charles of Anjou, brother of the French King Louis IX. In 1266 Charles eventually defeated

Manfred, who was killed in battle, and took southern Italy. Conradin, with an army of knights from several Italian cities, including Rome, from Germany, from Lucera, and from Spain (as the Hohenstaufen had intermarried with several royalty from the Kingdoms of Castile and Aragon), held out, but was defeated in 1268 and beheaded. Sicily was now Angevin.

Charles and his rude and uncultured French knights were highly unpopular on Sicily, and aristocracy loyal to the Hohenstaufen continued to try to organize a rebellion. According to legend, the inappropriate behaviour of one of the French knights towards a Sicilian woman was the spark for that rebellion in 1282, known as the Sicilian Vespers, but it had been years in the making.[110] Angevins on the island were expelled if not slaughtered, and the crown was offered by the still-powerful barons, the elite of the island, to Peter III, King of Aragon (who would eventually be known as Peter the Great) on account of his marriage to Constance, daughter of Manfred. They assumed the crown would pass to their children, who had Hohenstaufen blood.

The Aragonese period, which turned into the Spanish-Habsburg period when in 1479 the Kingdoms of Castile and of Aragon were united to form the Kingdom of Spain, was a period of peace and prosperity for the island's elite, but one of terrible consequences for the larger populace. Even though Peter had promised that Sicily would have its own king present on the island (hereditary, via Peter's second son), it was instead ruled by viceroys, who exploited it. Taxes were increased and grain production was intensified, at the expense of many of Sicily's forests. Religious intolerance rose under the Catholic Angevins and Spanish, which not only led to the expulsion (or forced conversion) of the remaining Jews of the island in 1493, but also to the loss of the erudite Muslim, Jewish, and Byzantine Orthodox cultures. This resulted in a drastic decrease in literacy and general sophistication among the populace. Once again, Sicily was rendered a 'province' without strong leadership, open for local exploitation by Spanish viceroys and greedy Sicilian barons alike. This neglect, reminiscent of Sicily under Roman rule, meant that there was little interest in scientific or artistic innovation.

Being in the Spanish sphere of influence furthermore meant that the north- and central-Italian Renaissance left Sicily largely untouched, both by its ideas and by its art, but with one notable exception: Sicily was home to one of the Renaissance's most influential figures, Antonello da Messina ('from Messina', c.1430–79). Antonello left the island to train at the royal court in Naples and, possibly, also in the Low Countries, in both of which he encountered Flemish, French, Provencal and Spanish painters, who all deeply influenced his work. He is often wrongly credited with the introduction of oil painting to Italy, but even if he didn't introduce it there, he perfected its use to a style envied and copied by Renaissance painters in northern Italy from then onwards. Antonello returned to Messina and set up a studio there, where he produced masterpieces until he died in 1479 (figs 227–8). During the subsequent artistic movements, Sicily followed rather than led, but slowly, and perhaps due to da Messina's fame, became a popular destination for some of Europe's most famous artists: Pieter Bruegel the Elder, Anthony van Dyck and Caravaggio all visited and painted on the island.

Sicily never really broke free of its reputation as a poor and uncultured island under subsequent Habsburg (until 1734), Savoy (briefly, between 1713 and 1720) and Bourbon rules (1734–1860). True, the dramatic landscape powerfully evoked the most romantic sentiments in visitors, as the quotes from two of the most famous Grand Tour admirers that opened this book made clear (see p. 19). European travellers visited the Greek ruins at a time when Greece itself was less accessible, and the temples in the south of Italy and on Sicily thus became northern Europe's first encounter with ancient Greek architecture. But among the wider population, feelings of neglect and of inferiority, especially in relationship to the Italian mainland, were strong, even still in the nineteenth and twentieth centuries. This inferiority

Fig. 226
Gold bulla or seal-impression of Prince Edmund, Earl of Lancaster, as King of Sicily (SICILIE REX). 1254–8.
Diam. 3.94 cm.
British Museum, London.

and the search for a unique local identity after centuries of foreign invaders became recurring themes in the writings of some of the greatest Sicilian authors of the modern period.

Poor island, treated as conquered territory! Poor islanders, treated as savages, who must first be civilized.
LUIGI PIRANDELLO, I VECCHI E I GIOVANI (1913)[111]

For over twenty-five centuries we've been bearing the weight of superb and heterogeneous civilizations, all from outside, none made by ourselves, none that we could call our own… This violence of landscape, this cruelty of climate, this continual tension in everything, and even these monuments of the past, magnificent yet incomprehensible because not built by us and yet standing round us like lovely mute ghosts; all those rulers who landed by main force from every direction, who were at once obeyed, soon detested and always misunderstood; their sole means of expression works of art we found enigmatic and taxes we found only too intelligible, and which they spent elsewhere. All these things have formed our character, which is thus conditioned by events outside our control as well as by a terrifying insularity of mind.
GIUSEPPE TOMASI DI LAMPEDUSA, IL GATTOPARDO (1958)[112]

Today, Italy has the most UNESCO world heritage sites of any nation in the world, and of Italy's regions, Sicily has the highest number of sites, even though the first one was only registered in 1997. The Valley of the Temples in Agrigento, the necropolis of Pantalica, and ancient Syracuse, with Mount Etna and the Aeolian islands, together show the importance of the Greek past and its dependence on the volcanic activities that fed the fertile soil. The Roman Villa del Casale near Piazza Armerina is also included in the list, because of the almost pristine state of its mosaics. In 2015 nine buildings were registered by UNESCO as the seventh world heritage 'site' of the island: Arab-Norman Palermo (the Palace, the Cathedral, Santa Maria dell'Ammiraglio, San Cataldo, San Giovanni degli Eremiti, La Zisa, and the Ponte dell'Ammiraglio) and the Cathedrals of Cefalù (fig. 229) and Monreale, thus finally acknowledging the profound influence the Norman period had not only on Sicily but throughout Europe and North Africa. Such recognitions are just part of Sicily's endeavours to celebrate the island's culture. It is not surprising that Sicily's Ministry of Culture is called the *Assessorato Regionale dei Beni Culturali e dell'Identità Siciliana* – the Ministry of Cultural Heritage and of Sicilian Identity. Sicilians are deeply aware of their complicated past and extremely proud of their diverse roots. Remnants of the various cultures that made the island what it is today are still everywhere: in the food, in the architecture, in the language, in the dress, behaviour, and appearance of the inhabitants. Whether they were peaceful settlers or violent conquerors, all the different incoming people contributed to the unique character of this Mediterranean island, 'born out of blood as much as out of sunshine.'[113]

And anyone who has once known this land can never be quite free from the nostalgia for it …
D.H. LAWRENCE, INTRODUCTION TO HIS TRANSLATION OF GIOVANNI VERGA'S *LITTLE NOVELS OF SICILY* (1925)

Fig. 227
'Virgin and Child' (the 'Salting Madonna') by Antonello da Messina, painted in Messina in the 1460s. Oil on wood. H 43.2 cm.
National Gallery, London.

Fig. 228 (left)
'Crucifixion' by Antonello da
Messina. In the background,
the harbour and city of the
artist's birthplace Messina
are used as a reference to
Jerusalem. 1454–5. H 39 cm.
Brukenthal National Museum,
Sibiu, Romania.

Fig. 229 (opposite)
The apse mosaic in the
cathedral of Cefalù, showing a
Christ Pantocrator, is probably
the most beautiful, most
famous, and most recognized
Byzantine Pantocrator mosaic
in the world, even though it
was not produced in the
Byzantine Empire.

Notes

Introduction

1 Agnesi, Di Patti and Truden 2007, pp. 263–70.
2 Homer, *Odyssey*, translation from Robert Fagles, London 1997.
3 Carandini et al 1982, p. 233, fig. 135.
4 Strabo, *Geography*, translation from D. W. Roller, Cambridge 2014.
5 Ovid, *Metamorphoses*, 5.572–641.
6 Diodorus Siculus, *Histories*, 5.69.3.
7 For a thorough account of their sanctuaries see Hinz 1998.
8 Apollodorus, *Library*, 1.6.2.
9 For the climate see Chester, Duncan, Guest and Kilburn 1985.
10 Wilson 1990, pp. 6–7.
11 *The Dispatches and Letters of Vice Admiral Lord Viscount Nelson, with Notes by Sir Nicholas Harris Nicolas Vol. 4, 1758–1805*, Boston 2005, 208, Letter from Palermo, 20 March 1800, to Commodore Sir Thomas Trourbridge, Bart.
12 Norwich 2015.
13 Strabo, *Geography*, 6.2.267–8.

1: Peoples of Sicily

1 Thucydides, *The Peloponnesian War*, translation by Steven Lattimore 1998.
2 Shepherd 2005, pp. 115–36.
3 See Leighton, 1999.
4 See Brea 1957, pp. 27–9; Leighton 1999, pp. 38–50; and Spoto 2002; Mannino et al. 2011, pp. 3094–100.
5 Robb 2007, pp. 192–7.
6 For the Aegean imports see van Wijngaarden 2002, pp. 203–49 and Blake 2008, pp. 1–34.
7 For the Castelluccio tombs and Luigi Bernabo see Brea 1957, p. 109, fig. 33; Crispino, 'Paolo Orsi innovatore. Lo scavo di Castelluccio di Noto e la nuovametodologia negli studi preistorici in Sicilia', XLVI Riunione Scientifica – 150 anni di preistoria e protostoria in Italia, Rome 2011, pp. 349–54. Drawing by Orsi of tomb door on p. 351.
8 See Leighton 1999, pp. 114–32.
9 See Leighton 1999, pp. 150–70.
10 Diodorus Siculus tells us the story that Lipari was settled by an Italic people from Campania in southern Italy, led by Liparus, son of Auson. Archaeologists used the Lipari-Ausonian name for convenience.
11 For a general discussion about the Phoenicians see Markoe 2000.
12 For an account of the sources see Hoyos 2010, pp. 6–11.
13 Giammellaro, Spatafora and van Dommelen 2008, pp. 129–58.
14 See Moscati and Uberti 1981.
15 For a discussion of these mask types see Orsingher 2014, pp. 145–71.
16 See Strassler 1996.
17 Thucydides, *The Peloponnesian War*, translation by Steven Lattimore, Indianapolis 1998, pp. 307–9.
18 For a discussion of Greek settlement on Sicily see Dominguez 2006, pp. 253–357.
19 Hodos 2010, pp. 81–106; Fitzjohn 2007, pp. 215–28.
20 Panvini and Sole 2009, p. 466, TA/184.
21 For a general discussion see De Angelis 2016.
22 See Palermo 2005, pp. 111–13.
23 Houël 1787, p. 48, plate CCXXXVII, fig. 2.
24 Pace 1953–4, 1, pp. 273–88. Illustration from di Trabia's publication on p. 278, fig. 5.
25 *Natura mito e storia nel regno sicano di Kokalos : atti del Convegno : Sant'Angelo Muxaro, 25–27 ottobre 1996*, Canicatti and Leighton 1999, pp. 258–61.
26 Palermo 2005, pp. 109–13.
27 See McInerney 2010.
28 See Hughes 2007, pp. 55–7.
29 Markoe 2015, p. 250.
30 For detailed discussion see Cordano and Di Salvatore 2002.
31 For the inscription see Tribulato 2012, p. 36.
32 De Angelis 2003a, pp. 19–50.
33 For a detailed discussion of the site see De Angelis 2003b.
34 Denoyelle and Iozzo 2009, pp. 54–65. Panvini and Sole 2009, pp. 115–21.
35 Including a pot in the Louvre, Paris, inventory CA 3837, see Stansbury-O'Donnell 2015, p. 142, fig. 6.12.
36 See De Angelis 2003b, p. 60.
37 Pugliese Carratelli et al 1985, p. 136, fig. 129.
38 See van der Meijden 1993.
39 See Panvini and Sole 2009, p. 266, no. VI/232.
40 Homer, *Odyssey*, translation from Robert Fagles 1997.
41 See Hurwitt 1999, p. 109, fig. 80.
42 See Wescoat 2012, plates 82–91.
43 Homer, *The Iliad*, translation by Stephen Mitchell, New York 2011.
44 See Panvini and Sole 2009, p. 263, no. VI/226.
45 Barletta 1983, p. 154, figs 30–1.
46 See Panvini and Sole 2009, p. 204, no. VI/108, and Stansbury-O'Donnell 2015, p. 191, fig. 8.10.
47 Shepherd 2015, pp. 215–6.
48 See *Gela Arcaica: Are Divinità Tiranni*, Rome 2000.
49 See Böhm 2007 for parallels.
50 See Stieber 2004, pp. 62–6 for references to lotus plants.
51 See Marconi 2007, pp. 96–9.
52 David Napier 1986, pp. 83–108.
53 Ovid, *Metamorphoses*, 4.615–9, translation by David Raeburn, London 2004.
54 Ismaelli 2011 and Orlandini 1966, pp. 13–35.
55 See articles about various Demeter sanctuaries and cults on Sicily in C. A. Di Stefano, *Demetra. La divinità, i santuari, il culto, la leggenda, Atti del I Congresso internazionale, Enna, 1–4 luglio 2004*.
56 Rutter 1997, pp. 101–16.
57 The pun might be accidental. See Nicholson 2016, p. 245, and note 32 for details.
58 Spatafora 2013, pp. 37–47, fig. 20.
59 Herodotus, *Histories*, 7.153.
60 See White 1965, pp. 261–79.
61 Mertens 2003.
62 Published widely in various volumes, including Dewailly 1992; Pautasso 1996 and see note 55.
63 Wiederkehr Schuler 2004, pp. 202–3, plates 58–9.
64 Karakasi 2003.
65 See Bell 1981, pp. 140–1, catalogue nos 106–9.
66 Diodorus Siculus, *Histories*, 12.29. Translation in Green 2006.
67 Raffiotta 2013, pp. 77–82.
68 Bonnano 2013, pp. 83–4 and Marconi 2008, pp. 2–21.
69 See Marconi 2011b, pp. 2–31.
70 See Bell 1981, plate 15, no. 60, plate 17, no. 66.
71 For example, Ovid, *Metamorphoses*, 5.362–84.
72 Ferruzza 2013, p. 192, fig. 133.

2: The Rise of the Tyrants

1 See Champion 2010.
2 Polyaenus, *Stratagems of War*, Books 1–5, translation by Peter Krentz, Chicago 1994.
3 Lucian, *Phalaris*, Book 1 in Lucian, *Volume I*, translated by A. M. Harmon, Harvard 1913.
4 A. L. Purvis in Strassler 2008, Book 7.153.
5 Diodorus Siculus actually allows Phalaris a hint of humanity, claiming that even Phalaris was shocked by Perilaos' delight at some of the bull's cruellest features that he had engineered. Thus the reason for Phalaris tricking Perilaos to be its first victim. Diodorus Siculus, *Histories*, 9.19.1.
6 Pindar, writing only a century after the reign of Phalaris, comments on the cruel execution device of the bull: Pindar, *Pythian 1*, 95. Translation by A. Verity, *Pindar: The Complete Odes*, Oxford 2007.
7 Cicero, *The Verrine Orations*, translated by L. H. G. Greenwood, Harvard 1988.
8 For an overview of ancient sources and an account of Phalaris' reign see Adornato 2012, pp. 483–506.
9 Translation by A. L. Purvis, in Strassler 2008.
10 Longo 2004, pp. 202–15 and Evans 2009.
11 See Herodotus' short account in *Histories*, 7.165–7. For a longer and different account of the battle see Diodorus Siculus, *Histories*, 11.20–1.
12 Diodorus Siculus, translation from Green 2006.
13 See Mertens 2006, pp. 268–74.
14 Ibid., pp. 266–8.
15 Vassallo 2010, pp. 17–38.
16 See Rehm 1989, pp. 31–4.
17 See Scott 2010 for further reading.
18 Pausanias, *Guide to Greece: Vol. 1, Central Greece for Delphi; Vol. 2: Southern Greece for Olympia*, esp. Vol. 2, Book 6, 19.7.
19 See Morgan 2015 for further reading.
20 See Morgan 2015, p. 40, note 52 and Ampelo 2013, p. 17, fig. 8.
21 Diodorus Siculus, *Histories* 11.26.7.
22 For an overview and bibliography see Famà 2013, pp. 84–6. Also Papadopoulos 2014, pp. 395–423.
23 See Antonnacio 2014, pp. 192–207.
24 For a discussion about the statue see Adornato 2008, pp. 29–55.
25 Morgan 2013, p. 100. For an example from Cyrene see Bonacasa and Ensoli 2000, p. 22.
26 Rutter 1997, pp. 122–3.
27 Diodorus Siculus, *Histories* 11.26.
28 Spawforth 2006, pp. 122–33; Cerchiai, Janelli and Longo 2004, pp. 156–277.
29 See Marconi 2007, pp. 29–32 for an analysis of the arguments and references.
30 For temples and sites see Mertens 2006; for some of the sculpture see Marconi 2007.
31 See Marconi 2007, pp. 38–45; Mertens 2006, pp. 104–11.
32 See Mertens 2006, pp. 110–2.
33 Moorman 2011, p. 15.
34 Guzzone 2005, pp. 322–3.
35 See Danner 1996, pp. 86–7, cat. R3, plate 22.
36 Ibid., pp. 80–5, cat. R1, plates 19–21.
37 See Danner 1997, pp. 44–5, plate 26.
38 See Marconi 2007, pp. 47–8.
39 See Panvini and Sole 2009, p. 151, no.VI/5 for the Gela example. Gabrici 1933-35, plate 32 for the Selinous fragments.
40 See Danner 1996, p. 23, cat. F28, plate 8.
41 See Wikander 1986, p. 39, no. 35, fig. 13 and Pironello 2011, pp. 536–8.
42 Ceserani 2012.
43 Angell and Evans 1826.
44 De Angelis, 2003, p. 164. Here the author says that each cubic metre of limestone equals 2.25 tons.
45 See Marconi 2007, pp. 77–126 and Mertens 2006, pp. 114–18.
46 See Marconi 2007, p. 103, fig. 45.
47 See Mertens 2006, pp. 118–26 and Marconi 2007, pp. 127–84.
48 See Marconi 2007, p. 68.
49 Ibid., pp. 137–8, fig. 67.

50 Ampolo 1984, pp. 81–9.
51 See Mertens 2006, pp. 231–6.
52 Ibid., pp. 232–6.
53 Ibid., pp. 279–84 and Marconi 1994.
54 See Marconi 1994, pp. 66–9, 145–7.
55 Ibid., pp. 94–5, 159–60.
56 See Mertens 2006, pp. 261–6.
57 See Spawforth 2006, pp. 54–5, 127–8.
58 Apollodorus, *Library of Greek Mythology* 2.6.4, translation by Robin Hard, Oxford 2008, p. 86.
59 Diodorus Siculus, *Histories* 12.82.4.
60 Rykwert 1996, pp. 131–3.
61 Translation from Schofield 2009.
62 See Miles 2013, pp. 149–50. For a more detailed analysis of the position of the Telamon sculptures see Broucke 1996.
63 Hornblower 2002, pp. 48–9.
64 Barbaenera 1995.
65 See Panvini and Sole 2009, p. 387, no. TA/14 for the example from Gela. See Brea 1956, plate 26 for examples from Akrai.
66 Bonanno 1998, plates 82,87, 90 and 91.
67 Ibid., plates 33–34, 36–41 and plate 74 for the example shown here from Kamarina.
68 Caltabiano et al 2003, pp. 162–4, 168 and plates 93.7 and 95.1–6.
69 Castagnino 2000, p. 513, figs 14 and 15.
70 For instance the head of the god Poseidon from the east frieze illustrated in Neils 2001, p. 121.
71 See Mertens 2006, pp. 410–6.
72 For the later Tyrants see J. Champion, *The Tyrants of Syracuse: Vol. 2, 367–211 BC*, Barnsley 2012.
73 For a recent interpretation of the event see Fields 2008.
74 Diodorus Siculus, *Histories*, 15.6.2–4.
75 Dante, *Inferno*, Canto 12, 107–8.
76 Plato, *Letters*, Letter 7, about 360 BC.
77 Patterson 1995, pp. 38–41.
78 Diodorus Siculus, *Histories*, 20.71–2.
79 MacIntosh, Turfa and Steinmayer Jr. 1999, pp. 105–25.
80 Athenaios, *Deipnosophistai* 5.206–9.
81 Wilson 2013, p. 81, fig. 4.2–3.
82 Portale 2013, pp. 55–60.
83 Di Pasquale and Parisi Presicce 2013.
84 Merra 2013, pp. 202–9 and articles in Osanna and Torelli (eds) 2006.
85 Vitruvius, *On Architecture*, translation by Richard Schofield, London 2009.
86 See Wilson 2013, pp. 83–7.
87 Guzzo 2003, pp. 45–87
88 de Cesare 2013, p. 71.
89 Lyons 2013, p. 5, fig. 3 and Lamagna and Amato (eds) 2015, pp. 8–11.
90 Libertini 1926 and Biondi (ed.) 2010.
91 van Wonterghem Maes 1968.
92 Musumeci 2010, pp. 39–114.
93 The statue is alternatively identified as Hades, Serapis and Zeus combined with the Phoenician Baal-Hammon. See De Vincenzo 2013, pp. 294–9.
94 Tusa 1985, pp. 610–11, figs 664–5.
95 Wilson, 2013, pp. 87–8.
96 Bloesch and Isler 1976, pp. 13–48, plates 1–23.
97 Bonacasa and Joly 1985, pp. 332–3 (for the Centuripe examples) and Bloesch and Isler 1976, plate 22 for the Syracuse sculptures.
98 Wilson, 2013, p. 88.
99 Campagna 2013, p. 53.

Chapter 4: Age of Conquest

1 Tusa and Royal 2012, pp. 7–48; Prag 2014, pp. 33–59.
2 For the 6th century, see Jordanes, *Getica*, 50.
3 Wilson 2013, p. 119.
4 Apuleius, *Metamorphoses* (*The Golden Ass*), 11.5.
5 Tribulato 2012, pp. 316–19.
6 Wilson 1990, p. 28.
7 Scheidel 2011, pp. 294–5.
8 Pliny frequently discusses the *latifundia* in his *Natural History*: 13.92, 17.192, 18.17, 18.35, 18.261 and 18.296.
9 Diodorus Siculus, 34–35.2.1–48.
10 Ibid, 34–35.2.
11 Cicero, *Tusculan Disputations*, 64–6.
12 For example, Cicero, *For Plancius*, 40.95.
13 See Wilson 1990, p. 189.
14 Stone III 1983, pp. 19–21.
15 See Wilson 1990, pp. 35, 38–40.
16 Ibid., pp. 188–91; Finley 1968, p. 153.
17 Barrett 2002, p. 210.
18 Athenaeus, *Deipnosophistae*, 1.27d; Strabo, *Geography*, 6.2.3; Pliny, *Natural History*, 14.66.
19 See Wilson 1990, pp. 191–2.
20 Cicero, *Against Verres*, 2.4.115.
21 Augustus: Strabo, *Geography*, 6.2.4; Caligula: Suetonius, *Gaius*, 21; Hadrian, as *Restitutor Siciliae*; Augustus also composed a poem called 'Sicily': Suetonius, *Augustus*, 85.2.
22 Gowers 2010, pp. 69–87; Suetonius, *Augustus*, 72.2.
23 Fuduli and Salamone 2015, 'Hadrianus Restitutor Siciliae', *Mélanges de l'École française de Rome – Antiquité* 127-1 [Online] Available at: http://mefra.revues.org/2737. [accessed : 14 January 2016].
24 Strabo, *Geography* 13.1.53; Thucydides, *The Peloponnesian War*, 6.2.
25 Schilling 1954, pp. 235–9; Wilson 1990, pp. 283–5.
26 Cicero, *Against Verres*, 2.2.7.
27 Cassius Dio, *Roman History*, 52.42.6.
28 Pensabene and Gallocchio 2011, p. 34; Carandini, Ricci, De Vos and Medri 1982; Wilson 1983; Settis 1975, pp. 873–994.
29 For example Tiberius: Suetonius, *Tiberius*, 70, or Trimalchio's dinner in Petronius' *Satyricon*.
30 Finley 1968, p. 165; Wilson 1990, pp. 244–51, 320.
31 Finley 1968, p. 165.
32 Merrills and Miles 2010, pp. 130–3.
33 Sami 2010.
34 By name of Quidila: see Martindale 1980, p. 932.
35 Al-Nuwayri (died AD 1333), echoing the historian Ibn al-Athir; translation from Metcalfe 2003, pp. 10, 233.
36 Sami 2010, pp. 210–11.
37 Gregory the Great, see Sami 2013, p. 32.
38 Molinari 2009, p. 131, though not all scholars agree (see there); Sami 2010, p. 210.
39 Baldini Lippolis 2010, pp. 128–9; Sami 2010, p. 177.
40 Paul the Deacon, *Historia Longobardorum*, see Chiarelli 2011, pp. 13–15.
41 Baldini Lippolis 2010, pp. 130–1; Annunziata Lima 2008, pp. 251–4, 269.
42 Translations from al-Muqaddasi in Collins 2001, pp. 182, 191–2.
43 See Metcalfe 2003, p. 9.
44 See Chiarelli 2011, p. 22.
45 Balog 1979, p. 611; Grierson and Travaini 1998, p. 74.
46 See Metcalfe 2003, p. 20.
47 Ibid, p. 12.
48 Nef 2001, pp. 191–211.
46 Translation from Crawford 1901, pp. 82–94.
50 See Metcalfe 2003, pp. 11–12.
51 See Tronzo 2006a, p. 444; The palm tree and the Tree of Life are described in the Bible, see John 15:5 and Psalms 92:12.
52 Date palms were certainly known under the Phoenicians, who featured the tree on their coinage; the Greek name for the date palm, *phoenix*, would actually become their internationally recognized name. However, there does not seem to be any evidence for their cultivation on Sicily itself in ancient times. Even if there was cultivation, it might have ceased during Roman and Byzantine times.

By the eighteenth century, there was no commercial cultivation of the tree, though some were maintained for symbolical reasons (Mazzola, Raimondo and Schicchi 2003, pp. 311–21; Hehn 1885, pp. 210–11; Mallette 2005, p. 62).
53 For example: Feltham 2010, p. 16.
54 Vitale 2008, pp. 290–1; Bonacasa Carra 1989, pp. 101–9.
55 al-Istakhri, *Kitab masalik al-mamalik*, translation from De Goeje, M. J., *Bibliotheca Geographorum Arabicorum* 1, Leiden 1967.
56 A term coined by Andrew Watson in 1974. Though the concept has been accepted by a majority of popular historians and archaeologists, there is still much debate whether there really was a revolution. Nevertheless, on Sicily, a clear increase of new crops and crop production did take place with the arrival of the Arabs.
57 There are a lot of misconceptions about the introduction of new crops by the Arabs. Many books about Sicily will mistakenly tell you that grapefruit were introduced (a hybrid pomelo that did not exist until the seventeenth century), carob trees (Greek cultivation or even earlier), artichokes (Theophrastus writing in the fourth century BC talks of them on Sicily), almonds and pistachios (Phoenicians or early Greeks grew them), and many others. It is true, nonetheless, that the Arabs intensified the cultivation of such crops.
58 Sugar-cane had been known to the Greeks and Romans, but only by hearsay (Strabo, *Geography*, 15.1: in India, honey without bees; Pliny, *Natural History*, 12.17). Honey, on the other hand, was of course known to the Greeks very early on.
59 As in Roman agricultural treatises; See also Beresford 2012, p. 262, and Palmer 2010, pp. 47–9; Watson 1983, p. 123.
60 See Chiarelli 2011, p. 213.
61 As described by Ibn Hawqal; Todaro 1988; Pizzuto Antinoro 2002.
62 Balog 1979, pp. 612–3; Bates 2002, pp. 115–16; although De Luca 2010 pp. 113–30 believes to have identified quarter *dinars* dated to 875, so before the conquest.
63 Balog 1979; De Luca 2010b, pp. 90–110.
64 Mangiaracina 2013, pp. 92–4; Bagnera 2012, pp. 26–37; Molinari 1995, p. 192; Rotolo 2011, p. 547; McSweeney 2012, p. 231; Molinari 2009, p. 136.
65 Bagnera 2013, p. 70.
66 Extract from Ibn Hawqal, *Portrait of the World*, translation by Alex Metcalfe.
67 Ibid.
68 Ibid.
69 Bagnera 2013, pp. 61–88.
70 Johns and Savage-Smith 2003, pp. 7–9; Rapaport and Savage-Smith 2014, pp. 1–2.
71 Johns and Savage-Smith 2003, p. 16.
72 Rapaport and Savage-Smith 2014, pp. 457–66.
73 Johns and Savage-Smith 2003, p. 17.
74 Chiarelli 2011, pp. 304–11.
75 Ibid., p. 303
76 The Palermo Qur'an is published in Déroche 1992, pp. 146–51, no. 81. The only discussion and interpretation of this Qur'an is Johns 2014.
77 Extract from Ibn Hawqal, *Portrait of the World*, translation by Alex Metcalfe.
78 Theotokis 2010, p. 391, numbers from Amatus of Montecassino, *L'Ystoire de li Normant*, 5.15 and Geoffrey Malaterra, *The Deeds of Count Roger of Calabria and Sicily and of Duke Robert Guiscard his brother*, 2.10.
79 Cassarino 2013, p. 115.
80 Translation based on Italian translation in Amari 1881, p. 434, and on Cassarino 2013, p. 116.
81 Simonsohn 2011, pp. 572–5; Simeti 1989; Sanchez Martinez 1996, p. 814.
82 See Metcalfe 2003, p. 18; Nef 2011, p. 377.

Chapter 5: The Normans

1 A probably biased but chronological overview of the conquest was written by the contemporary monk Geoffrey Malaterra as *The Deeds of Count Roger of Calabria and Sicily and of Duke Robert Guiscard his brother*. An English translation by Graham A. Loud has been published online at: *www.leeds.ac.uk/arts/info/125040/medieval_studies_research_group/1102/medieval_history_texts_in_translation* [accessed 14 January 2016].
2 Houben 2002, pp. 10–12.
3 See Metcalfe 2009, p. 88; Nef 2011, pp. 47–9.
4 See Houben 2002, p. 11; Metcalfe 2009, p. 91.
5 See Houben 2002, p. 11.
6 See Malaterra 2.10.
7 An overview of the conquest and its problems is Theotokis 2010, pp. 381–402.
8 See Malaterra 4.22 ('many thousand Saracens') and 4.26.
9 See Houben 2002, p. 15.
10 See Malaterra 1.19.
11 Metcalfe 2003, pp. 27–8; Nef 2011, pp. 34–6.
12 See Pezzini 2013, p. 200.
13 See Metcalfe 2009, p. 102.
14 Grierson and Travaini 1998, pp. 83–4, 87, 604 (nos 66 and 67), ditto for transcriptions and translations of all coins; on use of *comes*, see Nef 2011, p. 99.
15 See Nef 2011, p. 97; Travaini 1995, p. 39.
16 Grierson and Travaini 1998, pp. 87–9, 608 (no. 86), ditto for transcriptions and translations.
17 See Houben 2002, p. 25.
18 Ibid., p. 27; Johns 2002, p. 77.
19 Thomas, Constatinides and Constable 2000, p. 623.
20 See Johns 2002, pp. 39, 63, 74–8.
21 See Houben 2002, pp. 28–9.
22 Ibid., pp. 32–3.
23 See Metcalfe 2003, p. 24.
24 Alexander of Telese 1.11 – translation from Loud 2012.
25 See Houben 2002, pp. 29, 41–8.
26 Alexander of Telese, 2.1–2, translation from Houben 2002, pp. 51–2.
27 Alexander of Telese, 2.4–5; translation from Loud 2012.
28 Translation from Thatcher and McNeal 1905, no. 88.
29 Translation Loud and Wiedemann 1998, p. 58.
30 Britt 2007, p. 26.
31 See Houben 2002, p. 96.
32 Hayes (forthcoming), pp. 1–2, 8–9.
33 Kitzinger 1976, pp. 31 and 34, note 13; as well as Hayes 2013a.
34 See Kitzinger 1976, pp. 31–2, and Kitzinger 1990, p. 196.
35 See Kitzinger 1976, p. 34, note 13.
36 Kitzinger 1990, p. 190; Hayes 2013a, pp. 119–49.
37 Johnson 1999, pp. 237–62; see also Houben 2002, p. 115, note 36.
38 See Metcalfe 2003, pp. 111–12; Houben 2002, p. 108.
39 Translation from Loud and Wiedemann 1998, p. 58; Houben 2002, p. 108.
40 See Houben 2002, p. 96.
41 See Kitzinger 1990.
42 Ibid., pp. 263–8.
43 See Britt 2007, p. 24.
44 Hayes 2013, pp. 52–69.
45 See Grierson and Travaini 1998, p. 102.
46 See Metcalfe 2009, p. 239.
47 Grierson and Travaini 1998, pp. 111, 620 (nos 176–7)
48 Ibid., pp. 119–20, 626 (nos 212 13)
49 Ibid., p. 109.
50 Di Liberto 2013, p. 149; Johns 2002, p. 288.
51 Takayama 1993, p. 53; Houben 2002, p. 15, and note 15.
52 Ćurčić 1990, p. 62.
53 Though the Church shows more archaic Byzantine characteristics as well, see Ćurčić 1990, pp. 30–1.

54 See Ćurčić 1990, pp. 35–6; For squinches: Krautheimer and Ćurčić 1992, p. 403.
55 Warren 1991, pp. 59–65.
56 Kapitaikin 2013, p. 130; although Ćurčić 1990, p. 56 sees them more as Eastern Byzantine-Mediterranean.
57 See Johns 2002, p. 109, 279–80.
58 Translation from Broadhurst 1952, p. 349.
59 La Duca 1991, pp. 46–9.
60 Tronzo 2006, pp. 313–5.
61 Longo 2010, pp. 51–117.
62 Pezzini 2013, p. 201; Di Liberto 2013, p. 141; D'Angelo 2002, p. 96.
63 Translated into English from the Italian and French translations in Santagati 2010, pp. 32–5.
64 The anonymous *Letter Concerning the Sicilian Tragedy* is usually ascribed to Hugo Falcandus, see Loud and Wiedemann 1998, p. 2; Translation after Loud and Wiedemann 1998, pp. 258–9 .
65 For example by contemporary historians, Alexander of Telese and Romuald of Salerno, see Houben 2002, p. 125.
66 Bresc 1994, p. 252.
67 Piazza 2006, pp. 543–4.
68 See Longo 2010, p. 12; Tronzo 1997, p. 9.
69 Ćurčić 1987, p. 125.
70 See Longo 2010, p. 8.
71 Ćurčić 2011, p. 526.
72 See Kitzinger 1990, p. 262; Kitzinger 1986, pp. 277–94.
73 For symbolic meaning of these, see Johns 2011, pp. 561–2.
74 Bertaux 1903, pp. 496–500; Demus 1950, p. 28; Tronzo 1997, pp. 34–5.
75 Longo 2010, pp. 179–89.
76 See Tronzo 1997, pp. 62–8.
77 Johns 1992, pp. 151–2, 158; Tronzo 1997, p. 105. Translation based on Johns 1993, p. 151 and Johns 2015, p. 130.
78 See Johns 1993; Johns 2015, pp. 130–1.
79 Both translations from Grube and Johns 2005, p. 13.
80 Grube 2005, pp. 15, 18–9, 22–3; Metcalfe 2009, p. 240; Tronzo 1997, pp. 59–60; Johns 1993, pp. 153–5.
81 See Tronzo 1997, p. 60; Johns 2015, pp. 128–9, 132–3.
82 See Grube 2005, p. 24; also Tronzo 1997, pp. 61–2.
83 Johns 2005, pp. 1–12, dates the ceiling to 1140–7.
84 Kitzinger 1990, p. 262, argues for three different Byzantine workshops working on the island around the same time.
85 Called *simat*, and mentioned by Ibn Jubayr. Translation from Broadhurst 1952, p. 347; Pezzini 2013, p. 196.
86 Andaloro 2006a, pp. 558–9.
87 Gelfer-Jørgensen 1986, pp. 7–11.
88 See Tronzo 1997, pp. 61–2.
89 See Grube 2005, p. 19.
90 See Johns 1993, pp. 156–7.
91 Translation from Johns 2002, p. 82.
92 See Johns 1993, p. 157; Nef 2011, p. 129.
93 Translation from Johns 2002, p. 255.
94 Translation from Broadhurst 1952, pp. 340–1.
95 See Houben 2002, p. 128; Metcalfe 2009, p. 240; in Latin they were referred to as *puellae palatii* (e.g. 'Hugo Falcandus', Loud and Wiedemann 1998, p. 120 and footnote 103).
96 See Johns 2002, p. 4.
97 Although Roger was presumably fluent in Norman French dialect, Greek, Latin and Arabic, there is no evidence that he could also read and write all these languages. It is likely that the vizier signed on the king's behalf: Johns 2002, pp. 110–11.
98 See Johns 1993, pp. 136–8.
99 See Houben 2002, p. 108.
100 See Johns 2002, pp. 212–56.
101 See Metcalfe 2003, pp. 47, 99; listing also the contemporary sources Romuald of Salerno and

Falcandus; Johns 2002, p. 288, who lists all occurrences in Falcandus; Nef 2011, p. 351.
102 Translation from Metcalfe and Birk 2011, p. 237.
103 Marconi 2000.
104 For cultivation of sugarcane around Favara, see Bresc 1994, p. 245. See also Mandalà 2010, pp. 21–2.
105 See Metcalfe 2009, p. 243.
106 See Johns 1993, pp. 139–40.
107 See Bresc 1994, pp. 248, 251–2.
108 Translation adapted from Norwich 1992, p. 601 and Amari 1875, pp. 81–2.
109 See Metcalfe 2009, p. 240; Translation from Knight 1838, pp. 308–9.
110 See Metcalfe 2009, pp. 240–2; for hunting, see Romuald of Salerno references in Metcalfe 2009, p. 252, note 36.
111 See Cassarino 2013, p. 109.
112 See Mallette 2005, pp. 140–1.
113 See Cassarino 2013, pp. 109–10; Mallette 2005, p. 27; Corrao 1987, pp. 164–7.
114 Translation adapted from Mallette 2005, pp. 139–40, and Cassarino 2013, p. 109.
115 There is some controversy surrounding the name of the workshops in the royal palace, which have always been and often still are called *tiraz*, after similar use of the word at Islamic courts. However, both the inscriptions on the Robe of Roger and the Alb of William II call the royal workshops *khizana al-malikiya*: Bauer 2006, p. 403; Nef 2011, p. 129.
116 Alexander of Telese 2.1; Philagathos of Cerami: '*A great many curtains are hung, the fabric of which is threads of silk, woven with gold and various dyes that the Phoenicians have embroidered with wonderful skill and elaborate artistry*'. For the text and translation of Philagathos of Cerami's homily, see Johns 2005, pp. 5–6; also Metcalfe and Rosser-Owen 2013, p. 6.
117 Burns 2009, p. 43; Burgarella 2006, pp. 379–80; Jacoby 2006, pp. 383–9.
118 Translation from Johns 1986, p. 40; see Houben 2002, p. 125.
119 Tronzo 2006a, pp. 443–6, and Bauer 2006a, pp. 45–9; Bauer 2006, pp. 403 ff.
120 Silk textiles that used respectively one, two, three and six threads, ranging from cheaper to more expensive, while the *diarhodon* was dyed a bright and fiery red, Burgarella 2006, pp. 380–1.
121 Translation from Bauer 2006, p. 404.
122 Ibid., p. 403.
123 Bauer 2006b, pp. 55–9.
124 Granger-Taylor 2006, pp. 367–8.
125 Knipp 2011.
126 Guérin 2013, pp. 70–91.
127 Shalem and Troelenberg 2010, pp. 217–18.
128 Pinder-Wilson and Brooke 1973, pp. 261–305.
129 See Grube 2005, pp. 23–5.
130 Guastella 2006, pp. 298–301.
131 Report by Neil Stratford upon purchase of the casket, British Museum – Britain, Europe and Prehistory archives, 16 September 1981.
132 Original text from Whitehead 1946. Translation from Robertson 1972.
133 Shalem 2004, p. 79; Kühnel 1971, catalogue numbers 135, 136 and 137.
134 See Shalem 2004, p. 62.
135 MacGregor 2010, pp. 366–71; Whitehouse 2011; Lierke 2005; Lierke 2008, pp. 399–400.
136 See Metcalfe 2009, p. 247.
137 See Johns 2002, pp. 284–6; Johns 2006, pp. 324–37; Bresc 1985, pp. 243–65. Metcalfe is less convinced of such theory: Metcalfe 2009, pp. 247–8.
138 See Johns 2015, p. 125.
139 Johns 2006a, pp. 519–23; Houben 2002, p. 109.
140 See Houben 2002, p. 109.
141 See Johns 2015, p. 129.

142 Bongianino 2012, p. 109; Rocco 1994, pp. 220–1.
143 See MS Harley 5786 at the British Library; Haskins 1927, p. 184; Houben 2002, p. 109.
144 O'Hogan 2015.
145 As thought by Metcalfe 2009, p. 249.
146 Translation from Broadhurst 1952, pp. 340, 348–50.
147 D'Angelo 2002, pp. 27–8; Pezzini 2013, p. 213; Johns 2002, p. 284; Metcalfe 2009, p. 247.
148 See Pezzini 2013, p. 209.
149 Giunta and Rizzitano 1967; Norwich 1992, p. 751.
150 Translation from Johns 2015, p. 125.
151 See Johns 2002, p. 298.
152 Johns 2015, p. 137; Houben 2002, p. 108.
153 See Metcalfe 2009, p. 247.
154 A good summary is Dalli 2009, pp. 30–43.
155 Catlos 2014, p. 116.
156 See Metcalfe 2003, p. 29.
157 Ibid., pp. 30, 36.
158 Ibid.
159 See Houben 2002, p. 110.
160 According to Arab historian Ibn al-Athir, see Johns 2002, p. 255.
161 See Johns 2002, p. 289; Romuald of Salerno, see Loud and Wiedemann 1998, p, 220: *'Towards the end of his life, allowing secular matters to be neglected and delayed, he laboured in every conceivable way to convert Jews and Muslims to the faith of Christ, and endowed converts with many gifts and resources.'*
162 Ibn al-Athir: see Johns 2002, p. 289.
163 See Houben 2002, p. 112.
164 See Johns 2015, p. 137; Johns 2002, pp. 229–30 and note 68.
165 See Metcalfe 2003, p. 113.
166 See Metcalfe 2009, p. 238; Tronzo 1997, pp. 125–33; Tronzo 2006, pp. 313–15.
167 Brodbeck 2013, p. 384.
168 See Nef 2011, pp. 513, 634.
169 See Brodbeck 2013, pp. 388, 398.
170 Translation from Broadhurst 1952, p. 349.
171 A sentiment also expressed by 'Hugo Falcandus' in the *Letter Concerning the Sicilian Tragedy*, see Johns 2002, pp. 284–5; Loud and Wiedemann 1998, p. 255.
172 See Johns 2002, p. 288.
173 Ibid., p. 285.

Chapter 6: An Enlightened Kingdom

1 Translation from Loud and Wiedemann 1998, p. 219.
2 Translation based on Italian in De Simone 1999, p. 278.
3 Kinoshita 2008, pp. 371–85.
4 Translation from Broadhurst 1952, p. 341.
5 Geymüller 1908; Haskins 1927; Marongiu 1982, pp. 750–73.
6 Contreni 1995, pp. 709–57.
7 Ménager 1959, pp. 303–1, 445–68.
8 Kampers 1929; Burckhardt 1955. Contra: Abulafia 1988.
9 See Loud and Wiedemann 1998, p. 58.
10 Maqbul Ahmad 1992, pp. 156–7.
11 See Maqbul Ahmad 1992, p. 157; Dolan 2007, p. 97.
12 Translation from Houben 2002, p. 103.
13 See Maqbul Ahmad 1992, p. 156.
14 Translation from Houben 2002, p. 103.
15 See Maqbul Ahmad 1992, pp. 170–3 for influence on other geographers.
16 Tolmacheva 1995, p. 144; Maqbul Ahmad 1992, p. 158.
17 See Maqbul Ahmad 1992, p. 160; Park 2015, p. 90.
18 The Wall to keep out Gog and Magog as built by Alexander also appeared in the Hellenistic-period Alexander Romance. See Burnett 1984, pp. 151–2.
19 Translation from Norwich 1992, p. 462.
20 Translation from Houben 2002, p. 104.
21 Even though this inscription, as well as the trilingual psalter, is used by Metcalfe 2009, p. 248, to suggest a hierarchy between languages, with Latin at the top.
22 Johns 2006, pp. 513, 772–3, see also for translation; Metcalfe 2009, p. 242.
23 The Pantocrator was used in the Byzantine world as decoration for a dome. The Byzantine mosaicists working on Sicily had to adapt their style to Latin-style churches, without domes, and thus fitted the Pantocrator in the apse instead. Roger's cathedral at Cefalù is not only the earliest example of this scheme, but it is likely the best known representation of a Byzantine Pantocrator anywhere: Brenk 1994, pp. 193–8.
24 Grierson and Travaini 1998, pp.116 and 622 (no. 197); Gupta 1979, p. 27; Frey 1913, p. 12; Hill 1910, p. 146.
25 Hill 1910, p. 170.
26 Joseph 1991, pp. 464–6.
27 Translation from Sigler 2002, p. 15.
28 Burnett 2002, pp. 243–4.
29 See Jamison 1943, pp. 20–1.
30 Haskins 1913, pp. 515–6.
31 See Haskins 1911, p. 436.
32 Haskins 1910, p. 97; Grellard and Lachaud 2014, p. 57.
33 See Dolan 2007, p. 153; Haskins 1927, p. 104.
34 See Haskins 1927, pp. 60, 292, 344.
35 Translation from Berschin 1988, pp. 232–3.
36 Translation from Loud and Wiedemann 1998, p. 58.
37 For an overview, Loud 2003, pp. 540–67; Haskins 1910 and 1911.
38 Di Giacomo 2010, p. 186, see also for earlier bibliography.
39 See Haskins 1911.
40 Translation from Norwich 1992, pp. 462–3.
41 Garufi 1904, p. 13; Haskins 1911, pp. 438–43.
42 Amt and Church 2007, pp. 26–7, 54–5; Smith 2010.
43 Haskins 1911, pp. 641–65, esp. 651; Makdisi 1990, pp. 135–46.
44 Makdisi 1990, pp. 135–46.
45 See Houben 2002, pp. 135–47; Pennington 2006, pp. 37 and 60; Zecchino 1980, p. 92.
46 Translation from Houben 2002, p. 141.
47 Zecchino 1980, p. 38; See also Houben 2002, p. 143, for the original translation.
48 See Houben 2002, p. 140.
49 See Makdisi 1990.
50 Translation from Duggan 2000, pp. 966–71, letter 221.
51 Griffo 1994, pp. 16–20; Caruso 1998, pp. 234–6.
52 Taburet-Delahaye 1996, pp. 162–4; Thompson 1980, pp. 350–2, 357.
53 Jamison 1943, pp. 23–9.
54 Fagin Davis 2013, p. 407.
55 Handle 2010, p. 149.
56 See Loud and Wiedemann 1998, p. 253.
57 *Chronica* of Roger of Howden; see also Warren 1998, pp. 261–72; Mason 1990, pp. 126–31.
58 The *Authentica Habita*.
59 For example in the letters of Albert of Beham, an ally of Pope Innocent IV, Burnett 1984, pp. 157–8; or by the chronicler Salimbene of Parma.
60 Matthew Paris in his *Chronica Maiora*, see Liebermann 1888, p. 319.
61 Abulafia 1988, p. 407.
62 Haussherr 1977, p. 607.
63 See Bauer 2006b.
64 For completeness the influential 1952 publication by J. Deer, *Der Kaiserornat Friedrichs II,* on the gloves, shoes, sword and crown of Constance must be mentioned, even though many of his interpretations have now been surpassed, especially by the new studies prompted by the exhibition *Nobiles Officinae*, held in Vienna and Palermo in 2004.
65 Bauer 2006c, pp. 69–71; Trnek 2006, pp. 73–5; Bauer 2006d, pp. 425–9.
66 Guastella 2006a, pp. 371–7.
67 From *De Arte Venandi cum Avibus*.
68 See Dolan 2007, pp. 1–3.
69 Kedar and Kohlberg 1995, p. 167.
70 Burnett 1995, p. 233; Burnett 2006, pp. 99–118.
71 Haskins 1922, pp. 670–1; Siede 2010, p. 276.
72 Kinzelbach 2008, pp. 269-276.
73 Beseke 2010, p. 177.
74 See Kinzelbach 2008, p. 286; Wixom 1995, p. 490.
75 See Burnett 1984, p. 155.
76 Akasoy 2008, pp. 115–46.
77 Barber 1994, pp. 131–3.
78 See Burnett 1984, p. 156.
79 Poulle 1994, pp. 122–37; Needham 1959, p. 382.
80 Grierson and Travaini 1998, p. 184 see the minting of the coins as the final straw for Frederick II.
81 See Johns 2002, pp. 293–4, referring to Conrad, von der Lieck-Buyken and Wagner 1973, p. 40; generally on Luccra: Taylor 2003, esp. pp. 7–9 for Ibn Abbad.
82 Dante Alighieri, 'De vulgari eloquentia', edited and translated by Steven Botterill, Cambridge 1996.
83 Poetters 1998.
84 Zurich, Zentralbibliothek, registration no. C 88; Brunetti 2000, p. 304; Leonardi 2001, pp. 5–89 (no. 36–7); Vincent 2006, pp. 19-21.
85 Mascherpa 2013, pp. 9–37.
86 For example Vagnoni 2008, pp. 142–61.
87 Deer 1959, pp. 126 and 166.
88 See Grierson and Travaini 1998, pp. 132–5, 640 (no. 398), and 644 (nos. 425–7).
89 Breckenridge 1976, pp. 279–84.
90 Ricci 1913, pp. 400–1; Barbanera 2003, p. 433, with other references.
91 See Grierson and Travaini 1998, p. 4.
92 Ibid., pp. 147, 157–66, 177–81, 656 (nos. 493–6), and 664 (nos. 553–4), for original transcriptions and translations.
93 Spufford 1988, p. 169.
94 See Grierson and Travaini 1998, pp. 172–7.
95 See Abulafia 1988, pp. 222–3.
96 Breckenridge 1976, pp. 279–84.
97 Giuliano 2003b, p. 220; Kaschnitz-Weinberg 1953/54, pp. 1–21.
98 Kahsnitz 2010, p. 86.
99 See Barbanera 2003, pp. 427-8; Giuliano 2003a, pp. 148–9; Giuliano 2003b, p. 177.
100 Giuliano 2003, pp. 117–22.
101 Cellini 2003, p. 81; Barbanera 2003, p. 430.
102 See Barbanera 2003, p. 429, with reference to a medieval quote regarding sack; Dacos, Giuliano and Pannuti 1973, p. 64.
103 Byrne 1935, pp. 181–2; but Barbanera 2003, p. 425 lists 547 intaglios and 133 cameos.
104 Dacos, Giuliano and Pannuti 1973, p. 64, no. 37; p. 65, no. 39.
105 Pennington 1988, pp. 441–2.
106 Stein 2011, p. 104.
107 Dante Alighieri, 'De vulgari eloquentia', edited and translated by Steven Botterill, Cambridge 1996.
108 Farmer 2013, p. 119; Mandala 2010, pp. 21–2.
109 Weiler 2000, pp. 71–92. Translation from Craik and Macfarlane 1838, p. 680.
110 The best and most complete account for the history of Sicily under Manfred and Charles of Anjou is still Sir Steven Runciman's *The Sicilian Vespers*, Cambridge 1958.
111 English translation by Scott-Moncrieff, 1928.
112 English translation by A. Colquhoun, London 1988 edn, pp. 142, 144.
113 Andrew Graham-Dixon, *Sicily Unpacked*, a BBC2 documentary series originally aired in 2015.

All translations by Dirk Booms unless otherwise stated.

Bibliography

Original Sources

al-Muqaddasi, *The Best Divisions for Knowledge of the Regions*
Cicero, *Against Verres*
Diodorus Siculus, *Histories*
Geoffrey Malaterra, *The Deeds of Count Roger of Calabria and Sicily and of Duke Robert Guiscard his Brother*
Homer, *Odyssey*
Hugo Falcandus, *The History of the Tyrants of Sicily*
Ibn Jubayr, *The Travels of Ibn Jubayr*
Lucian, *Phalaris*
Ovid, *Metamorphoses*
Pindar, *Odes*
Pindar, *Pythian 1*
Polybios, *The Histories*
Thucydides, *The History of the Peloponnesian War*

Further Reading

Abulafia, D., *Frederick II: A Medieval Emperor*, Oxford 1988.
Andaloro, M. (ed.), *Il Palazzo Reale di Palermo*, Modena 2010.
Andaloro, M. (ed.), *Nobiles Officinae: perle, filigrane e trame di seta dal Palazzo Reale di Palermo, Vols. 1 and 2*, Catania 2006.

Bernabò Brea, L., *Sicily before the Greeks*, London 1957.
Bosher, K. (ed.) *Theater outside Athens: Drama in Greek Sicily and South Italy*, Cambridge 2012.
Burgersdijk, D. W. P. (ed.), *Sicily and the Sea*, Amsterdam 2015.

Carandini, A., Ricci, A., De Vos. M. and Medri, M., *Filosofiana, the villa of Piazza Armerina: The image of a Roman aristocrat at the time of Constantine*, Palermo 1982.
Cerchiai, L., Janelli, L. and Longo, F., *The Greek Cities of Magna Graecia and Sicily*, Los Angeles 2004.
Champion, J., *The Tyrants of Syracuse: Vol. 1, 480–367 BC*, Barnsley 2010.
Champion, J., *The Tyrants of Syracuse: Vol. 2, 367–211 BC*, Barnsley 2012.
Chiarelli, L. C., *A History of Muslim Sicily*, Malta 2011.

De Angelis, F., *Megara Hyblaia and Selinous. The Development of Two Greek City-States in Archaic Sicily*, Oxford 2003.
De Angelis, F., *Archaic and Classical Greek Sicily. A Social and Economic History*, Oxford 2016.

Finley, M., *A History of Sicily: Ancient Sicily To The Arab Conquest*, London 1968.

Grube, E. and Johns, J. (eds), *The Painted Ceilings of the Cappella Palatina, Islamic Art Supplement 1*, Genova and New York 2005.

Houben, H., *Roger II of Sicily, a Ruler Between East and West*, Cambridge 2002.

Johns, J., *Arabic Administration in Norman Sicily: the Royal Diwan*, Cambridge 2002.

Leighton, R., *Sicily Before History*, London 1999.
Lyons, C. L., Bennett, M. and Marconi, C. (eds), *Sicily: Art and Invention between Greece and Rome*, Los Angeles 2013.

Marconi, C., *Temple Decoration and Cultural Identity in the Archaic Greek World: The Metopes of Selinus*, Cambridge 2011.
Metcalfe, A., *Muslims and Christians in Norman Sicily: Arabic speakers and the end of Islam*, Oxford 2003.
Metcalfe, A., *The Muslims of Medieval Italy*, Edinburgh 2009.
Morgan, K. A., *Pindar and the Construction of Syracusan Monarchy in the Fifth Century B.C*, Oxford 2015.

Nef, A. (ed.), *A Companion to Medieval Palermo. The History of a Mediterranean City from 600 to 1500*, Leiden 2013.
Norwich, J. J., *Sicily: A Short History, from the Greeks to Cosa Nostra*, London 2015.
Norwich, J. J., *The Normans in Sicily. The magnificent story of 'the other Norman Conquest'*, London 1992.

Pugliese Carratelli, G. (ed.), *The Western Greeks: Classical Civilization in the Western Mediterranean*, London 1996.

Ridgway, D., *The First Western Greeks*, Cambridge 1992.
Ross Holloway, R., *The Archaeology of Ancient Sicily*, London and New York 1991.
Runciman, S., *The Sicilian Vespers*, Cambridge 1958.
Rutter, N. K., *The Greek Coinages of Southern Italy and Sicily*, London 1997.

Spawforth, T., *The Complete Greek Temples*, London 2006.

Tronzo, W., *The cultures of his kingdom: Roger II and the Cappella Palatina in Palermo*, Princeton 1997.

Wilson, R. J. A., *Piazza Armerina*, London 1983.
Wilson, R. J. A., *Sicily Under the Roman Empire: The Archaeology of a Roman Province 36 BC–AD 535*, Warminster 1990.

Master Bibliography

Abulafia, D., *Frederick II: A Medieval Emperor*, Oxford 1988.
Adornato, G., 'Delphic Enigmas? The Γέλας άνάσσων, Polyzalos, and the Charioteer Statue', *American Journal of Archaeology* 112, 2008, pp. 29–55.
Adornato, G., 'Phalaris: Literary Myth or Historical Reality? Reassessing Archaic Akragas', *American Journal of Archaeology* 116.3, 2012, pp. 483–506.
Agnesi, V., Di Patti, C. and Truden, B., 'Giants and elephants of Sicily' in Piccardi, L. and Bruce Masse, W. (eds), *Myth and Geology*, London 2007, pp. 263–70.
Akasoy, A. A., 'Ibn Sab'in's Sicilian Questions: the Text, its Sources, and their Historical Context', *Al-Qantara* 39.1, 2008, pp. 115–46.
al-Istakhri, *Kitab masalik al-mamalik*, tr. De Goeje, M. J., *Bibliotheca Geographorum Arabicorum* 1, Leiden 1967.
al-Muqaddasi, *The Best Divisions for Knowledge of the Regions*, tr. Collins, B., Reading 2001.
Amari, M., *Le epigrafi arabiche di Sicilia, trascritte, tradotte e illustrate. Parte prima: Iscrizioni edili*, Palermo 1875.
Amari, M., *Biblioteca arabo-sicula, Vol. 2*, Turin 1881.
Ampolo, C., 'Le ricchezze dei Selinuntini: Tucidide VI, 20 e l'iscrizione del tempio G Selinunte', *La Parola del Passato* 39, 1984, pp. 81–9.
Ampelo, C., 'History of Sicily, 480–211 BC' in Lyons et al 2013, p. 17.
Amt, E. and Church, S. D. (eds and tr.), *Richard fitz Nigel, Dialogus de Scaccario, Oxford Medieval Texts*, Oxford 2007.
Andaloro, M. (ed.), *Nobiles Officinae: perle, filigrane e trame di seta dal Palazzo Reale di Palermo, Vols.1 and 2*, Catania 2006.
Andaloro, M., 2006a, 'La Vergine Haghiosoritissa dalla Cattedrale di Palermo' in Andaloro Vol. 1, 2006, pp. 558–9.
Andaloro, M. (ed.), *Il Palazzo Reale di Palermo*, Modena 2010.
Angell S. and Evans, T., *Sculptured metopes discovered amongst the ruins of the ancient city of Selinus in Sicily by William Harris and Samuel Angell in the year 1823*, London 1826.
Annunziata Lima, M., 'L'età bizantina' in Gandolfo, L. (ed.), *Pulcherrima Res. Preziosi ornamenti dal passato, Catalogo della mostra*, Palermo 2008, pp. 234–69.
Antonnacio, C. M., 'Sport and Society in the Greek West' in Christensen, P. and Kyle, D. G. (eds), *A Companion to Sport and Spectacle in Greek and Roman Antiquity*, Malden 2014, pp. 192–207.

Bagnera, A., 'La ceramica invetriata di età Islamica' in Bagnera, A. (ed.), *Islam in Sicilia, un giardino tra due civiltà*, Gibellina 2012, pp. 26–37.
Bagnera, A., 'From a Small Town to a Capital: The Urban Evolution of Islamic Palermo (9th–mid–11th Century)' in Nef 2013, pp. 61–70.
Baldini Lippolis, I., 'Sicily and Southern Italy: Use and Production in the Byzantine Koiné' in Entwistle, C. and Adams, N. (eds), *Intelligible Beauty. Recent research on Byzantine jewellery. British Museum Research Publication 178*, London 2010, pp. 123–32.
Balog, P., 'La monetazione della Sicilia araba e le sue imitazioni nell'Italia Meridionale' in Gabrieli, F. and Scerrato, U. (eds), *Gli Arabi in Italia: cultura, contatti e tradizioni*, Milan 1979, pp. 611–28.
Barbaenera, M., *Il guerriero di Agrigento. Una probabile scultura frontonale del museo di Agrigento e alcune questioni di archeologia siceliota*, Rome 1995.
Barbanera, M., 'Alcune considerazioni su Federico II collezionista di pietre dure e sul destino della Tazza Farnese', *Archeologia Classica* 54, 2003, pp. 423–41.
Barber, M., *The New Knighthood*, Cambridge 1994.
Barletta, B. A., *Ionic Influence in Archaic Sicily: The Monumental Art*, Gotheburg 1983.
Barrett, A. A., *Livia: First Lady of Imperial Rome*, Yale 2002.
Bates, M. L., 'The Introduction of the Quarter-dinar by the Aghlabids in 264 H.(A.D.878) and its Derivation from the Byzantine Tremissis', *Rivista Italiana di Numismatica* 103, 2002, pp. 115–16.
Bauer, R., The Mantle of Roger II and the Siculo-Norman Vestments from the Royal Court of Workshop in Palermo, in Andaloro Vol. 2, 2006, pp. 403–7.
Bauer, R., 2006a, 'Manto di Ruggero II' in Andaloro Vol. 1, 2006, pp. 45–9.
Bauer, R., 2006b, 'Alba di Guglielmo II' in Andaloro 2006, Vol. 1, pp. 55–9.
Bauer, R., 2006c 'Guanti' in Andaloro Vol. 1, 2006, pp. 69–71.
Bauer, R., 2006d, 'Coronation vestments and Insignia' in Andaloro Vol. 2, 2006, pp. 425–9.
Bell, M., *Morgantina Studies, Volume 1: The Terracottas*, Princeton 1981.
Beresford, J., *The Ancient Sailing Season*, Leiden 2012.
Bernabò Brea, L., *Sicily Before the Greeks*, London 1957.
Berschin, W., *Greek letters and the Latin Middle Ages: from Jerome to Nicholas of Cusa, tr. J. C. Frakes*, Washington D.C. 1988.
Bertaux, E., *L'art dans l'Italie méridionale*, Paris 1903.
Beseke, J., 'Adlerstandarte' in Wieczorek, Schneidmüller and Weinfurter 2010, p. 177.
Biondi, G. (ed.), *Centuripe. Indagini archeologiche e prospettive di ricerca*, Enna 2010.
Blake, E., 'The Mycenaeans in Italy: a minimalist position', *Papers of the British School at Rome 76*, 2008, pp. 1–34.
Bloesch, H. and Isler, H. P., *Studia Ietina 1*, Zurich 1976.
Böhm, S., *Dädalische Kunst Siziliens*, Würzburg 2007.
Bonacasa Carra, R. M., Un rilievo bizantino del Museo Archeologico Regionale di Agrigento', *Quaderni dell'Istituto di Archeologia della Universita di Messina* 4, 1989, pp. 101–9.
Bonacasa, N. and Ensoli, S., *Cirene*, Milan 2000.
Bonacasa, N. and Joly, E., 'L'Ellenismo e la Tradizione Ellenistica' in Caratelli 1985, pp. 332–3.
Bonanno, C., *I sarcofagi fittili della Sicilia*, Rome 1998.
Bonnano, C., 'Gli acroliti' in Bonanno, C., *Il Museo Archeologico di Morgantina: Catalogo*, Rome 2013, pp. 83–4.
Bongianino, U., 'Al-Hadra ar-Rujjariyya. Arabismo e propaganda politica alla corte di Ruggero II di Sicilia', *Arte Medievale* 4.2, 2012, pp. 95–120.
Bosher, K. (ed.), *Theater Outside Athens: Drama in Greek Sicily and South Italy*, Cambridge 2012.
Botterill, S., *Dante: De Vulgari Eloquentia*, Cambridge 1996.
Brea, B., *Akrai*, Catania 1956.

Breckenridge, J. D., 'A classical quotation in twelfth-century Sicily', *Gesta* 15, 1976, pp. 279–84.

Brenk, B., 'La Simbologia del Potere' in D'Onofrio, M. (ed.), *I Normanni, popolo d'Europa 1030–1200. Catalogo della mostra*, Venice 1994, pp. 193–8.

Bresc, H., 'La formazione del populo siciliano' in Quattordio Moreschini, A. (ed.), *Tre millenni di storia linguistica della Sicilia. Atti del Convegno (Palermo, 25–27 Marzo 1983)*, Pisa 1985, pp. 243–65.

Bresc, H., 'Les jardins royaux de Palerme', *Mélanges de l'Ecole française de Rome – Moyen-Age* 106.1, 1994, pp. 239–58.

Britt, K. C., 'Roger II of Sicily: Rex, Basileus, and Khalif? Identity, Politics, and Propaganda in the Cappella Palatina', *Mediterranean Studies* 16, 2007, pp. 21–45.

Broadhurst, R., *The Travels of Ibn Jubayr*, London 1952.

Brodbeck, S., 'Monreale from Its Origin to the End of the Middle Ages' in Nef 2013, pp. 383–412.

Broucke, P., *The Temple of Olympian Zeus at Agrigento*, Yale 1996.

Brunetti, G., *Il frammento inedito 'Resplendiente stella de albur' di Giacomino Pugliese e la poesia italiana delle origini, Beihefte zur Zeitschrift für Romanische Philologie*, Tübingen 2000.

Burckhardt, J., *Die Kultur der Renaissance in Italien. Ein Versuch*, Leipzig 1955.

Burgarella, F., 'The Byzantine Background to the Silk Industry in Southern Italy' in Andaloro Vol. 2, 2006, pp. 373–82.

Burgersdijk, D. W. P. (ed.), *Sicily and the Sea*, Amsterdam 2015.

Burnett, C. S. F., 'An Apocryphal Letter from the Arabic Philosopher Al-Kindi to Theodore, Frederick II's Astrologer, concerning Gog and Magog, the Enclosed Nations, and the Scourge of the Mongols', *Viator* 15, 1984, pp. 151–67.

Burnett, C., 'Master Theodore, Frederick II's Philosopher' in (n.a.) *Federico II e le nuove culture, Atti del XXXI Convegno Storico Internazionale (Todi 9–12 Ottobre 1994)*, Spoleto 1995, pp. 225–54.

Burnett, C., 'Indian Numerals in the Mediterranean Basin in the Twelfth Century, with Special Reference to the "Eastern Forms"' in Dold-Samplonius, Y., Dauben, J. W., Folkerts, M. and van Dalen, B. (eds), *From China to Paris: 2000 Years Transmission of Mathematical Ideas*, Stuttgart 2002, pp. 237–88.

Burnett, C., 'A Hermetic Programme of Astrology and Divination in Mid-twelfth century Aragon: The Hidden Preface in the Liber Novem Iudicum' in Burnett, C. and Ryan, W. F. (eds), *Magic and the Classical Tradition*, London 2006, pp. 99–118.

Burns, E. J., *Sea of Silk: A Textile Geography of Women's Work in Medieval French Literature*, Philadelphia 2009.

Byrne, E., 'Some Mediaeval Gems and Relative Values', *Speculum* 10, 1935, pp. 177–87.

Caltabiano, M. C. et al, *Il centro antico di Monte Saraceno di Ravanusa : dall'archeologia alla storia*, Campobello di Licata 2003, pp. 162–8.

Campagna, L., 'Monuments and Royal Power in Syracuse in the Age of Hiero II' in Di Pasquale and Parisi Presicce 2013, p. 53.

Carandini, A., Ricci, A., De Vos. M. and Medri, M., *Filosofiana, the villa of Piazza Armerina: The image of a Roman aristocrat at the time of Constantine*, Palermo 1982.

Caruso, E., 'Urbanistica antica in una città medievale e barocca' in Ganci, M. (ed.), *Marsala*, Palermo 1998, pp. 231–45.

Cassarino, M., 'Palermo Experienced, Palermo Imagined. Arabic and Islamic Culture between the 9th and the 12th Century' in Nef 2013, pp. 89–129.

Castagnino, E. F., 'Sicilia e il commercio marittimo del marmo cicladico', *Paria Lithos: Parian Quarries, Marble and Workshops of Sculpture. Proceedings of the First International Conference on the Archaeology of Paros and the Cyclades, Paros 2–5 October 1997*, Athens 2000, pp. 507–18.

Catlos, B. A., *Muslims of Medieval Latin Christendom, c.1050–1614*, Cambridge 2014.

Cellini, P., 'Presenze Federiciane' in Giuliano 2003, pp. 71–86.

Cerchiai, L., Janelli, L., and Longo, F., *The Greek Cities of Magna Graecia and Sicily*, Los Angeles 2004.

Ceserani, G., *Italy's lost Greece: Magna Graecia*, Oxford 2012.

Champion, J., *The Tyrants of Syracuse: Vol. 1, 480–367 BC*, Barnsley 2010.

Champion, J., *The Tyrants of Syracuse: Vol. 2, 367–211 BC*, Barnsley 2012.

Chester, D. K., Duncan, A., Guest, J. E. and Kilburn, C., *Mount Etna: The Anatomy of a Volcano*, London 1985.

Chiarelli, L. C., *A History of Muslim Sicily*, Malta 2011.

Conrad, H., von der Lieck-Buyken, T. and Wagner, W. (eds), *Die Konstitutionen Friedrichs II von Hohenstaufen für sein Königreich Sizilien. Nach einer lateinischen Handschrifte des 13. Jahrhunderts (Ms. Vat. Lat. 6770) herausgegeben und übersetzt, Studien und Quellen zur Welt Kaiser Friedrichs II, Vol. 2*, Cologne and Vienna 1973.

Contreni, J. J., 'The Carolingian Renaissance: Education and Literary Culture' in McKitterick, R. (ed.), *The New Cambridge Medieval History*, Vol. 2, Cambridge 1995, pp. 709–57.

Cordano, F. and Di Salvatore, M., *Il Guerriero di Castiglione di Ragusa: Greci e Siculi ella Sicilia sud-orientale: atti del Seminario, Milano, 15 Maggio 2000*, Rome 2002.

Corrao, F. M. (ed.), *Poeti arabi di Sicilia*, Milan 1987.

Craik, G. and Macfarlane, C., *The Pictorial History of England, being a history of the people, as well as a history of the kingdom*, London 1838.

Crawford, F. M., *The Rulers of the South*, London 1901.

Crispino, A., 'Paolo Orsi innovatore. Lo scavo di Castelluccio di Noto e la nuova metodologia negli studi preistorici in Sicilia', XLVI Riunione Scientifica – 150 anni di preistoria e protostoria in Italia, Rome 2011, pp. 349–354.

Ćurčić, S., 'Some Palatine Aspects of the Cappella Palatina in Palermo', *Dumbarton Oaks Papers* 41, 1987, pp. 125–44.

Ćurčić, S., 'Architecture' in Kitzinger 1990, pp. 27–104.

Ćurčić, S., 'Further thoughts on the Palatine aspects of the Cappella Palatina in Palermo' in Dittelbach 2011, pp. 525–33.

D'Angelo, F., 'La città di Palermo tra la fine dell'età araba e la fine dell'età normanna', in D'Angelo, F. (ed.) *La città di Palermo nel Medioevo*, Palermo 2002, pp. 7–96.

Dacos, N., Giuliano, A., and Pannuti, U., *Il Tesoro di Lorenzo il Magnifico, Vol. 1: Le Gemme*, Florence 1973.

Dalli, C., 'Contriving Coexistence: Muslims and Christians in the Unmaking of Norman Sicily' in Brambilla, E. (ed.), *Routines of Existence: Time, Life and After Life in Society and Religion*, Pisa 2009, pp. 30–43.

David Napier, A., *Masks, Transformation, and Paradox*, Berkley and Los Angeles 1986.

De Angelis, F., *Megara Hyblaia and Selinous. The Development of Two Greek City-States in Archaic Sicily*, Oxford 2003.

De Angelis, F., 2003a, 'Equations of Culture: The Meeting of Natives and Greeks in Sicily (ca. 750–450 BC)', *Ancient West and East* 2.1, 2003, pp. 19–50.

De Angelis, F., 2003b, *Megara Hyblaia and Selinous: The Development of Two Greek City-States in Archaic Sicily*, Oxford 2003, p. 60.

De Angelis, F., *Archaic and Classical Greek Sicily. A Social and Economic History*, Oxford 2016.

de Cesare, M., 'Greek Myth and religion in the Sicilian Context' in Lyons 2013, pp. 67–79.

De Luca, M.A., 'Un contributo al dibattito sull'introduzione del quarto di dinàr e sulla sua possibile derivazione da modelli bizantini' in Nef and Prigent 2010, pp. 113–30.

De Luca, M. A., 2010b, 'La riforma monetaria dell'Aglabita Ibrahim II', in Callegher, B. and D'Ottone, A. (eds) *The second Simone Assemani Symposium on Islamic Coins*, Trieste 2010, pp. 90–110.

De Simone, A., 'Il Mezzogiorno normanno-svevo visto d all'Islam africano' in Musca, G., *Il Mezzogiorno normanno-svevo visto dall'Europa e dal mondo mediterraneo (XIII Giornate normanno-sveve, Bari, 21–24 Oct. 1997)*, Bari 1999, pp. 261–93.

De Vincenzo, S., *Tra Cartagine e Roma : I centri urbani dell'eparchia punica di Sicilia tra VI e I sec. a.C.*, Berlin and Boston 2013.

Deer, J., *Der Kaiserornat Friedrichs II*, Bern 1952.

Deer, J., *The Dynastic porphyry tombs of the Norman period in Sicily*, Cambridge MA 1959.

Demus, O., *The Mosaics of Norman Sicily*, New York 1950.

Denoyelle, M. and Iozzo, M., *La céramique grecque d'Italie méridionale et de Sicile*, Paris 2009.

Déroche, F., *The Abbasid tradition: Qur'ans of the 8th to the 10th centuries AD, Nasser D. Khalili Collection of Islamic Art, Vol. 1*, London 1992.

Dewailly, M., *Les statuettes aux parures du sanctuaire de la Malophoros à Sélinonte*, Naples 1992.

Di Giacomo, C., 'Grabplatte des Erzbischofs Richard Palmer' in Wieczorek, Schneidmüller and Weinfurter 2010, p.186.

Di Liberto, R., 'Norman Palermo: Architecture between the 11th and 12th Century' in Nef 2013, pp. 139–94.

Di Pasquale, G., and Parisi Presicce, C. (eds), *Archimedes: The Art and Science of Invention*, Florence 2013.

Di Stefano, C. A., *Demetra. La divinità, i santuari, il culto, la leggenda, Atti del I Congresso internazionale, Enna, 1–4 luglio 2004*, Enna 2004.

Dittelbach, T. (ed.), *The Cappella Palatina in Palermo. History, Art, Functions*, Künzelsau 2011.

Dolan, M., *The Role of Illustrated Aratea Manuscripts in the Transmission of Astronomical Knowledge in the Middle Ages* (unpublished PhD Thesis, University of Pittsburgh 2007).

Dominguez, A. J., 'Greeks in Sicily' in Tsetskhladze, G. R. (ed.), *Greek Colonisation: An Account of Greek Colonies and Other Settlements Overseas*, Vol. 1, Leiden and Boston 2006, pp. 253–357.

Duggan, A. J., *The Correspondence of Thomas Becket, Archbishop of Canterbury, 1162–70, Vol. 2*, Oxford 2000.

Ermete, K. and Fansa, M. (eds), *Kaiser Friedrich II. 1194–1250, Welt und Kultur des Mittelmeerraums*, Oldenburg and Mainz 2008.

Evans, R. J., *Syracuse in Antiquity: History and Topography*, Pretoria 2009.

Fagin Davis, L., 'The Epitome of Pauline Iconography: BnF Francais 50, The *Miroir Historial* of Jean de Vignay' in Cartwright, S. (ed.), *A Companion to St. Paul in the Middle Ages*, Leiden 2013, pp. 395–425.

Famà, M. L., 'The Mozia Charioteer' in Lyons et al 2013, pp. 84–6.

Farmer, S., 'La Zisa/Gloriette: Cultural Interaction and the Architecture of Repose in Medieval Sicily, France and Britain', *Journal of the British Archaeological Association* 166, 2013, pp. 99–123.

Feltham, H. B., 'Lions, Silks and Silver: The Influence of Sasanian Persia', *Sino-Platonic Papers* 206, Philadelphia 2010, p.16.

Ferruzza, M. L., 'Agalmata ek pelou: Aspects of Coroplastic Art in Classical and Hellenistic Sicily' in Lyons et al 2013.

Fields, N., *Syracuse 415–413 BC: Destruction of the Athenian Imperial Fleet*, Oxford 2008.

Finley, M., *A History of Sicily: Ancient Sicily To The Arab Conquest*, London 1968.

Fitzjohn, M., 'Equality in the colonies: concepts of equality in Sicily during the eighth to six centuries BC', *World Archaeology Vol. 39 No. 2*, 2007, pp. 215–28.

Frey, A. R., *The Dated European Coinage Prior to 1501*, *American Journal of Numismatics* 67, 1913.

Fuduli, L. and Salamone, G., 'Hadrianus Restitutor Siciliae', *Mélanges de l'École française de Rome - Antiquité* 127–1, 2015, [Online] Available at: http://mefra.revues.org/2737. [accessed 14 January 2016].

Gabrici, E., 'Per la storia dell'architettura dorica in Sicilia', *Monumenti antichi dei Lincei*, 35,1933–5, pp. 139–250, plate 32.

Gabrieli, F. and Scerrato, U. (eds) *Gli Arabi in Italia: cultura, contatti e tradizioni*, Milan 1979.

Gagarin, M. (ed.), *The Oxford Encyclopaedia of Ancient Greece and Rome*, Vol. 7, Oxford 2010.

Garufi, C. A., 'I diplomi purpurei della cancelleria normanna ed Elvira prima moglie di re Ruggero (1117? – Febbraio 1135)', *Atti della Reale Accademia di Scienze Lettere e Arti di Palermo* Ser. 3, Vol. 7, 1904, p. 13.

Gelfer-Jørgensen, M., *Medieval Islamic Symbolism and the Paintings in the Cefalù Cathedral*, Leiden 1986.

Geymüller, H., *Friedrich II von Hohenstaufen und die Anfänge der Architektur der Renaissance in Italien*, Munich 1908.

Giammellaro, A. S., Spatafora, F.and van Dommelen, P., 'Sicily and Malta: between Sea and Countryside', in Bellard, C. G. and van Dommelen, P., *Rural Landscapes of the Punic World: Monographs in Mediterranean Archaeology*, Vol. 11, London 2008, pp. 129–58.

Giuliano, A., '…la luce de la gran Costanza' in Giuliano, A. (ed.), *Studi Normanni e Federiciani*, Rome 2003, pp. 117–22.

Giuliano, A., 2003a, 'Simone Martini e Federico II' in Giuliano, A. (ed.), *Studi Normanni e Federiciani*, Rome 2003, pp.129–60.

Giuliano, A., 2003b, 'Lineamenti per una cultura formale di Federico II' in Giuliano, A. (ed.), *Studi Normanni e Federiciani*, Rome 2003, pp. 161–224.

Giunta, F. and Rizzitano, U., *Terra senza crociati: popoli e culture nella Sicilia del Medioevo*, Palermo 1967.

Gowers, E., 'Augustus and "Syracuse"', *Journal of Roman Studies* 100, 2010, pp. 69–87.

Granger-Taylor, H., 'Frammento di Tessuto della Veste di Enrico VI' in Andaloro Vol. 1, 2006, pp. 367–8.

Green, P., *Diodorus Siculus, Books 11–12.37.1: Greek History, 480–431 BC—the Alternative Version*, Austin 2006.

Grellard, C. and Lachaud, F. (eds), *A Companion to John of Salisbury. Brill's Companions to the Christian Tradition*, Leiden 2014.

Grierson, P. and Travaini, L., *Medieval European Coinage. With a Catalogue of the Coins in the Fitzwilliam Museum, Cambridge, 14: Italy III: (South Italy, Sicily, Sardinia)*, Cambridge 1998.

Griffo, M. G. (ed.), *La Chiesa Madre di Marsala*, Marsala 1994.

Grube, E., 'The Painted Ceilings of the Cappella Palatina in Palermo and their Relation to the Artistic Traditions of the Muslim World and the Middle Ages' in Grube, E. and Johns, J. (eds), *The Painted Ceilings of the Cappella Palatina, Islamic Art, Supplement I*, Genova and New York 2005, pp. 15–34.

Guastella, C., 'Cofano con Figure di Santi' in Andaloro Vol. 1, 2006, pp. 298–301.

Guastella, C., 2006a, 'Corona di Costanza d'Aragona' in Andaloro Vol.1, 2006, pp. 371–7.

Guérin, S. M., 'Forgotten Routes? Italy, Ifrīqiya and the TransSaharan Ivory Trade', *Al-Masāq*, 25:1, 2013, pp. 70–91.

Gupta, R. C., 'Spread and Triumph of Indian Numerals', *Indian Journal of Historic Science* 18, 1979, pp. 23–38.

Guzzo, P. G., 'A group of Hellenistic silver objects in the Metropolitan Museum', *Metropolitan Museum Journal 38*, 2003, pp. 45–87.

Guzzone, C. (ed.) *Sikania. Tesori archeologici dalla Sicilia centro-meridionale (secoli XIII-VI a. C.)* Palermo 2005.

Handle, E., 'Koenigreich Sizilien: Wiege der Kulturen' in Wieczorek, Schneidmüller and Weinfurter 2010, p. 149.

Harris Nicholas, N. (ed.), *The Dispatches and Letters of Vice Admiral Lord Viscount Nelson, with Notes by Sir Nicholas Harris Nicolas Vol. 4, 1758–1805*, Cambridge 2011.

Haskins, C. H., 'The Sicilian Translators of the Twelfth Century and the First Latin Version of Ptolemy', *Harvard Studies in Classical Philology* 21, 1910, pp. 75–102.

Haskins, C. H., 'England and Sicily in the Twelfth Century', *The English Historical Review* Vol. 26, No. 103, 1911, p. 436.

Haskins, C. H., 'England and Sicily in the Twelfth Century (Continued)', *The English Historical Review* Vol. 26, No. 104, 1911, pp. 641–65.

Haskins, C. H., 'Adelard of Bath and Henry Plantagenet', *English Historical Review* Vol. 28, Issue 111, 1913, pp. 515–16.

Haskins, C., 'Science at the Court of the Emperor Frederick II', *The American Historical Review* Vol. 27, No. 4, 1922, pp. 669–94.

Haskins, C. H., *The Renaissance of the Twelfth Century*, Harvard 1927.

Haussherr, R. (ed.), *Die Zeit der Staufer. Geschichte – Kunst – Kultur. Bd. 1: Katalog der Ausstellung des Württembergischen Landesmuseums Stuttgart*, Stuttgart 1977.

Hayes, D. M., (forthcoming) 'The cult of St Nicholas of Myra in Norman Bari, c. 1071–c. 1111.' *Journal of Ecclesiastical History*. [online] available at: http://www.academia.edu/9918105 [accessed 1 February 2016].

Hayes, D. M., 'The Political Significance of Roger II of Sicily's Antiquated Loros in the Mosaic in Santa Maria dell'Ammiraglio, Palermo', *Allegorica* 29, 2013, pp. 52–69.

Hayes, D. M., 2013a, 'French Connections: The Significance of the Fleurs-de-Lis in the Mosaic of King Roger II of Sicily in the Church of Santa Maria dell'Ammiraglio, Palermo', *Viator* 44, 2013, pp. 119–49.

Hehn, V., *Cultivated Plants and Domesticated Animals in Their Migration from Asia to Europe: Historico-Linguistic Studies*, London 1885.

Hill, G. F., *On the Early Use of Arabic Numerals in Europe*, Oxford 1910.

Hinz, V., *Der Kult von Demeter und Kore auf Sizilien und in der Magna Graecia*, Wiesbaden 1998.

Hodos, T., 'Globalization and Colonization: a view from Iron Age Sicily', *Journal of Mediterranean Archaeology*, Vol. 23, 2010, pp. 81–106.

Hornblower, S., *The Greek World 479–323 BC*, London and New York 2002.

Houben, H., *Roger II of Sicily, a Ruler Between East and West*, Cambridge 2002.

Houël, J.-P., *Voyage pittoresque des isles de Sicile, de Malte et de Lipari, Vol. 4*, Paris 1787.

Hoyos, D., *The Carthaginians*, Abingdon 2010.

Hughes, J. D., 'Hunting in the Ancient World' in Kalof, L. (ed.), *A Cultural history of Animals in Antiquity*, Oxford 2007, pp. 55–7.

Hurwitt, J. M., *The Athenian Acropolis*, Cambridge 1999.

Ismaelli, T., *Archeologia del culto a Gela: il santuario del Predio Sola*, Bari 2011.

Jacoby, D., 'Silk and Silk Textiles in Arab and Norman Sicily: the Economic Context' in Andaloro Vol. 2, 2006, pp. 383–9.

Jamison, E., 'Alliance of England and Sicily in the Second Half of the 12th Century', *Journal of the Warburg and Courtauld Institutes 6*, 1943, pp. 20–32.

Johns, J. and Savage⬚Smith, E., 'The Book of Curiosities: A Newly Discovered Series of Islamic Maps', *Imago Mundi: The International Journal for the History of Cartography* 55, 2003, pp. 7–24.

Johns, J., 'The Norman kings of Sicily and the Fatimid caliphate' in Chibnall, M. (ed.), *Anglo-Norman Studies 15: Proceedings of the Battle Conference and of the XI Colloquio medievale of the Officina di Studi Medievali*, Woodbridge 1992, pp. 133–59.

Johns, J., *Arabic Administration in Norman Sicily: the Royal Diwan*, Cambridge 2002.

Johns, J., 'The Date of the Ceiling of the Cappella Palatina in Palermo' in Grube and Johns 2005, pp. 1–12.

Johns, J., 'The Arabic Inscriptions of the Norman Kings of Sicily. A Reinterpretation' in Andaloro Vol. 2 2006, pp. 324–37.

Johns, J., 2006a, 'Lapidi Sepolcrali in Memoria di Anna e Drogo, Genitori di Grisanto' in Andaloro Vol. 1 2006, pp. 519–23.

Johns, J., 2006b, 'Lastra con Iscrizione Trilingue dalla Clessidra di Re Ruggero II' in Andaloro Vol. 1 2006, pp. 513, 772–3.

Johns, J., 'The Bible, the Qur'an and the Royal Eunuchs in the Cappella Palatina' in Dittelbach 2011, pp. 560–570.

Johns, J., 'The Palermo Qur'ān (AH373/982–83AD) and the triumph of Mālikism in Ifrīqiya', pre-print version of a paper delivered at the conference and interdisciplinary workshop The Aghlabids & their Neighbors: Art & Material Culture in Ninth-Century North Africa. 23–24 May 2014, UNC-Chapel Hill Winston House, London 2014, available at: https://www.academia.edu/6947926 [accessed: 21 March 2016].

Johns, J., 'Arabic Inscriptions in the Cappella Palatina: Performativity, Audience, Legibility and Illegibility' in Eastmond, A. (ed.), *Viewing Inscriptions in the Late Antique and Medieval World*, Cambridge 2015, pp. 125–37.

Johnson, M., 'The Lost Royal Portraits of Gerace and Cefalù Cathedrals', *Dumbarton Oaks Papers* 53, Washington D.C. 1999, pp. 237–62.

Joseph, G. G., *The Crest of the Peacock: Non-European Roots of Mathematics*, Princeton 1991.

Kahsnitz, R., 'Kameo: Herkules erwürgt den nemäischen Löwen' in Wieczorek, Schneidmüller and Weinfurter 2010, p. 86.

Kampers, F., *Kaiser Friedrich II. Der Wegbereiter der Renaissance*, Bielefeld and Leipzig 1929.

Kapitaikin, L., 'The Daughter of al-Andalus: Interrelations between Norman Sicily and the Muslim West', *Al-Masaq* 25.1, 2013, pp. 113–34.

Karakasi, K., *Archaic Korai*, Los Angeles 2003.

Kaschnitz-Weinberg, G., 'Bildnisse Friedrichs II. von Hohenstaufen. Teil I: Der Kolossalkopf aus Lanuvium, mit Tafel 1–13', *Mitteilungen des Deutschen Archaeologischen Instituts Roemische Abteilung* 60/61, 1953/54, pp. 1–21.

Kedar, B. Z. and Kohlberg, E. 'The Intercultural Career of Theodore of Antioch', *Mediterranean Historical Review* 10, 1995, pp. 164–76.

Kinoshita, S., 'Translation, empire, and the worlding of medieval literature: the travels of Kalila wa Dimna', *Postcolonial Studies* 11.4, 2008, pp. 371–85.

Kinzelbach, R., 'Kaiser Friedrich II. De arte venandi cum avibus. Die Arten der Voegel' in Ermete and Fansa 2008, pp. 269–99.

Kitzinger, E., 'On the Portrait of Roger II in the Martorana', in Kleinbauer, W. E. (ed.), 'Palermo', *The Art of Byzantium and the Medieval West: Selected Studies by Ernst Kitzinger*, Bloomington 1976, pp. 30–6.

Kitzinger, E., 'Two mosaic ateliers in Palermo in the 1140s', in Barral i Altet, X. (ed.) *Artistes, Artisans et Production Artistique au Moyen Age. Colloque International, Vol. 1, Les Hommes*, Paris 1986, pp. 277–94.

Kitzinger, E., *The Mosaics of St. Mary of the Admiral of Palermo*, Cambridge MA 1990.

Knight, H. G., *The Normans in Sicily*, London 1838.

Knipp, D. (ed.), 'Siculo-Arabic Ivories and Islamic Painting 1100-1300. Proceedings of the International Conference, Berlin, 6–8 July 2007', *Roemische Forschungen der Bibliotheca Herziana*, Munich 2011.

Krautheimer, R., and Ćurčić, S., *Early Christian and Byzantine Architecture*, Yale 1992.

Kühnel, E., *Die islamischen Elfenbeinskulpturen VIII–XIII. Jahrhundert*, Berlin 1971.

La Duca, R., 'Non erano rosse le cupole di S. Giovanni degli Eremiti. Una utile divagazione sui monumenti normanni di Palermo', *Kalòs. Arte in Sicilia* 3, 1991, pp. 46–9.

Lamagna, G. and Amato, R. (eds), *Tesori dalla Sicilia: Gli ori del British Museum a Siracusa*, Syracuse 2015.

Leighton, R., *Sicily Before History*, London 1999.

Leonardi, L., 'La poesia delle origini e del Duecento' in Malato, E., *Storia della letteratura Italiana X: La tradizione dei testi*, Rome 2001, pp. 5–89.

Libertini, G., *Centuripe*, Catania 1926.

Liebermann, F., *Monumenta Germaniae Historica Scriptorum 28*, Hanover 1888.

Lierke, R., *Die Hedwigsbecher. Das normannisch-sizilische Erbe der staufischen*, Mainz 2005.

Lierke, R., 'Der Mindener Hedwigsbecher' in Ermete and Fansa 2008, pp. 399–400.

Longo, F., 'Syracuse' in Cerchiai, Jannelli and Longo 2004, pp. 156–277.

Longo, R., 'L'opus sectile nei cantieri normanni : una squadra di marmorari tra Salerno e Palermo' in Quintavalle, C. A. (ed.), *Medioevo: le officine, XII Convegno internazionale di studi, Parma, 22–27 Settembre 2009*. Milan 2010, pp. 179–89.

Longo, R., 'La Fabbrica Medievale' in Andaloro 2010, pp. 51–117.

Loud, G. A. and Wiedemann, T., *The History of the Tyrants of Sicily by 'Hugo Falcandus', 1154–69*, Manchester 1998.

Loud, G. A., 'The kingdom of Sicily and the kingdom of England, 1066–1266', *History* 88, 2003, pp. 540–67.

Loud, G. A., *Roger II and the Creation of the Kingdom of Sicily*, Manchester 2012.

Lyons, C. L., Bennett, M. and Marconi, C. (eds), *Sicily: Art and Invention between Greece and Rome*, Los Angeles 2013.

MacGregor, N., *A History of the World in 100 Objects*, London 2010.

MacIntosh Turfa, J. and Steinmayer Jr., A., 'The Syracusia as a Giant Cargo Vessel', *The International Journal of Nautical Archaeology*, Vol. 28, No. 2, 1999, pp. 105–25.

Makdisi, J., 'An Inquiry into Islamic Influences during the Formative Period of the Common Law' in Heer, N. (ed.), *Islamic Law and Jurisprudence: Studies in Honor of Farhat J. Ziadeh*, Seattle and London 1990, pp. 135–46.

Mallette, K., *The Kingdom of Sicily, 1100–1250: A Literary History*, Philadelphia 2005.

Mandalà, G., 'La migration des juifs du Garbum en Sicile (1239)' in Grévin, B. (ed.), *Maghreb-Italie: des passeurs médiévaux à l'orientalisme moderne, XIIIe-milieu XXe siècle*, Rome 2010, pp. 19–48.

Mangiaracina, C. F., 'La ceramica invetriata nella Sicilia islamica e normanna (X–XII secolo)', in Caroscio, M. and Berti, F. (eds) *La luce del mondo. Maioliche Mediterranee nelle terre dell'Imperatore. Catalogo della mostra organizzata dal Museo della Ceramica di Montelupo (S. Miniato 2 marzo–19 maggio 2013)*, Florence 2013, pp. 89–105.

Mannino, M. A. et al., 'Upper Palaeolithic hunter-gatherer subsistence in Mediterranean coastal environments: an isotopic study of the diets of the earliest directly-dated humans from Sicily', *Journal of Archaeological Science*, Vol. 38, Issue 11, 2011, pp. 3094–100.

Maqbul Ahmad, S., 'Cartography of al-Sharīf al-Idrīsī' in Harley, J. B. and Woodward, D. (eds), *The History of Cartography Vol. 2, Book 1: Cartography in the traditional Islamic and South Asian Societies*, Chicago 1992, pp. 156–74.

Marconi, C., *Selinunte. Le metope dell'Heraion*, Modena 1994.

Marconi, S., *Il giardino-paradiso. L'influsso iranico negli orti-giardino e in altri ambiti materiali e immateriali della Sicilia islamica*, Rome 2000.

Marconi, C., 'Gli acroliti da Morgantina' *Prospettiva* 130–1: 2008, pp. 2–21.

Marconi, C., *Temple Decoration and Cultural Identity in the Archaic Greek World: The Metopes of Selinus*, Cambridge 2011.

Marconi, C., 2011b, 'L'identificazione della Dea di Morgantina.' *Prospettiva* 141–142, 2011, pp. 2–31.

Markoe, G. E., *Phoenicians*, London 2000.

Markoe, G. E., 'Current Assessment of the Phoenicians in the Tyrrhenian Basin: Levantine trade with Sicily, Sardinia, and Western Coastal Italy' in Babbi, A. et al., *The Mediterranean Mirror: Cultural Contacts in the Mediterranean Sea between 1200 and 750 B.C.: International Post-doc and Young Researcher Conference Heidelberg, 6–8 October 2012*, Mainz 2015, p. 250.

Marongiu, A., 'Ein 'Modellstaat' im italienischen Mittelalter: Das normannisch-staufische Reich in Sizilien' in Wolf, G. G. (ed.), *Stupor Mundi. Zur Geschichte Friedrichs II. von Hohenstaufen*, Darmstadt 1982, pp. 750–73.

Martindale, J. R., *The Prosopography of the Later Roman Empire*, Vol. 2, Cambridge 1980.

Mascherpa, G., 'Reliquie lombarde duecentesche della Scuola siciliana. Prime indaginie su un recente ritrovamento', *Critica del testo* 16.2, 2013, pp. 9–37.

Mason, E., 'The Hero's Invincible Weapon: an Aspect of Angevin Propaganda' in Harper-Bill, C. and Harvey, R. (eds), *The Ideals and Practice of Medieval Knighthood III*, Woodbridge 1990, pp. 121–37.

Mazzola, P., Raimondo, F. M., and Schicchi, R., 'The agro-biodiversity of Sicily in ancient herbaria and illustrated works', *Bocconea* 16.1, 2003, pp. 311–21.

McInerney, J., *The Cattle of the Sun: Cows and Culture in the World of the Ancient Greeks*, Princeton and Oxford 2010.

McSweeney, A., *The Green and the Brown: A Study of Paterna Ceramics in Mudejar, Spain*, (unpublished PhD thesis, SOAS 2012).

Ménager, L. R., 'L'institution monarchique dans les Etats normands d'Italie. Contribution à l'étude du pouvoir royal dans les principautés occidentales, aux XIe–XIIe siècles', *Cahiers de civilisation médiévale* 2, 1959, pp. 303–468.

Merra, A., 'Hellenistic Tradition in the Mural Painting of Ancient Sicily' in Lyons 2013, pp. 202–9.

Merrills, A. and Miles, R., *The Vandals (The Peoples of Europe)*, Chichester and Walden, MA 2010.

Mertens, D., *Selinus I: die Stadt und ihre Mauern*, Vol. 1, Mainz 2003.

Mertens, D., *Città e monumenti dei greci d'occidente*, Rome 2006.

Metcalfe, A. and Birk, J., 'Ibn Jubayr's Account of Messina and Palermo (1184–85)' in Jansen, K. L., Drell, J. and Andrews, F. (eds), *Medieval Italy: Texts in Translation*, Philadelphia 2011, pp. 234–40.

Metcalfe, A. and Rosser-Owen, M., 'Introduction, Forgotten Connections? Medieval Material Culture and Exchange in the Central and Western Mediterranean', *Al-Masaq* 25, No. 1, 2013, pp. 1–8.

Metcalfe, A., *Muslims and Christians in Norman Sicily: Arabic speakers and the end of Islam*, Oxford 2003.

Metcalfe, A., *The Muslims of Medieval Italy*, Edinburgh 2009.

Molinari, A., 'La produzione e la circolazione delle ceramiche siciliane nei secoli X-XIII' in (n.a.) *Ve Colloque sur la Céramique Médiévale en Méditerranée Occidentale, (11–17 Novembre 1991)*, Rabat 1995, pp. 191–204.

Molinari A., 'La Sicilia e lo spazio mediterraneo dai bizantini all'islam' in Fernández Conde, F. J. and García de Castro Valdés, C. (eds) *Symposium Internacional: Poder y Simbología en la Europa Altomedieval. Siglos VIII-X, "Territorio, Sociedad y Poder", Anejo 2*, 2009, pp. 123–42.

Moorman, E. M., *Divine Interiors: Mural Paintings in Greek and Roman Sanctuaries*, Amsterdam 2011.

Morgan, K., 'Imaginary Kings: Visions of Monarchy in Sicilian Literature from Pindar to Theokritos' in Lyons et al 2013, pp. 98–105.

Morgan, K. A., *Pindar and the Construction of Syracusan Monarchy in the Fifth Century B.C*, Oxford 2015.

Moscati, S. and Uberti, M. L., *Scavi a Mozia, le stele*, Rome 1981.

Musumeci, A., 'Le terracotte figurate della necropoli di contrada Casino in Centuripe' in Biondi 2010, pp. 39–114.

(n.a.) *Natura mito e storia nel regno sicano di Kokalos : atti del Convegno : Sant'Angelo Muxaro, 25-27 Ottobre 1996*, Canicatta 1999, pp. 25–27.

Needham, J., *Science and Civilisation in China. Vol. 3, Mathematics and the Sciences of the Heavens and the Earth*, Cambridge 1959.

Nef, A., 'Comment les Aghlabides ont décidé de conquérir la Sicile', *Annales Islamologiques* 45, 2001, pp. 191–211.

Nef, A., *Conquérir et gouverner la Sicile islamique aux XIe et XIIe siècles*, Rome 2011.

Nef, A. (ed.), *A Companion to Medieval Palermo. The History of a Mediterranean City from 600 to 1500*, Leiden 2013.

Nef, A. and Prigent, V. (eds), *La Sicile de Byzance à l'Islam*, Paris 2010

Neils, J., *The Parthenon Frieze*, Cambridge 2001.

Nicholson, N., *The Poetics of Victory in the Greek West: Epinician, Oral Tradition, and the Deinomenid Empire*, Oxford 2016.

Norwich, J. J., *The Normans in Sicily. The magnificent story of 'the other Norman Conquest'*, London 1992.

Norwich, J. J., *Sicily: A Short History, from the Greeks to Cosa Nostra*, London 2015.

O'Hogan, C., *The Harley Trilingual Psalter*. [online] 2015. Available at: http://britishlibrary.typepad.co.uk/digitisedmanuscripts/2015/05/the-harley-trilingual-psalter.html [accessed 21 March 2016].

Orlandini, P., 'Lo scavo del Thesmophorion di Bitalemi e il culto delle divinità ctonie a Gela', *Kôkalos* 12, 1966, pp. 13–35.

Orsingher, A., 'Listen and protect: reconsidering the grinning masks after a recent find from Motya', in *Vicino Oriente 18*, Rome 2014, pp.145–71.

Osanna, M. and Torelli, M. (eds), *Sicilia ellenistica, consuetudo italica. Alle origini dell'architettura ellenistica d'Occidente, Atti dell'Incontro di studio, Spoleto, complesso monumentale di S. Nicolò, 5–7 Novembre 2004*, Rome 2006.

Pace, B., 'Ori della reggia sicana di Camico', *Archaiologike Ephemeris* 1, 1953-4, pp. 273–288.

Palermo, D., 'La Manifestazioni Artische', in Guzzone, C., *Sikania. Tesori archeologici dalla Sicilia centro-meridionale (secoli XIII-VI a. C.)* Palermo 2005, pp. 71–80.

Palmer, R., 'Agriculture, Greek', in Gagarin, M. (ed.), *The Oxford Encyclopaedia of Ancient Greece and Rome*, Vol. 7, Oxford 2010, pp. 47–9.

Panvini, R. and Sole, L. *La Sicilia in età arcaica: dalle apoikiai al 480 a.C*, Caltanissetta 2009.

Panvini, R., *Gela Arcaica: Are Divinità Tiranni*, Rome 2000.

Papadopoulos, J. K., 'The Mozia Youth: Apollo Karneios, Art, and Tyranny in the Greek West', *The Art Bulletin*, Vol. 96, issue 4, 2014, pp. 395–423.

Park, H., *Mapping the Chinese and Islamic Worlds: Cross-Cultural Exchange in Pre-Modern Asia*, Cambridge 2015.

Patterson, R., 'Plato's Adventures in Syracuse' in de Luca, S. (ed.), *Syracuse, the Fairest Greek City: Ancient Art from the Museo Archeologico Regionale 'Paolo Orsi'*, Rome 1995, pp. 38–42.

Pautasso, A., *Terrecotte arcaiche e classiche del Museo civico di Castello Ursino a Catania*, Catania 1996.

Pennington, K., 'Law, legislative authority and theories of government, 1150–1300' in Burns, J. H. (ed.), *The Cambridge History of Medieval Political Thought C.350–C.1450*, Cambridge 1988, pp. 424–53.

Pennington, K., 'The Birth of the Ius Commune: King Roger II's Legislation', *Rivista Internazionale del Diritto Commune* 17, 2006, pp. 23–60.

Pensabene, P. and Gallocchio, E., 'The Villa del Casale di Piazza Armerina', *Expedition* 53.2, 2011, pp. 29–37.

Pezzini, E., 'Palermo in the 12th Century: Transformations in *forma urbis*' in Nef 2013, pp. 195–232.

Piazza, S., 'Pannello di Soffittatura dal Palazzo Reale di Palermo' in Andaloro Vol. 1, 2006, pp. 543–4.

Pinder-Wilson, R. H. and Brooke, C. N. L., 'The Reliquary of St. Petroc and the Ivories of Norman Sicily', *Archaeologia* 104, 1973, pp. 261–305.

Pirandello, L., *The Old and the Young*, tr. Scott-Moncrieff, C. K., Oxford 2011.

Pironello, V., 'Le terracotte architettoniche di Monte San Mauro presso Caltagirone. Una proposta di revisione' in Luloff, P. S. and Rescigno, C. (eds), *Deliciae Fictiles IV: Architectural Terracottas in Ancient Italy. Images of Gods, Monsters and Heroes*, Oxford 2011, pp. 536–8.

Pizzuto Antinoro, M., *Gli Arabi in Sicilia e il modello irriguo della Conca d'Oro*, Palermo 2002.

Poetters, W., *Nascita del sonetto. Metrica e matematica al tempo di Federico II*, Ravenna 1998.

Portale, C., 'Artistic Culture under Hiero II' in Di Pasquale and Parisi Presicce 2013, pp. 55–60.

Poulle, E., 'L'astronomia' in Toubert, P. and Paravicini Bagliani, A. (eds), *Federico II e le scienze*, Palermo 1994, pp. 122–37.

Prag, J. R. W. and Crawley Quinn, J. (eds), *The Hellenistic West. Rethinking the Ancient Mediterranean* Cambridge 2013.

Prag, J. R. W., 'Bronze rostra from the Egadi Islands off NW Sicily: the Latin inscriptions', *Journal of Roman Archaeology* 27, 2014, pp. 33–59.

Pugliese Carratelli, G. et al, *Sikanie. Storia e civiltà della Sicilia greca*, Milan 1985.

Pugliese Carratelli, G. (ed.), *The Western Greeks: Classical Civilization in the Western Mediterranean*, London 1996.

Raffiotta, S., 'San Francesco Bisconti: i santuari di Demetra e Persefone' in C. Bonanno, *Il Museo Archeologico di Morgantina: Catalogo*, Rome 2013, pp. 77–82.

Rapaport, Y.and Savage-Smith, E., *An Eleventh-Century Egyptian Guide to the Universe. The Book of Curiosities*, Leiden 2014.

Rehm, R., 'Aeschylus in Syracuse', in de Luca, S. (ed.) *Syracuse: The Fairest Greek City: Ancient Art from the Museo Archeologico Regionale 'Paolo Orsi'*, Rome and Atlanta 1989, pp. 31–4.

Ricci, C., 'Il sepolcro di Galla Placidia in Ravenna', *Bollettino d'Arte*, 1913, pp. 389–418.

Ridgway, D., *The First Western Greeks*, Cambridge 1992.

Robb, J., *The Early Mediterranean Village: Agency, Material Culture, and Social Change in Neolithic Italy*, Cambridge 2007.

Robertson, H. S., *The Song of Roland*, London 1972.

Rocco, B. in (n.a.) *L'eta normanna e sveva in Sicilia, Catalogo della mostra*, Palermo, 1994, pp. 220–1.

Ross Holloway, R., *The Archaeology of Ancient Sicily*, London and New York 1991.

Rotolo, A., 'Alcune riflessioni sullo stato delle conoscenze sulla ceramica d'età islamica in Sicilia occidentale (m. IX-s.m. XI secolo)', *Mélanges de l'École française de Rome - Moyen Âge* 123/2, 2011, pp. 545–60.

Runciman, S., *The Sicilian Vespers*, Cambridge 1958.

Rutter, N. K., *The Greek Coinages of Southern Italy and Sicily*, London 1997.

Rykwert, J., *The Dancing Column: On Order in Architecture*, Cambridge, MA and London 1996.

Sami, D., *From Theodosius to Constans II: Church, Settlement and Economy in Late Roman and Byzantine Sicily (AD 378–668)*, (unpublished PhD thesis, University of Leicester 2010).

Sami, D., 'Sicilian cities between the fourth and fifth centuries AD' in García-Gasco, R., González Sánchez, S. and Hernández de la Fuente, D. (eds), *The Theodosian Age (A.D. 379-455). Power, place, belief and learning at the end of the Western Empire, BAR International Series* 2493, 2013, pp. 27–36.

Sanchez Martinez, M., 'Muslims in the Iberian Peninsula, the Mediterranean Coast and its Islands' in Al-Bakhit, M. A. (ed.), *History of Humanity IV: From the seventh to the sixteenth century*, London 1996, pp. 806–18.

Santagati, L. (ed.), *La Sicilia di al-Idrisi ne Il Libro di Ruggero*, Caltanissetta and Rome 2010.

Scheidel, W., 'The Roman Slave Supply' in Bradley, K. and Cartledge, P. (eds), *The Cambridge World History of Slavery, vol. 1: The Ancient Mediterranean World*, Cambridge 2011, pp. 287–310.

Schilling, R., *La religion romaine de Vénus depuis les origines jusqu'au temps d'Auguste*, Paris 1954.

Scott, M., *Delphi and Olympia: The Spatial Politics of Panhellenism in the Archaic and Classical Periods*, Cambridge 2010.

Settis, S., 'Per l'interpretazione di Piazza Armerina', *Mélanges de l'Ecole Française de Rome – Antiquité* 87.2, 1975, pp. 873–994.

Shalem, A., *The Oliphant: Islamic Objects in Historical Context*, Leiden 2004.

Shalem, A. and Troelenberg, E., 'Bemalter Kasten aus Elfenbein' in Wieczorek, Schneidmüller and Weinfurter 2010, pp. 217–8.

Shepherd, G., 'Dead Men tell no Tales: Ethnic Diversity in Sicilian Colonies and the Evidence of the Cemeteries', *Oxford Journal of Archaeology* 24.2, 2005, pp. 115–36.

Shepherd, G., 'Women in Magna Graecia' in James, S. L. and Dillon, S. (eds), *A Companion to Women in the Ancient World*, Chichester 2015, pp. 215–28.

Siede, I., 'Neues Wissen' in Wieczorek, Schneidmüller and Weinfurter 2010, p. 276.

Sigler, L., *Fibonacci's Liber Abaci, A Translation into Modern English of Leonardo Pisano's Book of Calculation*, New York 2002.

Simeti, M. T., *Pomp and Sustenance: Twenty-five centuries of Sicilian food*, New York 1989.

Simonsohn, S., *Between Scylla and Charybdis: The Jews in Sicily*, Leiden 2011.

Smith, N. J. C., *Servicium Debitum and Scutage in Twelfth Century England With Comparisons to the Regno of Southern Italy*, (unpublished PhD thesis, Durham University 2010). [online] Available at: http://etheses.dur.ac.uk/454/ [accessed 21 March 2015].

Spatafora, F., 'Ethnic Identity in Sicily: Greeks and Non-Greeks', in Lyons et al 2013, pp. 37–47.

Spawforth, T., *The Complete Greek Temples*, London 2006.

Spoto, S., *Sicilia antica: usi, costumi e personaggi dalla preistoria alla società greca, nell'isola culla della civiltà europea*, Rome 2002.

Spufford, P., *Money and its Use in Medieval Europe*, Cambridge 1988.

Stansbury-O'Donnell, M., *A History of Greek Art*, Chichester 2015.

Stein, J. B., *Commentary on the Constitution from Plato to Rousseau*, Maryland 2011.

Stieber, M., *The Poetics of Appearance in the Attic Korai*, Austin 2004.

Stone III, S. C., 'Sextus Pompey, Octavian and Sicily', *American Journal of Archaeology* 87, 1983, pp. 11–22.

Strassler, R. B. (ed.), *The Landmark Thucydides: A Comprehensive Guide to the Peloponnesian War*, New York 1996.

Strassler, R. B. (ed.), *The Landmark Herodotus: The Histories*, London 2008.

Taburet-Delahaye, E., 'Chasse of Saint Thomas Becket' in Drake Boehm, B. and Taburet-Delahaye, E. (eds) *Enamels of Limoges: 1100–1350*, New York 1996, pp. 162–4.

Takayama, H., *The Administration of the Norman Kingdom of Sicily*, Leiden 1993.

Taylor, J. A., *Muslims in Medieval Italy: The Colony at Lucera*, Maryland 2003.

Thatcher, O. J., and McNeal, E. H., *A sourcebook for Medieval history. Selected documents illustrating the history of Europe in the Middle Ages*, New York 1905.

Theotokis, G., 'The Norman Invasion of Sicily, 1061-1072: Numbers and Military Tactics', *War in History* 17.4, 2010, pp. 381–402.

Thomas, J., Constatinides, A. and Constable, G., *Byzantine Monastic Foundation Documents: A Complete Translation of the Surviving Founders' Typika and Testaments*, Cambridge MA 2000.

Thompson, F. W., 'A graffito on the Society's Limoges chasse', *The Antiquaries Journal* 60.2, 1980, pp. 350–7.

Todaro, P., *Il sottosuolo di Palermo*, Palermo 1988.

Tolmacheva, M., 'The Medieval Arabic Geographers and the Beginnings of Modern Orientalism', *International Journal of Middle East Studies* 27.2, 1995, pp. 141–56.

Travaini, L., *La monetazione nell'Italia normanna*, Rome 1995.

Tribulato, O. (ed.), *Language and Linguistic Contact in Ancient Sicily*, Cambridge 2012.

Tribulato, O., 'Siculi bilingues? Latin in the Inscriptions of Early Roman Sicily' in Tribulato 2012, pp. 291–325.

Trnek, H., 'Spada con fodero' in Andaloro Vol. 1, 2006, pp. 73–5.

Tronzo, W., *The cultures of his kingdom: Roger II and the Cappella Palatina in Palermo*, Princeton 1997.

Tronzo, W., 'The Norman Palace in Palermo as Display' in Andaloro 2006, Vol. 2, p. 313–5.

Tronzo, W., 2006a, 'King Roger's Mantle, Part and Whole' in Andaloro Vol. 2, 2006, pp. 443–6.

Tusa, S. and Royal, J., 'The landscape of the naval battle at the Egadi Islands (241 B.C.)', *Journal of Roman Archaeology* 25, 2012, pp. 7–48.

Tusa, V., 'I Fenici e I Cartaginesi' in Caratelli 1985, pp. 610–1.

Vagnoni, M., '"Caesar semper Augustus". Un aspetto dell' iconografia di Federico II di Svevia', *Mediaeval Sophia* 3, 2008, pp. 142–61.

van der Meijden, H., *Terrakotta-Arulae aus Sizilien unde Unteritalien*, Amsterdam 1993.

van Wijngaarden, G. J., *Use and Appreciation of Mycenaean Pottery in the Levant, Cyprus and Italy 1600–1200 BC*, Amsterdam 2002.

van Wonterghem Maes, K., *De polychrome en plastische keramiek van Canosa di Puglia gedurende de Hellenistische periode*, Leuven 1968.

Vassallo, S., 'Le battaglie di Himera alla luce degli scavi nella necropoli occidentale e alle fortificazioni. I luoghi, i protagonisti' in *Sicilia Antiqua*, Vol. 7, 2010, pp. 17–38.

Vincent, N., 'Languages in Contact in Medieval Italy' in Lepschy, A. L. and Tosi, A. (eds) *Rethinking Languages in Contact. The Case of Italian*, London 2006, pp. 12–27.

Vitale, E., 'Relief mit Lebensbaum' in (n.a.) *Sizilien. Von Odysseus bis Garibaldi*, Munich 2008, pp. 290–1.

Warren, J., 'Creswell's Use of the Theory of Dating by the Acuteness of the Pointed Arches in Early Muslim Architecture', *Muqarnas* 8, 1991, pp. 59–65.

Warren, M. R., 'Roger of Howden Strikes Back: Investing Arthur of Brittany with the Anglo-Norman future' in Harper-Bill, C. (ed.) *Anglo-Norman Studies XXI: Proceedings of the Battle Conference 1998*, Woodbridge 1998, pp. 261–72.

Watson, A., 'The Arab Agricultural Revolution and Its Diffusion, 700–1100', *The Journal of Economic History* Vol. 34 Issue 1, 1974, pp. 8–35.

Watson, A., *Agricultural Innovation in the Early Islamic World. The Diffusion of Crops and Farming Techniques, 700–1100*, Cambridge 1983.

Weiler, B., 'Matthew Paris, Richard of Cornwall's candidacy for the German throne, and the Sicilian Business', *Journal of Medieval History* 26.1, 2000, pp. 71–92.

Wescoat, B. D., *The Temple of Athena at Assos*, Oxford 2012.

White, D., 'Demeter's Sicilian Cult as a Political Instrument', *Greek, Roman and Byzantine Studies* 6, 1965, pp. 261–79.

Whitehead, F., *La Chanson de Roland*, Oxford 1946.

Whitehouse, D., 2011, 'Hedwig Beakers: All About Glass', *Corning Museum of Glass*, [online] Available at: http://www.cmog.org/article/hedwig-beakers [Accessed 3 February 2016].

Wieczorek, A., Schneidmüller, B. and Weinfurter, S. (eds), *Staufer und Italien, II, Objekte. Ausstellungskatalog über die Staufer-Ausstellung im Reiss-Engelhorn-Museum*, Stuttgart 2010.

Wiederkehr Schuler, E., *Les protomés féminines du Sanctuaire de la Malophoros à Sélinonte, 2 Vols*, Naples 2004.

Wikander, C., *Sicilian Architectural Terracottas*, Stockholm 1986.

Wilson, R. J. A., *Piazza Armerina*, London 1983.

Wilson, R. J. A., *Sicily Under the Roman Empire: The Archaeology of a Roman Province 36 BC-AD 535*, Warminster 1990.

Wilson, R.J.A., 'Hellenistic Sicily, c. 270–100 BC' in Prag and Crawley Quinn 2013, pp. 79–119.

Wixom, W. D., 'Girifalco' in Calà Mariani, M. S. and Cassano, M. R. (eds), *Federico II. Immagine e potere*, Venice 1995, p. 490.

Woodward, J. (ed.), *The Physical Geography of the Mediterranean*, Oxford 2009.

Zecchino, O., *Le assise di Ruggiero II: Problemi di storia delle fonti e di diritto penale*, Naples 1980.

Illustration Acknowledgements

Collection inventory numbers of objects are given where known.

CRicd Centro Regionale per l'inventario, la catalogazione e la documentazione dei beni culturali della Regione Siciliana

© Regione Siciliana
 © Regione Siciliana, Assessorato dei Beni Culturali e dell' Identità Siciliana – Dipartimento dei Beni Culturali e dell'Identità Siciliana

* Exhibited *Sicily: culture and conquest*, British Museum 2016

Half-title page:
 * The Bodleian Libraries, The University of Oxford. MS Pococke 375, f.187a-188b
Frontispiece:
 * The Cloisters Collection, 1947 (47.101.60). © 2016. Image copyright The Metropolitan Museum of Art/Art Resource/Scala, Florence
p. 5: * © Regione Siciliana, CRicd, inv. G.E. 19286
p. 7: * Antiquarium S Cipirello (PA), inv. S 11 (photo: Dirk Booms)
p. 15 © The Trustees of the British Museum (artwork: Kate Morton)
Fig. 1: © Regione Siciliana, CRicd
Fig. 2: Planet Observer/ IUG/ Bridgeman images
Fig. 3: © The Trustees of the British Museum (photo: Dudley Hubbard)
Fig. 4: © Regione Siciliana, CRicd
Fig. 5: © Regione Siciliana, CRicd (Fondo Orao)
Fig. 6: © The Trustees of the British Museum, 1946,0101.1403
Fig. 7: © Regione Siciliana (photo: Giuseppe Mineo). Aidone Museo Regionale Archeologico, inv. 1981.11.22
Fig. 8: Diego Barucco / Alamy Stock Photo
Fig. 9: © The Trustees of the British Museum, 1946,0101.821
Fig. 10: © Bibliothèque Royale de Belgique, Brussels. Cabinet des Medailles, inv. DE Hirsch 269
Fig 11· © Regione Siciliana, CRicd (photo: Francesco Passante)
Fig. 12: DEA/ R. Carnovalini/ Getty Images
Fig. 13: * © Regione Siciliana (photo: Giuseppe Mineo). Museo Archeologico Regionale Di Agrigento, inv. AG 4328
Fig. 14: © Regione Siciliana, CRicd (Fondo Orao)
Fig. 15: * © Regione Siciliana, Archivio Museo Archeologico Paolo Orsi, Siracusa (photo: G. Gallitto), inv. 8922
Fig. 16: * © The Trustees of the British Museum, 1961,1203.1
Fig. 17: * © Regione Siciliana, Archivio Museo Archeologico Paolo Orsi, Siracusa (photo: G. Gallitto), inv. 14731
Fig. 18: © Regione Siciliana, Archivio Museo Archeologico Paolo Orsi, Siracusa (photo: G. Gallitto)
Fig. 19: © Regione Siciliana, CRicd (Fondo Orao) Museo Whittaker Giovinetti di Motya, inv. MT 67/316, inv. S 246

Fig. 20: Photo: Christopher Evans/ UNISA.
Fig. 21: * © The Trustees of the British Museum, 1856,1223.456
Fig. 22: © Regione Siciliana, CRicd. Museo Whittaker Giovinetti di Motya, inv. 2723/64
Fig. 23: © The Trustees of the British Museum (artwork: Kate Morton)
Fig. 24: Bibliothèque Nationale de France, RESAC K-720 face p. 48, pl.CCXXXVII, fig. 2
Fig. 25: * © The Trustees of the British Museum, 1772,0314.70
Fig. 26: * © Regione Siciliana, CRicd. Museo Archeologico Regionale Paolo Orsi, Siracusa, inv. 46517
Fig. 27: * © Regione Siciliana, CRicd. Museo Archeologico Regionale Paolo Orsi, Siracusa, inv. 45905
Fig. 28: © akg-images. Museo Archeologico Ibleo, Ragusa, inv. 8981
Fig. 29: From: *Sikanie*, © 1985 Credito Italiano (UniCredit group) /Museo archeologico Paolo Orsi, Siracusa, inv.96918
Fig. 30: * © Regione Siciliana, Archivio Museo archeologico Paolo Orsi, Siracusa, inv. 96918
Fig. 31: * © Regione Siciliana, Archivio Museo archeologico Paolo Orsi, Siracusa, inv. 84813
Fig. 32: * © Regione Siciliana, Archivio Museo archeologico Paolo Orsi, Siracusa, inv. 84819
Fig. 33: * © Regione Siciliana, CRicd. Museo archeologico Paolo Orsi, Siracusa, inv. 18670
Fig. 34: © Regione Siciliana, Archivio Museo archeologico Paolo Orsi, Siracusa, inv. N 53209
Fig. 35: © Regione Siciliana, CRicd. Museo archeologico Paolo Orsi, Siracusa, inv. 53234
Fig. 36: © Regione Siciliana, Archivio Museo archeologico Paolo Orsi, Siracusa, inv. 49401
Fig. 37: © Regione Siciliana, photo: Giuseppe Mineo. Museo Archeologico Regionale di Gela, inv. Sop BL 10
Fig. 38: © Regione Siciliana, CRicd Museo Archeologico Regionale di Gela, inv. Sop BL 12.
Fig. 39: * © Regione Siciliana, Photo: Giuseppe Mineo. Museo Archeologico Regionale di Gela, inv. Sop BL 30
Fig. 40: © Regione Siciliana, CRicd. Museo Archeologico Regionale Antonio Salinas, Palermo, inv. 3913
Fig. 41: * © The Trustees of the British Museum, RPK,p222B.2.Agr
Fig. 42: * © The Trustees of the British Museum, 1912,0714.8
Fig. 43: * © The Trustees of the British Museum, G.2829
Fig. 44: * © The Trustees of the British Museum, 1946,0101.1007
Fig. 45: © Regione Siciliana, Monte Iato Antiquarium, inv. V 2618
Fig. 46: * © The Trustees of the British Museum
Fig. 47: * © Regione Siciliana (photo: John Williams). Museo Archeologico Regionale Antonino Salinas, Palermo, inv. 309.
Fig. 48: © Regione Siciliana (photo: The J. Paul Getty Museum, California). Museo Archeologico Regionale, Aidone, inv. 62-1239
Fig. 49: © Regione Siciliana, CRicd. Museo Archeologico Regionale, Aidone, inv. E 9150
Fig. 50: © Regione Siciliana, CRicd. Museo Archeologico Regionale, Aidone
Fig. 51: © Regione Siciliana (photo: The J. Paul Getty Museum, California). Museo Archeologico Regionale, Aidone
Fig. 52: * © The Trustees of the British Museum, 1823,0610.1
Fig. 53: © The Trustees of the British Museum, 1848,0212.66
Fig. 54: © Regione Siciliana. Soprintendenza Beni Culturali e Ambientali di Palermo
Fig. 55: akg-images / Erich Lessing. Delphi Archaeological

Museum, Inv. 3484, 3450
Fig. 56: © Regione Siciliana, CRicd (photo: Marco Giacalone). Museo Giuseppe Whitaker, Motya, inv. 23102
Fig. 57: * © Regione Siciliana, CRicd. Museo Archeologico Regionale Antonino Salinas, Palermo, inv. 1553
Fig. 58: © The Trustees of the British Museum, 1946,0101.817
Fig. 59: © The Trustees of the British Museum, 1946,0101.1545
Fig. 60: © Dirk Booms
Fig. 61: © The Trustees of the British Museum (artwork: Kate Morton)
Fig. 62: © 2016 DeAgostini Picture Library/Scala, Florence. Museo Archeologico Regionale, Caltanisetta, inv. 675
Fig. 63: © Regione Siciliana, CRicd. Museo Archeologico Paolo Orsi, Siracusa, inv. 50681
Fig. 64: * Photo Scala, Florence – courtesy of the Ministero Beni e Att. Culturali © Regione Siciliana, Museo Archeologico Regionale di Gela, inv. 8585
Fig. 65: © Regione Siciliana, Archivio Museo Archeologico Paolo Orsi, Siracusa, inv. 34241
Fig.66: * © Regione Siciliana, Museo Archeologico Regionale di Gela, inv.35688 / The Trustees of the British Museum (artwork: Kate Morton)
Fig. 67: * © Regione Siciliana, Archivio Museo archeologico Paolo Orsi, Siracusa, inv. 23831 and 23708 / The Trustees of the British Museum (artwork: Kate Morton)
Fig. 68: © The Trustees of the British Museum, 2015,5009.48
Fig. 69: * © Regione Siciliana, CRicd. Museo Archeologico Regionale Antonino Salinas, Palermo, inv. 3919
Fig. 70: © Regione Siciliana (photo: John Williams). Museo Archeologico Regionale Antonio Salinas, Palermo, inv. NI 3920 C
Fig. 71: © Regione Siciliana, Museo Archeologico Regionale Antonio Salinas, Palermo, inv. NI 3920 A-C
Fig. 72: © Regione Siciliana, Cricd
Fig. 73: © noreal.it
Fig. 74: * © Regione Siciliana (photo: John Williams). Museo Archeologico Regionale Antonio Salinas, Palermo, inv. 3899
Fig. 75: © Regione Siciliana (photo: Giuseppe Mineo).
Fig. 76: © Regione Siciliana, CRicd Museo Archeologico Regionale Antonio Salinas, Palermo, inv. NI 3921C
Fig. 77: * © Regione Siciliana, CRicd (Fondo Orao). Museo Archeologico Regionale Antonio Salinas, Palermo, inv. NI 3884
Fig. 78: © Regione Siciliana, Museo Archeologico Regionale Pietro Griffo, Agrigento
Fig. 79: © Regione Siciliana, Museo Archeologico Regionale Pietro Griffo, Agrigento
Fig. 80: © Regione Siciliana, CRicd (Fondo Orao)
Fig. 81: * © Regione Siciliana, CRicd (Fondo Orao) Museo Archeologico Regionale Di Agrigento, inv. AG 217
Fig. 82: * © Regione Siciliana, CRicd. Museo Archeologico Regionale Paolo Orsi, Siracusa, inv. 20087
Fig. 83: © Regione Siciliana, Soprintendenza di Agrigento (photo: Angelo Pitrone). Museo Archeologico Regionale, Camarina, inv. 6305
Fig. 84: * © Regione Siciliana, CRicd (Fondo Orao). Museo Archeologico Regionale Paolo Orsi, Siracusa, inv. 4882
Fig. 85: © Regione Siciliana, CRicd
Fig. 86: © The Trustees of the British Museum, Oo,4.35
Fig. 87: © The Trustees of the British Museum, 1987,0649.173
Fig. 88: © Regione Siciliana, CRicd. Museo archeologico Paolo Orsi, Siracusa, inv. 741
Fig. 89: * © The Trustees of the British Museum, 1946,0101.1545

Index